OBJECTS/HISTORIES

Critical Perspectives on Art,
Material Culture, and Representation

A series edited by Nicholas Thomas

*Published with the assistance of
the Getty Foundation*

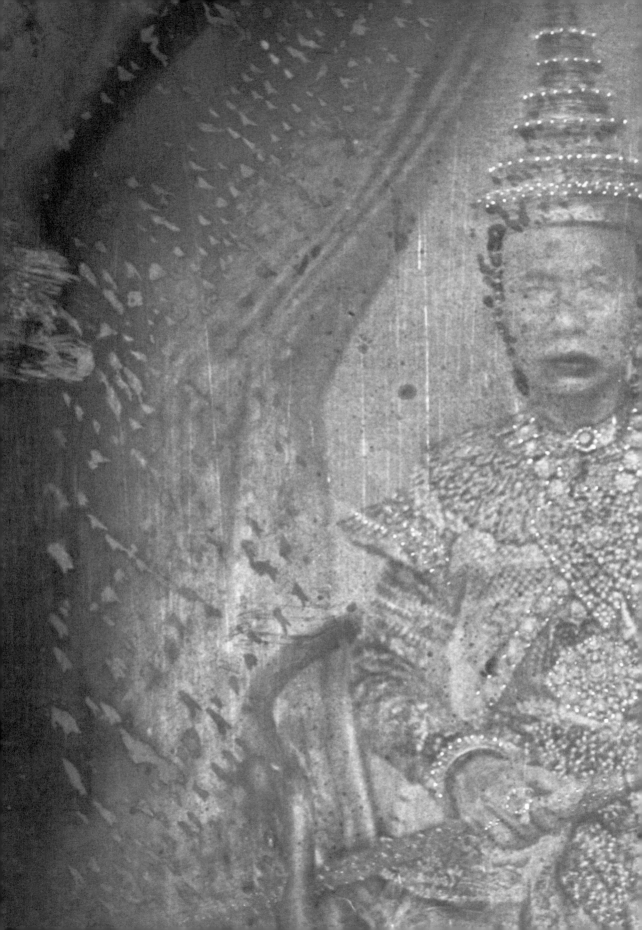

PHOTOGRAPHIES EAST

The Camera and Its Histories

in East and Southeast

Asia

EDITED BY ROSALIND C. MORRIS

Duke University Press

Durham & London

2009

© 2009 Duke University Press

All rights reserved

Printed in the United States

of America on acid-free paper ♾

Designed by Amy Ruth Buchanan

Typeset in Monotype Fournier by

Tseng Information Systems, Inc.

Library of Congress Cataloging-in-

Publication Data appear on the last

printed page of this book.

James Siegel's essay originally

appeared as "The Curse of the

Photograph" in *Indonesia* 80

(2005): 21–37. Reprinted

with permission.

THIS BOOK has been very long in the making, much longer than either I or the contributors could have wished. It was diverted at various points by the personal losses suffered by several of our contributors, a fact that perhaps infused our respective meditations on photography with an additional melancholia. Unlike Roland Barthes, who wrote the death of his mother into the very heart of his theory of photography, our text is more quietly haunted by the fact that three of our contributors suffered their mothers' death while the book was being compiled. It is dedicated to them, the women whom we recall with and without photos.

CONTENTS

ROSALIND C. MORRIS

Introduction

Photographies East

The Camera and Its Histories

in East and Southeast Asia

The contemporary student of photographic history in Asia, as elsewhere, is confronted with the enormously difficult task of apprehending the shock and sense of utter improbability that accompanied the new technology as it moved along the pathways of colonialism, adventurism, and modern capital to displace or transform existing economies of representation. In an era when the camera is not only universally ubiquitous but indissociable from almost every other mode of communication, that shock and sense of improbability is the very sign of the foreign. Indeed, it has been so since the earliest days of photography, when the camera was perceived as much as an instrument of European aggressivity and the occult power of technology as any other weaponry in the colonial arsenal.

IN AN IDEAL IMAGE, THE SPIRIT OF THINGS

Consider, in this context, the writings of John Thomson (1837–1921), the peripatetic photographer whose images of Siam, Cambodia, Vietnam, Penang, Singapore, and China would inaugurate so many of the conventions by which Asia would be represented to and for Europeans. Reflecting on his career in China, Thomson remarked, "[I] frequently enjoyed the reputation of being a dangerous geomancer, and my camera was held to be a dark mysterious instrument, which, combined with my naturally, or supernaturally, intensified eyesight gave me power to

see through rocks and mountains, to pierce the very souls of the natives, and to produce miraculous pictures of some black art, which at the same time bereft the individual depicted of so much of the principle of life as to render his death a certainty within a very short period of years."[1] Thomson continues in this vein of romantic self-othering, and thus of self-constitution, by noting, "[The] superstitious influences . . . rendered me a frequent object of mistrust." His account is a veritable cliché of the encounter between East and West via the aperture of the camera, and one is tempted to disregard it as a result. And yet, these by now banal claims to technological heroism and subjective mastery, as well as the insinuations of superstitious excess among the peoples of Asia, are punctuated by two remarkable and revealing observations. The first informs us that greater animosity was displayed toward camera-bearing foreigners in the city than in the country, an observation that forces us to reconsider any temptation to conflate technophobia with rurality. The second is that Chinese photographers fared even more poorly than did Europeans when the suspicions of the mob became cathected to the camera — revealing the problematic of the foreign to be irreducible to radical or at least visible cultural or political difference.

I linger, if only briefly, on these otherwise rather prosaic remarks by Thomson because, despite being mired in a somewhat trite Manichaeism, they also open onto a set of questions about photography in Asia that exceeds the commonly posited dichotomy of East and West as the seats of technological modernity and organic primitivity, respectively. Distilled here are the germs of several themes that are taken up by the contributors to this volume: the intimacy between photography and death, and also between photography, the crowd, and violence; the perception of occult powers inherent in technology, for which the camera serves as figure; the capacity of the camera to disseminate, dislodge, and transmute the category of the foreign; the question of vision as being either prostheticized or surpassed by the camera; the linkage of the camera with practices of political domination and suppression; and the sense that photography is the instrument of History. Of these issues, more will be said. But let us not leave Thomson just yet.

Thomson was a devoted, not to say servile student of Ruskin.[2] For all his proto-ethnographic pretensions (and influences: he was the instructor of photography at the Royal Geographic Society from 1886 onward), he imagined photography to be an art, albeit one in which the photographer

was less an auteur than a mere "operator" of light. In this regard he was typical of his moment, expressing the simultaneously positivist enthusiasm for nature's trace and the democratic artist's hope that the camera could also liberate a new form of beauty for the cultivated and also the unschooled eye. In this particular combination of attributes and possibilities, Thomson thought, a pleasurably and ethically cosmopolitan pedagogy might be found. "The camera should be a power in this age of instruction for the instruction of the age," he pronounced.[3] Accordingly, he submitted his work to sociological ends in both Asia and London. These ends called forth the image of a social type, which Thomson construed in class terms in Europe and in national and racialized terms in Asia.[4] Thus, his archive is known for the faces of destitution in London's slums and the situated portraits of both kings and rice winnowers in Asia. In both cases, the essence of the type was tied to the context and the activities of the sitter, but the English subjects appear to have been caught in their respective acts, while the Asians seem rather to be demonstrating theirs.

Despite the relative contingency and temporal situatedness of the European photographs and the self-disclosing and static quality of the Asian images, Thomson's sociological photography was driven by the possibility that the photograph could distill the essence of a social position. And it is no doubt for this reason that his sociological ambitions were articulated in an aesthetic idiom not far removed from allegory; composition was to be guided by the pursuit of unity, and this was to be achieved through the elevation of a single element to the status of guiding principle for the entire view. In short, the photograph was to exceed the mere reproduction of nature by becoming emblematic. Roland Barthes would later describe this as the basis of a quality in journalistic photographs that he would call, someone disparagingly, "unary," and it is one of the reasons why much of Thomson's imagery now seems so stereotypical.[5] The banality of this stereotypy is a function of its having been reproduced in history; we are now more than familiar with these kinds of images, and they elicit little more than a nod of recognition from us. But the stereotypy itself was intentional. Or, rather, the recognizability of the imagery, as representative of a type, was the goal.

Such stereotypy would be the opposite of what Siegfried Kracauer, in contrasting properly historical representations with the historicism of photography, called the monogram.[6] The monogram in Kracauer's analysis is the memory image, the last recalled image of a person whose lived

history and relations to others generates a sense of his or her "truth"; anything which does not signify in terms of that truth—what is often called the essence of a person or personality—is generally omitted from these images. Historically, the monogram was associated with other forms of representation, whether painterly or fictional. And in the early days of photography, when sitters were required to pose for many seconds or even minutes, photographs retained something of this distilled and distilling quality. For this reason, Walter Benjamin suggested that the "procedure caused the subject to focus his life in the moment."[7] But with the advent of the snapshot, photographs abandoned this capacity to the other arts. In Kracauer's reading, the relatively instantaneous photographs were absolutely of the moment in which they were produced and possessed a timeliness which could be seen in the outdated fashion that adhered to older photographs, especially of women. He concluded that, as a consequence, they could not emit the truth of memory or function as monograms.

Kracauer's pronouncements notwithstanding, the allure of portrait photography continues to be the promise of this now surpassed representational capacity. Indeed, it was the essential or focused truth of being that Barthes sought, so mournfully, in a photograph of his dead mother, and which he finally acknowledged could not be located there (hence, there is no picture of his mother in *Camera Lucida*, the book dedicated to her). Nickola Pazderic tells us of similar, if ironically codified ambitions in the industry of contemporary marriage portraiture in Taiwan. In the end, however, we find this residual but endlessly renewed hope articulated most potently in the moment of a photograph's perceived failure. It is voiced each time someone says or thinks, "That photograph does not look like me."

When, by contrast, people say, as they do in some situations, that they do not resemble their photograph, we know that something profound has occurred in the history of representational practice and in the popular consciousness that inhabits the people photographed. I believe it is such a change, at once minute and enormously significant, that becomes discernible when one juxtaposes the writings of Thomson and Kracauer on the question of the stereotype and the monogram. Between the former's enthusiasm for the imagery of essence and the latter's jubilant abandonment of it lies the tale of a small revolution, a photographic revolution. Recognizing it, we learn to ask if a comparable change can be perceived elsewhere, in other worlds that the camera has transformed.

Instead of photographs as emblems or stereotypes, Kracauer's analysis sees photography as the evidence of an economic system of which it is the mere "secretion" and which has reduced everything to mere materiality.[8] This is what it can reveal. Retrospectively (or anachronistically), Kracauer's text contains an implicit accusation against the error of a typological ethos in photography, on the grounds that it misrecognizes in the timely photograph the timeless image of the social type, whether the pauper or the rice winnower, the shoeshine man or the Oriental monarch.[9] One can imagine Kracauer chastising Thomson for not knowing that the pursuit of emblematic representation is a violation of photography's more radical promise. The criticism would be well taken; many censorious histories of anthropological and colonial photography rest on similar grounds (though they are rarely so evocatively or eloquently stated). Yet, if it is true that the endeavor to produce representative photographs can only fix a moment, thus severing it from a life which must otherwise culminate in death, it is also true that this violent ambition of photography leaks back into the social world and summons people to perform in terms of an image that circulates on their behalf and in terms of which they become recognizable — first to authorities, and then to themselves.[10] Here, the dissonance between life and photography threatens to dissipate in a lived deathliness, as people increasingly attempt to resemble, under the influence of various institutional and technological encouragements, their own (future) images. This, rather than pornographic objectification, is the violence of representation to which so many postcolonial critics point (with more or less precision) when they accuse photography and colonial-era visual anthropology of complicity in cultural destruction.[11]

The social and historical effectivity of the camera in this sense was rather remote on the horizon of Kracauer's thought. In comparison, Thomson's writing assumes additional interest. This is because it not only espouses the ideology of photography at the moment in which it appears regressively attached to representational functions (allegory, the emblem) previously assigned to painting, but because it also discloses the unseen and not yet realized truth of a world-transforming process which it has inaugurated. That is the process by which people start to comport themselves in terms of the ideal images of cultural types and class profiles which photography disseminates, through such devices as ethnically marked costume, poses, and the ethnographic mise-en-scène. If this pro-

cess is dissimulated in and by the fashion industry, which offers the consolation of false difference while artificially hastening the transformation of such images in Western and Westernized contexts, it is nonetheless an increasingly ubiquitous process. Often accompanied by sartorial regulations and practices of governance that entailed ethnic registration and identity documentation, it became a compulsion in many colonial contexts. It was absolutely central to the experience of photography in Asia, where the question of the foreign would lead to a demand for the production of forms that could permit recognition.

What does foreignness mean in this context? And what was photography's relationship to that foreignness, other than the promise of containment through recognition? For, despite being associated with a capacity for linguistic transcendence, the camera seems also to have been inextricable from the experience of an emergent difference. This is why, despite his aspiration to unity and despite his labor to generate the emblems of various social types, Thomson could nonetheless recognize that different aesthetic and social standards governed the portraiture produced by European and Chinese photographers—and the latter were growing in numbers as he made his way across Asia. It was a recognition that may be said to constitute something of a repressed origin for the form of visual anthropology, increasingly prevalent today, which takes for its object the discovery of visual vernaculars and culturally specific modes of photography.[12]

The question of the vernacular retains its significance, and there is much to be gained from accounts of the specific traditions within which photography is taken up, used, and refused (as the writers in this volume attest). However, foreignness, that which the camera generates and that to which the discourse of photography responds with the fantasy of transcendence, cannot be reduced to the question of the local or the idea of the vernacular. The foreignness that Thomson reveals in the discourse of his Asian interlocutors is not a matter of cultural style, and it cannot be properly analogized with language unless, as Marx once said of the commodity form, it is analogized with language as translation.[13] But the difficulty of analyzing it arises from the fact that it emerges precisely in the talk about cultural style and local predilections.

Whenever he attempted to grasp something of the difference that opened in the field of photography as practiced and experienced by Europeans and Asians in Asia, Thomson seems to have been gripped by two particularly powerful tropes. These tropes expressed an answer to

the question What do they think of the camera? or What does photography represent to and for them? The first trope attributed morbid powers to the camera and linked it with death. It posited the camera as a parasitical technology whose capacity to produce vivacious imagery relied, precisely, on the evacuation of life from the living.[14] The second trope expressed an aspiration to totality in a visible mode and often took the form of an aesthetic that required every photographic portrait (if it was to be made) to reveal both eyes, both ears, and the entire front of the body—all the features deemed representative of a person's wholeness and humanness. According to this aesthetic, which seems, at first sight, to contradict the former, nothing should be withheld from the camera, and nothing should be occulted in or by the image. Such an ambition or prohibition appears to be linked to a suspicion of shadow and, moreover, to express a belief that the camera itself projected shadow upon the face of the one photographed. In this normativizing aesthetic, shadow is a kind of defacement, a wound in the transparency which ought to define the photograph and the communicative relation it was thought to facilitate by those who embraced it.[15]

In Thomson's writings, as in those of myriad proto-ethnographers, the talk about local style invariably collapses into a discourse upon either the illegibility of the photograph to non-Western eyes or the supernatural capacities imputed to the camera by naïve, usually non-Western sensibilities. On the one hand, it is a discourse about the lack of signifying capacities in the photograph for those unfamiliar with it; on the other, it is a discourse about the excess of signifying power in the photograph. The choice is meaninglessness or magic.

One may read these putatively Oriental conceptions of photography as mere projections (Thomson's imagining of their imagining). We can also read them as misrecognitions of a discourse that remained largely untranslatable to Thomson, though in this regard, it is not incidental that Thomson produced translations of photographic terminology from English to Chinese.[16] We can even imagine them as an accurate transcription of the alarmed responses of people who would yet submit to photographic technology as an instrument of nature's self-reproduction or as a technique of violent objectification, or even as a mode of self-extension (renown-making) through the circulation of copies. To the extent that Thomson's renditions of Asian responses merely caricature expressions of a falsely essentialized Asian relationship to photography, they can be dismissed. To the extent that they reflect sentiments that have been

superseded, they may be relegated to history, where they can function as the trace of an encounter to which the archive will provide only partial access. But we may also wonder if the insistent and regular recurrence of such statements and their echoes (as described in the essays that follow) reveals something not only about local codes of representation and representability (and the colonists' drive to represent everything as that which can be seen),[17] but also about photography itself. This is, perhaps, an imprecise formulation. I do not mean that these multiply redacted statements reveal something about technological essence. If they can be made to reveal something about photography, it is because they reveal photography *as* discourse, as a discourse of technology—a discourse that is at once of and on the camera, emanating from it and addressing it as an object. Photography may, in the end, be said to constitute the discursive elaboration of a technologized relationship to difference.

What of this discourse, which takes so many forms in so many places and is articulated in so many distinct languages and idioms? If we relinquish a literalist reading of the tropes mentioned above, and if we consider the seemingly contrary sentiments as being, somehow, related to each other, we can perhaps understand that, at least according to Thomson, the camera was conceived by the Asians he met as a source of absolute foreignness. It introduced that which not only interrupted the form and course of a singularly experienced life, but which could contradict it to the point of destruction (either by robbing the subject of life, or by defacing him or her and thereby undermining his or her place in the social field). This foreignness, if we are to grant its existence as a force, was variously related to the fact of European colonialisms and their aftermaths, but while it is indissociable from these histories it is not reducible to them. Foreignness as it emerges in Thomson's account of his photographic journeys in Asia is not a property of Asians or of Asians as seen by Europeans, or even of Europeans as seen by Asians in Asia, so much as the structure of a relation between Asia and Europe and within Asia itself: one that marks and figures the experience of a new, technologically mediated historical consciousness and a new experience of history as the name of a mutually othering relation between the bearers of technology and their others. This possibility hangs above all of the essays in this volume, though it is not articulated as such by any. It is perhaps premature to postulate it as an overarching structure within which to read them at this point. I introduce it here as a way of indicating that impossible coherence toward which a collection of differently authored essays can only point.

What characterizes those with photographic technology, it seems, is their own experience of difference as temporalized. The idea of foreignness contained in the discourse of photography, as relayed to us by John Thomson, has as its corollary a conception of the camera as the origin of a fissure. This fissure marks the point of separation between two very different orientations to time. It opens between an orientation to the past as that which is cut off from its own future, and an orientation to the future as the ideal form of the past. Accordingly, there is, on one side, mourning and, on the other, an anticipatory melancholia. These poles are structured by the phantasmatic image of what would have been (that always receding idea of a history or a tradition interrupted) and the conformity of one's self to an image of that which will have been. This polarity emerges because the camera inserts itself into history as something that calls up a consciousness of being looked at — in a very special way, for this being looked at requires the mediation of the camera in order that the reciprocity of gazes not be simultaneous. Reciprocity is both reduced to visuality and subjected to a temporal spacing. The Chinese photographers who, in their conversations with Thomson, insisted that a proper portrait show a man as whole, so that he be judged by others, namely, those viewing his image, on the totality of his physical merits, articulate this sense that a camera produces the conditions in which one poses for others by posing for the camera. They know that this posing entails a waiting. The instantaneity of the photograph is thus consciously bracketed by them, as a ruse behind which social relations are extended in time. This is a radical fact, one that transforms manners and the cultural discourses of propriety at every level. In contexts where photography is organized by the idea of the type, however, the anticipated gaze will greet the image not as the sign of how one once looked, but as the evidence of one's look, in general and for all time. It expresses itself in those quotidian statements, permanently inscribed in the present tense: "Ah, so this is what she looks like." Here, the monogram returns as a specter of desire.

This experience of photography is not peculiar to the Asian context, of course. Wherever there is photography, it seems, there is a conflict between (at least) two times and two modalities of duration and a repeating drama of disappearance and persistence. Wherever there is photography there is a relation of seeing and being seen which rends the co-presence of the seer and the seen and risks casting the latter into an abyssal space

where history constantly threatens to become, quite simply, the past, and even the surpassed. This risk is, perhaps, especially threatening in the space of colonial encounters. In Asia, as many writers in this volume show, photography often appears to illuminate the past as a space of the dead and of those who are condemned to death, of the defeated and the ravished. But an attentive eye also discovers it to be the space of endurance, of fantasy, and of self-making. Photography, we might say, generates the past both to which present lamentation offers its obeisance and from which anticipation makes its own offerings, even when that anticipation is itself simply the imagination of a future anterior in which the subject will have ceased to be.

How, then, shall we write the story of photography in Asia without making it appear either as a mere case study of a universal phenomenon or as an absolutely particular and hence untranslatable experience which remains mute in the face of comparative aspirations? How can we tell this story, or rather, these stories, without hypostatizing as an essence the space called Asia? Without reducing discourse to technology, and hence according it a unity which it does not possess? Perhaps it is necessary to understand something of the contemporary discourse of photography that accompanied people like Thomson in order that we be able to comprehend what happened to that discourse in (East and Southeast) Asia, and what that discourse did within Asia. And perhaps this understanding can reinflect what we think we can understand of history and culture-in-history through the analysis of photography. To this end, I believe it is helpful to briefly consider the writings of Oliver Wendell Holmes (1809–91), a slightly older contemporary of Thomson whose unbridled enthusiasm for photography generated some of the most influential popular commentaries on the camera's uses and potential in the English-speaking world. To be sure, Thomson inhabited the sphere of British Empire, Holmes that of American republicanism before it assumed the mantle of the new imperium. But for this very reason, the relationship between their discourses proves instructive. Reading between their texts allows us to observe how the dynamic of foreignness and the conception of photographic technology as that which mortifies by revealing death, but also as that which marks the entry of the newest of the new, was played out in the relation between Britain and the United States. If we can discern this dynamic operating in the space between the two great engines of Western capital and imperialism, then we may well have the means to escape the

persisting tendency which reduces the problem of foreignness to a formula that pits the West against the East.

But first to Oliver Wendell Holmes. Holmes managed to capture something of the temporal duality associated with photography when he described the marvels of the early stereoscope, which was the form through which many people experienced photographs. In retrospect, his writings acquire an uncanny sound, disclosing as they do the power of the camera not only to mortify but also to project deathliness onto history. Surveying the detailed minutiae of the carte de visite, which he likened to "sun sculpture" (in contrast to the "sun painting" of the single photograph), Holmes offered the macabre assessment that "England is one great burial-ground to an American. . . . No one but a travelled American feels what it is to live in a land of monuments." He concludes wistfully, anticipating his compatriot, Henry James, that it is perhaps "well that we should be forced to live mainly for the future; but it is sometimes weary and prosaic."[18] What enabled this particular historical consciousness, this sense of being a foundling and of living for the future because one can hold the image of the past almost unto eternity, what attuned Holmes to the merely necrophiliac cult of monuments (and hence, monogrammatic representation) was, precisely, photography.

From the beginning, Holmes's writings were possessed by what Allan Sekula aptly terms "two chattering ghosts: that of bourgeois science and that of bourgeois art," and he shared in the "comic, shuffling dance between technological determinism and auteurism."[19] The photochemical processes for fixing an image represented for him something utterly unanticipated by previous generations. Thirty years after their first appearance, they remained for him a surprise, their discovery an event. The images they produced offered both pleasure and knowledge, as well as the possibility of traversing distance and establishing the parameters for comparative forensic analyses of everything from disease symptoms to inherited resemblances among family members. Most important, photography also promised new kinds of sociality and new desolations. "A photographic intimacy between two persons who never saw each other's faces . . . is a new form of friendship," he wrote.[20] But also: "The time is perhaps at hand when a flash of light, as sudden and brief as that of the lightning which shows a whirling wheel standing stock still, shall preserve the very instant of the shock of contact of the mighty armies that are even now gathering."[21]

Insofar as he thought of it as an art form, Holmes saw only gain in the photographic image: "The painter shows us masses; the stereoscopic figure spares us nothing." The result is "infinite charm" and a small library comparable to "infinite volumes of poems."[22] Although many art historians have since argued that quattrocento perspectivalism was the precondition if not the anticipation of photography, thereby implying a long and continuous history within which photography arrived as the telos of a contrived and specifically European naturalism, Holmes's ecstatic writings about the new technology emphasize a sense of rupture. It is not an overstatement to observe that, for him, photography constituted an irrevocable point of departure from all that had preceded his moment.

From our own vantage point at the beginning of a new millennium, surveying the totality of transformations of which photography was a part, this discontinuity described photography's relationship to the field of representation more than to industrial technology. When Holmes recounted his visit to a photographic materials factory for the readers of the *Atlantic Monthly*, it had all the hallmarks of an industrial system, with a division of labor so extreme and alienating that few workers could even conceive of the finished product.[23] Perhaps, then, we can rethink his perception of discontinuity without entirely abandoning it. What if we were to say that, if photography took leave of anything in the Western tradition, it was not of the history of painterly arts but of their future history? For, if the camera introduced a new mode of representation, it did so by preserving perspectival depth in the very moment that painting was abandoning it. Its discontinuity was thus a stubborn continuity, one which may itself have incited a further movement toward that self-reflexive internalization of the exhibition's plane that would characterize modernist painting, as Rosalind Krauss defines it.[24]

Reading Holmes's texts on stereography, Krauss herself repudiates those historians (and they are legion) who want to include photography in the development of modernism. She remarks instead the split within photography that separated lithography and other forms of two-dimensional photographic inscription from stereography. The former, she says, citing Alan Trachtenberg, were part of a cartographic project, linked not only to science but to an expansionist politics based on natural resource extraction.[25] The latter constituted something like an effort to redeem the image for depth, and thus for a hallucinatory tactility. In Holmes's language, its analogue would not be painting but sculpture. Krauss's attention to the split in Holmes's discourse encourages us to consider whether the arrest

of tradition is not merely an element of photography in its colonial mode, but is intrinsic to its operations from the start. This possibility allows us to think differently about the fact that photography elsewhere, and certainly in East and Southeast Asia, seems to have operated to transform representational histories by preserving them, which is to say by prohibiting their transformation. And yet, when it goes elsewhere, photography effects more than an interruption of the present. Because it often provides a figure and a metadiscourse for its own operations, photography may be understood not only to have arrested those traditions but, in the colonial context where it was annexed to other institutions and discourses of alterity, to have projected and dissimulated that arrest as the mere object of its representations. What photography in this part of Asia claimed to capture was not only cultural essence, but an essence doomed to vanish; not a fixed moment, but stasis.

This much has already been argued by many others. Indeed, when writing about photography, one often feels that almost everything has been said before—though it is a testimony to the particular capacity of the camera to renew our sense of invention that this familiarity neither becomes uncanny nor seems to exhaust our need to address these persistently recurring issues. Not everything has been or can be said, of course. The essays in this book offer some strikingly new observations to the analysis of photography, and they do so, partly, by extending the analysis of photography's ambivalent temporality—its haunting and haunted status, its split and receding horizon—to the question of foreignness. They help to elucidate the ways photography in Asia often dissimulates the capacity (one wants to say drive) to generate foreignness as a mere technique to typify foreigners, be they peasants, ethnic minorities, criminals, revolutionaries, anticolonial warriors, or simply elders. They show how photography has been projected and misrecognized in the complex relations of mutual othering that have traversed the relentlessly modernizing fields of Asia. In many instances they address not only the mortifying powers of the colonial gaze in its photographic mode, but also the histories by which photography came to be integrated with other aesthetic traditions as the source of their fracturing and preservation through arrest.

The reader must await these careful, historically and ethnographically detailed analyses for a deeper understanding of these issues. But if I may proffer a formula here, we could say that, if photography worked to preserve perspectivalism in the West, it also introduced the perspective of

preservationism everywhere, ensuring the improbable afterlife of what would have passed, and perhaps even gone unnoticed. When Susan Sontag takes up Walter Benjamin's surrealist insight and says that photography makes it possible to discover a new beauty in that which is vanishing, she is only partly correct.[26] The question here is not simply a matter of capture, or even of aestheticizing the process of ruination. It is a matter of banishing disappearance while rendering passage irresistible. And one ought to recall here that among the many representational possibilities that photography seems to foreclose are forgetting, anticipatory censorship, and even indifference: the unmarked burial, the demand that proper names become mute, the turning away or masking of oneself. These are all forms of resisting the reduction to a visible trace. In this volume, both Patricia Spyer and James Siegel suggest ways of thinking a negative relation to photography. In doing so, they open the way to a radical thinking about what cannot be narrated within the now familiar rhetoric of the hegemony of photographic vision.

REMAINING DETAILS

Ultimately, what the writers in this volume do is attend to photographs. In addition to their shared acknowledgment of the stereotypy, the discursive violence, and the political asymmetries within which the images they consider have been produced or withheld, they turn to the photographic image and to the history of its viewing for clues and incitements. In each essay, whether written in the grateful shadow of Barthes, Benjamin, Derrida, Foucault, Freud, Heidegger, Kittler, Kracauer, Said, or Sontag, there is an empiricism that matches the compulsive demands of the technology and its claims to manifest the industrial form of facticity. This empiricism, whether virtuous or begrudging, avowed or apologetic, allows these writers to read against the grain of history, of the photographers' intentions, and even the writers' own desires. It allows them to ask, What is that?, or it allows them, all scholars of East and Southeast Asia, to discern in the seemingly saturated plane of an image a significant blank spot and to ask, accordingly, What does this invisibility veil? Sometimes it allows them to wonder what difference is marked by the absence of an image altogether.

In the end, perhaps, this empiricism is itself evidence of the accomplishment of photography, an accomplishment of which we are all at least partially observant. Which of us looks on the photograph of a loved one

and does not say "It is she"? Which of us ever thinks of a photograph as merely constructed, though almost none of us ever pretends that it is not also constructed? What I am calling empiricism here should not be confused with scientism or positivism, for there is no presumption that the observed detail discloses the truth in these essays. Nor does it imply a universally accessible referent. In the peripatetic idiom distilled in the onomatopoeic word *click*, a term that can be heard in so many languages, one could perhaps believe that photography does enable a universal language. This would be the languageless language of signifying reproductions, of naturally produced traces in which truth is equivalent to that which can be seen.[27] The conflation of a generalized idiom for a universalized language must be resisted, however, now as in the past.

The empiricism incarnated in these essays never devolves into such an ideological fantasy of universality. Rather, it manifests an ethos and an ethics of careful observation. It redeems detail, as it were, from the ransom of fastidiousness, turning the tyranny of minutiae into a gift. This too is an old theme in theories of photography, though one less admired in anthropology and postcolonial studies, where the critique of the frame (its history and conditions of production) can sometimes obliterate that which survives the violence of the photographic exchange. Barthes famously described the singular detail as that which can wound (rather than shout at) the viewer. He gave it the name *punctum*. Holmes similarly valorized the detail, but described it in an exemplary mode. Its symptomatic form was, for him, the clothesline, whose omnipresence in the urban landscape photographs from across Europe marked the point of departure from painterly convention. Though the clothesline is now a cliché in and of itself (a sign of quaintness if not kitsch), Holmes found in it proof of the inexhaustibility of the photograph, and its discovery in an image was, for him, a moment in which what generally goes unobserved makes itself available to be seen. Long before Benjamin coined the language of the optical unconscious, Holmes remarked that the "distinctness of the lesser details of a building or a landscape often gives us incidental truths which interest us more than the central object of the pictures."[28]

These truths survive as remainders in the images that are otherwise intended to communicate more "unary" significations. And it is in the tension between them that a good analyst finds the evidence of an actuality which exceeds its representation, including that of the photograph (though such a discovery does not guarantee access to what exceeds the form of its appearance). So, for example, the slippage and abrasion at the

edge of a journalistic portrait showing the execution of Chinese rebels shows something about the organization of state violence. And the severed head of a bovine in the cogs and wheels of an industrial factory in Java bespeaks something about the synchronicity of two regimes of spectrality. The gold-dusted fingerprint on a portrait of a king evidences reverence for a monarch who has only just emerged into visibility but who is already available for fetishization. And so forth. These examples from the essays that follow should forewarn readers that they are about to encounter a form of analysis that demands attention to the kind of detail that photographic images are so especially, though not uniquely, able to store.

The question of effects is another matter. Sometimes the persistent visibility of the dead, which photographs afford, generates uncanny aftereffects, haunting not only the memory of times past but everyday life in thoroughly modern contexts. At other times the camera seems an agent of truly occult powers and appears to reveal magic in the heart of the mechanical order. Sometimes too the object of the camera's gaze refuses to provide that consoling reciprocation of looks that colonial powers and their neocolonial heirs, the tourists, demand and fantasize as their own acknowledgment. The latter example is particularly instructive. One is never sure whether the blank stare or furrowed brow, the turned back or obviously fatuous grin should be written as repudiation, rage, incomprehension, or indifference. The detail never surrenders this other story, this other afterlife of the image. Instead, the detail marks the place from which it may be approached. It is from that location that the writers here begin.

Often enough, when one looks at photographs the fecundity and the instability of the detail is testified to in the caption, which attempts to restore the unity of the image and appears to temporarily reanchor the photograph in the tradition of the monogram from which Kracauer tried so hard to extract it. Bluntly stated, the caption is the linguistic supplement that reduces the photograph to a mere index. This is why there is always a risk that an essay addressed to photographs will appear to function merely as an elaborate caption, a swollen and distended summary. In this sense, the essay addressed to (documentary) cinema can risk transforming the film into a mere photograph. However, to the extent that writing remains dedicated to an exploration of the tension between the generality of the image and the specificity of the detail, as all the essays here do, it avoids the worst pitfalls of captioning. For where a caption

would have reduced language to the lexical fixing of referents, these essays manage to lend language to the photographic. They make it speak in answer to the question What can these images (or their lack) say to us about the history of their production, the world they depict, the lives they transformed, the ways they were appropriated, the possibilities they seemed incapable of acknowledging?

In giving language to photography, by acknowledging its simultaneous paucity and superabundance of signification (what the people represented by Thomson thought of as meaninglessness or magic), the writers in this volume cannot help but construe the relationship between photography and language as a supplementary one. But in writing of photography and thereby posing the question of language, they also pose the question of desire. Indeed, at the end of these introductory musings, what remains to be told is the story of desire. Desire is that which traverses the archive and extends beyond it. It is woven into the fabric of these other discourses: about foreignness, about the fetishization of the past, about the relations between Easterners and Westerners. It is sometimes violent, sometimes mutual, sometimes romantic, occasionally revolutionary, at other times nationalist, and very frequently intergenerational. But there is no account of photography which can evade the force of desire, if by desire we understand both attraction and aggressivity toward the other.

Once again, Holmes. Despite the marvelous uses that he conjured for the new technology, Holmes thought that photography's greatest gift lay in its promise of a duration beyond that which mortal flesh could ever achieve. This duration was a function of its capacity to separate form from substance, a capacity that Holmes not incidentally narrated in a retelling of the myth of Marsyas and Apollo. In the American's version, the flaying of the one who attempted to compete in music with the gods was imagined as a photographic session, the flesh being transformed into the mere image that the vanquished aspirant shed for the camera.[29] In other words, photography usurped the place of vengeance (death) with the promise of immortality (the death of death), but only because the victorious competitor, the Apollonian photographer, desired his impudent challenger. Eros inflames this tale, just as it inflames Barthes's adoring account of Alexander Gardiner's 1865 photograph of a young man, Lewis Payne, who, like Marsyas, was sentenced to die. Like Barthes's account, Holmes's narrative depends on the story of violence being subsumed within a story of desire. He imagines Apollo "pleased with his young rival," and hence moved not to kill him but to photograph him. Similarly,

Barthes concedes his own attraction to the languid youth who has been photographed prior to (but not instead of) being executed, in a manner that bespeaks not the bureaucratic interests of the state or the phrenological ambitions of the criminologist, but the unabashed desire of one who is "pleased" with the image of the voluptuously reclining young man. In her first book on photography, Sontag boldly asserted that it transforms everything into a potential beauty. This too is only partly correct. Pleasure exceeds the question of beauty. It is, as Freud well knew, the point at which life and death touch. Another punctum.

It is not always easy to read desire in the photographs and the oeuvres described by most of the authors collected here, even in that genre, the wedding portrait (discussed by Pazderic) that is most overtly structured by the requirement that it show love and beauty. Certainly it can be discerned in the fashionable photo albums described by Carlos Rojas, and Thomas LaMarre reveals to us the deeply fetishistic structure of Tanizaki Jun'ichirō's cinema, which deploys the woman as a sign around which viewers' desire can be organized. But in the collections of images of corpses, the brutal residue of state and imperial violence discussed in James Hevia's and my essays, and in the brittle surfaces of shadow and flash which expose the underside of Enlightenment, as Marilyn Ivy points out in her explication of Naitō Masatoshi's use of flash, one is confronted by a certain resistance to the discourse of desire. This resistance can be overcome, however, if we acknowledge that the photograph is not only the site of desire but also its cause (even when one is merely thinking about taking a picture).

The desire that operates in photography can never be confined to that of the photographer, whose investments will remain at least partially opaque to all future inquiry. The desire of photography is both fractured and mediated, passed through the circuit of future regard. It is our desire that sustains photography, our sense of wanting to look, of being unable not to look. For all the hand-wringing and unctuous assertions of righteous disinterest, there is no analysis of colonial photography that does not also desire to look at its images, no anthropology of visual anthropology that is not captured by its pictures, no reading of photojournalism that does not repeatedly invest, if only momentarily, the eventful image. Our curiosity, even when motivated by critique, is a form of desire. This does not mean that we all share the same violent impulses that generated the images in the first place. Sometimes desire is what saves us from the more aggressive desire enacted by someone who went before. What sum-

mons this compulsive looking is, I believe, the indefatigable sense that in each photograph, however familiar, there is also something absolutely singular. That singularity is simultaneously inaccessible and traced in the photograph. Only the most complete repudiation of a transcendental communication could escape this desire, though this is precisely what James Siegel describes in his account of the holy warriors in Atjeh, men who do not care to leave a trace.

Maybe the one who looks at the photograph is attracted to death in an effort to stave it off, while the one who refuses to look has already determined to die — to die in a manner that separates him or her absolutely from the living. In any case, the intimacy between death and photography which so moved both Holmes and Barthes is variously acknowledged in all of the essays here. For this reason it must be understood that this intimacy is not one in which death stands for the force of abstraction, though stereotypical photographs mortify. To the contrary, it is the principle of singularity. (This is why Barthes thought of the photograph as being more theatrical than cinematic.) Because every death is absolutely singular, the culmination of a life which is itself singular, death's laceration of the photographic image is the source of the image's capacity to communicate singularity. This does not mean that the photograph itself (in whatever form, from paper to digital), is singular; since the daguerreotype's surpassing, it has been defined by its reproducibility. Nonetheless this morbid capacity to communicate singularity constitutes one, perhaps the only basis of its ethical possibility, and it is what grips the viewer — to the extent it does — and provokes him or her to survey its detail and imagine, for a moment, that the two, detail and singularity, are the same. They are not, of course. The detail stands in for singularity and, without representing it (that would be impossible), conveys its force. Anthropological and historical readings of photographs often attempt to mobilize this capacity by testifying to the dissonance between the photograph and the one photographed, the image and the actuality. Thus, for example, Ishii may have been posed in his ridiculous role as the last of his kind, but in his photographs we find, in addition to the pathos of costume and the horror of cultural death, the face of a man who exceeds the caricature to which he was so violently subject. In short, he becomes one whom we could desire, however violently. It is what is left of reciprocity in the time of photography. This may be a good thing, or at least not a bad thing, if it is recognized that the camera also enters the world, instigates new modes of worlding, interrupts existing aesthetic codes and forms of representation,

solicits new self-conscious postures, fractures the temporality of the here and now, and introduces foreignness everywhere. But, Holmes's story of Marsyas and Apollo notwithstanding, photography rarely substitutes for violence; the story is, as I said, one of subsumption.

ITINERARIES TO COME

Reluctant though we may be, we — anthropologists and historians of photography in East and Southeast Asia — are all John Thomson's heirs. It is not merely fortuitous, of course, that I commenced this introduction and this book with the work of Thomson. For his itineraries in Asia constitute something of an anticipatory map of the terrain covered by the writers in this volume. This is not because I intend to valorize a colonial perambulation. Thomson's journeys do not chart a geopolitical reality which has remained unchanged since he took his camera with him, nearly 150 years ago. Nonetheless, because he did not merely picture the world but entered it, his interventions have resounding significance for our queries here. The concatenation of essays under the unwieldy geopolitical moniker of East and Southeast Asia nonetheless needs some explanation, for, while it resonates with and even ghosts Thomson's early route, the rationale for this book is not derived from it.

The countries and communities addressed in these essays do not constitute a culture area, a single geopolitical territory, or a bounded sphere of economic activity. The languages spoken in the sites discussed are diverse, from Aru to Atjeh and Java, from Siam to Taiwan and China, to Japan. The forms of economy and society, the traditions of representation, the systems of ritual and belief — all differ from place to place and time to time. Nonetheless, this does not mean that there are no material connections among and between them. Thus, for example, in both island and mainland Southeast Asia, Chinese merchants played a crucial role in the early history of photography's dissemination throughout the region. Though many of these countries were the subject of imperial ambition and outright colonization (British and Dutch, in this case), Chinese merchants worked as intermediaries, apprenticing to European photographers, then investing capital and establishing studios, circulating photo albums, and so forth.[30] These material economies and biographical histories formed the basis of an expanding network of discursive and technological exchanges, and they, in their turn, facilitated flows of many others sorts. Historically speaking, these exchanges constitute one of the

conditions of possibility for the comparative project incipient in this volume. They were also augmented by other networks, such as those forged in ironic solidarity between the upper classes of Europe and Asia and produced through the diplomatic gifts of cameras and photographs that laced together the monarchs and statesmen of far-flung worlds in deferred but reciprocal gazes—tokens of that strange new friendship of which Holmes wrote. To the extent that middle classes emerged in these contexts, they became the subjects and the markets for the proliferating pastime that was photography, a pastime inseparable from tourism but also incorporated into other traditions, such as the filial worship of ancestors (photographs of parents and grandparents on shrines in many places).

Japan's experience with the technology was shaped differently in the early decades from that of China and the Southeast Asia states with significant Chinese populations. But it also took place against the backdrop of European colonization. Moreover, Japan's relationships to European empire were spectralized by its relations with China, to and from which it transmitted texts, commodities, ideas, and wealth. Many of the stories of photography's early history in East and Southeast Asia could also be told of South Asia, of course. But unlike South Asia, the histories of which photography was a part in East and Southeast Asia were not as thoroughly overdetermined by British colonialism, and there is some virtue, I believe, in marking the difference that is a corollary of that fact. But not all the absences in this volume reflect a decision of boundary marking, however provisional. The book is not representative. Silent here are the histories of photography in the Philippines, Malaysia, Vietnam, Laos, and Cambodia. Partly that reflects the fact that work on these topics has been published elsewhere. Partly it reflects the need for even more work to be done. And partly too it expresses the merely coincidental connections and partial knowledge of the editor.

Today the rapid and fluid movement of images, texts, ideas, and fashions across vast spaces and between former political antagonists has rendered the question of photography's original itinerary somewhat moot. Many of the essays here are concerned with emphatically contemporary phenomena, phenomena which depend on transnational capital and the globalization of style, as well as nationalist aesthetics and sovereign politics in the post–Second World War period. The continuing coherence of a rubric such as East and Southeast Asia must therefore be understood partly as a function of institutional and disciplinary history in the United

States, where all of us were trained. One must always acknowledge that the boundaries which continue to emanate from a cold war area studies framework have shaped and continue to shape the discursive communities within which Asianists, even those critical of its paradigms, tend to operate. For better and for worse, this volume is haunted by that history. But there is also a set of theoretical affinities which simultaneously cross-cut and reinforce this historically and geopolitically shaped nexus. And they are the deeper source of the book's internal conversation.

There is obvious agreement among the authors here that, despite its many forms and deployments in various times and places, photography invariably entails the logics of iterability and reproducibility, and that it effects a temporal instability which is absolutely central to the temporal consciousness of modernity. But it is also possible to discern a gathering sense that photography must be further understood as the technology that calls for representation to surpass itself. Moreover, the consequences of an increasingly mobile, increasingly instantaneous capacity for image making, the development of more and more forms of light sensitivity, and both digitization and the complete blurring of the boundary between the photographic and the cinematic in the new generations of digital cameras and even cellphones with capacities for movies, and of course iPods, has ensured that the encounter between the new and the obsolete, the modern and the primitive is an experience that everyone undergoes again and again.

The order of this book is determined neither by area nor by historical epoch. There are three essays concerning island Southeast Asia, all from the space now called Indonesia: Pemberton's, Siegel's, and Spyer's. My essay is on Thailand, and Ivy's and LaMarre's are on Japan. Three focus on China and Taiwan: Hevia's, Pazderic's, and Rojas's. It would have been possible to simply group papers according to their geopolitical or linguistic affinities. Similarly, it would have been possible to arrange the essays by historical period: those dealing with earlier moments of colonialism and colonial violence (Siegel, Hevia, and Pemberton, but also Morris), those with contemporary forms of culturalist representation (Spyer, Pazderic, and, differently, Rojas), and those with the question of representation, state power, and the relationship between the aesthetics and the technologies of modernity (Ivy, LaMarre, Morris, Pazderic, and Rojas). There is much to commend these strategies of juxtaposition and organization. Arranging essays according to geopolitical location would have permitted an overt and obvious comparativist analysis within relatively

limited frames of language and shared historical experience. Historical location would have allowed the tracking of emerging problematics and questions across a broader range of locations, and would perhaps thereby facilitate an enlarged form of comparativist analysis, that of a slightly longer durée. It is my hope that both of these kinds of readings remain available, despite the fact that I have chosen another set of interests on which basis to place the essays.

The structure of the book emerges from my sense that each of the essays in this volume introduces a particular set of questions, terms, and analytic perspectives, and that, in reading the essays in the order presented here, these questions gather force, complicating each other, reorienting our understanding of what the anthropological analysis of photography might be, and, yes, dislodging us from more familiar approaches to the question. John Pemberton's essay both explores and thematizes the question of conjuncture as the unprecedented experience of coincidence and thereby sets the stage for a series of readings in which the question of photography's history in Asia is understood as one of repeated encounters between forms of foreignness. In addition, his excavation of technological magicality and of the violence of photography's time machine calls attention to that repressed dimension of the camera's sensory impact: the aural. It thereby dislodges the easy readings of photography as the instrument of vision's hegemonization and frames the book as a call for radical attention to the unexpected.

James Siegel's reading of different relationships to history, photography, and the idea of holy war in Atjeh forces us to consider the question of conjuncture when it entails a radical disjuncture, and silence or invisibility. His essay addresses an instance when photography was disavowed not because it threatened the loss of essence but because those pursuing holy war against the Dutch (who bore their cameras with them) did not yearn to be memorialized. Death was not loss but a beginning for them. Siegel thereby opens the question of photography's relationship to colonial and anticolonial violence in an entirely unprecedented fashion.

James Hevia analyzes photography as part of the complex of colonialism, but in such a way as to cast light on the forms of resistance that may actually remain residual in photographs that, so often, are considered not to work. He attends to the blur and makes us see the trace of that which exceeds the frame as he rereads the faces whose putative passivity has been forcibly discerned in an archive made to validate colonial ambition. In this way, he helps us understand that the filling of our consciousness

by the photograph is not only the actualization of photography's force, but may be the effect of a force that has instrumentalized photography.

My own essay continues these themes and explores the relationship between force and power in the history of political representation in Thailand. In asking what binds the ritually elaborated surface of a monarchical portrait with the widely coveted journalistic images of the corpses which the state produced in the moment that power became mere force, I also pose a question about how and under what circumstances we can presume continuity in the body of images that comprise any of photography's local archives. Here, the question of a photograph's capacity to bespeak a failure arises again.

It is not so much failure as anticipated absence, and the redoubling of photography's relationship to cultural othering that Patricia Spyer illuminates in her poignant account of ritual and photography in Aru. Her analysis of the logics of enframement reveals a complicitous relation between anthropology and photography, and an uncanny power at the heart of modernity's claims to technological modernity. In this respect, her essay echoes themes taken up in several of the other essays, but most notably those of Pemberton, Pazderic, and Ivy. But it is the relationship between the enframed and the marginalized that elicits the anticipation of being photographed, which links her essay back to Siegel's in an inverted form.

There is a powerful resonance that links the four remaining essays of this volume, though they vary widely in thematic, theoretical, and aesthetic affinity. Each considers the work of photography in the context of emphatically urban, metropolitan centers of Asian capital, albeit at slightly different moments in their histories. Each of them considers the ways the camera can expose that which the dream of modernity would repress as its condition of possibility.

Nickola Pazderic reads the ur-form of stabilizing ritual photographs, namely, wedding portraits, in terms of an overall demand for the "life-like" and a structure of "transforming/saving" that can lead only to the disavowal of life. He then links this structure to the repression of the "white terror" and to a biotechnological frenzy on which Taiwan has built its so-called economic miracle. Why, in the midst of these seemingly triumphant discourses of successful modernization, he asks, do the images of ideal relation seem so constantly to be disturbed by the contaminating presences of ghosts?

Marilyn Ivy considers the ways a classical set of narratives about such

ghosts becomes the mise-en-scène for a photography that seeks to illuminate, through intensified contrast and saturated surfaces, the ineradicable darkness that modernity hides in the glare of its all-too-bright "enlightenment." Her juxtaposition of Weegee and Naitō Masatoshi's work exposes something as well about the lack of pure translatability when the terms of comparison are limited to those of technique. In her insightful distinction of their oeuvres, partly understood as the different relationship each has to the caption, her essay complements Carlos Rojas's Lacanian-inspired reading of the marginalia by which photography works as the supreme mode of enframement. His essay, which actually precedes Ivy's, provides an uncommon literate account of the entextualizing of photography in Chinese cultural production. Moreover, his particular staging of the problem of the fetish brings to the volume a necessary perspective from which to comprehend the place of sexuality in the history by which modernity made the subject of desire the subjects of photography.

Desire returns in Thomas LaMarre's essay, less as a theme than as that structuring principle through which narrativity and feminization operate. His essay is the only one to consider the question of camera work in the context of cinema. While in some ways it appears as a moment of leave-taking from photography — in the volume and in the object of his analysis — it is striking (and therefore useful) to note how much the conception of cinematic essence for Tanizaki Jun'ichirō was defined in terms of the camera's capacities for enlargement and distillation, capacities that are associated with still photography as much as with cinematography. To end this book with an essay that opens up the analysis of photography to that of cinema, not as a distinct kind of social institution (which anthropological analysis tends to do) but as the extension and apotheosis of photography (as the technology of the shadow), is perhaps to invite recollection of Barthes's concluding remarks in *Camera Lucida*: that cinema, fictional cinema, participates in the domestication of photography, being an oneiric rather than ecmnesic art.[31] Yet, if there is some truth in Barthes's claim that the lacerating power of an image which appears as the emanation of the real (the photograph) is different from that which appears as the effect of imagination (he would say hallucination), namely, the cinema, one feels in LaMarre's essay that it is precisely the continuity or residual presence of photography in cinema that invigorates the latter medium and that permits the cinema, as much as still photography, to make us conscious of that which is, and to provide those memorial images through which everyone now so constantly memorializes himself or her-

self. (One notes that in the international media art world, it is no longer the photo album but the home movie of childhood abandon that stands as the ideal type of global memorial practices.)

There is, perhaps, need for one or two concluding remarks in this, the introduction to a volume of essays. The first concerns the notable fact that the essays dealing with China and Southeast Asia treat the phenomenon of relatively authorless archives, whereas those treating Japan focus on the oeuvres of single auteurs. This division corresponds, perhaps unfortunately, to a tendency in Asian studies to exceptionalize Japan and to attribute to (or grant) it forms of aesthetic and political subjectivity which are often not acknowledged in studies of other parts of Asia. Highbrow art criticism often turns to Japan to find ideal forms of auteurist subjectivity, and if something similar is emerging in regard to contemporary Chinese cinema, the interpretive social sciences (including history) more generally read East and Southeast Asian aesthetics in general and specifically cultural terms. That is not to say that Ivy and LaMarre do not perform social analysis of their materials. They do, in profoundly illuminating ways. Nonetheless, it is clear that the structure governing the constitution of their objects is different from that which governs the structure of such object constitution for the other contributors. And it is remarkable, though perhaps in the end merely coincidental, that this structuring difference corresponds to a real one. I will not try to explain this difference here, but merely take note of it, as part of the general reflexivity that informs our shared project.

Finally, it will strike the reader as notable that the individual essays gathered here each use photographs and photographic evidence so very differently, even though all of them attend assiduously to the photographs of which they write. For some of the writers, the presence of individual images is absolutely central to the analysis, and there is something like a relation of mutual reference between the visual and the discursive aspects of their texts. For others, the gap between the singular instance and the discursive generality of which each photograph is but one example eliminates the need and perhaps the utility of displaying individual images. For others, the very absence of images is the point, and the blankness which meets the eye of the reader is experienced as a resistance to photography, and to the reader as viewer. In an era of unrestrained iconophilia, a book on photography that contains such diverse orientations to the necessity of seeing that to which speech directs itself must come as a provocation. The provocation concerns the relationship between the sayable and the

visible, between discourse and what exceeds it. But often, the writers in this volume attest, the absence of an image must function as the truest index of its force.

NOTES

1 Thomson, *Illustrations of China*, 1: 143, quoted in White, *John Thomson*, 44, 197 n.104.
2 Thomson, "Three Pictures of Wong-nei-chung."
3 Quoted in White, *John Thomson*, 7.
4 It is not possible here to pursue the very different status of the social type in European and non-European contexts, despite the significance of this distinction for any history of anthropology. It is nonetheless important to note how different they were.
5 Barthes, *Camera Lucida*, 40–41.
6 Kracauer, "Photography," 51.
7 Benjamin, "A Short History of Photography," 245.
8 Kracauer, "Photography," 61.
9 To my mind, the best discussion of the emergence of social types is that in James T. Siegel's account of the history of the camera in Indonesia in *Fetish, Recognition, Revolution*.
10 Kracauer saw the consumption of news magazine images as a function of the "fear of death." He wrote, "In the illustrated magazines the world has become a photographable present, and the photographed present has been entirely eternalized. Seemingly ripped from the clutches of death, in reality it has succumbed to it." "Photography," 59.
11 There are numerous studies which reveal the violence or, simply, the stereotypical insipidity of colonial photography and its relationships to early (and later) anthropology. Among the most insightful are Alloula, *The Colonial Harem*; Edwards, *Anthropology and Photography*; Rony, *The Third Eye*; Ryan, *Picturing Empire*. All of these works owe a more or less substantial debt to Edward Said's *Orientalism*, which provided the discursive framework for understanding the aesthetic and aestheticizing representations of totalized otherness, whether Oriental or African, Native, or merely primitive.
12 The locus classicus of this trajectory in anthropology is Christopher Pinney's book, *Camera Indica*.
13 Marx, *Grundrisse*, 162–63.
14 Thomson repeated this assertion in a variety of contexts. After the Taiping rebellion, when he returned to Nanking to photograph Tseng Kuo-fen, who had played a key role in suppressing the rebellion, Thomson was relieved to recognize that Tseng's death (he had died in the interim) could not be attributed to him (Thomson), for he had not yet taken the photograph. Had he done so, Thomson believed, he would have been accused of taking a "portion of [Tseng's] vital principle." He also reported that stories in the Chinese press described photography as a foreign

process that required and used the eyes of Chinese children. See Parker, "John Thomson," 468.

15 On the structure and logic of defacement as a negative form for producing power, see Taussig, *Defacement*.

16 Thomson, "Photographic Chemicals and Apparatus."

17 An excellent analysis of this demand that truth take the form of visibility in anthropological representations of otherness is provided by Rachel Moore in "Marketing Alterity."

18 Holmes, "Sun Painting and Sun Sculpture," 209.

19 Sekula, "The Traffic in Photographs," 15.

20 Holmes, "Doings of the Sunbeam," 279.

21 Holmes, "The Stereoscope and the Stereograph," 164.

22 Ibid., 148, 153.

23 Holmes, "Doings of the Sunbeam."

24 Krauss, "Photography's Discursive Spaces," 313.

25 Trachtenberg, *The Incorporation of America*.

26 Sontag, *On Photography*.

27 Allan Sekula has traced this concept of a "universal language" across three epochs in the theorization of photography, beginning as early as 1839 and receiving new articulations in the work of August Sander (1931) and Edward Steichen (1960), who curated the Family of Man show in 1955. See Sekula's stridently materialist critique of that concept in "The Traffic in Photographs."

28 Benjamin, "The Work of Art in the Age of Mechanical Reproduction"; Holmes, "The Stereoscope and the Stereograph," 151.

29 Holmes, "Sun Painting and Sun Sculpture," 166.

30 I do not want to imply that photography was confined to an ethnically minoritized sphere, or that capital in Southeast Asia was exclusively Chinese. Much has been written about these issues, and it need not be repeated here. My point is simply that the pathways along which the camera moved were facilitated by already existent structures of capital and trade.

31 Barthes, *Camera Lucida*, 117.

JOHN PEMBERTON

The Ghost in the Machine

As thus presented, minds are not merely ghosts harnessed to machines,
they are themselves just spectral machines.
— GILBERT RYLE, *THE CONCEPT OF MIND*

Not only did he disbelieve in ghosts; he was not even frightened of them.
— SIGMUND FREUD, *JOKES AND THEIR RELATION TO THE UNCONSCIOUS*

A photograph recalls the Netherlands East Indies governor general
A. C. D. de Graeff, his long arm stretched forward, hand held palm down,
blessing sacrificial offerings prepared for machinery at the Tjolomadoe
sugar mill in Central Java on 21 May 1928. De Graeff performs this gesture
ostensibly in acknowledgment of the ceremonial attitude associated with
setting into motion milling machines at the advent of each harvest season
in Java. He is presented in the photograph as calm, confident. He is as re-
assuring that the mill's enormous cogwheels of production will perform
smoothly, without accident, profitably, as he himself appears reassured.
It is as though he does not see the ghost in the machine, particularly ma-
chine Number One.

This ghost does not have a name, or at least her name was no longer
known by the time the photograph was taken.[1] She is a spectral presence
that appears momentarily, sometimes as a detached head, vaporously pro-
jected and enlarged within the cogwheels of the machinery, sometimes as
a well-dressed figure, wholly intact, suspended in midair. She is Javanese.
She never speaks. She wears a watch. Her sudden appearance threatens
to induce distraction that turns fatal. Grasp slips, a machinist is drawn
into the cogs, and the sugar for a while runs red. The ghost is said to be
as old as the once-modern Dutch milling machines themselves, already
well worn in 1928 and still in operation at the close of the twentieth cen-

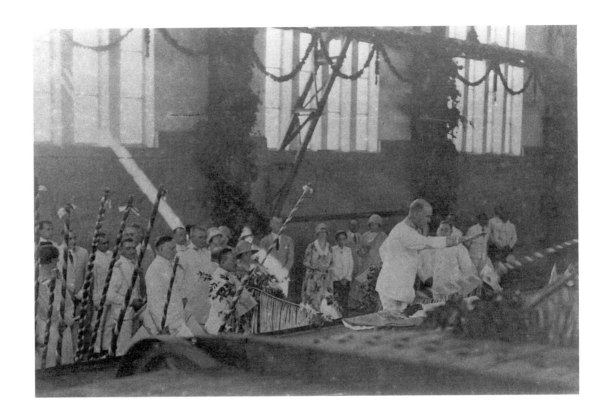

1. "Governor General A. C. D. de Graeff Blessing Offerings at the Tjolomadoe Sugar Mill, Central Java, 21 May 1928."

tury: remainders of modernity — this ghost and its machinery — become vestiges of antiquity.

The name of the photographer (who was most likely Dutch, though quite possibly not) is also no longer known, to Javanese at least. The album in which the source of this print is preserved by the Mangkunagaran Palace in Surakarta, Java, notes only, "In Remembrance of the Visit of Netherlands East Indies Governor General JHr. Mr. A. C. D. de Graeff to Surakarta on Monday the 21st of May 1928." What remains in the photograph is the specter of de Graeff poised in a moment when sacrifice is acknowledged. Behind him, also dressed in colonial whites, appears Prince Mangkunagara VII, remembered for his commitment to cultural preservation, a commitment matched only by his devotion to technological innovation, to the unabashedly "modern" (that is, *modhèren* in Javanese, *moderen* in Malay, and *modern* in Dutch).[2] Just eight years earlier, in 1920, the prince had officiated at ceremonies that dedicated the setting of the cornerstone for the palace's Tirtomarto Reservoir, the epicenter of a massive Javanese waterworks system that rivaled even Dutch accomplishments in modern hydraulics. The year 1920 also marked the prince's

meticulously documented, highly publicized "traditional" (*tradhisionil* in Javanese, *tradisionil* in Malay, and *traditioneel* in Dutch) performance as a Javanese groom, executed in royal fashion, a fashion so lavish that it might even exceed the ritual performances of his ancestors. The Tirtomarto dedication itself marked, in fact, the first in a series of calendrically divined postnuptial ceremonial events that wedded signs of a technologically driven modernity to cultural scenes portraying, in effect, tradition. These events thus wedded what was perceived in the Indies at the time, by Javanese and Dutch alike, as the quintessentially modern to the patently cultural. Moments of dedication—the opening of the Mangkunagaran's southern territories Wonogiri railway line by means of shadow-puppet performance; the presentation of choreographically reconfigured Javanese dance traditions under the insistent glow of newly installed electric lighting; the unveiling of architecturally reconstituted traditional monuments, now retrofit through modern techniques—were all attended, necessarily, by the camera. All such moments anticipated a place in palace photograph albums.

From about 1900 on, palace archives were increasingly devoted to documenting, on the one hand, scenes self-consciously celebrated in the Indies as traditional ritual performances (weddings, shadow-puppet theater, princely coronations, village commemorations, funerals, harvest festivals) and, on the other, the machinery so emblematic of modern times (sugar mills, hydroelectric plants, locomotives, railway stations, telegraph lines, radio towers). These twin photographic obsessions—rituals of tradition and machines of modernity—were no doubt informed by the dialectically charged opposition "traditional/modern" (again, *tradisionil/moderen* in Malay, with the concept "traditional" itself expressing a fundamentally modern shift in perspective), an opposition which in the Indies at the time (and particularly in Java) characteristically associated tradition with culture and modernity with technology. And yet what the archived albums reveal, time and time again, is an obsession of a different order, an obsession which would transcend traditional/modern or cultural/technological dichotomies, a truly singular obsession with a force that is (now) ritual, (now) mechanical, (perhaps always) habitual. This is the force of repetition, of repetition itself.

Dedication ceremonies such as those just noted, which wedded technological innovation to cultural tradition, thus redoubled the attention paid to just such a force. The 1928 gala event in the Tjolomadoe sugar factory was no exception. The moment marking, ritually, the advent of

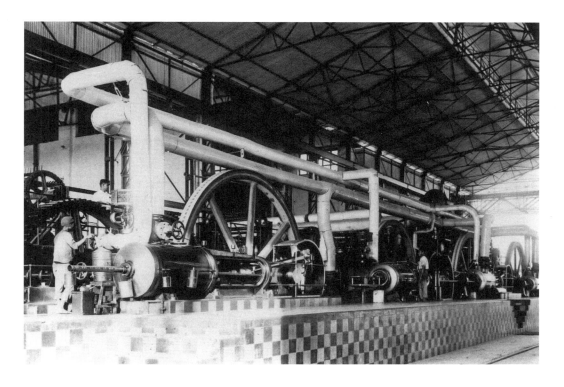

the annual harvest coincided exactly with the dedication of the factory's recently renovated facilities, now modernized, expanded through a novel technology of skeletal ironwork. As de Graeff leans forward to bless the offerings just before they are transported by the new conveyor belt into the geared four-ton rolls of the first milling machine, it is as if the camera is similarly compelled, almost automatically, by such a force—this force of repetition. For the apparatus of the camera is yet again drawn to a scene of repetition and enmeshed, momentarily, with the click of its shutter, in precisely the machinery of the modern for which the camera would seem to stand, on its tripod at a distance, as the hallmark. Such enmeshment suggests, as we shall see, a point where the critical distance between the camera and its subject might collapse and the machine consume its own mechanism of reproduction. Coincidentally, this photographic moment of shutter-cock timing also suggests a point, *the* point, as we shall see as well, when the ghost in the machine cannot be seen. What remains in the 1928 photograph is the figure of de Graeff himself, suspended, ceremonially buoyant. Prince Mangkunagara VII and others look on, ceremonially attentive.

So many worlds—those of farmlands and their villagers; the palace with its numerous kin, servants, artisans, and advisors; the colonial bu-

(opposite, top)
2. "Prince Mangkunagara VII Dedicating the Tirto-marto Reservoir, Central Java, 11 October 1920."

(opposite, bottom)
3. "Prince Mangkunagara VII and Princess Ratu Timur Sitting in State for their Royal Wedding, Surakarta, Central Java, 1920."

(above)
4. "Exemplary Steam Turbines, Tjolomadoe, Central Java, c. 1930."

reaucracy with its local administrators and their families and servants; Dutch engineers and native trainees; Javanese machinists, Chinese chemists, and Indies coolies; railway personnel, security men, and shamanic technicians — coincide in the strange convergence that produces a sugar factory that it feels almost inappropriate to speak of place. Yet a ghost would seem to desire siting. To the extent that one might attempt to locate a specific place for this vast machine called Tjolomadoe, it would no doubt lie in the very coincidence of such worlds, as ephemeral as that may be. Were one to retrace the various paths out of cane fields lined with ox carts, paved roads with bicycles and personnel, and railway lines tracking milled cane to storage and market, they all cross, eventually, the threshold of the mill proper as they pass under the clock that watches over the mill's acutely synchronized operation. There is a precarious sense in which the convergence of routine labors and the geared coupling of the machines themselves reiterates the peculiar logic of coincidence conjoining such worlds. "Without the strictest punctuality in promises and services the whole structure would break down into inextricable chaos," observed Georg Simmel of modern life in 1903. "If all the clocks and watches in Berlin would suddenly go wrong in different ways, even if only by one hour, all economic life and communication of the city would be disrupted for a long time."[3]

For colonial administrators in Tjolomadoe, one of the primary perceived threats that accompanied this novel synchronization — beyond breakdown, accident, and the subsequent loss of profit — was the sheer monotony of the thing. Having worked for decades in a Javanese sugar mill from 1902 on, Jan Poll wrote late in his career to correct this commonplace perception: "Life in the sugar business is not as monotonous as it may seem." Poll recalls happily, "One could always play bridge, dance while the gramophone is played, and billiards were soon available. . . . When one loves the Indies one does not need much to be happy there. You can be happy there without champagne. A social club with its own cinema and gramophone is all one needs for conviviality."[4] Leisure times, amusements, and socials also were mechanically engaged, synchronically sensed — "a social club with its own cinema and gramophone" — and the camera was drawn, of course, toward these times as well, these pastimes of modernity.

In Tjolomadoe, at the virtual center of all such mechanized synchrony, monotonous or otherwise, looms machine Number One. One particular place appears to give this factory a certain grounding, and that is a grave-

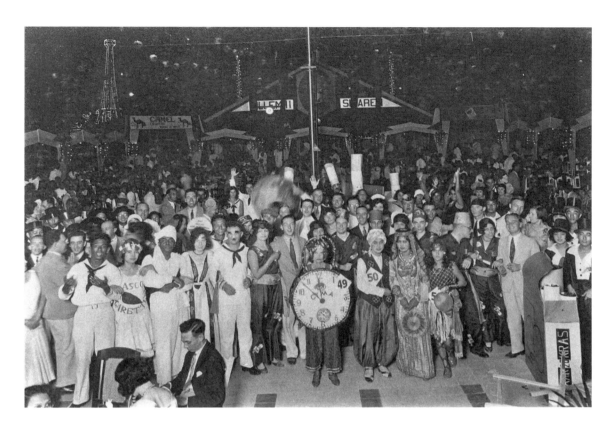

5. "New Year's Eve,
Semarang, Central Java,
1931."

site just east of the mill where Nyai Pulungsih is entombed. (*Pulungsih*—
her very name recalls the Javanese myth of a woman who dreams she
devours the moon and begets future kings.) Through monthly séances,
Pulungsih is invoked as the founder of Tjolomadoe, whose farmlands
she commanded through inheritance and whose initial crude machinery
she procured in the early nineteenth century through a bold exchange in
which she hawked all of her heirloom jewelry. She is also invoked as a
figure endowed with magical powers, manifested in amulets, especially
brilliant agate stones whose refracting centers reveal undulating snakes.
And she is invoked, finally, as the ancestress of kings, the last woman of
common birth to be of genealogical significance to the Mangkunagaran
royal house.[5] Not only was she a power source for dominant bloodlines,
but she demonstrated formidable economic prowess. Countering such
a power emanating from outside the walls of the palace, as well as the
specter of an enterprising woman operating on her own, Prince Mang-
kunagara IV (grandfather of Mangkunagara VII) took over the sugar
estate in 1861, secured investments from Dutch financiers, named its
factory Tjolomadoe (Mountain of Honey), expanded facilities, formal-

ized administrative structures, and inscribed his name as the enlightened founder of this highly profitable sugar business.

It is not surprising, then, that workers employed by the mill have speculated, from at least the 1920s on, that the ghost of machine Number One is intimately associated with, if not identical to, the spirit of Pulungsih: a specter of origins that seeks revenge for a legacy lost — appropriated by Mangkunagara IV and his successors, all men — and demands continued sacrificial exchange in a ghostly economics no longer thoroughly comprehended, senior machinists say. The fact that this ghost's most commonly sighted companions assume the form of snakes bearing rust-gold stripes, snakes said to vary in length from the size of a thumb to full-blown crowned serpents, recalls as well the amber agates in Pulungsih's paraphernalia of power. But this speculation stops here, for the ghost never speaks. Her name is never revealed.

It is also speculated that the spectral appearances within the milling machinery emanate from (as do many other commanding spectral forces in Central Java) Ratu Kidul, spirit consort of kings and legendary, all-powerful empress of Java's southern coastline and waters. This possibility is reconfirmed by the fact that Central Javanese palaces were known to have engaged this spirit queen's army of protection as guardians of the royal walls, sealing off inside from out. But again, the ghost in Tjolomadoe never reveals her identity and shows no outward signs of Java's famous spirit queen — none at all.

It is thus further speculated that this specter was once a member of Ratu Kidul's spirit entourage and sought out by Mangkunagara IV as a guardian of the factory, but who then developed a special late nineteenth-century fondness for machinery, parted ways with her commander, and began to operate with powers all her own. This possibility repeats, in turn, the logic of Pulungsih's threatening prowess of the uncannily undomesticated, of forces moving on their own, operating by uncertain contracts and demanding untoward sacrificial exchange. It, too, necessarily stops short of conclusion, unnamed, silent.

All such speculation concerning Tjolomadoe's origins and the peculiar spirit of the thing was meant to be put to rest, officially, on 18 April 1937. This date marked Mangkunagara VII's unveiling of a stone taken from the palace's south coast hills and erected in a formal courtyard facing the factory entrance, a stone said to have mysterious powers, a stone sculpted in the likeness of Mangkunagara IV. This figure, reckoned the twentieth-century prince at the time of the unveiling, represented the real spirit

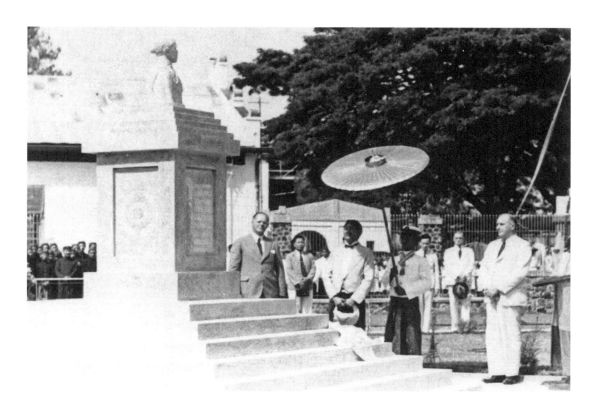

6. "Prince Mangkunagara VII Unveiling a Bust of Prince Mangkunagara IV, Tjolomadoe, Central Java, 18 April 1937."

of the place, a nineteenth-century Javanese ancestor who appeared to foresee the undeniably mechanized age ushered in by Tjolomadoe. The monument would act as a sort of formal lodestone, somehow centering the modern factory squarely within a Mangkunagaran legacy, thus permanently grounding the mill's unsettled past and ghostly encounters. Ever since the stone's emplacement in 1937, each year just before the milling season commences the twentieth-century classically European bust of Mangkunagara IV, which rests on an Art Deco pedestal, has been treated in the fashion of a ninth-century classically Hindu-Javanese *lingga*, that is, a figure of phallic design and fertile intent. The marble head is proffered incense and incantation, anointed with consecrated water, ritually scrubbed, and circumambulated in silence. This Mangkunagaran ritual moment is, indeed, most remarkable. Nevertheless, a few weeks later in 1937, just after the monument was dedicated and at a point of peak intensity in milling, the newly ground sugar yet again ran red. Inside Tjolomadoe, Javanese machinists were not at all surprised.

It seemed self-evident to those close to the milling machines that the monument, magically endowed or not, had little effect in securing pro-

tection from accidents associated with ghost appearances — thrown tie rods, blown boiler heads, sudden irregular grinding of tensed mill rollers, and so on. Even offerings such as those blessed by de Graeff in 1928, poised before the camera and machine Number One, were not really all that effective. These were offerings placed upon the conveyor belt of the primary milling station at the beginning of each year's "campaign," or *campagne*, as it was termed in Dutch (with *kampanje* following in Malay, then Indonesian): a season of overdrive, of round-the-clock machine operation attempting to keep pace with freshly harvested cane as it rolled into the factory. It was also a season of acute industrial fatigue, a highly modern concept that, circa 1900, applied equally to the machinery and its operators. "The curves of fatigue for metals coincided in a remarkable way with the curves of fatigue for muscular effort," reckoned the Smithsonian's *Yearbook* in 1911.[6] One is tempted to say that it is just such a coincidence, whether charted or not, that so haunted Tjolomadoe, from its nineteenth-century colonial-era inception to the repeated campaigns of its late twentieth-century postcolonial operation.

"For the well-being of Tjolomadoe, the campaign, the workers, and the machines," began the invocation as the offering was conveyed to the black-hole portal of machine Number One on 18 April 1984. (This offering consisted of a pair of sugarcane stalks, "finest in the fields," adorned as a bride and groom.) The utterly mechanical, keep-the-wheels-turning sentiment of progress and profit within this official prayer on behalf of Tjolomadoe toward the end of the twentieth century was essentially the same as that offered during de Graeff's visit in 1928. Such conveyor-belt offerings, formal prayers, and administrative dreams have been of little concern, however, to those working the milling and boiler stations. The machinists have long had something else in mind, something not in the picture of de Graeff bestowing blessings, not in the picture at all.

The ghost in machine Number One was not the only presence completely uncaptured by the ceremonial photograph documenting de Graeff's 1928 visit to Tjolomadoe. Embedded within much of the machinery of Tjolomadoe — underneath boilers, at the base of electrical terminals, along rail tracks, in the chained sprockets, ratcheted wheels, and pitched runoff troughs of the milling machines themselves — were heads of water buffalo and cows, decapitated vestiges of sacrifice. The dozen or so heads were already present at the moment when the sugarcane offering was blessed. They had been placed in their respective positions so matter-

of-factly, so quietly, without any apparent rites of sacrifice or ceremonial speeches, that it may very well have seemed that they belonged, somehow, to the machines themselves. The camera was not drawn to them in 1928. In the Indies, the camera was characteristically engaged with scenes dramatizing repetition, whether manifested ritually in moments of dedication ("finest in the fields," a "bridal couple" ceremoniously offered) or manifested mechanically in moments of industrial production (geared four-ton rolls, gleaming, conveying material into the future, product into circulation), or both: sugarcane brides and grooms caught in the machine and, spectacularly, crushed.[7] The water-buffalo heads had ostensibly little to do with such moments of ritual or mechanical drama. Perhaps they seemed indifferent to de Graeff's call for campaign success and harvest productivity, for they were left unphotographed in 1928 as their glassy eyes stared vacantly into the workings of the factory.

Javanese machinists working the milling and boiler stations had put the animal heads into position on the eve of the milling season, just before boilers were ignited and cogs slipped into gear. This was done in 1928 just as it had been done for years before and would be every year thereafter.[8] For the machinists, the advent of the campaign meant not productivity and prosperity but the heightened possibility of accident and ghostly encounter. They were just as sure to set the heads in place as they were to set steam valves, to grease cogs and chains. While factory administrators (in colonial as well as postcolonial times) would make reference to "harvest-time rituals" and similarly optimistic phrasings of celebration, it was the machinists' own term for events linked with the advent of milling that would prove, through alliteration, the most compelling for Javanese and thus become pervasive: *tjembrèngan*, the noise of machines in operation, a strange sound of metallic rattling.[9]

The severed heads have not displaced the possibility of accident in Tjolomadoe. Instead, they have called attention, annually, to that very possibility for those working close to the machines. In this sense, they have never failed. In this sense, too, their presence is not unlike that of the ghosts—whether in the figure of a woman, spectrally projected, or her serpentine consorts—associated with the machines. The peculiar thing about the snakes who appear occasionally, always one at a time, is that they go through the milling machinery unharmed, completely intact, and then just disappear. A snake appears on a boiler and two hours later the machine stalls, is repaired, then stalls again. The spectral snake's appear-

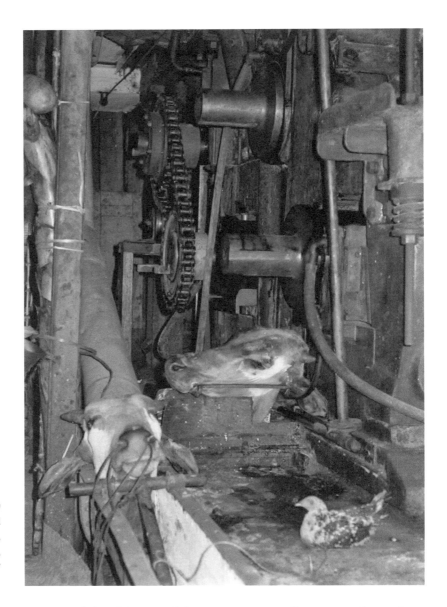

ance signals breakdown and thus serves, potentially, as a warning to those able to maintain a certain distance, momentarily reflect on the sighting, and, in so doing, recognize the premonition.

In the case of an extraordinarily large snake or crowned serpent, the sudden appearance itself may prove so startling that an accident follows immediately, without any pause whatsoever. This is especially likely to happen when the ghostly appearance is that of the figure associated with machine Number One, the specter unacknowledged by de Graeff. "There she was, floating over the milling rolls, and he was stunned, ter-

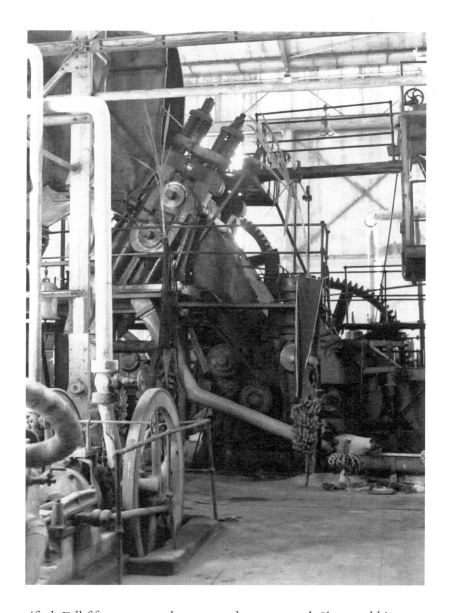

rified. Fell fifteen meters down onto that pump rod. Skewered him, ran clean through. Left him just hanging there," recalled a senior machinist in 1984.[10] The accident is almost as automatic as the timing of the pumping rod's arc. Both reflexes, those of the victim and the instrument of death, are mechanized. One is not even certain about what, exactly, has just "left him": the machine in gear, as its cogs continue to turn, or the ghost as she vanished without a second thought.

This lack of certainty derives, in part, from the fact that the ghosts of Tjolomadoe do not speak but simply linger in the factory, silent, dis-

appearing just as quickly as they appear. There is a sense that they once, perhaps, had names and were able to be summoned up with mantras and appeased. But that was a different time. What remains is the space of a spectrality now generalized. Machinists note that the milling machines are old, very old—much of the Tjolomadoe's machinery dates from circa 1900—and were they to be replaced by new equipment, perhaps ghosts would not appear and accidents not occur. The same is said of the factory's oldest railway engine, Loco Number One: "Should've been retired years ago."[11] This is not intended as a comment on the condition of Tjolomadoe's machinery, for the same machinists speak with much pride of their smoothly functioning milling stations, and the milling machines themselves appear in remarkably good shape, well-tuned and polished. Instead, the very antiquity of the machinery recalls a past that should be obsolete but for some reason is not. The space is thus genuinely haunted.

Within this space, even the most intimate of offerings—the lovingly positioned heads of sacrificed domestic animals—presented by those closest to the machines, appear unusually ominous. They recall danger that is conjured up in order to be expelled, yet the precise source of this danger that takes the form of accident is uncertain. Coupled to this uncertainty is a pronounced ambivalence toward the ghosts themselves, for these ghosts can be reassuring indicators of an accident to be avoided and, at the same time, startling signs of an accident already in progress. To tell stories of such accidents and apparitions is to reaffirm one's distance from ghostly effects, to replay the possibility of a timely premonition when a ghost was once sighted and is now safely recalled. And yet these stories are themselves ephemeral, existing, like ghosts, only in the time of their appearance, in the time that their recollection takes. To place the severed heads of sacrificial substitutes within the machinery of Tjolomadoe replays a similar possibility, anticipating, as it does, an accident yet to be avoided. It is as if one is given a shadow of a chance, known only in due time at the moment when the accidental aspect of accident becomes fortunate or otherwise.

While de Graeff seems not to have been aware of such an offering or the ghostly effects it portends, Dutch personnel closer to the workings of the sugar factory were not uninformed. Jan Poll, commenting on what he perceived as "native rituals" held at "the beginning of a new harvest season," recalls, for example, "the bleeding water-buffalo heads. . . . One

factory may take these things more seriously than another." After dwelling at length on Javanese ritual affairs, particularly communal feasts, Poll concludes, "While it may be true that in many domains we have something to teach the Indonesians and can bring forth their development, in the domain of culture which is natural and inborn, we can take a lesson from them and then come back for a second one."[12] With their finely tuned sensibilities in ritual matters, Javanese know, somehow, something that "we" too should know but do not. Offerings are read as traces of this privileged knowledge, just as ritual behavior in Java is sensed to be uncannily in touch with something still beyond the grasp of even the most dedicated of the colony's administrators.

Such a perception no doubt sentimentalizes the sense of otherness that authorized a declared need for colonial development, for transmission of the modern. That this perception should arise within what Poll calls "the domain of culture" — something "they" have, from birth — is not surprising. At the same time, Poll appears genuinely drawn to this thing, ritual or otherwise, about which he knows that he knows little. This sort of attraction appears at another moment in his recollections of the sugar factory, but this time wholly outside the domain of culture and within, instead, what one would assume to be the domain of the modern itself:

> I can never express enough admiration for the special qualities I discovered in our Indonesians during my long career in the Indies. I say "discovered" but that in no way means that I really understood. I must confess that I still am not able to understand.
>
> I will elucidate this with a concrete example. When I had been first machinist for a year in a factory new to me and had the opportunity to train my [native] folk, I made the following proposition to the "toe-kangs," who are their craftsmen. Whoever among you has a son, if you want him to work in the factory, let him line up tomorrow at such and such hour.

Poll goes on to describe how he chose a dozen native boys who looked bright and were around twelve years old, boys who proved extraordinarily quick at picking up the trade: "They became, almost without exception, excellent specialists."[13]

Such a comment again sentimentalizes relations, this time featuring Poll as the source of lessons learned. And again, at the same time, there is the acknowledgment of something highly admired but not understood. It

is not the fact that native youths of the Indies become highly skilled machinists that astonishes Poll. That is quite clear, as Poll repeatedly notes with satisfaction. Rather, it is the way this skill manifests itself:

> It is not at all clear to me how such a youth later arrives at the science of how a steam engine works, or a motor drive, how they know their lathes, which pinion they must set to turn one or another screw-thread. In less time than I would have needed to make a very complicated calculation, he knew it all and had done his job without error. People pointed out to me that this was purely routine work, well then I take my hat off to such routine, which even knows what to do with a rare screw-thread. People sometimes explained this as intuition, but surely this is intuition that is determined by an understanding!

Yet what could such an understanding be? "I must confess that I still am not able to understand."[14]

The point where the two domains of "special qualities" coincide — ritual on the one hand, mechanical on the other — lies precisely in the realm of repetition. While the potential force of repetition conveyed by ritual may be partially contained under a rubric of culture (in Java, at least, in colonial as well as postcolonial times), the implications of a purely mechanical repetition exceed such containment. And it is the acutely sensed conjunction of the two here — the traditional ritual and the modern mechanical — that so eludes understanding, as Poll notes, and remains unsettling. It is as if the culture of premodern Java were already somehow in sync with modern skills, and thus the modernist distinction itself, which would separate the modern from the premodern (the here from the there, the inside from the out, the now from the then, and so on), has begun, uncannily, to disappear, taking with it the guiding principles of colonial progress. Through this sensation of routine, this sense of repetition which some would say is informed by intuition, the logic of mechanized behavior has begun to assert itself. It informs all the workings underpinning the vast machine of Tjolomadoe, producing uncanny effects.[15] Poll is attracted and drawn to this unthinkable logic just as certainly, just as automatically, as the camera itself is drawn to de Graeff in 1928, as he ritually blesses the offerings conveyed up the ramp of machine Number One.

Nowhere is the extent of Tjolomadoe's reach more evident than on the railway tracks that extend out from the factory. The camera is drawn to this as well, and it sits so close to the rails that it becomes enmeshed,

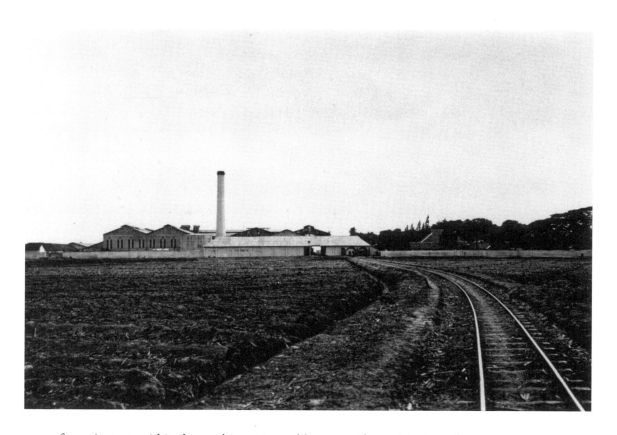

9. "Rails Reaching Out from the Sugar Mill, Tjolomadoe, Central Java, c. 1910."

for an instant, within the machinery it would expose. The positioning of the camera is not accidental; it has been repeated obsessively in a history of photographic encounters with the railway that can be tracked from the mid-nineteenth century on.[16] The fact that essentially the same shot might also have been achieved from the front of a train (as was often done) or from the back reiterates this sense of mechanical conjunction between camera and railway. The viewer is drawn in and inhabits this point of conjunction where the space behind the camera coincides with that of the train. It is a precariously empowered viewpoint that is driven by the machinery of locomotion behind it and, at the same time, is completely vulnerable to whatever might come down the tracks. It is the point that views the point where, or when, a "viewing point" becomes impossible. It is the point that indicates accident.

A second conjunction between camera and railway occurs from within the train as one looks out through the coach window, away from the oncoming tracks. It facilitates a point of view that, in its very denial of any untoward conjunction, appears far more reassuring.[17] Recalling a 1924 visit to the Indies by the Dutch architect H. P. Berlage, Rudolf Mrázek

notes, "As the train pulled out of the station, Berlage pulled his window up: 'the aspects are fleeting . . . cinematographic . . . palm groves, *kampongs* [neighborhoods, here rural], bridges, green sawah rice fields . . . blue and hazy horizon.'" "As far as Berlage could see," Mrázek adds, "beyond the window glass and framed by the window frame there lay the *mooi Indie*, 'beautiful Indies,' a late-colonial image often more significant than the colony itself."[18]

What passes by in this sequencing of framed scenes of village cultivation, unfolding in time with the regular rhythms of the rails, is the image of an Indies at marvelous right angles with the modern railroad, yet all the while in sync with it. This was the beautiful Indies, endowed with a pronounced sense of culture, as Poll reckoned, natural and inborn and exhibiting an abundance of harvest-time celebrations of well-being and prosperity. Such was the image projected by de Graeff as he blessed Javanese sugarcane in 1928. Click, the "beautiful Indies." The camera could not, would not, miss it.

What is repeatedly bypassed by such an image in its compulsive articulation and reproduction of well-being, the very thought of accident. Just as incidental jolts are cushioned by railway shock absorbers and padded coach interiors, putting out of mind the dangers of machine irregularities and letting the eye drift effortlessly across rice fields, village rooflines, and palm tree tops, so too similar irregularities remain invisible — out of frame, perhaps — in the photograph of de Graeff. Potential shocks are absorbed by his figure's ceremonial gesture. This figure's arm extends outward, as if holding off something at a distance, yet all eyes seem to adopt the viewpoint of the camera here and look, reassuringly, toward de Graeff himself.

At the moment when an accident does occur, shock is doubled. For it is not simply the sudden derailment of a locomotive or the suddenly thrown rod of a tensed milling machine that proves so shocking during the moment of accident, but the coincidental shock that comes with the abruptly recalled memory of forgotten danger, with the uncanny sensation of something (potentially dreadful) known all along but routinely suppressed. Just such a moment is approached by the camera when it is positioned on the tracks, as noted earlier, exposing the instant of conjunction between two converging viewpoints, those of the camera and the train. Sometimes the camera is placed dead center. (This is not a position de Graeff would assume.) The machine appears to reassert itself. The repercussions of repetition — mechanical, habitual, ritual — return, full

force. Even sustained attempts to locate a position for oneself at a distance from such a force become derailed.[19] When confronted with an unnerving coincidence between the seemingly automatic, rapidly executed skills of native machinists and his own slow logic of studied calculation, Jan Poll articulated this desire for distance, so critical to the colonial enterprise, in terms of a need "to understand," to comprehend objectively, not intuitively, that is, with the proper perspective on things, to truly grasp. Yet there may be other terms for registering distance.

The machinery of Tjolomadoe is indeed extensive. To locate a position from which one might point at the thing and hold it at a distance, in view, is not easy. The camera placed close to the tracks confronts us with this difficulty. Just as there is a certain convergence between the apparatus of the camera and that of the railway outside the factory, so too one recalls the numerous moments when the milling machines within the walls of the factory proper presented themselves as perfectly fitting photographic subjects and drew the camera in automatically. And just as the railway tracks connect these moments of engagement between the camera and the machine, between the machine and extensions of its own making, so too one recalls a certain convergence, very real, between the

10. "Dead-Center: A Bridge Near Surakarta, Central Java, c. 1915."

railroad and the sugar factory. Made up of primarily the same mechanical parts and design — steam valves, pressure seals, and contoured plates for boiler units; slip rings, piston rods, and geared cogs for motor drives — and forged from essentially the same materials, these two aspects of the machine that is Tjolomadoe are virtually indistinguishable. The carriage had become inseparable from the road in the singular system that became known as the railway. "The wheels, rails, and carriages are only part of one great machine, on the proper adjustment of which, one to the other, entirely depends the perfect action of the whole," observed C. H. Greenhow in 1846, introducing *An Exposition of the Danger and Deficiencies of the Present Mode of Railway Construction*.[20] The milling stations within the factory are tracked into precisely the same machine. They are inseparable from it. Through a system of conveyor belts, linked rollers, and mechanized chutes, they are bolted to it. With its oversized steam boilers and multiple cog ensembles, the sugar factory is, in effect, an enormous, monstrous locomotive — without wheels.

In colonial Java no doubt the most significant point of coincidence between the railway and factories such as Tjolomadoe was their shared reputation as sites known to produce, without fail, fatal accidents. To the extent that one observes in this pair of sites one great machine, such a coincidence is not surprising. In Tjolomadoe, this coincidence between train and mill marks the moment when the machine makes its most obviously aggressive move by operating entirely on its own, as if moving by its own geared will. Some nights the factory's oldest steam locomotive has tracked its way out of the mill. There appears to have been no engineer operating the machine, only, in fact, the remains of a victim discovered near the tracks the next morning. There also appears never to have been a ghost sighted in conjunction with this form of accident, not in the manner that ghosts have appeared within the factory, just as it seems that there has never been any apparent reason for the person who would become the victim to be there at that time. This is the most automatic form of accident, when coincidence feels fated.

The relatively modest offerings placed by machinists near locomotive Number One appear there more frequently than the sacrificial heads that are positioned, by the same machinists, at their milling stations annually on the eve of the campaign. The timing of these more frequent offerings is not coordinated in any way with harvest seasons or milling events. It is strictly calendrical and observed every thirty-five days, marking a sig-

nificant coincidence between the cycling of five- and seven-day weeks within Javanese systems of divination.[21] Which is to say, the presentation of these offerings acknowledges a cycling of temporalities that intersect like cogwheels, repeatedly marking intervals whose significance is purely coincidental. The very automaticity of the accident here indicates a moment that cannot be distanced. The accident occurs right on track, without any possibility of deferral. There are no ghostly sightings that might be recognized as premonitions. The victim has, precisely, not a ghost of a chance.

Inside Tjolomadoe a possibility of deferral remains. Accidents are not (necessarily) automatic. Ghosts emerge occasionally amid factory machinery. A ghost hovers, if only for a moment, appearing as a potential sign of an accident yet to occur, an accident yet to be avoided, thus an accident whose outcome will be known only in the time it takes to happen. Some machinists keep a distance from such appearances and maintain their stations without mishap. Others, so startled by the sight of a ghost, fall headlong into this moment of accident already now irreversibly in progress. Fainting, these victims seem to have seen something that they apparently thought they should not.

In their capacity to startle, ghosts resemble photographs, including many of those appearing in the Mangkunagaran palace albums. Like ghosts, photographs bring into view something that has passed away and is not usually seen, something that perhaps should no longer be seen and yet will not stay away. Photographs remain as unintended traces of a ghostliness within the machinery of the modern. It is no accident that in the early days of the camera such ghostly implications were developed into spirit photography.[22]

A significant difference nevertheless distinguishes these two manifestations of spectral projection. The appearance of a ghost, like that which emerges near machine Number One, is momentary, fleeting. Its being does not depend on, much less derive from, its preservation, but just the opposite: a disappearance which is as sudden as its appearance. It is just this sort of passing—this coming to pass, without a trace—that so eludes photography. While the photograph recalls an absence and acknowledges, even foreshadows a passing, it does so by material means. Something is left behind, a trace. A photograph remains, like that taken of de Graeff in front of machine Number One on 21 May 1928. A ghost, on the other hand, simply flashes past, in a photographic-like instant, as

if mimicking the camera, and then vanishes, without any material trace whatsoever, into the memory of precisely that which cannot be photographed, no matter how ingeniously the camera may try.

The capacity to startle is not the only respect in which ghosts and photographs resemble one another. Both instances of spectral projection appear unusually capable of anticipating their future recalling as markers of that which no longer is. The moment of the camera's shutter click becomes extended into the future, prefiguring a reappearance of something that otherwise would have long faded from sight. The appearance of a ghost, itself already a reappearance, similarly exhibits this sense of anticipation, which operates every time a sighting occurs. Each appearance prefigures a peculiar certainty of return.

Such a sense of anticipation is particularly compelling in the case of ghosts appearing within modern machinery, like that associated with Tjolomadoe. The ghost in machine Number One is Javanese, yet she is silent. She may have originated from a source outside the factory and then have been drawn in by a fondness for machines at a time in the late nineteenth century when the novel powers of mechanical operation were increasingly sensed. But even this is uncertain. In that very uncertainty, her own powers of operation—the regularity of her movements, timed exactly with milling machine operation; the extraction of sacrificial offerings; the generation of breakdown and accident; and the production of victims—have coincided so perfectly with those of machine Number One that the ghost and the machine here seem virtually indistinguishable. The fit is precise, so precise that the machinery is truly ghostly. Indeed, it is as if a place for the ghost had already been reserved in the machine, this milling machine of Dutch design so capable of recalling ghosts. Or, to put it another way, it is as if this ghost, presumably from the Javanese past, were capable of anticipating its future recalling in the machinery of the modern.

Anticipation, here, thus again signals an unsettling coincidence of perspective, a point where the distinction separating the modern from the premodern begins to vanish, a point where perspective, as it were, begins to collapse. What emerges in the gap in understanding posed by such a vanishing is a ghost that appears somehow intrinsic to the machine and, at times, separable from it. This coincidence-turned-collapse of perspective recalls, in turn, the unnerving apparent coincidence between Javanese powers of routine, of ritual, and modern European workings of logic, of

intellect, that so haunted Poll: "I must confess that I still am not able to understand." In both instances of coincidence, a sense of critical distance collapses. All that remains is the apparition of repetition.

Nevertheless, anticipation extends another possibility. When Tjolomadoe machinists encounter a ghost and are able to maintain their distance from this thing in machine Number One, this thing about machine Number One, they do so not by removing themselves from their stations — that is, not by backing off as if to gain perspective — but by remaining perfectly still. This is the moment when they know that, *in time*, an accident will occur and the moment of the accident itself will pass, just as assuredly as the ghost will disappear. This is the moment when anticipation assumes the form of waiting: a marking of time that counters both the startling potential as well as the very monotony of the thing in the machine. A possibility of critical distance (that is, a distance which becomes critical) thus emerges in this moment of waiting, but distance here is marked as time, exactly the time it takes for chances to have been taken, for chances to have been given.

One wonders, then, how, precisely, the apparatus of the camera might be capable of registering such a moment, such a temporality oddly informed by the ghost of chance. Perhaps the closest the camera has come in its many encounters with Tjolomadoe was during the time of the factory's reconstruction just before the dedication ceremonies in 1928. This was a time when neither machines nor sacrificial offerings were in operation. With most of its machinery disassembled and lying in pieces on the factory floor awaiting replacement parts that would be borrowed second-hand from other factories, Tjolomadoe was immobilized. Its space exhibited a strange disarray. It was an out-of-gear time that slipped easily into an extended moment, a moment of waiting, a moment apparently so marked that the camera would not, could not, miss it.

A photograph recalls the foregrounded figure of an Indies laborer who is seated, resting, perhaps waiting. The man is looking in the same direction as the camera: their attention is drawn together to the figure of another laborer positioned almost dead center in the photograph, surrounded by factory scaffolding. This other figure stands motionless, waiting, perhaps resting, as he looks directly back into the camera. Viewpoints in this photograph converge and coincide in a manner that is fundamentally different from the point of view represented in the photograph of de Graeff on 21 May 1928, when milling machines were once again engaged,

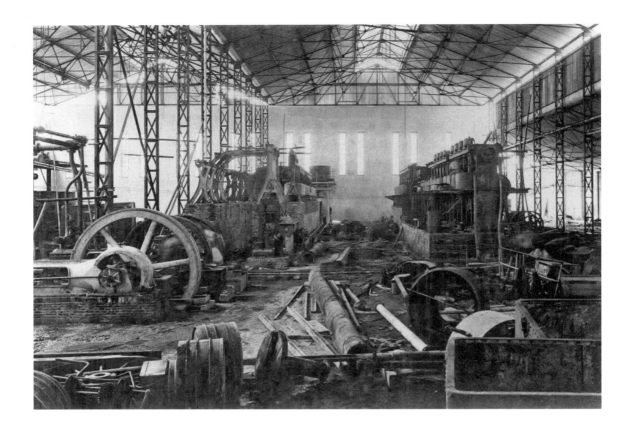

11. "The Sugar Mill Immobilized for Reconstruction, Tjolomadoe, Central Java, c. 1925."

offerings blessed, and the camera looked on reassuringly from the side at its ritual "beautiful Indies" scene. Here, from the viewpoint of waiting, the camera is drawn into a far more precarious position, akin to that looking straight down the railway tracks into a moment of convergence and the possibility of accident. The central figure of the other laborer in this photograph looks straight back and attracts the camera to a point of coincidence with itself, in a moment of potential collision with its own mechanics of operation. The figure does so simply by looking at the camera and standing still, perfectly motionless, waiting for the click. It is as if, in such a moment of coincidence, one were waiting for the ghost in the machine to appear.

Yet still the ghost is not exposed. During this time of disassembly, when machines are not yet in gear, the ghost should, in fact, *not* be in the picture. Through the very appropriateness of an absence, then, the ghost becomes all the more possible here, all the more anticipated in this extended moment of mechanical pause and waiting, all the more tangible

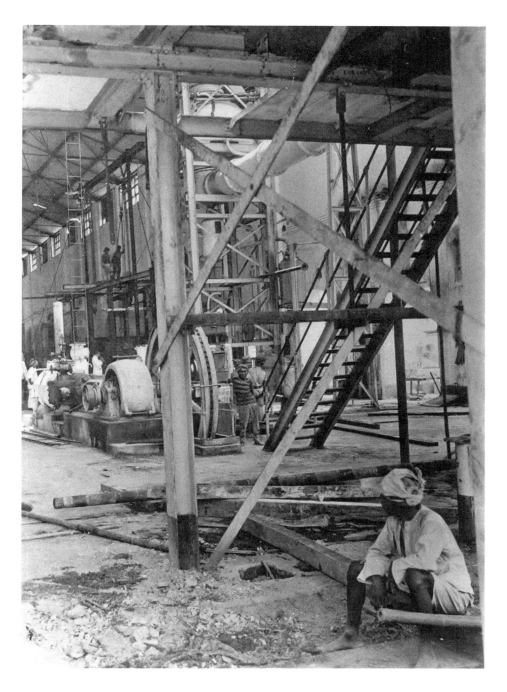

12. "Laborer Resting,
Tjolomadoe, Central
Java, c. 1927."

in this photograph. And when the ghost does reappear, as she did with a vengeance, most visibly, just after the 1928 dedication ceremonies, foreshadowing accidents for that year, she carries with her not a camera, but the instrument of modernity that might, in time, most accurately register the exact moment of her own passing. She carries a watch.

NOTES

I would like to thank Nancy Florida, Rosalind Morris, and James Siegel for their insightful reflections on issues addressed in this essay and for their suggestions for changes.

1 This information and much of that informing this essay comes through personal communication in and around the Tjolomadoe factory, Kartosuro, Central Java, in 1976, 1982–84, and 1996. I am particularly indebted to Pak R. Parmodisastro (b. 1897, senior machinist since 1922), Pak Karya (b. 1900, senior machinist and offerings specialist), and Pak Sujono Wiradisastra (b. 1908, Mangkunagaran representative). I am indebted as well to Pak Hatmokartoyo (village head), Pak Marlan (head of milling stations), Pak Rachmad (senior clerk), Pak Utomo (junior clerk), Pak Budiyanto (engineer), and other workers at the sugar mill. I am especially grateful to the late KRMTH Sanjoto Sutopo Kusumohatmojo (head of palace affairs at the Mangkunagaran), who introduced me to the Mangkunagaran Palace's Reksa Pustaka library and graciously permitted me to reproduce colonial-era photographs from the palace's collection, including the photographs used in the present essay.

2 For a history of the emergence and various effects of a sense of Javanese "tradition" (in contradistinction to the "modern") in colonial Java, see Pemberton, *On the Subject of "Java"*; see 125–32 for a discussion of Mangkunagara VII's particular role in this regard.

3 Simmel, "The Metropolis and Mental Life," 412–13.

4 Poll, "Op een Suikerfabriek," 154, 162. Translation mine.

5 Pulungsih wedded a Mangkunagaran prince (Suryamijaya, circa 1810) and bore a daughter (Samsiyah), who wedded the future Mangkunagara III (r. 1835–53) and bore a daughter (Dunuk), who, in turn, wedded the future Mangkunagara IV (r. 1853–81) and bore the future Mangkunagara V (r. 1881–96), father of Mangkunagara VII (r. 1916–44).

6 Quoted in Schivelbusch, *The Railway Journey*, 124.

7 In the early twentieth century, in addition to the sugarcane offerings conveyed into the machine, one also still found *bekakak*: human figures shaped from rice flour and filled with reddish-brown sugar syrup which discharged dramatically, in a moment of liquid brilliance, when the milling station's rollers engaged.

8 The sacrificed heads displayed in figures 7 and 8 were photographed in 1984, when the camera (in the hands of the present author, at least) could no longer resist what seemed to be the completely ritual attraction of the moment.

9 Another reading of *tjembrèngan* suggests that the term derives from *tjèngbèng*, a Chinese Malay ritual of graveyard purification held during the month of April. Indies natives serving as chemists in sugar mills were characteristically of Chinese descent.

10 Pak Karyo, personal communication, Tjolomadoe, 24 April 1984.

11 Pak Parmodisastro, personal communication, Tjolomadoe, 28 April 1984.

12 Poll, "Op een Suikerfabriek," 164, 165.

13 Ibid., 152.

14 Ibid.

15 Here, one recalls Freud's (1919) discussion of automata in relation to uncanny sensations. Recalling Jentsch's (1906) study of the "uncanny," Freud notes as well "the uncanny effect of epileptic fits . . . because these excite in the spectator the impression of automatic, mechanical processes at work behind the ordinary appearance of mental activity." Freud, "The 'Uncanny,'" 226.

16 See, for example, Kirby, *Parallel Tracks*.

17 This viewpoint, too, has a history that can be tracked from the mid-nineteenth century on. In Wolfgang Schivelbusch's indispensable *The Railway Journey*, we find this description: "Jules Clarétie, a Parisian journalist and publicist, characterized the view from the train window as an evanescent landscape whose rapid motion made it possible to grasp the whole, to get an overview; defining the process, he made specific use of the concept of panorama: 'In a few hours, it [the railway] shows you all of France, and before your eyes it unrolls its infinite panorama, a vast succession of charming tableaux, of novel surprises'" (61). Clarétie's comment is from 1861. On the linking of railway and photography, Schivelbusch moves on to note, "What the opening of major railroads provided in reality—the easy accessibility of distant places—was attempted in illusion, in the decades immediately preceding that opening, by the 'panoramic' and 'dioramic' shows and gadgets. These were designed to provide, by showing views of distant landscapes, cities, and exotic scenes, 'a substitute for those still expensive and onerous journeys.' . . . That the diorama fad died out in Paris around 1840, more or less at the same time that the first great railways were opened . . . would seem corroborative evidence for the presumed connection. The simultaneous rise of photography provides more support for the thesis" (62).

18 Mrázek, "From Darkness to Light," 18.

19 It is probably no accident that one of only two personal encounters with the uncanny which Freud recorded in "The 'Uncanny'" should occur on a train: "I was sitting alone in my *wagon-lit* compartment when a more than usually violent jolt of the train swung back the door of the adjoining washing-cabinet, and an elderly gentleman in a dressing-gown and a traveling cap came in. I assumed that in leaving the washing-cabinet, which lay between the two compartments, he had taken the wrong direction and come into my compartment by mistake. Jumping up with the intention of putting him right, I at once realized to my dismay that the intruder was nothing but my own reflection in the looking-glass on the open door. I can still recollect that I thoroughly disliked his appearance" (242). In this

instance, "a more than usually violent jolt" produces not an accident, but the conditions for an uncanny reemergence of the double itself.

20 Quoted in Schivelbusch, *Railway Journey*, 20.

21 An introduction to such systems appears in Geertz, *The Religion of Java*, 31–35.

22 See Gunning, "Phantom Images and Modern Manifestations."

JAMES T. SIEGEL

The Curse of the Photograph

Atjeh 1901

When I was in Aceh,[1] the province of Indonesia on the northern tip of
Sumatra, in 2000, I was not surprised to find nearly every Acehnese I met
strongly against the government. Most people supported the Free Aceh
Movement, which meant they wanted to secede from Indonesia. They
claimed an Acehnese identity in the face of the depredations of the Indo-
nesian army, which for decades has killed, raped, and robbed throughout
the province. I was all the more surprised, then, when I heard so few ref-
erences to the Atjehnese War, as the Dutch spoke of it. From the time of
the Dutch invasion of the sultanate of Atjeh, Acehnese conducted a fierce
resistance lasting about forty years. It is not easy to establish a new iden-
tity even when it claims to be grounded in an old one. Why, then, more
references were not made to the war, and why, in particular, nothing like
the jihad that was waged against the Dutch is being waged now — this
despite the examples from other places in the Muslim world — interested
me. One cannot treat an absence directly. Looking again at photographs
of the war made by the Dutch, I asked myself about the place of photog-
raphy throughout the conflict, hoping that this necessarily oblique ap-
proach might suggest an answer to my question.

Photography came early to the Indies, in particular to Java. As else-
where in the world, it arrived in the wake of a tradition of pictorial repre-
sentation which, according to Liane van der Linden, reduced the strange-
ness of the island and its population.[2] There were two aims of this form of
representation: to show the place as it was and to be aesthetically pleasing.
When photography began, it furthered this double aim. The first major
use of photography by the state was in archaeology. Under the influence
of the Napoleonic inventory of Egypt and for the sake of the prestige of

the Netherlands, the government wanted to show the great temples of Java, particularly the Borobodur. The drawings that had been commissioned for this purpose were thought to fail. They "were not considered suitable for scientific study, nor did they do justice to the artistic value of the Borobodoer."[3] The governor general gave the task of photographing the monument to a photographer, Isidore van Kinsbergen, who had maintained a studio in Batavia since about 1860. There was little general interest in these pictures.[4] Yet at least from an artistic point of view, they were a success, inspiring Gauguin, for instance.[5] The double interest in scientific recording and in aesthetic rendering continued as the photographic inventory became one element in the general recording and, some say, invention of Javanese culture by the Dutch.[6]

Van Kinsbergen taught his photographic skills to a man named Kassian Céphas, who became the first Javanese photographer. Another story has it that it was not van Kinsbergen, but another Dutchman, Simon Willem Camerik, who taught Céphas. Whatever the case, Céphas apparently learned photography from one European or another between 1861 and 1871.[7] He was subsequently hired by the archaeological service to photograph many important monuments, including the Borobodur. In that case, he was a success in the first aim, "to show the place as it was," but there was controversy about his degree of success in the second. Some notable Dutch authorities at the time felt that his photographs lacked the modeling that would show the beauty of the temples. They felt that his pictures were too stiff. Not everyone agreed with this assessment; the Jogjanese court retained him to photograph its members and to record its ceremonies. The controversy continues into the present. The French historian Claude Guillot said of Céphas's pictures, "With rare exceptions, all life seems to have disappeared. Nothing indicates a trait of character: there is no overall plan; all the portraits are taken standing, face forward, stiffly posed, under equal light. Images of dignity and not images of individuals."[8] He was answered by a Javanese, Yudhi Soeryoatmodjo, who argued that the images were not supposed to represent character, and that faulting them for its absence would be a judgment foreign to the time and place. They were meant to show dignity. It is not a question of technical ability. The pictures show what the sitters intended, which was not the individual characters but what surrounded them. Their regalia, the batik they wore, and the positions of their hands represented the tradition and identity of the Yogyakarta court. These critics agree about the character of the photographs, but they disagree about their value. I say this in order

to say that there was little problem in adopting photography in Java. The very mechanical quality of the camera may have enabled it to show what Yudhi Soeryoamodjo says Javanese wanted it to show.

In any case, the most important achievement of the camera—memorialization—was precisely what all parties wanted. As the Dutchman J. Groneman said in the preface to a volume of Céphas's pictures of court ceremonies, "One day this shall belong to the history of the past. May then this book preserve the memory and manifold remarkable imagery of it."⁹ That is exactly what happened. And that is because there was an accord of ideas about the aims of photography between the Dutch who taught Céphas, thus indirectly establishing a line of Javanese photographers after him, and the Javanese consumers of his pictures. The disagreement between some Europeans (not including Gauguin, for instance, who used his pictures) and the Javanese only shows how photography suited Javanese aims and even their tastes.

All this sounds unexceptional, but the compatibility of photography with the cultures of the archipelago should not be taken for granted because photography was not adopted elsewhere in the Indies. I will now turn to one area where it found no place in local culture. My point, in fact, is to explain why, when the camera, as an instrument of memorialization, ought to have been quickly adopted (providing always that there are no myths about its technology, as there apparently weren't in the case I will discuss), it was not. I hope thereby to say something further about the place of the camera generally.

To do so I will turn to the story of another photographer, this time Dutch, from a few decades later but from quite a different place. In 1873 the Dutch invaded the Sultanate of Atjeh. Dutch ships anchored off the coast near the seat of the sultanate and landed their troops. The Dutch forces had only poor maps and guides. They got lost repeatedly during their first foray. They found themselves surrounded and attacked by Atjehnese snipers, whom they could not see. They managed to get to the palace grounds and burned down the palace, only to find they had actually destroyed the mosque. General Kohler, in charge of the expedition, standing under a nearby tree, was killed by a sniper. The Dutch forces retreated and did not return until the next year. When they came back, they brought photographers with them, members of the Topographical Service, whose job it was to help in gaining knowledge of the terrain, but who also photographed the troops and the areas where they were found, as well as Dutch fortifications and, eventually, the results of Dutch vic-

tories.[10] Unlike in Java, then, photography in Atjeh was not a tool for the preservation of a culture, but a technological device devoted to its defeat and to the recording of the remnants of that defeat.

The Topographical Service pictures reproduced in a book by Louis Zweers are not those used for the preparation of maps, however. They show the inside of Dutch forts, the position of the cannon, the cannoneers with them, the mortars and their accompanying soldiers, poised to shoot. They also show a team in charge of provisions positioned next to their supplies and warehouses and sailors in ranks on board their ships. These photos associate people and things: soldiers with their tools. They show installations new to the sultanate. They show the occupation of Atjeh, insofar as it had progressed, but more than that, they show the Dutch in the process of inhabiting the sultanate. These men belong in the landscape, in the first place because they have wrenched the land away from its inhabitants. There are pictures of soldiers at ease, in half-dress, comfortable in their surroundings. They are in Atjeh, but the gap between Atjehnese and Dutch was surely greatly widened by the prevailing hostility between them. The Dutch did not drive the population out of the capital, which they named Kota Radja, City of the King, but they had little to do with them. Given the hostility of the Acehnese toward the invaders, the pictures of Dutch soldiers in Atjeh reflected back to them their presence in the sultanate in the absence of the usual reflection one gets from the glances one exchanges with local inhabitants, whether one is at home or in a foreign place. The lack of reassurance furnished by mutual looks was compensated for through the mediation of photography.

The Atjehnese War lasted perhaps forty years or more. No one is certain when war turned into a resistance movement sustained by small bands of guerrillas and individuals. Several times this conflict was wrongly declared over. After Dutch forces took the palace in 1874, they thought they had won, but it was still more than twenty years before the large valley around the capital was cleared of resistance forces. At that point, in 1898, Dutch forces moved to Pidie, an area of the sultanate on the east coast. Their success there again led to announcements of the end of the war, but again this was not the case; no one dates the end of that conflict before 1914. In 1901, General van Heutsz, the Civil and Military Governor of Atjeh and later governor general of the Indies, who, along with Christian Snouck Hurgronje, is given credit for the policy that eventually led to the ending of the war, moved to the next important site of resistance, Samalanga, in Pidie. By this time, the influence of Atjehnese *ulama* (religious

scholars) had risen considerably, and the doctrine of the holy war was widely influential.

"Atjehnese will never be defeated except by force, and then only someone who shows himself to possess power [*macht*] to make his will respected shall be the master whose orders they will obey." This sentence of General van Heutsz, widely quoted, is repeated in the introduction, pseudonymously signed, to a book written by a commercial photographer, C. Nieuwenhuis. Van Heutsz invited Nieuwenhuis to join his troops in their expedition to Samalanga to record it. The writer of the introduction notes that popular interest in the war in Holland waxed and waned, depending on major events. Much took place during what he thought was the final stage of pacification, a stage that he believed the Dutch public should be aware of and yet was apparently ignoring. He hoped that the photographs would arouse interest and thus support for the war. In point of fact, the brutality of van Heutsz, of a sort repeated later on a larger scale by General van Daalen and carried out prior to his campaign in the clearing of the Atjeh valley, aroused indignation in Holland. The book reports the burning of villages, for instance, and there is a photo showing victorious KNIL (the acronym for Royal Netherlands Indies Army) troops staring down onto an Atjehnese fortification they had just defeated.[11] Atjehnese corpses are scattered over the earth. This photograph became the model for others taken later, as photographers fulfilled van Heutsz's goal of recording Dutch victories. Other photographs, showing Atjehnese women among the corpses, with only babies left as survivors, are even more difficult to look at.[12]

Nieuwenhuis was not self-conscious about his work. He says of himself that, thanks to the good offices of a certain Lieutenant Colonel Van der Wedden, van Heutsz, allowed him to be "a witness to the foremost events of the Samalanga campaign."[13] He wrote a short account of the expedition rather than an account of how he took his pictures, though he sometimes includes such information incidentally. He lists the participants in the march through the forest to the series of Atjehnese fortifications and describes the difficult conditions they encounter. His photographs are illustrations; he could well have written the book without including them, since one can comprehend his perceptions of the course of the expedition without them. He reports that he was the first photographer to be invited on such a military expedition in the history of the KNIL. His account shows him to be a nonsoldier who was much impressed by General van Heutsz and by the prowess of his soldiers. It was probably

that admiration that gave Nieuwenhuis the courage to make the horrifying photograph he did of the Atjehnese victims of this aggression.

Events that took place before the scene of the final battle he records without much feeling. For instance, at one point the artillery destroyed an Atjehnese fortification. When Dutch troops reached a nearby village, they discovered that the inhabitants had fled when the fortification was destroyed. Nieuwenhuis writes, "The warships off the coast thus got the chance to successfully harass the refugees with their salvos." The initial plates in the volume have captions such as "Panorama of Meuredoe," a place on the coast; "Naval artillery, 10.5 cm, on Glé Nang Roë," Glé Nang Roë being the mountain where fighting began; "Bivak Nang Roë," showing about two dozen soldiers posed in a group before an Atjehnese house where they apparently put up. And so on. But Nieuwenhuis also continues to use the camera to show things never before registered on film and to create a record to be used later, as photographers in Atjeh did before him. He describes, for instance, how in certain places there is practically no trail at all: "At 10:30 am the head column reached Oeloë Oë; the artillery left the path and tried to find a better way to Gampong Ankieëng. But this path too was scarcely passable." The way is rough, and it takes a full day to march ten kilometers. At this point, the author inserts a photograph of the troops wading across a river for lack of a bridge. When a bridge does appear in the photographs, it is an Atjehnese bridge, a series of bamboo poles set in a line over a swamp, with another such series raised above it to be used as a railing. The soldiers balance their way across, but several seem to have fallen into the water.[14]

When the Dutch forces finally reach the enemy positions they have sought, Nieuwenhuis takes pictures of the approach to the battle. The line advances, and he follows. But when the fiercest fighting ensues, he is unable to photograph it: "A fearfully obstinate fight now began of which I, alas, took no picture. My servants and the coolies who carried the apparatus were nowhere to be found; frightened by the rattling gun fire, they had run to safety in a sheltered place, and only with great difficulty, after the first storming, could I get my camera 'in position.'" He does, however, picture the troops storming through a thorny bamboo barrier, up a hill to an Atjehnese fortification.[15]

Having missed most of the close fighting, Nieuwenhuis nonetheless is able to capture a picture of the immediate aftermath. This picture, "Photo showing the still burning fortification of Batéë Ilië'," shows Dutch troops looking down over the palisades onto Atjehnese corpses strewn over most

of the ground.[16] There is still smoke rising from the firing of weapons, and this obscures a great deal. Nieuwenhuis has added numbers and plus signs, which identify "1. Lance 2. Blunderbus 3. Grenade launcher 4. Oven 5. Rice Sack. ++++ Bodies of Atjehnese."

The taking of the fortress entailed fierce hand-to-hand fighting. The defenders would not surrender. The Dutch troops (which is to say Dutch officers, whose soldiers were largely Ambonese and some Africans) pressed on over the top of the fortress and fought inside. Nieuwenhuis describes the battle: "There now began a terrible fight, man against man. The enemy defended himself heroically, that has to be recognized, and they chose to the last man to die with *klewangs* [Atjehnese short swords] in their fists rather than surrender. The dreadful drama became more terrifying at each moment through the bursting of powder mines which, no matter how badly laid, the enemy now and then succeeded in exploding."[17]

Nieuwenhuis sees this event "close up." Still, it is a synoptic picture he offers us, obviously made afterward ("they chose to the last man"), from the point of view of an observer who saw it all, unobstructed by smoke or other obstacles to vision. It pictures the conflict as a conflict, that is, not as the sense impressions of someone who, "up close," cannot impose a structure on the confusing impressions that reach him. Furthermore, he does not fail to recognize the courage of "the enemy."

> Also the Atjehnese had a brave van Speyk in their midst who, still even then, before he could be bayoneted, found a way to stick a fuse in a big powder vat.
>
> I have seen this brave man, old and wrinkled, and, regardless of the wounds to our side caused by the explosion, I felt respect for the gray hero, who, rather than surrender, blew himself up with friend and foe.[18]

Nieuwenhuis thus remained clear about who was who, what qualities counted, and what happened. If he missed photographing all this, it was only because his bearers had run off. He apologizes. But, he implies, there is nothing he describes which in theory the camera could not capture.

After describing the battle he sums up his impressions:

> Whoever as a civilian and a peaceful citizen has seen the dreadfulness of such a battle close up shall never forget it. When our troops were positioned for the storming of Batéë Ilië, the fire power of the

Atjehnese from Batëë Ilië as well as from Asam Koembang was deafening. The fort was covered and surrounded with heavy powder smoke. Then, the assault; the wild hurrah of the attackers, once or at most twice, followed by the prolonged and penetrating battle cry of the Atjehnese, Allah il Allah, swept away by fanaticism into uncontrollable madness. In addition to this appalling turmoil of fighting and hellish noise, the sound of some shots, the clank of *klewangs*, steel on steel, then again a raw shriek; we can only guess whether it is the death cry of a friend or an enemy. From time to time there is a red flash which for an instant interrupts the powerful rays of the sun immediately followed by somber, dull thuds of explosions of powder which again and again make clouds of powder smoke rise up, finally the noise quiets down for a moment and then come the yells of the victors, Batëë Ilië has fallen.[19]

Here, battle as conflict is replaced by battle as confusion; often one cannot tell who is on which side. The explosions of light—brighter than sunlight—and sound overwhelm the senses. The picture of events changes, I believe, when, in the midst of his synoptic account, Nieuwenhuis remarks that he has seen the wrinkled old man just moments before he blows himself up "with friend and foe." He remarks on a detail of the man's features, his wrinkles, introducing a singular perception into an otherwise formulated account. This detail is associated with death, as though what he has seen and what happened are conjoined, but in an incomprehensible way.

This, indeed, is how we often think of the sublime. It occurs at moments when we have had a narrow escape from danger. Afterward, we feel once again in charge of our cognitive powers. Before this recovery, "we flee from the sight of an object that scares us," Kant says. Overwhelmed by a danger we cannot cognize, our cognitive facilities are exhausted, yet we are faced nonetheless with something we cannot take in. At those moments, Kant adds, we experience "a momentary checking of our vital powers."[20] Without vital powers, we are of course dead, though how we could represent that to ourselves Kant does not say.

Nieuwenhuis recollects how he admired, and thus in a certain way identified with, the brave Atjehnese man he saw just before his death. At this point Nieuwenhuis feels that he too could well have been killed. After we have made our way out of danger, according to Kant, there is a sense of well-being because we have escaped and because we know that our cognitive powers in fact do function, even if the overwhelming danger

itself was and remains beyond our comprehension. We know that we are safe and that our mind functions. When we recover in this way, there is a moment of exhilaration, as we regain the ability to unify our thoughts. First comes a moment of disunity of perception experienced as death, if one so reads the "checking of our vital powers." Then, as Neil Hertz shows, in the descriptions of the experience of the sublime there is not only a consolidation of our cognition, but a reconfirmed sense of personal integration. We have the feeling of having escaped death. We were "almost" dead, and finding ourselves not so, we feel more ourselves than ever.[21]

In the case of Nieuwenhuis, the moment just after the battle appears in his picture of Atjehnese corpses. Viewing it, one has no doubt who is who. The Dutch stand above, looking down; the Atjehnese lie on the ground, looking nowhere. This distinction, however, does not mean that the boundaries between the dead and the living, the Atjehnese and the Dutch, were always firmly in place. What follows Nieuwenhuis's moment of cognitive disorder—also, of course, a moment of killing—is a picture of corpses. It is a picture, that is to say, of the fate that Nieuwenhuis, so close to the battle, seems to have felt he narrowly avoided himself. All the more so since, although the corpses in the picture are all Atjehnese (there are seventy-nine of them), there were also five Dutch soldiers killed, one of them a European.[22]

At the moment death occurred, it could not be shown. Just after, the corpses attest to its arrival. The photograph, then, shows the moment of consolidation in which what one avoided is illustrated to the degree possible. It thus fulfills the role given to it when it was an instrument used to mediate what had never before been seen. Such confusion, when the Dutch first landed, brought the risk, sometimes realized, of death. Here, in this picture, the camera shows it has not mastered but has gone beyond those moments of confusion and captured what it cannot understand.

This photograph was not viewed differently from the way we are accustomed today to viewing photographs, particularly those of bloody events. We see pictures of the victims of earthquakes, massacres, and starvation from around the world almost daily. It is commonly said that, shocked as we might be, we still say to ourselves "He is not me." In the end, we are satisfied and able to put these terrible images out of mind, though we of course do not want to admit our satisfaction to ourselves. Nonetheless, we enjoy seeing what we fear—the loss of ourselves—in order to be reassured that annihilation is not the case for us. This is the

logic implicit in the sublime. It is important today because it allows us to manage an economy of identification — "We are who we see" / "We are not" — by which the mass of photographs from no matter where becomes available to us and for which we develop a taste. Everyday we seem to need to see them.

To my knowledge, there were no Atjehnese photographers in the nineteenth century and probably none well into the twentieth. There was no one like the Javanese Céphas, who was taught photographic technique by a European and found a way to adapt it to his own conditions. Naturally, the war itself was an obstacle to such a development, but it would not have been impossible. The Islamacist Snouck Hurgronje, for instance, could not have written his important ethnography, *The Achehnese*, without the help of his Atjehnese assistant. If there was no Atjehnese photography it was because the war was perceived by the Atjehnese as a holy war (*prang sabil*). The doctrine of the holy war varies from century to century and even place to place. In Atjeh it meant that, under the prevailing circumstances, Muslims there had the duty to fight the unbeliever. One who died in the war against the unbelievers would not have to await the day of judgment to enter paradise; he would be instantly transported to that place, where he would enjoy all its pleasures. Under ordinary circumstances, in Islam the corpse is buried, never cremated, because it will rise again on the day of judgment. At that time its hands, its mouth, and other parts of its body will testify to the worthiness of the person, and on that basis he will or will not be allowed to enter paradise. The corpse of someone who died in the holy war was sometimes displayed for a few days in honor of the deceased and to stimulate others to go on the jihad. The corpse was no longer the lifeless remains of someone lost to the living. It was the sign that the person was now alive in paradise.

The corpses and the graves of those who died in the holy war thus lost their function as memorials. Some graves were thought to contain a certain power that worshippers at these places might appropriate. However, the objections of modernist Muslim leaders from the 1920s on largely eliminated this practice. Today there are not only no memorials in Aceh to anyone who sacrificed himself in the holy war against the Dutch (this could be for religious reasons), there are also no statues or plaques of the sort that are raised by Indonesian nationalists to commemorate the anticolonial revolution. The preservation of the memory of the martyr is of no importance in the unusual condition in which the notion of the holy war prevails.

However the involuntary recurrence of the memory of the deceased might be dealt with, it was not by exteriorizing it in the form of memorials or by trying to stabilize it by embodying it in stories of martyrs. There are such stories in the epic devoted to the holy war, but they are few, and they often do not concern Atjehnese at all, but others who died in other places. The war, sometimes claimed as the moment in which Atjehnese nationalism was born, has in fact been largely ignored in recent times and into the present, as Atjehnese are demanding their independence from Indonesia. This indicates the success of the notion of the holy war, in which gaining paradise meant for many Muslims putting the world behind them. Martyrs were apparently seen from their own posthumous point of view. Thus the photograph of the person, a memorial too, of course, had no place. Atjehnese had no interest in photography at that moment in their history.

When "risk" means "I might not be killed" rather than "I might have been killed" (this second response is typical, even instinctive, in cultures where the sublime is known), corpses take on a different sense. To the Atjehnese viewer at the time of the Dutch incursions, the view of corpses would not mean that the viewer had narrowly escaped, with the result that he is now even more himself. The image would mark at best his failure to achieve paradise and the neglect of his religious duty. The narrow escape that reinforces identity would be instead a moral reproach and a reminder of a worldly identity that the person was trying to shed.

The Dutch photographer who, in the midst of dead bodies, takes photographs and sends them home might share the glory or the opprobrium of the Dutch soldier. But the Atjehnese photographer who did the same would be sending nothing of importance. His association with death would not stimulate the imagination of risk, as the corpse would not allude to the destruction of the person, his loss, or the death that threatens us all and that we can imagine now through the photograph. The equivalent position for him, if there is one, would be paradise. Only there, in the place that eradicates death, loss, and suffering, could he send back pictures from an "elsewhere" that would stimulate Atjehnese to put themselves in the picture. Alas, for us here today with our secular imaginations. We would find only one more tourist's snapshot. Lacking a notion of the sublime with Western roots, developed with religious overtones, and having no room for such an idea, Atjeh did without indigenous photographers.

The Atjehnese, Nieuwenhuis said, instead of surrendering, died

"*klewangs* in hand." Had they surrendered, they would have lived. It was not the pursuit of honor that led to their death, but the hope of gaining paradise. The klewang opened the gates. Doing so, it had one of the functions of the camera: It revealed what no one had yet seen, in the way the camera helped to map uncharted land. The descriptions of paradise that assume the sword's use are the major substance of the epic of the holy war. This epic testifies to the fact that, in the end, there was revelation and memorialization; after the end, there was still the world in which the epics were chanted. But there is a certain paradox in understanding the position of these texts. They pass on to others, later, whatever they might say. But they enjoin men to leave their families to find in paradise an existence that makes that break permanent. Paradise is not life on earth made perfect; it is life elsewhere, with all connection to earth broken. It is difficult for most people to imagine their own deaths without imagining those they leave behind; this is just what the texts that announce the holy war accomplish. They ask that the texts themselves be forgotten. What the fate of the Koran itself would be I cannot say.

If the camera extended the power of the gun, the klewang's relation to power was altogether ambiguous. One can rightly say that it extended the power of the Koran, turning its words into actions. But its power was also turned away from the world, and this was the chief message of the epic of the holy war: not the defeat of the unbeliever, but his death. And the unbeliever's death figured as the means to one's own. Furthermore, standing in relation to the Koran, the holy war was available to all Muslims without need for intermediaries. The klewang, then, was ungoverned by worldly centralized political authority. Even after Atjeh was finally considered pacified, up through the 1930s, almost to the time of the Dutch defeat by the Japanese, individual Atjehnese, coordinated by no general plan of resistance, would suddenly stab Europeans in the hope of being killed themselves and gaining paradise. The Dutch considered them mad, and from a secular standpoint there is a case to be made for that view. Madness puts the person who suffers it outside communication. We lack sufficient words for its various forms, and necessarily so, since we cannot see from the point of view of the mad; some of the mad suffer, others seem happy. But the mad by definition live in worlds that are unavailable to the rest of us. With these Atjehnese, long after Atjeh had been restored to order, its economy functioning, a nascent modern form of nationalism on the rise, family life again established, the older way continued. Killings continued. And always it seems by stabbing, if not with the klewang, then

with the other important Atjehnese weapon, the *reuntjong*, or Atjehnese dagger.[23] A fetishistic power, again figuring in relation to death, phallic in form but outside phallocentric organization, the dagger came to be used less frequently, although its uses did not cease. But this took place in an Atjehnese world that progressively refused to take the claim of the jihad to heart and which, therefore, isolated the perpetrators and led to the cultural forgetting of the holy war against the Dutch.

The camera assumes the presence of a viewer to see the picture and in some way to have it reflect himself back to himself. The klewang was a weapon whose goal, from a secular point of view, was to eliminate self-consciousness. In my opinion, the eradication of memories of the war as important elements in the politics and the identity of Acehnese shows that, by and large, this elimination of consciousness of self succeeded. There is nothing in the logic of the holy war that can bring it to an end except the defeat of the unbeliever. However, without this defeat, and with the restoration of a functioning economy and the rise of ideas of nationalism, the promise of the jihad in Atjeh gradually lost its force for most. Eventually, few in this world saw what the klewang and reuntjong revealed when their mission was taken seriously. If one thinks that the klewang was used to eliminate self-consciousness, this, perhaps, is the sign that it succeeded—not, of course, by instituting the holy war in the heart of Acehnese society, leaving a place where Atjehnese could always find, not themselves, but the negation of themselves. Rather, success was accomplished by having a highly important segment of their history that depended on the practice of the holy war for its energy and focus remain suspended in Acehnese memory—remain, that is, without being incorporated into the dialectical development of Acehnese identity. The recitation of the epic of the holy war gradually stopped. On the other hand, photographs appeared, taken mainly by Chinese commercial photographers, showing those Atjehnese who could afford to have their portraits made, attesting to a world where memory of a conventional kind was restored.

Before the conventional functioning of Atjehnese society was fully re-established, the very lack of a wish to leave behind memory in the world made it possible for individuals to perceive death in the holy war as a goal that could be achieved through individual action, without the need for the candidate to imagine how he would be viewed by the community. They could thus continue their suicidal killing even when the community had lost interest in martyrdom. It is exactly this that made the Dutch feel

that the acts of such people were not political, but the effects of madness.

But it would be better to accept the holy war according to the terms set by the Atjehnese and to follow their logic. The lines from the Koran that founded the jihad are these: "God has bought from the believers their selves and their possessions against the gift of paradise; they fight in the way of God; they kill and are killed; that is a promise binding upon God" (9:111). Dying in the holy war, one achieves paradise directly without waiting for the day of judgment. These lines were propagated not directly from the recitation of the Koran, however, but principally through the Atjehnese literary form called the *hikayat*, and in particular through the *Hikayat Prang Sabil*, the *Hikayat of the Holy War*, various versions of which were written in Aceh during the war.[24] It is by interpreting the call to jihad in the tradition of the hikayat that we can return to consideration of the camera.

According to the great Islamicist, colonial advisor, and ethnographer Christian Snouck Hurgronje, to whom I have been referring off and on in this essay, the hikayat tradition was likely to have been of considerable length. He based his judgment on two hikayats from the eighteenth century, which, he believed, were of such outstanding quality that many more must have preceded them. The earlier body of work had disappeared, however.

Their disappearance was probably not an accident. The chanting of hikayat was done in such a way that the contents of the epic were dissolved as listeners attended to its sounds. The hikayat's prosodic structure made this possible. All hikayats have the same strict structure, consisting of a line divided into two phrases, with a single rhyme at the end of the line and another bisecting the phrases of the line. Hikayats were chanted to a single melody with two tempi, fast and slow. As it was explained to me, one follows the rhyme scheme, which, along with other things, such as the tempi and the melody, breaks up the meanings of the line. An example:

Hantòm / di gòb / na di *geutanjòë* / sabòh / *nanggròë* /
Never / by others / exists by us / one / land /
 Dua / RAJA /
 Two / KINGS /

Here the rhymes occur in the syllables in italics as well as at the end of each line. The linking of "us" (geutanjòë) with "land" (nanggròë), rather

than with "gòb" (others), with which it is contrasted, is an example of how the sense of the sentence is broken up in favor of conveying the sounds of the words. Rhyme divorced from meaning in this way makes it seem as if certain words respond to patterns set before the construction of meaning and without reference to what is said. All the more so, of course, because of the repetitive nature of the prosodic structure. The final rhyme, for instance, is likely to go unchanged for over two thousand lines. Similarly, the melody is likely to begin in the middle of the line and to end there as well. It too is repetitious; one melody was repeated 662 times in a hikayat of 2,117 lines. Furthermore, the tempi are likely to be used so that they contrast with what is portrayed. Thus, a battle scene might be recited in slow tempo. Acehnese describe listening to chants delivered in this way with the word *mangat*, or "delicious." They devour the contents, as it were, taking them in, as they drift in and out of the performance, listening when they are hungry to do so and resting when they are satiated.

The decomposition of the contents might seem merely an aesthetic pleasure, that is, one sealed off from the rest of life in the interest of enjoyment. But it is not exactly that. The epics were the major archives of Atjehnese history. In effect, Atjehnese were devouring their own past. One can see this in one of the hikayats that Snouck Hurgronje praised. That hikayat describes the most revered Atjehnese king to be a coward. A European account shows the same man dispatching elephants to trample to death anyone the king thought a threat to himself. In this context, it is easy to understand the hikayat as an instrument of defense set against whatever menaced Atjehnese, whether it be the king or the past more generally.

The long-term effect of hikayat recitation was to eliminate history. But no society can continue without its archive; its genealogy, at the very least, its tracing of kinship, is necessary to its very structure. Were the hikayats ever to have been decisive, permanently effective, Atjehnese society would have disappeared. I argue that, in effect, this is what happened. But not before the war with the Dutch.

The structure of the hikayat, its modes of recitation and hearing, stood in contrast with everyday speech. In the first there was the alternation of the two reciters' voices, echoes of each other, at best, rather than replies, tending toward music. Heard or overheard by listeners, hikayats produced a pleasure leading out of the world as meaningful sound decomposed. In everyday life there were alternating responses as each speaker in turn lis-

tened and replied, engaging speakers with each other and thus locating them in the present world. It was a question of one set of rules or another, marking off two linguistic realms. These were not merely coexisting registers to which one could turn as one chose. They were antithetical. One could "speak" in the language of the hikayat, but what one said was not then presented, as speech might be, for instance, in opera, especially after Wagner. Rather, to say something "in hikayat," as it were, would be to decompose what was said. The prosodic structure of the hikayat was the opposite of what has been posited for the Yugoslav epic, for instance. It was not an aid to memory, but a means of setting aside what was said, to the point where the success of doing so can be judged by the disappearance of the hikayat, a tribute not to its failure, but to its success.

Prosodic form seems to have remained constant. Whatever was set into it was eventually lost. What remained was the form itself, at hand to take on all sorts of things, whether historical events, stories arriving from outside Aceh, or fantasies. The only important modification came with the Atjehnese War. With it came the definitive end of the hikayat tradition. After that point, no more were written, or at least none that ever became popular. And this is because a final pleasure was made possible, one that no longer depended on the reduction of sense to sounds, but rather on the sealing off of the picture of paradise in another form and another language, a sacred language, indicating something attainable in its full form only after death.

The *Hikayat of the Holy War* in its most popular version is the story of a young man who overhears his elders, who are speaking of the holy war, quote the lines of the Koran I have cited. These lines are of course in Arabic, and then paraphrased, rather than translated, into Acehnese. "Hearing the line from the Koran, Moeda Bahlia felt a yearning. . . . It was as if he were already dead." He decides to go to the holy war. He has a dream of entering paradise. When he awakens, he tells his elders the pleasures he saw there and how he met the nymph who will be his wife. He then goes to battle. There "he chopped away like lightning running through clouds. The unbelievers collapsed front, back, left, and right . . . [until finally] Moeda Bahlia then became drowsy, his body weak and without energy. He had no one left with him, and so he joined his fallen comrades."

The lines from the Koran are exempt from the prosodic structure of the hikayat. They are chanted in Arabic according to the rules that govern Koranic recitation. With this, the decomposition of sense becomes a rhetorical device, a way of intensifying what is said about paradise. It shows

that no representation is adequate to the description of heavenly bliss. As an attempt to indicate something that cannot be comprehended, these recitations might constitute a step in the logic of the sublime, except that another tradition altogether intervenes. The pleasures of paradise await, sealed off by their setting in holy Arabic, immune to the sort of listening that the prosodic structure of Acehnese offered before the war, while the Acehnese language itself becomes merely a way of inadequately para-phrasing inalterable holy truth.

Within the hikayat there are a series of images of the nymphs, the rivers of paradise ("Along the river bank all was green and white" [242]), jewelry, and even the market ("The market was not a place where things were sold but a place of pleasure for every day. [There were] fine clothes and diamonds for hands and toes," [243]), and so on. These are related by the boy to his elders and by the reciters of the hikayat to their listeners. These pictures thus have viewers. But their point is that they mark not the end of the world, but the stimulation of the suicidal end of their viewers, who are told about them to incite them to join the holy war, to destroy themselves there. They are photographs in a way, but photographs that contravene the idea of photography as we commonly understand it.

The purpose of these images is to stimulate listeners to find the origi-nals by going to the holy war themselves. I do not want to say that they are photographs avant la lettre, however. Photographs, at least of the sort we have seen, depend on the logic of the sublime. One sees death and one escapes it in the very act of doing so. One is reconstituted as oneself, but even more coherently so than before. These pictures have the effect of dissolving the viewer and listener. He is not to regain himself. Thus the hikayat no longer functions as an hikayat did before the war, as an antirepresentational machine, but as a literary form promoting repre-sentation. The assumption about the hikayat as it functioned before the holy war was that it was always available as a defense against the world, turning its events into senseless pleasure. After the holy war, sense and pleasure were conjoined. There was now only one topic, and it was meant to be pictured and preserved. But the preservation of images was meant to be only temporary. It was to last until the original was found. One does not recover from the description of paradise or the fighting of the Atjehnese War feeling more oneself. The aim, on the contrary, was not to recover at all. Instead, inspired by the hikayat, one is compelled to actually destroy oneself. The separation between oneself and whatever it is that produces a feeling of sublimity is neither attained nor sought. The

hikayat is now at odds with social life. It attempts to separate the listener from the world and to prevent his exit from the pleasure of listening.

The subject who could completely enjoy the pleasures the hikayat now promised, of course, is the dead person in the photographs we have seen. With the invention of this new subject, the hikayat form became a funeral ritual, but a peculiar one. It lacked the aim of such rituals: to turn the memory of a deceased person from involuntary to voluntary memory, retrievable at will, a transformation that ensures it will not appear as an invasion. Instead, the aim was to exhaust the viewers and listeners of the hikayat, to effect their disappearance from the earth without regard for their memorialization. They would survive only in paradise, the last memory of them being the moment of transition as their earthly identities were shed. With the success of the *Hikayat Prang Sabil*, there would then be no body of people left whom one could imagine guarding the memory of the deceased. Of course, I do not claim that the idea of the holy war was totally successful in Atjeh. Many Atjehnese survived. But there is evidence that the concept of the holy war was pervasive at the time. Had it not been so, had there been instead an idea of martyrdom as it is understood now in the Palestine of what we call "suicide bombers," whose aim is as political as it is religious, the memory of martyrs would have survived. But that is not the case. There are no memorials to the holy war in Aceh today. Nor is the war much referred to during a historical moment when the inhabitants of the Province of Aceh, opposing Indonesia, claim to be no longer Indonesian, but Acehnese.

Without memorialization—which means there is no intent or expectation that a viewer will see the photo later, perhaps after the death of both the photographer and the photographed—there can be no interest in photography. It took decades after the war ended for Acehnese to become photographers themselves. This does not mean that there were no photographs of Atjehnese, however, as we have seen. But these photographs were neither for nor made by Atjehnese. They were made by Dutch photographers for Dutch consumption. They were made on various occasions, one of which is of special interest. When the Atjehnese surrendered, the Dutch often photographed them, no doubt to create pictures which, when viewed in the Netherlands, would build support for the war there. But it was not only Atjehnese who were photographed. There is a photograph of a man called Demang Léman, an important figure from the Bandjarmasin War, photographed in shackles ten minutes before his execution. Rob Nieuwenhuys, who reproduced this picture in one of his

volumes of photographs, says of Demang Léman, "He looks at the photographer [one might rather say 'camera'] uncomplainingly, almost indifferently, but in any case, without fear." The surrender, when not followed by execution, was not always final. Teuku Umar, the most famous warrior chief of the Atjehnese War, surrendered, was made an ally of the Dutch, and then, after he had defeated numbers of his fellow Atjehnese and after having been heavily armed by the Dutch, changed sides again.[25] Dutch troops then hunted him down. Hundreds were killed on both sides before he was slain. His wife, Tjut Nja' Din, who was nearly blind, replaced him as the leader of his followers and fought the Dutch fiercely. Then one of her bodyguards, who had also been the bodyguard of her late husband, led them to her. The Dutch photographed her also. It is said that "she behaved savagely, screaming, cursing, and spitting."[26] In the picture she is scarcely indifferent, but what is interesting is that she is not facing the camera. Her hands are bent in the gesture of Islamic prayer. She is beseeching God, still full of fury. Here, God has replaced the camera as the one who, in her estimation, sees her.

I think this is true even of others who surrendered and who faced the camera. One need not be anguished facing God. One might be indifferent to one's captors, as Nieuwenhuys said of Demang Léman and as can be seen, for instance, in a photograph Nieuwenhuys reproduces of a group of chiefs who have surrendered. The man second from the left in this picture has three klewang slashes on his face. When he smoked, the smoke issued from five places in his head. This extreme disfigurement does not prevent him from having the same expression as the others. They have none of the shame of the defeated. They look straight at the camera, but it is evident that they are not defying their captors, nor do they appear defeated. Demang Léman leans on a chair, relaxed despite being bound. The chiefs stand erect and look straight ahead. The energy of their bodies, apparent in their posture, is transferred to their eyes. They are not subjugated in attitude, but neither are they *conventionally* defiant. If they are defiant, it is not toward their executioners but toward anyone who dares return their gaze, understanding that moments later they will die and that this knowledge informs their look.

"Defiance" is not the exact word for them. They are, I believe, indifferent. Which is to say that they do not anticipate the return gaze of the photographer nor of those who will see the photographs. Their images will be preserved, but they will never see them. They are, in that sense, about to disappear, and they do not regret it. Their disappearance is a

curse of a sort. These people still have the holy war in mind. They face viewers who do not understand them, and who, as kafirs, promise only savagery in all its senses. But the indifference of those photographed does not stem simply from the impossibility of mutual understanding occurring across such a gap. It derives also from their comprehension that their own disappearance forecasts that of their viewers. Their indifference says, in effect, that whoever sees their images meets an empty gaze. It is empty not because it lacks life, but because it does not anticipate a response. The presence of the potential viewer is of no value to these subjects because they do not value memorialization. Whoever sees these pictures and understands what they mean will lack a reflection of himself in the gaze of the photographed subject. The viewer thus disappears along with those invested in the jihad. Such is the curse.

These photographs, of course, belong to the archive of Atjehnese history. Their curse seals that archive, protecting it against anyone who interrogates it. They mark the line between a culture where the sublime is established and one where it is not. Nieuwenhuis, seeing the old Atjehnese man just before he blew himself up, knows that the man is now in a realm to which he, Nieuwenhuis, has no access. He knows he cannot comprehend anything about the state of the man after that moment. But he has a name for the elsewhere, "death," where he knows the man is now to be found. He, Nieuwenhuis, is on one side; "death" is on the other.

"Dead," however, is not the word Atjehnese of that era accepted for the man's condition, and consequently they did not accept the difference between themselves and the overwhelming power that Kant claimed was produced with sublimity. Their elsewhere was not that of the Dutch. It is not a simple matter of contrasting beliefs, however. Atjehnese produced an elsewhere out of language. In the context of discourses within Atjeh, between the hikayat and everyday speech, the hikayat for a while was ascendant. The hikayat achieved that place, however, only by incorporating an element foreign to its structure. The jihad of that time was the culmination of a process of the elimination of history already contained in Atjehnese literature, but which could succeed as far as it did only by modifying the prosodic structure on which it depended. Doing so, it introduced a reference analogous to, but in competition with, the power said to produce sublimity. Eventually, with the introduction of modernity through nationalism, Atjehnese came to share the cultivation of the sublime which Kant said was necessary to it.

The line between the two systems is not absolute. Photographs of cap-

tured Atjehnese show that one infiltrated the other. The persons in the photographs, now long deceased, still tell us that they ignore us, that they are dead in a way beyond our capacity to understand or even to put aside by saying that we do not understand as we turn to Atjehnese history. It is that persistence which, I believe, prevents a jihad in Aceh today of the sort that the Atjehnese practiced earlier.

NOTES

1 I use the Dutch spelling, "Atjeh," to refer to the sultanate. The contemporary Indonesian spelling is "Aceh," and I use that to refer to the province of Indonesia. The followers of the Acehnese independence movement often use English orthography, spelling the name "Acheh."

2 Van der Linden, "Inleiding," 8–13. Translations are mine throughout unless otherwise noted.

3 Groeneveld, *Toekang Portret*, 17–18.

4 Ibid., 20.

5 Fontein, "Kassian Céphas," 47.

6 For a recent development of the idea of Java defeated by the Dutch and turned into an object of Dutch study, see Tsuchiya, "Javanology and the Age of Ronggowarsita." For the Javanese response to this effort, see Pemberton, *On the Subject of "Java,"* chapter 2.

7 The second story is included in the introduction to Céphas, *Yogyakarta*, 7. There is some dispute about whether Céphas was of mixed ancestry. Claude Guillot seems persuasive in arguing that he was not. Guillot, "Un example d'assimilation à Java."

8 Guillot, "Un example d'assimilation à Java."

9 Groneman, *De Garebeg's te Ngajogyakarta*, 3.

10 A selection of these pictures can be found in Zweers, *Sumatra*, from which I also draw the information concerning the Topographical Service. For a description of the encirclement of the Dutch troops, see Kielstra, *Beschrijving van den Atjeh-Oorlog*, 1–97.

11 The photograph is that on p. 29 captioned "Foto Genomen in de Nog Brandende Versterkking Batéë Ilië" (Photo taken in the still burning fortification of Batéë Ilië). See Nieuwenhuis, *Expeditie naar Samalanga*.

12 See the photograph by H. M. Neeb, "Gezicht in de kampong Lahat, na de inname door de marechaussee onder leiding van Van Daalen" (View of Lahat Village after its capture by *marechaussee* [special forces] under the leadership of Van Daalen), reprinted in Zweers, *Sumatra*, 57, as well as another entitled "In de veroverde benteng Koeto Reh, tijdens den tocht onder van Daalen door het Gajoland, op 14 Juni 1904; er bleven 561 gesneuvlde Gajoes liggen. Bij een in leven gebleven kind staat een schildwacht. Links bove, staande, donkere figuur: Van Daalen" (In the captured fort of Koeto Reh during the expedition of Van Daalen, 14 June, 1904;

561 slain Gajos lay there. A sentry stands next to a still living child. Above left, standing, dark figure, Van Daalen). The picture is reproduced with this caption in Zentgraaff, *Atjeh*, 190.

13 Nieuwenhuis, *Expeditie naar Samalanga*, 1.

14 Ibid., 17, 20, 15: plate 12, "Atjehsche Brug door de Rawa (moeras) bij den Glé Risa Boengang" (Atjehnese Bridge over the swamp near Glé Risa Boengang).

15 Ibid., 26–27, 28: plate 18, "Versperringen van bamboe doeri (stekelige bamboe)" (Thorny bamboo obstruction).

16 Ibid., 29: plate 19.

17 Ibid., 29.

18 Ibid., 30.

19 Ibid., 32.

20 Kant, *Critique of Judgment*, 120.

21 Neil Hertz has two essays on the sublime in his book *The End of the Line*. These essays are, to my mind, crucial in understanding the role of the sublime in the everyday life of modernity, including, of course, in understanding the place of photography.

22 Ibid., 30.

23 For an exposition of the jihad or holy war as it was understood in Atjeh during the anticolonial war, see Siegel, *Shadow and Sound*, 229–65; Siegel, *The Rope of God*, 68–77. For a discussion of the continuation of the jihad by individuals, see *The Rope of God*, 82–84.

24 The text referred to can be found in translation in Siegel, *Shadow and Sound*, 33–159.

25 Teuku Umar is a possible exception to my statement that there are no monuments to those who died in the holy war. There is an elaborate monument built at his tomb on the west coast. However, Teuku Umar is celebrated there as a nationally designated hero rather than as someone who died as a martyr (*mati syahid*).

26 Nieuwenhuys, *Met vreemde ogen*, 149, 163.

JAMES L. HEVIA

The Photography Complex

Exposing Boxer-Era China (1900–1901), Making Civilization

Perhaps no technological innovation of the nineteenth century compressed time and space more effectively and efficiently than photography. Certainly none did it in quite the same way. Photography not only created a sense of simultaneous temporal presence between a viewer and the images in a photographic print, but was capable of bringing distant and remote places into the visible space of a viewing subject. It accomplished this spatiotemporal compression through a marvelous sleight of hand. Photographs were understood to be a perfect mimetic medium, one that delivered an unmediated and pure duplication of another reality. Moreover, it could mime itself in an eminently replicable form for wide dissemination and inclusion in other forms of media. Copies could be inserted into books, pamphlets, newspapers, magazines, posters, slides, and stereographic apparatuses (of which more will be said below). The photograph could also be rerendered using older technologies such as engraved etchings. In a concise blending of animate and inanimate materiality, Oliver Wendell Holmes, in an 1859 article, captured the mimetic reproductive potentials of photography when he referred to the photograph as a "mirror with a memory."[1]

Yet it was, of course, not so simple as that. Even Holmes, who was himself a superlative promoter of photography and stereography, knew as much. The more he was drawn to the new medium, as much as he fantasized about a photographic archive so vast and immense that it could store all of reality, he was also concerned with the illusory qualities of the photograph.[2] As he put it in a less sanguine moment, the photographic image did not so much mirror the real as create an "appearance of reality

that cheats the senses with its seeming truth."[3] The tension evident here between "appearances" and the memory mirror points to a certain discomfort with the unmediated, a sense that there was more to the event of producing a photograph than a simple reflection — that the purported mirror effect of the reproducible image was itself an ideological construct that hid as much as it exposed.

Such skepticism about the ontological and epistemological status of the photograph remains a significant point of departure for critical traditions that interrogate representations. This kind of critique has also been important for constructivist social history, for histories of reception, and for phenomenological approaches to perception and visuality. Although these critical engagements with photography have been theoretically and empirically productive, they have tended to keep critical attention focused on the printed image itself, whether it stood alone or was embedded in a sociopolitical context. To put this another way, Holmesian-style skepticism tended to focus attention on the effects of photography — the end product, the outcome — rather than on the technomaterial process of photographic production and reproduction.

In part, this fixation on the image, and the variety of fetishisms that have resulted from it, is due to the ubiquity of the photograph. While mechanically reproduced photographs suffuse the social world in which many of us live, the multifaceted phases of the photography complex (of which the printed image is merely a part of the production process) remain relatively obscure. As a result of this occlusion, the image has been given precedence and ontological priority over other elements which temporally precede or follow upon it. Regardless of whether the photograph is isolated through aesthetic analysis or its reception is seen as part of a social process, the elements of production are usually perceived in an instrumental relationship to their "output," the photograph. This is not an unusual situation in studies on the relationship between technology and cultural production. As Daniel Headrick has noted in his discussion of the relation between technology and imperialism, the technological object is often divorced from its social production and naturalized as a passive object.[4] Others, such as Bruno Latour and Donna Haraway, have drawn attention to the propensity to identify clear ontological demarcations between the "mechanical" and the "human." Latour in particular has suggested ways of thinking about more complex agents momentarily made up of different materialities (microbes, slides, chemical solutions, barnyard animals, an entity known as Pasteur, the microscope).[5]

In terms suggested by Latour, we might, therefore, see the photography complex as a network of actants made up of human and nonhuman parts, such as the camera (including its container, lenses, treated plates, moving parts, and the many variations of its form), optics theory, negatives, and chemicals for the development of "positive" prints (the albumen process, the moist collodion process, gelatin emulsions, dry plates). There is also the staggering array of reproductive technologies through which images move and circulate, especially those for printing photographs in books and newspapers (e.g., photolithography, photography-on-the-[wood]-block, line engraving, photogravure, and process halftone engraving).[6] Then there is the photographer, that which is photographed, the transportation and communication networks along which all of these parts travel, and the production and distribution networks that link far-away places to end-users. There is also the question of storage and preservation; the image cannot be redistributed unless it is saved, so there must be a photographic archive. Such an archive is itself a new reality, one that is embedded in a unique Euro-American cultural formation that emerged in the second half of the nineteenth century and continues to the present, and whose epistemological status requires attention. Last, it would probably be unfair not to include in the complex light itself (waves? pulses?) as an author or actant (photography = light writing). When put in these terms, photography seems to be more like a heading under which a range of agencies, animate and inanimate, visible and invisible, are clustered.

But this Latourian-inspired arrangement is only part of the issue. These elements of the photography complex not only posit a more intricate set of relationships than the usual tripartite division photographer/camera/photograph; they also suggest a novel form of agency, one understood in terms of the capacity to mobilize and deploy elements for generating new material realities. The photograph is thus neither reflection nor representation of the real, but a kind of metonymic sign of the photography complex in operation.

What I propose to do in this essay is explore this complex and some of the novel realities it generated in the early decades of its global development. To do this, I intend to slice into the complex at a particular historical moment in which its outlines appear particularly susceptible to scrutiny, serving up a snapshot. My objective is to demonstrate not only how new realities are instantiated via the photography complex, but how older realties could be incorporated to create the illusion of an almost seamless fit between past and present. The spatiotemporal moment

in question is China 1900–1901, the period of the Boxer Uprising and the multinational invasion and occupation of north China that resulted. I have selected this moment not simply because I am familiar with much of its history. It is also the case that contemporary developments in camera and print technology made the photography complex ubiquitous in the events surrounding the uprising and the occupation. Equally important, there remains an enormous archive of the photographs produced at that time, an archive that continues to reproduce images of China in academic and commercial publications.

Within this cross section I examine four aspects of the complex. The first of these involves what Daniel Headrick has termed the "tools of empire." Here I will deal with the complex as a kind of multi-application apparatus (not unlike a Swiss army knife) that has the capacity not only to expose and copy things, but to pry them open. The process of opening, exposing, and replicating seems to have been understood by contemporaries as having effects that not only documented reality, but fundamentally altered it. The second aspect to be explored involves the relationship between photographic images and different forms of representation that also circulate through the complex, such as written description and other visual media (e.g., etchings, drawing, maps). The third element involves an unusual and now almost forgotten aspect of the complex, stereography. Perhaps at the time the densest and most complicated of all the subsystems within the complex, the stereographic component will require not only a degree of explanation, but a consideration of its rather unusual status within our present. The last element of this cross section involves reproductive technologies used by the popular press, in particular those apparatuses that lend themselves to the easy appropriation of the image and the implications for their dissemination of the photographic print. I begin with the photography complex as a tool of empire.

TOOL OF EMPIRE

European imperial powers entered China in force in 1900 to suppress the violent Chinese reaction to the European presence conventionally known as the Boxer Uprising or Rebellion. The Boxers had emerged as a loose-knit anti-Christian social movement in 1898 and began to attack Christian missionary stations and Chinese Christian converts the following year. In north China, in and around the capital of Beijing, the Boxers also destroyed railroad and telegraph lines and, eventually, in collusion with

Qing Dynasty military forces, attacked the Western enclaves outside the city of Tianjin and the legation quarter in Beijing, laying siege to the latter. The European powers — Great Britain, Germany, France, Austria, Italy, Russia — and the United States and Japan dispatched military contingents to relieve the besieged legations. Once this was accomplished, the powers were determined to punish and teach lessons to the Chinese government and people for their assault against "civilization." In this large-scale project, the photography complex functioned as an apparatus of surveillance documenting the "reality" of Boxer China and as an instrument of punishment and lesson teaching.[7]

Documentation

The camera was present from the moment the allies disembarked on the China coast near Tianjin, and it recorded the campaign from there to the capital. Once in Beijing, each of the occupying countries was intent on creating, as the American commander General Chaffee put it, "a record of our occupation of Peking."[8] The Forbidden City was an especially popular subject for photography, with the French even launching a balloon to capture the city from above, but there were quite literally thousands of photographs taken by military and civilian photographers in and outside Beijing. This hypersensitivity to the documentary power of photography was paralleled by the participation of the camera in performances of power. Photographers, often en masse, recorded spectacular staged events, such as a "triumphal march" through the Forbidden City and the executions of purported Boxers.[9]

A look at the photographic record of the U.S. Army helps to illustrate this process. Early in the occupation, Capt. Cornelius Francis O'Keefe, the official army photographer, was ordered to photograph sites in Tianjin, Shanhaiguan, and Beijing and its environs where American forces were operating.[10] These efforts were understood to be an official documentary project; that is, it was to create a public record of the American presence in China and transfer that record to archival depositories in the United States.[11] Over the course of the fall and winter of 1900–1901, O'Keefe produced well over a hundred photographic plates, many printed versions of which are in the U.S. National Archives in College Park, Maryland. The subjects include the "principal throne room" and halls of the Qing imperial palaces (the Forbidden City); the water gate under the Tartar Wall, where allied forces entered the city, and the Tartar Wall itself; the Summer Palace; the Great Wall and Ming Tombs; the fort at Shanhaiguan (on the

coast a few hundred miles northeast of Beijing); the Temple of Agriculture; and the Temple of Heaven. O'Keefe also photographed U.S. troops advancing on Beijing, General Chaffee receiving a Chinese delegation, group photographs of participants in the occupation, and soldiers of the allied armies. One of the photographs, labeled as having been exhibited at the Louisiana Purchase Exposition (1904), is of the triumphal march through the Forbidden City, which involved contingents from each of the allied armies. There is also a picture of the photographer and his equipment and of a group of photographers prepared to shoot the triumphal march.[12]

O'Keefe's photographs rarely involved human figures, unless the piece was staged, and they appear to have been almost exclusively used to produce the visual record Chaffee had ordered of the encounter with Boxer China. What is perhaps most important to emphasize about O'Keefe's work is that it primarily provided illustrations to accompany the *already* written accounts of the American occupation produced by army command. The image followed upon the text, with the latter functioning as a determinant of the former. At the same time, O'Keefe recorded little of the warfare itself; there is only one picture that has any signs of death and destruction.[13] If there was an ideological impetus in these pictures, therefore, it lay not in warfare itself, but in the way Beijing was opened to the photographer's gaze, a gaze which sought physical reference points whose meaningful content was to be filled in by a source outside the photograph proper. Like the official report, the camera spent little time dwelling on death and destruction.[14]

A similar pattern of imperial state-based mobilization is discernible in what was perhaps the most ambitious photographic project launched in Beijing: a documentary view of the city and its environs carried out by a team of Japanese engineers from the University of Tokyo. Led by Ito Chuita and the photographer Ogawa Kazuma, the team published a collection under the title *Shinoku Pekin kojo shashincho* (Photographs of the Palace Buildings of Peking) in 1906. Apparently the only such publication contemporaneous with the occupation, the volume contained 170 photographs, with text in Japanese, Chinese, and English. The preface to the work indicates that the project was designed to document and expose that which "on account of secrecy" had been "jealously kept from public sight."[15]

Printed on oversize folio pages, the photographs themselves are quite stunning. In addition to images of all of the palaces and many of the side

halls of the Forbidden City, the collection is of interest in the way human forms are related to architectural features. A picture of the Prayer Hall at the Temple of Heaven was taken with a Sikh guard standing at the door (plate 154). At the Temple of Agriculture a blanket hangs over a fence as a shirtless American soldier gazes out a window at the camera (plate 159). The approach to the Supreme Harmony Hall was shot while foreign "tourists" walked toward the entrance door (plate 27). In a Buddhist temple, two Europeans appear to be making a sketch or a rubbing (plate 126). There is even a photograph of Chinese people near the Chaoyang gate getting water and fishing in the city moat (plate 4).

These apparently candid compositions were seldom present in other photographs. Here, however, the composition may have had more than one purpose. According to the preface to the volume, this photographic record of Qing palaces was done for the purpose of "architectural study," that is, to enable the analysis of "the arrangement, construction, and decoration" of the Forbidden City and other palace grounds in the area.[16] Interest in the Qing imperial palaces for reasons other than punishment and humiliation was unusual, and at least two decades ahead of any similar kind of systematic archiving effort by Europeans or Americans.[17] As Jordan Sand has argued, Japanese interest in Qing imperial forms was part of an effort, in which Ito Chuita played a part, to produce a new architecture that would draw upon East Asian traditions.[18] In this case, therefore, the photographing of Qing palaces and temples, with human beings occasionally in the frame to indicate a sense of scale, was designed not only to provide a visual record of events of 1900, but to document simultaneously a dying tradition, punctuated by the presence of foreign soldiers and "tourists" at the center of the old empire. The Japanese team treated the Forbidden City as if it were an exhibition that could then be salvaged to produce whole new realities in the form of a "traditionalist" East Asian architecture.

Other kinds of documentary photography are also worth consideration. For example, there were the many photographs that appeared in memoirs and histories published in the wake of the Boxer Uprising. The Reverend Arthur Smith's *China in Convulsion* (1901) collected the pictures of several missionary photographers, such as the Reverend C. A. Killie, who took photographs in the Forbidden City in April 1901.[19] There are shots of the imperial throne room and palace where the emperor lived, the ruins of the legation quarter, and many street scenes, including ones showing people identified as "Boxer Types" and "Manchu Types." Smith's

volumes also contain a number of pictures of scenes from the siege, a group photograph of missionary siege survivors, ruined churches and mission stations, and some of the "missionary martyrs." Thus, the images in the Smith volumes provide visual documentary evidence for the main stories of 1900: the siege of the legations, the persecution of Christians, and the punishment or humiliation of the Chinese emperor.

There are at least two photographs that appear to do more than document events, however. The first of these is a photograph captioned "Dr. Ament Receiving Village Deputation" (fig. 1), set in Smith's text where the "ignorant charges" leveled by Mark Twain concerning missionary looting are disproved.[20] The faces of Chinese male villagers smiling at the camera presumably reinforces Smith's rebuttal. The other photograph shows "The First Train Passing through the Wall of Peking" (fig. 2) at the "Great British Gate,"[21] an opening blasted through the outer wall of Beijing for the laying of track into the Temple of Heaven, the site of the British encampment during the occupation of the city. We see the blur of smoke from the stack and several soldiers standing beside or near the train, while a solitary upper-class Chinese person stands looking at the train. The composition is significant. No trains had ever entered Beijing before. Breaching the city wall, moreover, was understood as more than a utilitarian act: it also was thought of as striking at the pride of the city's wall-obsessed inhabitants. In these two instances, the camera does more than document. In staging and fixing an ideologically charged scene, the photography complex participates in and structures the punishment of China for transgressions against "civilization." To put this another way, even in its documentary form, the photography complex was more than supplement. Visual technology reworked the ground on which Western superiority was based and incorporated the masses into imperial adventures in new and productive ways.[22] In the case of China, words might demonstrate just how depraved, backward, or stagnant the Chinese were beneath their vaunted claims of cultural superiority. But the photography complex simultaneously depicted such shortcomings, and their opposite, Western moral and technological supremacy.

Punishment

As we have seen, the photography complex documented the progress of the allied expeditionary force into China, meticulously recording the details of its movements and providing the visual imagery for collateral

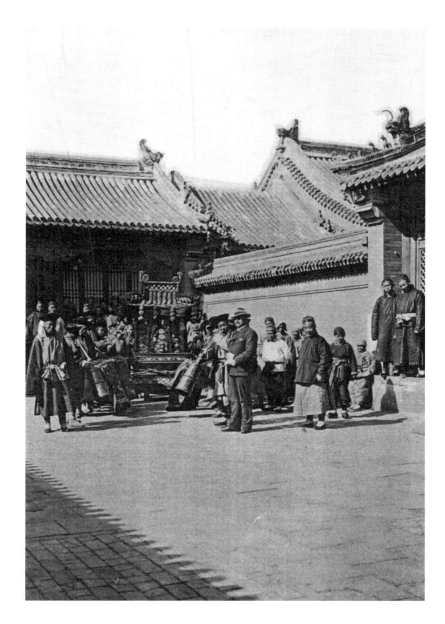

1. "Dr. Ament Receiving Village Deputation." From A. H. Smith, *China in Convulsion* (New York: Fleming H. Revell, 1901), vol. 2.

projects such as the "missionary apologetics" launched by the Reverend Arthur Smith in *China in Convulsion*. In these instances, the photography complex was more than "a mirror with a memory" of events that unfolded in front of the camera's lens. It was an apparatus of action and intervention that helped to shape the reception of events in the aftermath of the war. Probably the best example of the constitutive aspects of the photography complex is the way the camera penetrated, revealed, and re-

2. "The First Train Passing through the Wall of Peking." From A. H. Smith, *China in Convulsion* (New York: Fleming H. Revell, 1901), vol. 2.

corded what had previously been denied to the gaze of Euro-Americans, specifically the Qing Dynasty's audience halls and residences known to Europeans as the Forbidden City. These buildings were not only located in the very center of Beijing (just north of the foreign legation quarter), and thus seen as occupying the very heart of China's peculiar form of "Oriental despotism," but more important, they were a place no member of the Euro-American legations had entered since the establishment of

legations in Beijing in 1861. It was also believed by foreigners that the city was the most "sacred" place in all of China, China's holy of holies.

Following the relief of the legations in August 1900, the palaces took on great importance as emblems of Chinese haughtiness and sites for the staging of humiliation. Desecrating the Forbidden City would be a direct blow to the emperor and his court, a fitting symbolic retaliation for having attacked Euro-Americans.[23] Western diplomatic and military officials in Beijing decided to perform an act of humiliation by staging a triumphal march directly through the center of the Forbidden City. Since many also believed (erroneously) that no "white man" had ever stepped inside the Forbidden City, this event could also be constructed in terms of a masculine geographical "discovery" expedition, much like those into Africa, Afghanistan, and other non-"white" and hence "dark" areas of the world. The march took place on 28 August 1900, with contingents from each of the eight armies marching right along the central axis through the palaces.[24] Cameras followed each step of the route, exposing the forbidden to the gaze of strangers and disclosing the city's secrets. A series of photographs of the march was published in *Leslie's Weekly* on 3 November 1900. The captions revel in the fact that the sacred had been violated and opened to scrutiny, while the photographs perform and record the humiliation of the Chinese emperor and his palaces (fig. 3).

Once the palaces had been thus ritually opened, the photography complex, with its capacity to write with light, was the ideal tool for accomplishing a further discovery and exposure of the dark interior of the Forbidden City. The process began with numerous photographs taken of the emperor's thrones and of the private quarters of the emperor and empress dowager.[25] Eventually the entire Forbidden City was inscribed by light onto photographic plates, developed, and widely circulated. Later, the palaces and other imperial preserves, such as the Temple of Heaven and the Summer Palace outside of Beijing, were photographed, often with other kinds of staged events under way. For example, the thrones of the Forbidden City could be used as locations for diplomats such as the French minister M. Pichon and his entourage on which to pose (fig. 4); the Meridian Gate courtyard could be used for a memorial service for Queen Victoria in 1901 (fig. 5); the grounds of the imperial palaces could be used to pose groups of visitors (fig. 6); and the stairs of the Prayer Hall at the Temple of Heaven made an ideal location for photographing the entire 16th Bengal Lancers in full dress uniform.[26]

In these and other instances, the photography complex was an inte-

(overleaf)
3a, 3b. "The Famous Forbidden City of China Photographed for the First Time." From *Leslie's Weekly*, 3 November 1990 (2 parts).

IN THE HEART OF THE FORBIDDEN CITY — THE CANAL THROUGH THE COURT BEFORE THE EMPEROR'S PALACE.

LIEUTEN&
SU

THE M

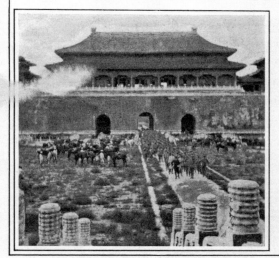

GENERAL CHAFFEE AND STAFF, JUST DISMOUNTED FOR THE MARCH THROUGH THE PALACE GROUNDS.—IT WAS NOT DESIRED TO DESECRATE THE SACRED CITY BY GOING THROUGH IT ON HORSEBACK.

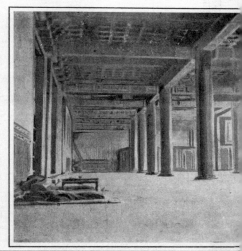

INTERIOR OF THE AUDIENCE-HALL, NEVER BEFORE PHOTOGRAPHED OR SUBMITTED TO PUBLIC GAZE.

THE FAMOUS FORBIDDEN CITY O

THE ENTRANCE OF THE ALLIED FORCES INTO THE SACRED COURTS OF THE FORBIDDEN CITY WAS THE GREATEST HUMILA

E. NINTH UNITED STATES INFANTRY,
DEN CITY FROM THE PORTICO
OF THE EMPRESS.

AN ENGLISH DETACHMENT MARCHING DIRECTLY THROUGH THE
AUDIENCE HALL OF THE EMPEROR'S PALACE, WHERE NO
WHITE MAN HAD EVER BEEN BEFORE.

A SOLDIER INSPECTING ONE OF THE MYSTERIOUS SACRED
GROTTOES IN THE PALACE GARDEN.

BRIDGE OVER THE MOAT, BEFORE THE SOUTHERN GATE OF THE FORBIDDEN CITY.

THE ONLY BUILDING WHICH NO FOREIGNER ENTERED—THE PERSONAL RESIDENCE OF THE
EMPEROR, THE PRIVACY OF WHICH WAS RESPECTED—IT WAS GUARDED BY EUNUCHS.

A VIEW ALONG THE TOP OF THE WALL OF THE FORBIDDEN CITY—THE TOWER
MARKS A CORNER OF THE WALL.

ONE OF THE ENTRANCES TO A COURT OF THE FORBIDDEN CITY.

POTOGRAPHED FOR THE FIRST TIME.

SUFFERED.—PHOTOGRAPHS BY SYDNEY ADAMSON. THE SPECIAL ARTIST OF "LESLIE'S WEEKLY" IN CHINA, AND THE FIRST EVER MADE.—[SEE PAGE 319.]

N° 114. — TROISIÈME ANNÉE.

Prix : 30° centimes

L'Univers illustré

et
la Vie Illustrée réunis

JOURNAL HEBDOMADAIRE

21 Décembre 1900

APRÈS L'ENTRÉE DES ALLIÉS A PÉ-KING. — M. PICHON ASSIS SUR LE TRONE DE L'EMPEREUR DE CHINE
(Photographie de notre envoyé spécial, Lucien Leroy.)

ABONNEMENTS AVEC PRIME :

France : Un an 26 fr. Union postale : 27 fr.

SANS PRIME :

France : Un an 16 fr. Union postale : 22 fr.

Adresser toutes les Communications au Directeur

M. F. JUVEN, Éditeur,

122, rue Réaumur, 122

Magasins de Vente et Abonnements : 9, rue Saint-Joseph, 9

PARIS

gral part of the performance of Western imperial power in north China, making each of these acts of desecration more meaningful because they could be "staged" over and over again by simply taking additional photographs and reproducing the image (as has been done in a sense by showing them here). Moreover, because of its unusual capacity to act simultaneously as a participant, instrument, and record-keeper of aggressive acts of humiliation and punishment, the photography complex could both teach lessons (If you trifle with us, we will expose your secrets to the entire world) and record the reactions of the students to the lesson. Perhaps no image better captures the indexical and the constitutive aspects of the photography complex than an image that appeared on the cover of *Leslie's Weekly*, a popular American illustrated newspaper, on 3 November 1900 (fig. 7). The caption reads, "Mandarins in the Palace Court-yard—Chinese watching with Indignation and Astonishment the Desecration of the Sacred City by the Allied Forces."

(opposite)
4. M. Pichon on the Chinese emperor's throne. Cover of *La Vie Illustrée*, 21 December 1900.

(above)
5. Memorial service for Queen Victoria at the Forbidden City. Courtesy of U.S. Army Military History Institute, Carlisle, Pennsylvania.

6. "Distinguished visitors to the Imperial Palace (Forbidden City)." From *Military Order of the Dragon* (Washington, D.C.: Press of B. S. Adams, ca. 1912).

(opposite)
7. "Mandarins in the Palace Court-yard." Cover of *Leslie's Weekly*, 3 November 1990.

TEXT/IMAGE—IMAGE/TEXT

The photograph of Qing officials purportedly expressing shock and indignation at the presence of Westerners in the Forbidden City raises the question of the relationship between text and image in the photography complex. In this case, regardless of what might be interpreted from the expressions on the faces of these palace attendants, without the text, the image, if not mute, certainly has a limited vocabulary (men in long gowns with strange hats, one of whom is wearing spectacles. Are they Mandarins at all? Is this a staged event?). At a minimum, therefore, the caption seems essential for citing place and time. But this one does a bit more. Like the photographs of the march through the Forbidden City, it positions the image within a history of contact between China and Euro-American nation-states and, more broadly, within a history of colonial encounters. In the former case, the caption directs attention to the exclusion of Westerners from the imperial palaces throughout the nineteenth century. In the latter case, we are shown that it was not uncommon for Western armies to desecrate the sacred sites of others as an act of retribu-

CHINA'S WONDERFUL FORBIDDEN CITY—FIRST PHOTOGRAPHS EVER TAKEN.—IN THIS ISSUE.

LESLIE'S WEEKLY

·ILLUSTRATED·

VOL. XCI.—No. 2356. Copyright, 1900, by JUDGE COMPANY. No. 110 Fifth Avenue. Title Registered as a Trade-mark. All Rights Reserved.

NEW YORK, NOVEMBER 3, 1900.

PRICE, 10 CENTS. $4.00 YEARLY. 13 WEEKS $1.00. Entered as second-class matter at the New York Post-Office.

MANDARINS IN THE PALACE COURT-YARD.

CHINESE WATCHING WITH INDIGNATION AND ASTONISHMENT THE DESECRATION OF THE SACRED CITY BY THE ALLIED FORCES.

tion or violent pedagogy. And while these Qing officials might be indignant and shocked, they are also quite helpless, as the photograph shows.

Whether specific to China or to other colonial situations, the point is that the references mobilized to help the image speak exist outside of the image proper. They are drawn from imperial archives, those vast epistemological networks for gathering, processing, cataloguing, and filing information about other people and places.[27] These information systems were not only essential for planning and administering the work of Western imperial officials both in the colonies and in the imperial metropole, but through the broad dissemination in popular media of imperial knowledge about others they provided the fundamental touchstones for the journalistic coverage of any event that might occur across the expanse of empire and in areas peripheral to it. To put this another way, any image produced in the photography complex existed in relation to a preexisting body of imperial knowledge and popular reporting about China and the Chinese people.

The capacity for linking elements of the epistemological complex of empire with those generated through the photography complex was, therefore, critical. As a way of considering this relationship, I turn again to Bruno Latour and his discussion of objects, such as photographs, that he has termed *immutable mobiles*, immutable in the sense that they do not alter their material character or degenerate as they travel and in the sense that they can achieve *optical consistency*. Such traveling inscriptions and images are consistent and comparable with each other because they are presentable, legible, scalable, and combinable with other, similarly constructed things on flat surfaces (e.g., Mercator projection maps, census data, commercial reports, notes on natural history and human behavior). With real subjects and objects in the world translated onto the two-dimensional surface of the page or the plate, they could now be manipulated through various representational devices: English descriptive prose, statistics, tables, charts, and maps. Once this sort of optical consistency was achieved, once the drawings, the numbers, the images, and the descriptions were arranged on a common surface and in a compatible scale, the photographic immutable could become highly mobile. On paper, faraway things were transported to other sites where they could be held in the hands of one person and scanned by his two eyes, as well as reproduced and spread at little cost throughout the networks of empire. It was thus possible to project, at ever accelerated rates, instances of one time and space into other times and other places. At collection sites,

accumulated information of this kind allowed work to be planned and manpower to be dispatched. It also allowed authority to collect at the site where the many immutable mobiles converged and, in cases such as the one considered here, a consensus to be forged by the imperial state about its actions in China.[28]

Latour's description of immutable mobiles seems a useful way to introduce a booklet published by the Visitors' Inquiry Association at the famous resort town of Brighton. Its bold black ink announces against a blood-red background UNIQUE PHOTOGRAPHS OF THE EXECUTION OF BOXERS IN CHINA. Selling for the hefty sum of 5 shillings (an illustrated tourist guide to Brighton was advertised in the same publication for 6 pence),[29] the booklet presented four photographs in an order that created the illusion of a temporal sequence. Probably printed in the screened halftone engraving process,[30] they were accompanied by a text that told a story about public executions in China within the framework of the unquestioned moral superiority of the British.

The first photograph, "Led to Execution" (fig. 8), is followed by a full-page discussion by an author identified only as R. N. The opening sentences set the style of the commentary. It is a collection of clichés about China and the Qing realm, facts or assertions that the photograph purportedly confirms. Drawing attention to the first photograph, R. N. notes, "These Illustrations, the result of the camera, . . . give some idea how callous and indifferent the Chinese are to their final exit from the world; they commit suicide as a solution of a difficulty, and endure the most cruel and painful tortures with indifference. . . . The Mongolian race is confessedly obtuse, nerved and insensible to suffering. . . . Chinese criminals do not suffer nearly as much as members of more sensitive races would under similar conditions."[31]

This collection of "Chinese characteristics" is imperial archival knowledge of the first order. The passage comes from the article on China written by Robert K. Douglas, a former British consul in China, a professor of Chinese at King's College, London, and keeper of the Oriental and Printed Books collection at the British Library, for the ninth edition of the *Enyclopaedia Britannica*. R. N copied passages verbatim without citation.[32] But that is not the most interesting point to be made about this instance of plagiarizing the imperial archive. The unimpeachable source on the physical characteristics of the "Chinaman" and Chinese cruelty does more than simply provide racial details to accompany the photographs. Here the archive functions not only to create a precise interface

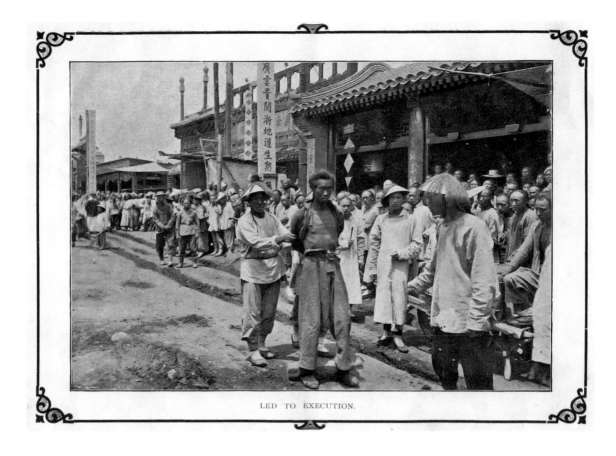

LED TO EXECUTION.

between knowledge of the locale and the imperial state, but to ensure that the latter is not polluted by the former: photograph confirms text, text reinforces photograph, rendering a timeless and remote "China-land." There is no acknowledgment, indeed no hint that the activities of the British imperial state might in some way be connected to what is recorded in the photographs. Instead, we are told that although there is no apology for "the refined cruelties inflicted on Chinamen by Chinamen," the "presence of European officers at 'The Executions' prevented cruel and needless torture . . . torture of any description being very abhorrent to an Englishman."[33]

From this position of superiority constituted by the graphic display of Chinese executions, the author could conclude, "These unique illustrations cannot be viewed without pain and repugnance. However, it is not with any view of gratifying a morbid curiosity that these are offered to the public, but for a three-fold purpose: To enlist our sympathy for an unfortunate people; to arouse in our hearts a strong abhorrence of cruel

practices; and to cause us to feel thankfulness that we live in a land where Justice is tempered with Mercy."[34]

While this conflation of the social world of the viewer with the interests of the imperial state may seem unexceptional — it is repeated in the press coverage of all the "little wars" of the British empire in this era[35] — the combination of image and archive serves to position this assault of Chinese "barbarisms" against Christian civilization within the masculine moral universe of British imperial warfare. In operations like this one, the photography complex helped to enfold China into a global narrative of the righteous use of violence and the just punishment of the guilty.

VIRTUAL TOURS

Perhaps the most spectacular image or text of the time, and one that found innovative ways of resolving the contradictions of Euro-American behavior in China, was the stereographic project of James Ricalton. Published under the title *China through the Stereoscope*, with maps, diagrams, and a lengthy text written by Ricalton, the work was part of Underwood & Underwood's "stereoscopic tours" series that included India, Palestine, Russia, the Paris Exposition of 1889, and southern and eastern Europe. The form itself, now mostly forgotten, was one of the more ambitious representational projects of its time. Indeed, in terms of technological sophistication and the way it melded multiple media, stereography was both the state of the art and ahead of its time. It was also the form of photography for which Oliver Wendell Holmes imagined vast libraries.[36]

Stereography had been a photographic technology since the middle of the nineteenth century. Its basic purpose was to add a level of realism to the image by providing an exaggerated illusion of depth, or "hyperspace,"[37] in the photograph. This was done with a double-lens camera, whose negative was used to print side-by-side double images taken at slightly different angles. The results were then viewed through a stereoscope, a handheld mechanism with two lenses mounted at one end of a bar or piece of wood approximately 20 inches long, with a divider between the lenses. At the other end was an adjustable holder for a card printed with the double image.[38] One slid the card holder along the bar while looking through the viewer, until the image clicked into an appearance of three dimensions.[39]

By the 1890s, although stereographs were available throughout Europe, the industry was dominated by companies based in the United States.

Among these was Underwood & Underwood. Originating in Ottawa, Kansas, the company had expanded to New York and Baltimore by 1891, and to Toronto and London by the end of the century. In 1901, Underwood was producing 25,000 stereographs a day and 300,000 stereoscopes a year. The company pioneered a number of innovations, one of which is particularly relevant here. This was the boxed set, a kind of household version of the vast library about which Holmes fantasized. The sets ranged in size from ten to one hundred stereo cards and included maps, diagrams, and a guidebook. Imagined as a virtual tour of a famous or exotic place, Underwood's sets were available with English, French, German, Russian, Spanish, and Swedish captions and tour texts.[40] In addition, a unique copyrighted map was included that showed the exact position, direction, and boundaries of each stereograph.[41] With all this, plus the tour book, the viewer could mentally place himself or herself in the position of the camera, purportedly allowing a vision of a faraway world as it actually is. Like other boxed sets, *China through the Stereoscope* was made up of one hundred stereographs, a text, and eight maps; it sold in the United States for $17.60.[42]

Given both the dissemination of the images produced in this medium and the nature of the medium itself, the stereograph and the stereographic tour served to reinforce the more general cultural phenomenon of approaching the world as if it were an exhibition, while also generating new techniques and methodologies to do so.[43] Critical to this process was the constitution of new subject positions made by the wedding of the three-dimensional viewing apparatus with a written narrative and multiple kinds of diagrams. Indeed, one can imagine a complex subject made up of stereographic image, stereoscope, one or more viewers, diagram consulters, and readers or reciters of the travel text. What was operating here, in other words, was the potential for an active and interactive experience that offered up the world in a kind of hyperreal mode of presentation.

If we turn now to Ricalton's China tour, we may be better able to grasp some of the ideological work the photography complex can do. However, it should be borne in mind that because we have lost ready access to stereographic technology, there are certain limitations to what can be addressed. Today we confront the images as flat surfaces, whereas Ricalton discussed them in the tour book as three-dimensional. However, while we may not be able to replicate the collective subject of the virtual tour, we can make an approximation.[44]

A perusal of the images makes it clear that Ricalton composed his stereographs to take full advantage of three-dimensionality: he photographed the emperor's throne at an angle, instead of head-on as most other photographers did [60], and placed his camera off to the side of the marble bridge at the Summer Palace so that there is a marked distance from the lower left foreground to the upper right background [70]. In addition, in virtually all of his pictures of architecture and scenery, there are human figures, sometimes many layers deep into the distance, that provide not only a sense of scale but a feeling of human contact, even intimacy [see 57; 52, a Beijing resident standing among the ruins of the legation quarter; 65, Imperial Observatory with a resident in the foreground; 69, Chinese man in foreground, Hill of Ten-thousand Ages in background].

Ricalton's photographic technique made for extremely dramatic compositions. This was especially the case in his coverage of the battle of Tianjin, where he insisted upon showing at least some of the "horrors" of war. The dead, the wounded, and the destruction of the city appear in a succession of vivid shots [35, 39, 40]. One of these, entitled "Terrible Destruction Caused by Bombardment and Fire, Tientsin" [41], is accompanied by a text that talks about the "sadness" of a deserted city, particularly one "sacked, looted, and in ashes, by a Christian army." The picture is bisected by a long thoroughfare, flanked by destroyed houses on either side. Up this street comes a "slow-moving line of homeless, weeping human beings — their homes in ashes, without food, friendless, and . . . their kindred left charred in the ruins of their homes." This picture of "pathetic desolation," painted in words and images, like much of the social realism common to the muckrakers of the era, appears to build sympathy for the victims of this disaster, humanizing the Chinese even as their way of life is shattered.[45]

Immediately, however, a second image appears, one that flips the entire tone of the presentation. The next stereograph is entitled "Some of China's Trouble-makers — Boxer Prisoners at Tientsin" [42]. Often reproduced, this image is accompanied by a description that thrusts us out of the world of universal humanist empathy and into the realm of Arthur H. Smith's *Chinese Characteristics*.[46] Ricalton tells us that the group depicted had been rounded up by the "boys" of the Sixth Cavalry (in the background), who were certain that one of the Chinese, who was carrying a weapon, was an actual Boxer. One of the soldiers, grabbing the "real thing" by the pigtail, thrusts him into the front row, where he sits, arms

across his knees, squinting slightly at the camera. Ricalton then invited his viewers to take a closer look:

> This is truly a dusky and unattractive brood. One would scarcely expect to find natives of Borneo or the Fiji Islands more barbarous in appearance; and it is well known that a great proportion of the Boxer organization is of this sort; indeed we may even say by far the larger half of the population of the empire is of this low, poor, coolie class. How dark-skinned, how ill-clad, how lacking in intelligence, how dull, morose, miserable and vicious they appear! This view was made during a very hot day in a torrid sun: and still they sit here with their heads shaven and uncovered without a sign of discomfort.[47]

With race, social status (i.e., coolies), character, and physical peculiarities now firmly established—thematically this will continue through the rest of the journey—Ricalton recalls the form of the tour. In spite of "pathetic desolation" and vicious dark-skinned natives, this is travel in an exotic land, and we must return to the exhibition. "We are but a short distance from the Pei-ho. Leaving the Boxers with the guards, let us stroll to the river, where we may witness a novelty in transportation."

What are we to make of these abrupt shifts from sympathy to racial denigration to the soothing monologue of the tour guide? If we pause for a moment and compare the image and text of Ricalton with that found in the Brighton booklet, something of interest suggests itself. We have seen how both encourage the viewer and reader to see the images of China in terms of the accompanying text, which itself is a product of conventional wisdom. Although each of them expresses a distaste for violence, recall that the Brighton booklet firmly displaces aggression onto the Chinese people. Ricalton had a far more difficult problem because his stereographs included images of the destruction of Chinese cities by "Christian armies."

As the sequence discussed here indicates, Ricalton's presentation of Christian barbarism, repeated on other occasions throughout the text, was negated or justified by the encounter with the Boxers, producing what appears to be a zero-sum outcome. Yet not quite. Christian barbarism, as distasteful as it appeared, was accompanied by outward expressions of empathy and concern. The Tianjin sequence also included, for example, American soldiers caring for a wounded Japanese soldier [38]. The people of China, on the other hand, remain a permanently racialized other—foregrounded in one set of text and photographs through a com-

parison of the noses of Chinese and Tartar women[48] [67 and 68] — whose responses and reactions were predictable, knowable, and always already well documented as "Chinese characteristics." Perhaps this is why the sequence ends with a diversion; that is, we are pulled away from the unequal exchange that the tour guide has created and whisked to the Summer Palace on the outskirts of Beijing. Violence thus becomes one more element of the exhibition offered up by the photography complex, to be consumed but not unnecessarily fretted over.

ARCHIVES, REPRODUCTION, AND DISSEMINATION

The effectiveness of the photography complex as an element of Western imperialism, as has already been suggested, attained a reach beyond the immediate spatiotemporal staging area of empire building. In conjunction with other apparatuses of empire, the complex functioned as part of a material and discursive network that not only kept the administrative functionaries of empire informed, but helped to forge a popular consensus at home for imperial adventures abroad. Books such as Arthur Smith's *China in Convulsion* and the Brighton booklet might be understood, therefore, as collection points for bringing the output of the photography complex into conjunction with China knowledge and as vehicles of dissemination to the general populations of Europe and North America. But they were by no means the only or even the most pervasive vehicle in which text and image moved through the realm of the popular. Perhaps the most common form in which images of Boxer China appeared was the weekly illustrated newspaper.

In Great Britain, France, and the United States, the illustrated newspapers found in the occasion of the Boxer Uprising an opportunity to recirculate the late nineteenth-century photographic archive of China. While the quantities of published material varied from paper to paper, there seemed to be ample resources for providing illustrations to accompany the reports of events flowing into imperial metropoles. Such insertions from the visual archive not only aligned past China knowledge with present events, but supplied resources that could be mobilized to project or anticipate events to come. On 28 July 1900, a month before the relief of the legations in Beijing, *Leslie's Weekly* published two photographs on its front page (fig. 9). The top photograph was of a public execution in China; the bottom showed the aftermath of a mass execution, with Europeans standing over decapitated corpses. A *Leslie's* editorial intervention

MIDSUMMER NUMBER—A CHARMING DOUBLE-PAGE DRAWING OF A SUMMER SCENE,
BY HOWARD CHANDLER CHRISTY.

LESLIE'S WEEKLY

★ ILLUSTRATED ★

Vol. XCI. No. 2362.
Copyright, 1900, by JUDGE COMPANY, No. 110 Fifth Avenue.
Title Registered as a Trade-mark. All Rights Reserved.

NEW YORK, JULY 28, 1900.

PRICE, 10 CENTS. $4.00 YEARLY, 13 WEEKS $1.00.
Entered as second-class matter at the New York Post-Office.

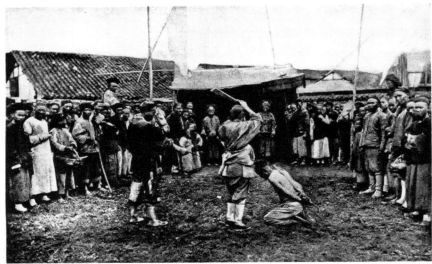

A CROWD IN THE STREETS OF SHANGHAI LAUGHING OVER A GRUESOME EXECUTION.

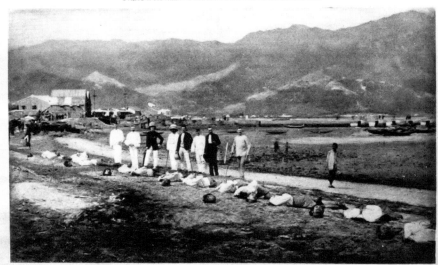

A WHOLESALE EXECUTION IN CHINA—BEHEADING A GANG OF PIRATES.—*Reproduced from "Leslie's Weekly" of October 25th, 1894.*
Copyrighted in 1894 by the Arkell Publishing Company.

THE THIRST OF THE CHINAMAN FOR HUMAN BLOOD.

GHASTLY SCENES AT THE EXECUTION OF OFFENDERS ON THE STREETS AND IN OTHER PUBLIC PLACES.

boldly proclaimed **The Thirst of the Chinaman for Human Blood**. Less provocatively framed, the same two photographs also appeared in *La Vie Illustrée* on 6 July 1900 (pp. 224 and 229), with the bottom image labeled "Hong Kong — Execution of Pirates." I will have more to say on the lower photograph shortly. For now it is sufficient to note that the top image also appeared in the London-based *Black & White* on 14 July 1900 (p. 78). What is striking about these publications is that editors in three countries decided that these same images of beheadings were critical for understanding what was happening in China. Moreover, by framing events in these terms, the editors not only anticipated things to come, but encouraged readers to fantasize about the fate of Western diplomats and missionaries in north China.

Following the entry of allied forces into Beijing on 18 August, the illustrated newspapers vied with one another to provide visual images of the effects of the uprising and of subsequent acts of "retributive justice." The *Illustrated London News* (*ILN*), one of the most widely circulated of British illustrated weeklies at the time, ran a series of drawings depicting the fighting in and around Beijing in its September and October issues. The first photographs were printed on 20 October 1900, barely two months after the relief of the legations, providing some sense of the rapidity of communications at the time. These photographs showed the massive destruction of the legation quarter area. Later issues printed photographs of the trophies collected by the allied contingent, including Boxer and Qing imperial banners and the state seals of the emperor of China and the empress dowager.[49]

The mixed media of drawings and photographs used by the *ILN* as well as other papers is worth comment. Drawings had been a staple of the illustrated weekly for some time, and imperial warfare was a common theme of these pictures. Such images were an artist's renditions of military actions figured from the accounts of "special correspondents" often sent by telegraph or from official dispatches. Or they were drawings made by the correspondents themselves, which by the mid-1880s could be photographed and transferred to a wooden print block (photography-on-the-block).[50] Here, however, something quite different seems to be emerging. What we see in the drawings involving events in China in 1900 are pictures that mimic the compositions of photographs. In some cases, the relationship is direct: an engraving would often be made from a flawed negative taken on the scene. One such example can be found in the Parisian weekly *L'Illustration*. In its 3 November edition *L'Illustration*

(opposite)
9. "The Thirst of the Chinaman for Human Blood." From *Leslie's Weekly*, 28 July 1900.

published a double-page drawing of the French contingent marching into the Forbidden City when the allied forces staged their triumphal march (pp. 276–77). On 1 February 1901, *La Vie Illustrée* published a photograph almost identical to the drawing in *L'Illustration*, but taken either a moment before or after and from an angle slightly to the right, suggesting that the drawing was from a nonprintable photograph. These images direct attention to the interplay of old and new technologies of vision, providing evidence of the convergent relationship between the elements of the photography complex at this particular moment. Different visual media could be used in identical ways to advance imperial projects.

In other cases, it is more difficult to determine whether an actual photograph was the original of the drawing. Yet there are numerous drawings in publications such as the *Illustrated London News* that follow the conventions of photographic realism, of the "mirror with a memory." To put this another way, the structural composition of the drawings is such that even if they were not copied from photographs and given depth and visual subtlety through halftone engravings,[51] they seem to have been imagined as such, particularly insofar as they reference the compositional structure of the small group vignette as their model. The subject matter of these pictures is also consistent: it is of punishments and humiliations meant to impress "the Far Eastern mind."[52] So, for example, there are photograph-like drawings of the destruction of the walls of Tianjin as a means for punishing the entire population of the city, a depiction of the trial of a purported Boxer, and "Boxer thieves" tied together by their queues, surrounded by foreign solders, some laughing, some looking on sternly (fig. 10).[53]

There is also one of "Tommy Atkins," the universal British soldier,[54] standing at the center of the round altar of the Temple of Heaven (fig. 11). The accompanying text reads, "A humorous touch is afforded by another drawing, which represents Thomas Atkins occupying for the moment, before the admiring gaze of an Indian orderly, the centre of the Chinese Universe. This spot, marked by circular pavement, represents to the Celestial the centre of his Universe, as Delphi did to the Greeks of old. The symbolism of the picture might have been more complete had the counsels of Russia been less potent than they are just now in the ear of the Chinese government."[55] While the humiliation of the Chinese emperor and the Chinese people embodied by the posing of a British and an Indian soldier at the Round Altar is obvious, the last sentence, a reference to a perceived British weakness in the face of Russian ambitions and actions

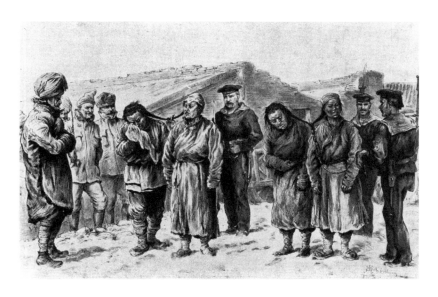

10. Austrian soldiers with four captured Boxer thieves. From *Illustrated London News*, 1 March 1901.

11. "Tommy Atkins" at the center of the Chinese universe. From *Illustrated London News*, 20 April 1901.

in East Asia,[56] draws the audience back to the hard realities and responsibilities of empire. This was a subject the *ILN* took every available opportunity to highlight. In this case, it helped readers understand that China and Russia posed threats to the defense of British interests in Asia.

But if drawings like that of Tommy Atkins and his Indian orderly imitated photographic compositions and incorporated visual images into broader imperial concerns, there were also a large number of photographs that were fit for direct reproduction. This was especially the case in the United States, where *Leslie's Weekly* was exemplary in its use of photographic images. Like the *ILN*, *Leslie's* published its first photographs from the allied invasion in October, running a full page showing "Death and Destruction" at Tianjin, with close-ups of individual Chinese bodies photographed by Sidney Adamson, *Leslie's* special correspondent on the scene. On 13 October, *Leslie's* cover carried two photographs, one of British cavalry troopers atop the wall of Tianjin, the other of Chinese people fleeing the city with their belongings on their backs. Inside, their were several photographs of the allied forces on their "rapid march" to relieve the legations.

These photographs were nested, in turn, within a body of coverage of events in China that had opened spectacularly on 21 July 1900 with the execution photographs previously discussed. A week later a bright yellow cover with a dragon in the center proclaimed **THE YELLOW HORROR** in bold black letters. The 4 August edition provided a bird's-eye view of the theater of the war, showing the area from the Dagu forts on the coast to the walls of Beijing. Inside was a double-page spread and, from the photographic archive, images of the many Western-style buildings in the foreign concessions at Tianjin. But perhaps the most intriguing aspect of *Leslie's* coverage was its gleeful presentation of the penetration of China's holy of holies, the Forbidden City, discussed earlier (fig. 3). The foreign presence, including that of the camera, was presented as a humiliating lesson that "barbarism" needed to learn.

As coverage continued into 1901, *Leslie's* demonstrated the power of the photography complex, and the networks with which it was linked, to structure the meaning of global events such as the Boxer Uprising. By combining a variety of immutable mobiles — old and new photographs, drawings, maps, descriptive texts — *Leslie's* editors and craftsmen created a new China, one that was no different from any other place where natives had transgressed against a white world of "civilization" and "civilizing missions." Captured in the photography complex, Chinese cities, palaces,

temples, and people performed as mute subjects the tasks assigned them by the production apparatus of the imperial state and its allies in the press. The results of this almost seamless blending of photographic image with textual knowledge about China fixed into place an authoritative and monotone account of the events of 1900, producing reality not only for audiences in Europe and North America, but also, eventually, in China.

Because of the storage and preservation capacities of the imperial archive, images such as those collected here could be inserted into subsequent histories, structuring the understanding of 1900 for a succession of generations. Book lists on electronic distributors such as Amazon.com contain over a dozen recent titles on the Boxer Uprising, many of which contain images similar to those reproduced here. And this does not include publications in China itself, where the immutable mobiles of the photography complex have been assembled into a nationalist discourse to "never forget national humiliations."[57] Thus, the China staged through the 1900 photography complex remains very much part of our global collective present.

GHOSTS IN THE ARCHIVE

In this essay I have attempted to place photographs within a broader context of imperial practice and to demonstrate how the complex structure of photographic production contributed to Euro-American imperial hegemony in the early part of the twentieth century. As an apparatus of empire, the photography complex could bring events from distant places to bear on the political and social dynamics of imperial metropoles. The output of the complex also linked to other modes of cultural production of the era, the exhibitionary and representational regimes discussed by Tony Bennett, Carol Breckenridge, Donna Haraway, Timothy Mitchell, and Thomas Richards being the most obvious examples. Given these powerful connections, it seems reasonable to wonder if there are ways of undermining the authority of these technologies of empire. Can the remnants of the nineteenth-century photography complex provide resources for counterhegemonic struggles in the present? Can they, as they seem to have done in China after 1949, provide elements that can contribute to the construction of alternative histories of Western expansion in the nineteenth century?

To the degree to which I and others in this volume have been successful in opening the question of photography as a complex form of agency

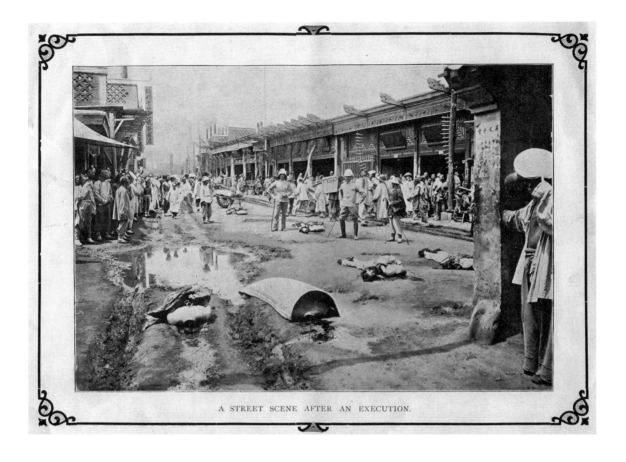

A STREET SCENE AFTER AN EXECUTION.

12. "Street Scene after an Execution." From *Unique Photographs of the Execution of Boxers in China*, ca. 1901.

in the colonial context, some counterhegemonic work may already have been done. It is also the case that any of the images produced here, as well as the vast storehouse still available in the imperial archives from which many of these images came, can be read against the grain of dominant narratives. Close scrutiny of the faces present at the executions depicted in the Brighton booklet (fig. 8), for example, might be interpreted as contradicting the *Britannica*-inspired characterization of the Chinese people as capable of expressing only insensibility to suffering. These faces suggest a variety of emotions, ranging from empathy and sympathy to perhaps even contempt for the foreigners and their devices. One might consider "A Street Scene after an Execution" in a similar way (fig. 12). Given the high moral tone of the Brighton booklet, what are we to make of the gazes of the Beijing residents at British artillery officers posing over the beheaded bodies of Boxers? Or of the pose itself? Similar postures — leg thrust forward, one hand on hip, the other on a walking stick — can be seen among the Europeans standing over the bodies of "pirates" on the

cover of *Leslie's Weekly* (fig. 9, above). Often seen in photographs from hunts in India and Africa, this "imperial" stance suggests that those punished for defying British imperial authority were not unlike trophies of war. How secure, then, is the high moral certainty in R. N.'s tone? Does not the contrast between the humane phrases that dot the text and the arrogant posture of these soldiers destabilize imperial condescension?

Incongruities between text and image are evident in a variety of other contexts as well. Mislabeled sites are not uncommon. In the images of the triumphal march, for example, *L'Illustration* has the French column exiting the north gate of the Forbidden City, while *Le Vie Illustrée* has them entering the palaces through the same gate. Such confusions are evident in other published sources and in the official record. There is also at least one case where an older photograph was labeled *as if* it recorded one of the events of 1900. The image in question is the one mentioned earlier, the execution of pirates in Hong Kong that appeared in *Leslie's Weekly* and *Le Vie Illustrée*. Prior to having seen these published copies, I saw the same photograph in 1992 on a research visit to the archives of the U.S. Army Military History Institute in Carlisle, Pennsylvania. In white ink directly on the print, it bore the label "Scenes after the Beheading of 15 Boxers in China." Thus, for some unknown pen wielder, *Leslie's* editorial speculation on future events in China had been moved into the realm of "fact," manufacturing a new reality in which the ten or eleven dead "pirates" were transmuted into those of an even larger body count of "Boxers."[58]

This particular photograph raises another issue. To this point, I have been careful to consider only photographs that have had a public life, that have, in other words, been reproduced and circulated. These are, however, not the only images in the imperial archives. As a way of ending this essay, I would like to deal with three photographs produced in the complex but apparently never published, that in themselves cut against the grain of the stern authority of imperial power, and that in at least one instance appear to mock it.

The first of these images (fig. 13) is another example of an execution scene to be found in the archives of the U.S. Army Military History Institute. It is set in a street filled with European soldiers and civilians and is the final in a set of four photographs.[59] The third in the series makes it quite clear that the bulk of the audience observing the execution are Europeans; some are actually looking down from the top of the building below which the execution is taking place. Although no labels are on the photographs, this may well have been the execution of two Chinese

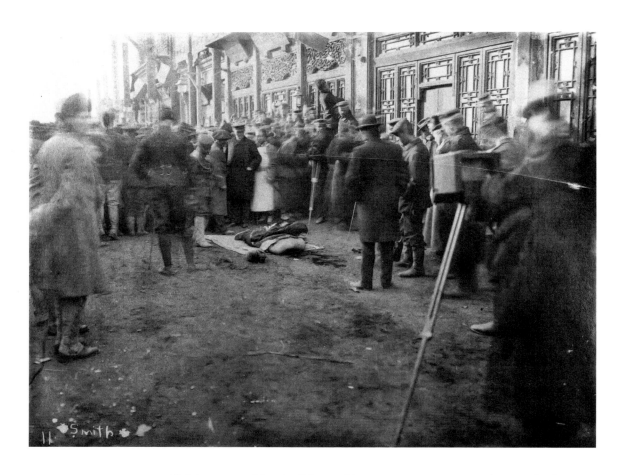

13. Blurred photo of execution. Courtesy of U.S. Army Military History Institute, Carlisle, Pennsylvania.

officials reported in *Leslie's Weekly*, on 18 May 1900. By the standards of other outputs of the photography complex, however, the photograph in question is not a very good production and certainly not as clear and vivid as the drawing on *Leslie's* cover. In addition to having caught another photographer in the act, it also has blurred sections indicating motion of the subjects within the frame. Lack of visual clarity is often the reason pictures like this one are not reproduced. But, given what I argued earlier, there may be another reason as well. Blurred images and the presence of another photographer in the picture immediately call into question any unmediated claims about colonial photography. Instead of focusing attention on the key event, the execution of a Chinese official, this photograph draws attention to itself and to the processes involved in fabricating photographs. Insofar as it makes visible that which the photography complex conspires to hide, it is indeed a bad photograph.

The second example comes from the India Office Archives in London (fig. 14). Two policemen flank four others who were no doubt part

of the poor vagabond class (like those in fig. 10, above) that made up a floating population in Beijing. Yet, as disturbing as is the condition of these disheveled men, there is something even more unsettling about the photograph. It seems clearly staged, but to what end or purpose? An explanation written on the back of the photograph helps to clarify matters. It reads, "The prisoners were told to look miserable for the photograph . . . certainly did." Not only is attention once again drawn to the process of photographic production, but perhaps even more than the Brighton photograph of British soldiers standing over decapitated bodies, this image suggests that lurking in the complex is a disturbing perversity, a desire to denigrate still further, through staged performances like this one, those who have already been brought low by a host of forces, domestic and foreign, around them.

The final example also draws attention to what is being staged before

14. Looking miserable. Courtesy of Oriental and India Office Collection, British Library.

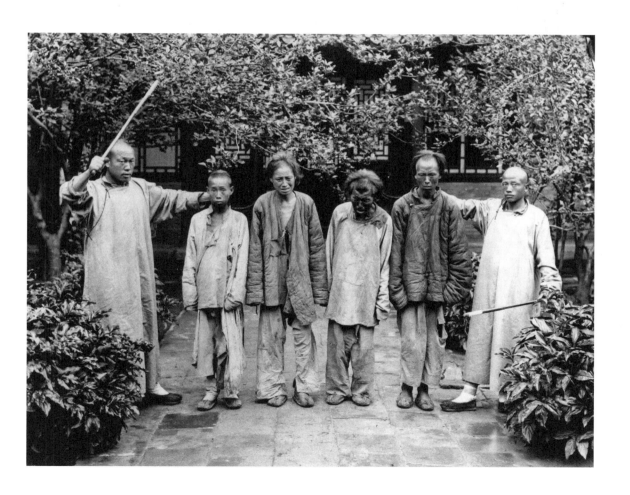

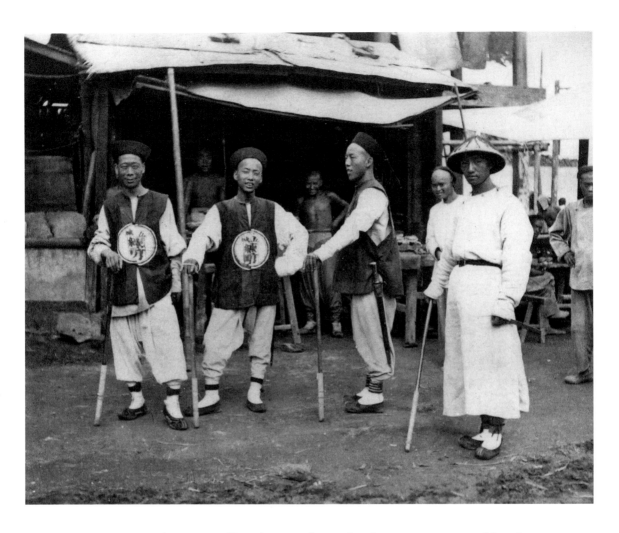

15. Qing police. Courtesy of National Army Museum, London.

the camera (fig. 15). From the National Army Museum archives in London, it is perhaps one of the few photographs in which anyone in Beijing is caught smiling at the camera. But that is not the only thing that makes it unusual. Equally interesting are the poses of the three Qing policemen in dark hats. When this picture was taken, photographers such as Cornelius O'Keefe were constructing a documentary record of the soldiers in the contingents of other countries. In O'Keefe's case, he photographed soldiers from British India Army units standing three abreast in front and side view positions.[60] Perhaps these policemen had seen one of these staged events, or perhaps they had noticed the way Englishmen stood with a hand on one hip and a walking stick in the other. Regardless of the source of inspiration, the impression is of more than mimicry. They seem

to be laughing at the photographer and his apparatus and mocking the posture of European soldiers.

Insofar as photographs like these disturb the regularities of the photography complex, they have subversive content. By drawing attention to the making of the image, by forcing us to consider the staged nature of the events before the camera, these pictures push us out of the frame and into the processes and technologies through which photographs were produced, circulated, and saved. If we return to where this essay began, with Oliver Wendell Holmes's discomfort over the possibility that pure, unmediated "memory" could be subverted through the manipulation of the image, it should be clear that there was more at stake than the truth-value of the photograph. The more profound issue indexed by these unstable images is the relationship between new technologies and the claims and powers of the imperial state. The value of the "bad" photograph, of staged misery, or of the Qing policeman's hand on his hip is that each in their own way helps to demystify "the mirror with a memory" and thereby open to scrutiny mechanisms of imperial power and technologies of rule. Such images also suggest that a tool of empire such as the photography complex is not omnipotent: It too can be tricked and made to look foolish.

NOTES

1 Holmes, "The Stereograph and Stereography," 739.

2 Ibid., 748–49.

3 Ibid., 742.

4 Headrick, *The Tools of Empire*. See especially his discussion of efforts by historians to deny or limit the role of technology in European empire building, 5–8.

5 Latour, *The Pasteurization of France*. Also see Haraway, *Simians, Cyborgs and Women*.

6 For a discussion of these printing processes, see Jussim, *Visual Communication and the Graphic Arts*, 82–83 and under each technique in the glossary, 339–45.

7 On surveillance, law, and evidence, see Tagg, *The Burden of Representation*, 66–102. For a more detailed discussion of the pedagogy of imperialism, see Hevia, *English Lessons*.

8 See National Archives and Record Administration (NARA), Washington, D.C., Record Group (RG) 395, 906, boxes 2 and 4. (Hereafter NARA-WDC.)

9 There is at least one photograph showing photographers at the triumphal march. It is a shot looking south from Tianan Gate; see U.S. National Archives, College Park, Md., NARA, folder 75140 (hereafter NARA-CP). On the triumphal march, see

Hevia, *English Lessons*, 203–6. Motion pictures were also taken within the Forbidden City by William Ackerman; see NARA-WDC, RG 395, 898, no. 229, 24 October 1900. Ackerman was employed by the American Mutoscope and Biograph Company of New York; see Sharf and Harrington, *China, 1900*, 243–44.

10 O'Keefe had been a professional photographer working in Leadville, Colorado, when the Spanish-American War broke out. He enlisted in the army and was sent to the Philippines, where he covered the Filipino Insurrection in 1899–1900; see Sharf and Harrington, *China, 1900*, 246–47. O'Keefe also sold some of his China photographs to *Leslie's Weekly*, a publication discussed in detail below. O'Keefe's orders are in NARA-WDC, RG 395, 911, Special Orders 78, 24.

11 There are two references in NARA from General Chaffee to the adjutant-general of the army in Washington, D.C., indicating the shipment of photographs to his office; see NARA-WDC, RG 395, 898, no. 123, which mentions ninety-five photographs, and RG 395, 898, no. 498, which lists a group of photographs to illustrate reports Chaffee had forwarded on foreign armies (see below).

12 There are also some additional photographs at NARA-CP in the General Photographic File, U.S. Marine Corps, 1872–1912, 127-G, box 4. They include two of the triumphal march and one of the throne room in the Preserving Harmony Hall (Baohe dian) in the Forbidden City.

13 See NARA-CP, folder 88881.

14 For the official published account, see U.S. War Department, *Reports on Military Operations in South Africa and China*.

15 *Shinoku Pekin kojo shashincho* [Photographs of the Palace Buildings of Peking], n.p.

16 Ibid.

17 Osvald Sirén's similarly ambitious project would appear twenty years later; see *The Imperial Palaces of Peking*.

18 Sand, "Was Meiji Taste in Interiors 'Orientalist'?"

19 Smith, *China in Convulsion*. For Killie's photographs, see NARA-WDC, RG 395, 898, no. 469.

20 Smith, *China in Convulsion*, 2: 730–31. On the Twain-missionary exchange, see Hevia, *English Lessons*, 206.

21 For a photograph providing clearer scale on the opening in the city wall, see Hevia, *English Lessons*, 200.

22 See, for example, Benjamin, "The Work of Art in the Age of Mechanical Reproduction." For a similar argument on imperialism and popular culture, see MacKenzie, *Propaganda and Empire*.

23 For a fuller discussion of "symbolic warfare," see Hevia, *English Lessons*, 195–206.

24 The event was well documented in image and text. See, for example, Landor, *China and the Allies*. The pictures were taken by Landor himself, probably with a Kodak box camera.

25 See Hevia, *English Lessons*, 267, 261.

26 The image in figure 6 is from a collection of photographs assembled in a volume

titled *Military Order of the Dragon, 1901–1911*. The order was an international fraternal organization of officers from the eight armies that occupied Beijing in 1901. See Hevia, *English Lessons*, 305–8. Second from the right is Sarah Pike Conger, the wife of the American minister to China, and next to her is Gen. James Wilson. The remaining people in the photograph are American solders and legation officials. On the photograph of the Bengal Lancers, see Hevia, *English Lessons*, 199–200.

27 Richards, *The Imperial Archive*.

28 Latour, "Drawing Things Together," especially 26–35.

29 *Unique Photographs of the Execution of Boxers in China* (Brighton: Visitors' Inquiry Association, n.d.). I received the booklet from Bruce Doar as a gift in Beijing in 1991. He said he had bought it at a book sale in Melbourne a few years earlier. It bears evidence of having been in an Australian public library.

30 For a description of the process, see Jussim, *Visual Communication*, 345.

31 *Execution of Boxers*, 3, 5.

32 The ninth edition of the *Britannica* was published in 1874. I have consulted the 1878 Scribner's edition. See "China," 5: 626–72. The passage in question is on 669. The eleventh edition of the *Britannica* (1910–11), while retaining much of the descriptive account of capital punishment in Douglas, dropped the elements cited here.

 While it may seem odd to characterize the *Britannica* as part of an imperial archive, its frequent citation in British military intelligence reports on Africa and Asia seems enough justification. See Hevia, "Secret Archive."

33 An almost identical descriptive tone combined with claims that projected responsibility for the executions wholly onto the Chinese people can be found in *Leslie's Weekly*, 18 May 1901, 484. Under the title "The Awful Reality of Chinese Executions," the author claimed that executions by beheading in present-day China were even more hideous than in sixteenth- and seventeenth-century England.

34 *Execution of Boxers*, 6.

35 See Farwell, *Queen Victoria's Little Wars*, for a stunning catalogue of these wars (364–71). Farwell also includes "illustrations" culled from photo archives and the graphic press.

36 Holmes, "Stereograph," 748.

37 See Darrah, *The World of Stereographs*, 3.

38 Ibid., 1–5. Ample pictures of the stereoscopic viewer can be found online; see, for example, http://www.rleggat.com, accessed 12 May 2007.

39 This, at any rate, has been my experience with the stereograph. An enormous collection of images can be seen with stereoscope viewers at the Library of Congress, including Ricalton's China tour, discussed below.

40 Darrah, *Stereographs*, 46–48. Underwood also developed a unique distribution system that employed clean-cut college and seminary students as salesmen. The young men were trained to canvass school superintendents, librarians, and bankers in territories assigned to them.

41 It is extremely difficult to assemble these various sources in one place to repro-

duce the experiences of early twentieth-century stereoscope users. Extant texts, images, and maps are dispersed in different parts of libraries, or holdings are incomplete.

42 Sets were also marketed in smaller, less expensive units, including one on Beijing made up of thirty-one stereographs, text, two maps, and a diagram of Beijing for $5.25. See Ricalton, *Pekin*. The Library of Congress's copy of this volume contains the maps and diagram. The other subunits were "Hong Kong and Canton," with fifteen photographs and three maps, $2.50; and "The Boxer Uprising Chefoo, Taku, and Tien-tsin," with twenty-six photographs and three maps, $4.40. As near as I can estimate, the Library of Congress stereographic collection has a complete set of the Ricalton China tour.

There are also echoes in the stereographic package of the eighteenth-century phenomenon "world in a box." See Heesen, *The World in a Box*.

43 Since international exhibitions were a major theme of stereography, one is also tempted to suggest exhibitions of exhibitions. On the exhibitionary regime, see Mitchell, *Colonizing Egypt*; Bennett, *The Birth of the Museum*.

44 Ricalton's stereographs and text are in Lucas, *Ricalton's Photographs of China during the Boxer Rebellion* (Lewiston: Edwin Mellen Press, 1990), 176–77. In this publication a single, as opposed to a double, image is reproduced and diagrams and maps excluded. Numbers in brackets refer to plate numbers in Lucas.

45 Lucas, *Ricalton's Photographs*, 176–77.

46 Smith's *Chinese Characteristics* became a staple for missionaries going to China.

47 Lucas, *Ricalton's Photographs*, 178.

48 Ricalton made the comparison in order to point out that the Tartars were considered by "some authorities" to be the "most improvable race in central Asia." Lucas, *Ricalton's Photographs*, 225–26.

49 *ILN*, 29 December 1900, 980–81, and 20 July 1901, 89–90.

50 See Springhall, "'Up Guards and at them!'" He discusses *ILN* production processes for drawings and photographs; see 51–55, 59–61.

51 See Jussim, *Visual Communication*, 138–40, on halftone engravings of drawings and paintings.

52 *ILN*, 13 October 1900, 516.

53 See *ILN*, 6 April 1901, 489, and 1 March 1901, 299. *Black & White*, another London weekly, published a photograph of reputed Boxers tied together by their queues, 2 March 1901, 285.

54 The name comes from early nineteenth-century British army regulations, where it is used on sample forms. See also the Rudyard Kipling poem "Tommy," in *Barrack-Room Ballads*, 7–9, which was first published in 1890.

55 *ILN*, 20 April 1901, 566.

56 At the time, Russian forces occupied Manchuria and, many British critics feared, were in a position to seize all of China north of the Yangzi River. See, for example, Krausse, *Russia in Asia*, and *The Story of the China Crisis*; Boulger, "The Scramble for China."

57 The quotation is a translation from a monument at the Summer Palace (Yuan-

mingyuan) in Beijing, an extensive ornamental garden destroyed by the British in 1860 for the Qing Dynasty's transgressions against "civilization." For a discussion of this monument, as well as museum displays, many of which include photographs discussed here, see Hevia, "Remembering the Century of Humiliation."

58 The photo is in an album attributed to J. D. Givens entitled "Scenes Taken in the Philippines, China, Japan and on the Pacific (1912)." See RG49-LD.222–23, photo 187, U.S. Army Military History Institute, Carlisle, Pennsylvania. This same image, I am fairly certain, has appeared on a postcard once sold on the website of a company located in Vienna; see www.collect.at.

59 These photos are in the James Hudson album, 44–47, U.S. Army Military History Institute, Carlisle, Pennsylvania.

60 See NARA-CP, folder 74956, 7th Rajputs; folder 74955, 24th Punjabs; and folder 74954, 1st Sikhs.

ROSALIND C. MORRIS

Photography and the Power
of Images in the History of Power

Notes from Thailand

Two sets of images sit before me.[1] One set is a pair of photographic like-
nesses depicting King Rama IV or Mongkut of Siam (r. 1855–68). In each
of the two portraits, the king appears attired in the regal drape of his
office and burdened by a veritable crust of signs, but whereas one image
features the king enthroned and with his scepter in hand, the other shows
him in a less monarchically theatricalized context, surrounded by objects
of daily, if no less royal, existence. The former image, which was ulti-
mately given as a gift by the Siamese ambassadors to Queen Victoria, is
framed and assiduously adorned with gold leaf; the other, which returned
to Scotland with its photographer, John Thomson, is flat and undeco-
rated, although a border of scarred paper marks its exterior limit (figs. 1
and 2).

The second set of images comes from a more recent period in Thai his-
tory and includes two distinct moments: the democracy protests and their
aftermath in 1992, and the Thai state's crackdown on so-called southern
insurgents in 2004. The photographs from 1992 depict the protest, with its
swelling crowds, the violence that ensued, and the extraordinary drama
of reconciliation in which the king and the leaders of both the military
and the popular uprising appear together in a single frame. Those from
2004 include graphic photographs of corpses taken by journalists in the
aftermath of a violent clash between protestors and state representatives
in the province of Pattani, in the mainly Muslim, ethnically Malay south
of Thailand. The photographs from 1992 and 2004 are perhaps most re-
markable for the degree to which they depict people bearing photographs;

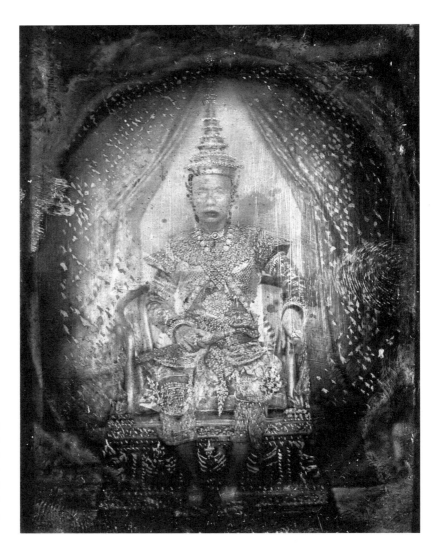

1. Daguerreotype of King Mongkut of Siam, illuminated and presented as a gift to H.R.H. Queen Victoria. The Royal Collection © 2007 Her Majesty Queen Elizabeth II.

in them one sees the residue of a process by which the photograph itself has become a force in the political domain.

Nonetheless, all of these pictures — from each of these times — appear to be the photographic traces of moments that are indissolubly bound to the history and future of political power in the Siamese and then Thai state. In this sense, they tend toward an iconicity that exceeds their status as photographs. That is, they seem not only to be indexically marked by the moment of their production (by the "that-has-been" of an event, as Barthes would say),[2] but to represent it in a distilled and abstracted form. Still, they retain their status as photographs, and it is from the ground of their being as photographs that they can rise to another level of represen-

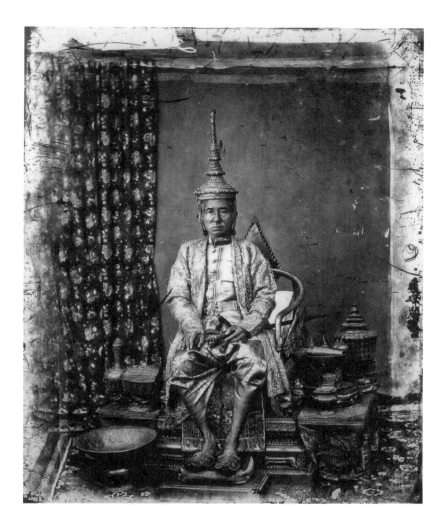

2. King Mongkut of
Siam. Photograph by
John Thomson, 1865.
© Wellcome Trust.

tation, one that, though it retains the aura of facticity, also bespeaks its transcendence.

If these pictures appear to us now to share a quality that marks them as self-evidently photographic images, they are nonetheless different in profound ways. Indeed, in casting one's eye from the first set of images to the next, and from the seemingly blank gaze of an adored monarch to the unseeing faces of the corpses and the apparently indifferent looks of the armed men who stand and walk among them, and in considering them as photographs from a history of photography in Thailand, one is struck by the enormous and nearly insurmountable chasm that separates them. It is therefore not irrelevant to ask, What, if anything, binds these pictures under a single name such that they may appear to be instances of the

same imageric practice? For to write a history of photography in Thailand (which is not yet a photographic history *of* Thailand, in Kracauer's sense) requires precisely that such an identity be thought, that it be written at the beginning and even before the beginning of any narrative which asserts that the portrait of a king stands at the origin of a history which moves toward images of a death that has been effected in his name, but possibly without his foreknowledge and perhaps even against his wishes. The question concerns the nature of sovereignty and the forms in which political power can appear. It therefore also concerns the place of photography in the history by which politics has become representational. I will return to these questions of photography in the history by which power has assumed its representational form and as an object of historiography. First, however, it is necessary to consider the pictures *in their difference*.

PORTRAITS OF A KING

Here, then, is a photographic likeness of King Rama IV (fig. 2), known in the West as Mongkut. It is a modern albumen print made from a wet silver collodion negative. It was made in 1865 by the Scottish photographer John Thomson, who traveled to Siam and China in the middle of the century and created a veritably proto-ethnographic aesthetic, remarkable for its naturalistic quality at a time of laboriously staged portraiture. Thomson's audience with the king of Siam was an extraordinary feat (the king did not generally allow himself to be looked at directly by commoners), but one that drew upon the ageing king's own fascination with photochemical technologies. As part of the exchange of diplomatic gifts between Siam and England (and the United States), Mongkut had received a number of cameras, photographs, and also stereoscopic images. These had whetted a deep curiosity, one that he transmitted to his sons and his nephews, some of whom would become accomplished photographers in their own right. Mongkut seems to have recognized early on that photographic portraiture had a capacity to extend the domain of his influence. By transmitting his image and hence the authority of the monarchy which he incarnated, he could solicit recognition from those abroad, and this recognition would itself testify to his potency. To be sure, it entailed a risk: a subjection of the king to the gaze of mere commoners could, from the Siamese perspective, imply his vulnerability, and at the time of his ascending the throne the boundary between monarchs and commoners was so vast as to prohibit any reciprocation of looks. At the same time, how-

ever, photographic portraiture could assert the equivalence between the Siamese and European institutions of monarchy. For this reason, perhaps, it was a risk that Mongkut was prepared to take, for his alliance was with monarchy, and monarchy itself was not yet dependent upon its validation by the people. Even today it has yet to be fully subject to the constitution, and the Thai system of government is formally translated as "democracy with the king as head of state," and not as "constitutional monarchy."

Mongkut had come to power in Siam at a time when Britain and France were both expressing a desire to acquire Siamese territorial and trade rights. His predecessor had resisted British pressure to open local markets and had expressed deep suspicion of British motives, refusing to receive English negotiators when they attempted to open talks for the revision of trade agreements. For their part, the English merchants, particularly those in Manchester, had been unhappy with the terms of the treaties binding the two nations, and so it was that George Bowring arrived in Bangkok almost immediately upon Mongkut's coronation to negotiate what would become the treaty of 1855. The treaty secured for Britain privileged and relatively unfettered access to Siamese commodities and, more important, Siamese markets. It also provided the basis for claiming extraterritorial rights for British subjects in Siam. The burden of instituting a colonial bureaucracy was thereby avoided, and Britain was able to establish and satisfy its economic ambitions with relatively modest investment. Subsequent treaties expanded both British and French trade rights, and Siam was forced to cede not only economic autonomy but also territory, including substantial Malay-speaking, largely Muslim areas in the south — the area from which our final photographs arise. This territory was historically contested, however, and, as in the Ayutthayan period, it would become a volatile entity within the Siamese polity when, some half a century later, Siam reclaimed it by annexing the four provinces of Yala, Narathiwat, Pattani, and Setul. Over the decades, the variously contracting and expanding domain of the Siamese monarch would be mediated by an image of putative unity, one that would convey the power of both King Mongkut and his successors and kingship in general. Indeed, the former was to derive his power from the latter, and the latter was to be intensified through the instrument of photography, which was also the medium of that misrecognized and emphatically unequal exchange between Siam and England in Mongkut's time.

Bowring's success and his apparent rapport with Mongkut facilitated a long and long-distance conversation between the Siamese king and his

British counterpart. Indeed, Mongkut undertook a loquacious correspondence with Queen Victoria — in English — and along with the letters and gifts that typify such international relations, the two exchanged portraits. Not all the pictures for which Mongkut posed took the form of royal portraiture, however. He had himself photographed in a variety of guises, appearing not only in Siamese regalia, but in the uniform of a French field marshal (fig. 3) and a Russian general. Photography, it seemed, afforded an opportunity for sartorial play and for resembling the forms of European power. Inhabiting this diversity permitted the diminutive Siamese monarch to effect a new form of comparability and to partake of that which was being compared, namely, power as representation. But his capacity to appear in the image of European power, and hence to appear as comparable to European powers, also intensified his relative claims upon local power, for his sartorial mobility was itself uncommon. One might say that his uncommon (but not absolutely unique) capacity to determine the form of his own representation marked and expressed Mongkut's special situation in Siam: his situation as king.

A culturalist speculation on this capacity might remark that the prerogative of the monarch who could appear in the image of a French field marshal or a Russian general, to say nothing of a Siamese king, was a manifestation of his divinity, for Theravada Buddhism, like the Brahmanic traditions from which it emerged, attributes to all divinities a capacity to appear in myriad forms and to be known by myriad names. And the monarchy to which Monkgut ascended in 1855 was, in some senses, a divine one.[3] However, this kind of anthropologically hermeneutic speculation, however accidentally insightful, merely transfers more properly Christological histories of sacralization and idolatry to the Siamese image. It makes sacrality an explanation for power rather than a form of its appearance or a representation of power's own self-transcendentalization. In truth, we do not know that Mongkut allowed himself to be photographed in this diversity of appearances because of his sacral status or because of his human status, to solicit a wider audience and hence a broader recognition of his very sacredness or to indulge a personal fantasy of universality made possible by his office, or all of these things. Moreover, the Siamese king's sacrality was unlike that associated with divine monarchs familiar to the readers of Kantorowicz.[4] Mongkut was not born a king but was appointed by his father (and, indeed, shared the throne with a brother), and his status was said to be evidence of accumulated merit rather than the inexplicable gift of an unknowable but nonetheless singu-

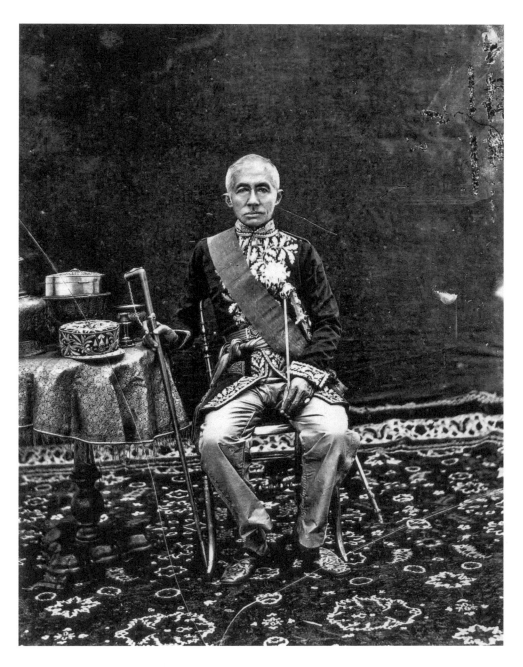

3. King Mongkut of Siam, attired in the uniform of a French field marshal. Photograph by John Thomson, 1865. © Wellcome Trust.

lar God. Throughout his life, he made offerings to the sangha, or Buddhist clergy, in which he had himself served for several decades, performing in public his subservience to the institution that validated his claim to merit by permitting him to make more claims. In other words, his occupation of an office was a function of what we might term his prehistory and was evidence not only of the office's durability but also of his own soul's extraordinary longevity. The immortality of the kingship which Kantorowicz observed in the moment when a king's death could elicit an assertion of his office's continued life ("The king is dead, long live the king") was present in the Siamese monarchy, but in addition to being a dimension of institutional duration it was redoubled in the actual person of the king, whose very appearance as king was evidence of his successful and progressively ascending transmigration.

Transmigration is not immortality, of course; it has a finitude, albeit on a scale so vast as to approach the infinite from the perspective of mere mortals. Thus, in Siam, as in Western monarchical traditions, it is possible to discern two temporalities in the institution of kingship. But if kingship in the political sphere separated itself from the materiality of its inhabitant (and the lives of kings were marked by a variety of rites that recognized this separation, the most obvious being those associated with death), the nature of that separation was not entirely the same in premodern Siam as in premodern Europe.[5] Thus it becomes necessary to look elsewhere for an explanation of the processes by which photography became the instrument of comparability and, hence, a spectral relation between Siamese and European monarchs and monarchies.

Other men, members of the aristocracy and relatives of the king, also seem to have engaged in the phantasmatic and sartorial traversal of social and cultural difference that Mongkut's portraits make visible. There are photographs of Prince Damrong dressed like an English gentleman and of other men of means attired as American cowboys. What distinguishes the range of possibilities available to the king and to his lesser compatriots, however, was the right to appear as king. Only the king could bear the insignia of the monarchy; only the monarch could appear in the bejeweled cloth and the tiered crown that represented the power of his office. The only legitimate imitation of this appearance is that which occurs within the specifically and self-consciously neutral space of the theater, especially the puppet theater, where the image of the king always announces its origins in an ontologically distinct domain. If we cannot know *why* Mongkut dressed as he did, in so many styles and fashions, we

can nonetheless conclude that neither he nor his aristocratic compatriots assumed that their appearance had to signify Siameseness in a form that made appearance the external manifestation of a cultural type. And we can assert that the representation of the king which consisted of his royal robes and insignia was the object of a taboo. In a manner that differed from the sartorial transgressions of lesser men, however, *the king's appearance as a king was the prerogative of one whose appearance as something else could be read as evidence of his monarchy*.

SET UP

Let us consider the images more attentively. Thomson's photograph of 1865 features the monarch on a modest seat, surrounded by the banal accoutrements of everyday regal existence. But the earlier daguerreotype shows the monarch in full regalia and on the Emerald Palace throne. It is a younger visage that peers at us from this historically prior image, not from the flat surface of the paper but from behind a densely reworked glass surface. The older image (fig. 1, above) of the younger king, which continued to circulate within the sphere of royalty, is notable for the gold leaf with which it is carefully overlaid. The leaf traces the lines of the drape enframing the monarch (the drape is indeed present in the original, but only faintly), but the gold leaf also contains a number of royal symbols, such as a *garuda* and crown, which, though they appear at the bottom of the image, are not part of the original. These signs of monarchy, one might say, are added belatedly, even though they seem justified in advance by the exceptional status of the man who is king. In this picture, an iris effect multiplies the sense of the king's isolation, giving him the aura of sacred solitude. Some of the embroidery on his regalia is also mimetically redoubled by the gold leaf, intensifying this isolation and making the frame appear entirely exterior to the man and to the kingship he occupies. Strikingly, the monarch's lips, whence emerged the commandment of a world not yet subject to the rule of law, are similarly illuminated.

The gold leaf renders the image something more than itself, a veritable illustration rather than the reflection of a light said to be natural to both Nature and Reason. That is to say, the illumination of the image seems to take place as a supplement to the photochemical process. It is not internal to the daguerreotype, does not condition its possibility, as the lighting of the figure would (and it has nothing to do with what Fox Talbot described as photography's "pencil of nature").[6] Rather, these tracings

on a trace of the king stand out, giving the picture a nearly holographic intensity and attributing to it a material density which renders it nearly three-dimensional. Such illumination has many analogues, from the painted backdrops of photographs in early Indian studio portraiture to the filigreed borders of medieval Christianity and the illumined margins of Persian manuscript traditions.[7] Nonetheless, it is the analogy to manuscript illumination that seems most apt, given that the gold leaf on the daguerreotype works to achieve what extravagant calligraphic elaboration did in a different medium, namely, the interruption of both reading and the illusion of transparency. One hastens to add that that interruption has a history and is indeed the sign of representation's self-historicization.

If manuscript illumination distorted and dilated a letter or distended a line, it did so in order to beautify but also to rend the time of reading by making the time of writing erupt onto the page. Despite or because of its thickness, despite or because its material density was a function of this interruption, the manuscript page so illumined was characterized by an odd temporal instability. One could read through the text to the historical moment of its narrative or rest on the surface with the moment of writing.[8] So too the gold-leafed image of the Siamese monarch vacillates between the time of the photographing and the time of its adornment, the time of the referent and the time of its beholding. The reproducibility of this image is not merely an aspect of its status as photograph (in this sense the daguerreotype is continuous with the photograph), but is inscribed into a second level of repetition: that of the look or the gesture by which the image is beheld. It is this redoubling of reproducibility in repetition and, hence, of the temporalities of production and consumption that one experiences as the thickness of the image and that one is tempted to read in ontological terms — as the unity of photography — when gazing upon it now.

In this sense, the illuminated daguerreotype/photograph of a Siamese king seems to ally itself with those theoretical arguments which insist that the visual image, unlike the linguistic sign, can never truly disappear in the act of reading. The adorned portrait hails us from across the decades, as if to say, The image is that which obtrudes upon the eye, that whose capacities to signify never exhaust it as an image. It is a Thing, excessive of language, even if legible only by virtue of linguistic operations, operations whose very inadequacy it constantly makes visible. This particular image's resistance to semiological readings, its excessive status as thing, is testified to most by the trace of its having been held. In the upper right

quadrant there is a fingerprint, its ridges negatively revealed by the accumulation of what appears to be gold dust in the troughs.

Here, then, is the trace of attention and possibly reverence, of the hand that adorned and materialized that density which distinguishes this image from the photograph that Thomson took home with him to the rain-drenched sobriety of Scottish positivism, where it came to occupy its place in the archive of the ethnographic Other and the social type. It must be remembered that King Mongkut could never appear as *the* king in Britain, but only as *a* king, of a sort and after a fashion. Indeed, the pretense to translatability that seems to reside in the plural term "kings" masks not only an ambivalence but indeed an intractable resistance within the category of monarchy (the name of one historical form of sovereignty) to comparativism. The fingerprint therefore incarnates a difference, one that bespeaks the relative recognition of *a* king as *the king*. We might call this the difference of discourse and, more specifically, a difference located between the discourses of science and politics. We might call it the difference between positivist, evidentiary photography and royal portraiture. Or we might call it the difference between knowledge and belief. The point to be made here is that this difference is not *in* or *of* the photograph per se. It is a matter of framing. For if these two instances of photography, organized around the same object as they are, can aspire to such different ends and solicit such different responses, then the ontological argument that would oppose image and language while conflating the photograph with the image must be put in abeyance. The photographs of King Mongkut, I suggest, open up an era and a history which will be characterized precisely by this duality, this split in representation. In this new era, photographs will constitute a new form of inscription, but one that is not so much poised between the transparency of prosaic writing or realist figuration and the hypervisibility of manuscript illumination or allegorical illustration, as it combines them both. Integrating indexicality with iconicity, the photograph is that which disappears only to demand looking. It is this looking, born of the senses but enframed by discourse, that ultimately gives to the photograph the possibility of being an image and that renders it an object of investment and identification. Moreover, it is this looking that permits the photograph to be not only a trace of past presence but an image of power, and hence of presence deferred. I will return to this question of photography and the representation of power, but first I want to consider the discourse and the history of monarchical imagery as such in Siam/Thailand.

Images of kings, and of Buddhist saints, as well as Buddhas and revered monks and abbots, may all be subject to the kind of illumination with gold leaf that the mid-nineteenth-century portrait of Mongkut received. This caring gesture of adornment is a kind of tribute, but it is not (in an avowed manner) supposed to be a tribute to the presence whose absence the image substitutes for. It is, rather, supposed to be a means of preparing the self for betterment through gestures of selflessness. The attention and care rendered to the image of one who achieved enlightenment, or even who aspired to such a goal with exemplary deeds, aids one in focusing on what enlightenment entails. That is to say, the care for the image ought not conflate with the adoration of the one represented. For the latter must inevitably, if imperceptibly, collapse into a form of spirit worship, something that orthodox Theravada Buddhism eschews. I say ought not because, in practice, images often receive precisely such a conflated and conflating kind of investment. And if Mongkut had, as a monk, presided over a reform movement that advocated stringent anti-ritualism, Thai Theravada Buddhist practices have remained tenaciously concrete even into the present. It is as though presence adheres to the adored image the more it is made the object of attentive addition and in inverse proportion to the disavowal of metaphysical investments.[9] Photography's claim upon pure re-presentational power withers here like the atrophying soul of the one whom Daguerre's images were originally said to rob of substance. The careful re-marking of the photograph's surface seems, indeed, to suggest that the presence which the photograph is so commonly thought to re-present is here constantly retreating, and that it is salvaged by being looked at. Thus, technology alone does not accomplish the re-presentation of the absent figure, but vacillates on the threshold between presencing and representation. In both cases, however, representation occurs by virtue of the appropriation of the (photograph as) image in another time. Whether it is apprehended as the conservation of force or as evidence of its dissipation depends on how it is framed.

This is true despite the fact that illumination is not a prerequisite to the treatment of such images as material objects, worthy of reverence or, for that matter, deserving of defacement. Photographs of the present king, Bhumipol Adulyadej, often feature him attired in leisure suits and carrying his own camera (with which he documents his good works), and these may be worn by commoners in lockets, inserted into elaborate

frames, or simply carried on one's person, to receive caresses, prayers, and invocations. Many people prefer the image of Mongkut's son, Chula-longkorn, the dashing monarch on whose muscular, English-educated shoulders is laid the mantle of modernity in most nationalist historiography. A veritable cult surrounds him (replete with shrines and communities of mediums who are possessed by his returning spirit).[10] Indeed, his images function like the amulets of Buddhist saints described by Stanley Tambiah, in that they are trafficked, can be purchased in markets, and are often blessed by monks to intensify their apotropaic powers. One can say of them what was said about the portrait of Mongkut illumined with gold leaf: they are objects whose capacity to bear presence is dependent on their separation from the moment of their production. Adoration is a gesture that constantly asserts the moment of reverence, the "now" of devotion, even as it submits this present time to the presence of a past. It inserts a space between the reverential figure and the revered one, a space that we may call auratic. This is the frame.

It must be said that enframement is not simply a matter of boundaries or borders. Rather, it is the function of a mediation by the foreign. And it is this mediation by foreignness that photographic technologies facilitated in Siam. Moreover, it is via this mediation by foreignness that Siamese monarchy came to be reconstituted in a (possibly transient) proto-constitutional form. So we must yet linger with "Mongkut's image," for it is in the history of this image that we see the effects of such mediation most clearly. And it is from this image that the other, vastly different images of the contemporary moment seem to derive their force — as testimonies both to a power that remains in reserve and to its dissipation in a violence which marks the limits of the state's capacities for representationalism.

What, then, can one say about this adorned and adored image? It appears in a recent volume on the history of photography in Thailand with the simple caption "Phra'baat Somdet Phra'jomklao cao yuu hua Ratcha-kaan thii IV." We could translate this as "His Royal Highness (or His Utmost Highness), King Rama IV," depending on the lexicons of regal title that seem to convey the status of the divine but appointed King Mongkut. So translating it, we would have conveyed the sense of the caption and reproduced the absence of any reference to the image as such. But we could also designate it with one of several other captions: *a* Siamese king, *the* Siamese king, the king of Siam in 1866. Each of these captions obliterates the photograph in the aura of the referent and submits itself to the thrall

of presence that photography, as a technology and an ideology (of secular magic), continues to claim as its ground. In the moment that we designate it *as an image*, calling it a "photograph or likeness of a Siamese king" or "of Mongkut," for example, another set of possibilities and another set of captions arise. However, even before making that gesture of recognition, it is possible to construe the photograph as an image, without referring, reflexively, to the fact of photography. Thus, for example, we may refer to this image, indicating that which is represented but not re-presented in the image: "Siamese monarchy," perhaps. If we read Siamese monarchy here and if we read it from the perspective of a representational political system, we might conceive of the image as a redoubled representation of the Siamese people, or even as representative Siameseness. Perhaps we could historicize it to invoke premodern Siameseness? Sliding along a vector of relative abstraction, these possible readings, from the formal Siamese title of the king to the typified sign of a generalized social identity, are determined by the image's mediation and abstraction. Each designation responds to one of two possible questions: Of what is this an image? and What does this image represent? But, as already suggested, there is another possibility governed by the refusal of these questions, a refusal that is sustained by the idea that the image is, before anything else, a photograph. The refusal asks not of the image but of the world, What or who is this?

The refusal of representation's question, and the insistent invocation of a Real event, is sustained by the embrace of photographic magicality: the idea that the photograph is not an image but that it *is* that which it shows (the mark of which is a caption which no longer says "portrait of a king" but simply "the king"). The peculiarity of photographic portraiture associated with kings is that all possibilities, including the question of representation and the insistence on an absolutely unique existence traced by the photograph, can be sustained simultaneously. In the portrait of a king one can have an image of a monarch who represents the people but who is as inseparable from his image as his image is inseparable from the fact of his uniquely empowered being. More than painted portraiture, which, in any case, is virtually absent in Thailand, photographic portraiture of the king effects this conflation. That it does so can be explained only as a kind of magic.

The gesture which Marcel Mauss, invoking the grammatical term of the copula, identified at the performative core of all magic is that which conjoins as identical two otherwise distinct things.[11] In this case, the magic

conjoins a man and an image. To say that this image *is* Phra'baat Somdet Phra'jomklao cao yuu hua Ratchakaan thii IV, without surrendering the recognition that the image and the man are distinct, this is the magic of the photographic copula, which sustains two entities in their duality but binds them in an indissoluble equation of identity. But it is said only by Thais who recognize the image as such. The English-speaking anthropologist or non-Thai-speaking historian who reads it as an image of "King Mongkut" performs a different action, which no translation can ever fully convert. The one who reads it as an image of "Siamese monarchy" performs yet another, now more abstract gesture. And so on, until the slippage along a chain of signifiers has reached the point of near ruin, where ruin is the point at which the signifying function finally outstrips the testimonial function of the referent, about which one can ultimately say, only, it, something, was there, once.

Foreignness, whether temporal, social, or spatial, is that principle which permits the image to open outward, so that it can signify something other than itself. It is what permits the magical unity of the event and its persistent if flattened double to represent not only the one who was there, once, but a whole class of people, a principle of political power, or a moment in which they are bound to each other. It enters in the moment that the photograph is imagined as that which can or must be adorned, modified, enhanced, framed, or defaced — in a word, supplemented.

But photography does not invent the need for supplementation. Nor does photographic portraiture inaugurate the monarch's dependency on representation, a dependency that, perhaps inevitably, culminates in one or another form of political representationalism.[12] For, as Louis Marin made so clear, the representation of the monarch encompasses not only the "portrait" of the king, but the whole assemblage of narratives, discourses, entourages, processions, and architectural frames that "surround" the king and provide for him (or the queen) the image through which he achieves the capacity to convert force into power.[13] Among these many and historically diverse accoutrements, however, photography, more than any other technology of representation, has been associated with the transition from absolute monarchies to populist forms of governmentality — even when, and Thailand is no exception here, populism is associated with the intensification and even sacralization of state power and monarchy.[14] So photography is both a type of supplementation characteristic of all representation and the sign of a particular paradox within the field of power.

Observing King Mongkut's exchange of photographs with Queen Victoria, we begin to see that photography seems to have made it possible to disseminate presence while also enabling a new comparability (as Mongkut's exchange of monarchical portraits suggest). What mediates between the extension of presence, on the one hand, and the possibility of comparisons (which mark the limit of presence), on the other hand, is the politicohistorical fact of the nation-state. The nation is a unit of comparison, as Benedict Anderson has so persuasively argued.[15] Hence, it is the space in which absolute power reaches its limit. But it is also the space within which force can be exercised. A portrait of a monarch is always a picture of power. If, as in Siam, an elaborate code governs the treatment of this image and makes defacement of the image a form of *lèse-majesté* (wounding the king), it is because, in a profound sense, the image is the king, and the power in reserve which is the image cannot be questioned without bringing about the force that it dissimulated.[16] Here we see what is at stake in the untranslatable difference between a picture of "a Siamese king," such as John Thomson took back to Scotland, and a portrait of Phra'baat Somdet Phra'jomklao cao yuu hua Ratchakaan thii IV, which entered the British royal archive.

POWERS OF THE IMAGE

Power, as Pascal told us and as Marin reminds us, is force put into reserve, force which does not expend itself or annihilate all other forces, but rather institutes the potential deployment of force as law, and, indeed as the threat of violence that makes an apparent peace possible.[17] Marin observes that the rule which attends absolute monarchy is the prohibition on naming and locating the king, for to do so is to imply not only where he is but also where he is not. In other words, identifying the king means pointing out his finitude, his nonuniversality.[18] Ideally, of course, absolute monarchy would be omnipresent. It would not have to assert its capacity for force but would have only to be recognized by those who are its subjects. And this recognition would be felt as a compulsion, but more important, as a natural necessity. The king would appear less as one who speaks than as one who makes things happen, as the very author of history. It is the task of the king's historiographer, and of all monarchical historical narrative, to produce the kind of subject who will respond in this manner, argues Marin.

One can imagine that any technology which can appear to transmit

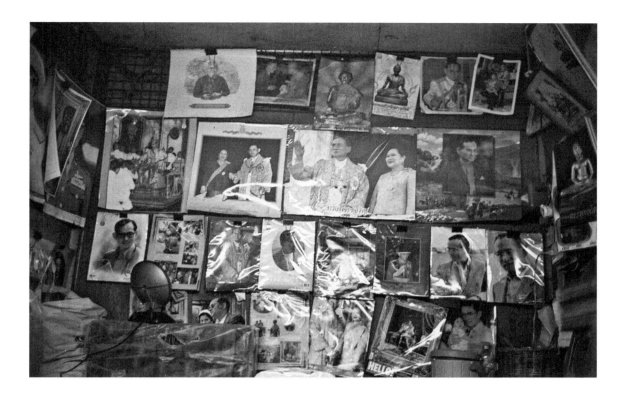

the presence of the king to locations in which his actual body is absent would augment his power, while also risking it. In Siam the era of photography marks the end of the king's absolute withdrawal from public space and his increasing emergence into the public sphere. Where before he lived cloistered in the palace, seen only by other royals and ministers, the middle of the nineteenth century saw the commencement of a fully processional and even ritually peripatetic monarchy, one that asserted itself not by claiming an absolute gaze but by demanding recognition in the looks of commoners (albeit, a nonreciprocal kind of look). Not incidentally, this change was accompanied by the development of a new genre of royal historiography. It was also accompanied by the widespread appearance of images and narratives about the king in the popular media, a tradition that continues today (fig. 4). Yet the risk of a new omnipresence, made possible and materialized in the ubiquity of the serially reproducible photograph, is also, as we shall see, the risk of power reverting to force, of the reserve of law being spent, if not squandered, in eruptions of state violence exercised against those whose interests that same state claims to represent. What one sees in the history of photography in Siam/ Thailand is the simultaneous fantasy of a presence extended to extremity

4. A makeshift shop is adorned with photographs of royalty. Photograph by Christopher Wise. Reprinted by permission of OnAsia.com.

and the recognition that no presence can be politically efficacious without a supplementary practice.

The very ubiquity of the king's photographic image in modern Thailand is demanded by law; display of these images is required in all commercial establishments. Defacement of the image is, as already indicated, also sanctioned by law (and bearing the image can protect one for this very reason). So the photograph, the seeming representation of the king's presence, is guaranteed by a discourse that already exceeds that presence. This discourse guarantees the force of its origin by threatening the application of another, vindictive force. But less formal and less powerful discourses also secure this original potency, and one sees them in those careful elaborations and reverential gestures that are accorded to images of the king and that leave in their wake the traces of fingers. The cults of Chulalongkorn materialized in amulets that bear his image, the baroque frames and offerings of flowers that surround the images of Bhumipol, the invocations and caring gestures that are made in the presence of the images of virtually all monarchs in Thailand: all such phenomena betoken a habituation and internalization of the commandment to not only revere the king, but to revere him *by* revering his image.

So, a question: What happens when force is no longer conveyed as power, when the imageric extension of the king's power fails to guarantee, by representing, the law that emanates from him? In an absolute monarchy, this possibility defines the end of kingship, the unthinkable terminus of a whole system of power. In a constitutional monarchy, or in a "democracy with the king as head of state," the situation is more complicated, for the king himself inhabits his office only as the supervisor of laws that now claim to incarnate the force of a whole community, unmediated by the carnal sign which he is as king. In such contexts, the king himself represents power rather than being the one from whom it issues. Yet if the king's portrait provides an image of power in such milieus, any breach of civil order must also be construed as a defacement of the king's image. When such a breach is conducted "in the name of the king," as has so often been the case in Siamese/Thai history, then we can perhaps infer that the idea of monarchy expresses both the ideal of absolute power and the failure of representation.

Failures of this sort invariably manifest themselves in bloody conflicts—in coups and assassinations, massacres or deployments of martial law. The restitution of order, if and when it occurs, requires that the order of representation also be restored, and this means a re-auraticization of

power's image, whether in the imaginal visage of the king or the portrait of a dictator or president. But how does such a restoration take place? What permits an image to regain its power in the aftermath of its denuding? For, in twentieth-century Thailand at least, the fortunes of the monarchy have waned time and again, only to be reconsolidated through the careful staging of imagery or, rather, through the theatricalized reading of images that depict the king in the role of transcendent peacemaker. This theatrical staging of power's image is, however, itself buttressed by other kinds of looking and, perhaps most perplexing, by the habitual looking at images that depict the effects of force when it is unrestrained in and by power. In clandestine alleys and dubious magazines in contemporary urban Thailand, alongside the carefully staged pictures of statesmen at the feet of the king there is a circuit of images of death and dismemberment. Comprising mainly photographs from police files and official accident reports, as well as journalistic documents of catastrophe, these circuits are especially active and are indeed available to be activated in times of political unrest, when military confrontations, police actions, and protests produce violent death and the corpses which, though they fail to signify power, nonetheless testify to the deployment of force. Not only is there an enormous market in such photographs and the magazines (such as *999*) that function as their media, but displays of such images are not uncommon features in the traveling fairs that move between towns and villages in contemporary Thailand. Typically, the audiences that gather around such images, which are often captioned with wry and obscene titles ridiculing the postures of the dead bodies or mocking the ethnic and sexual identities of the corpses, are composed of young men. It is not overstating the matter to say that these pictures function like pornography functions anywhere else: to incite a libidinous but literal investment in the visible.

The task of politics in the era of photography is not only to render photographs as particularly meaningful images, but also to transform the erotic or traumatized, and therefore transform immediate cathexis to photographs into acts of imagination that include the self-representation of the crowd as an agentive collectivity. In 1992, following popular protests against the military government of Suchinda Khraprayoon (and his efforts to install himself as prime minister), a brutal deployment of force by the military left scores dead and many more wounded. Photographs of the bloody aftermath were initially suppressed in the media, but underground circuits of image exchange quickly restored them to the space of

contest, and they were then incorporated into the protests themselves, where they functioned as seemingly self-explanatory signs of the movement's justness. In the display of the photographs of wounded protestors, other activists appropriated the power of the index and transformed the images of violence into the rationale of its risked recurrence (figs. 5 and 6). The seeming transparency of the images nonetheless concealed a profound instability. They soon found their way into outlying cities — partly through the image circuits more typically reserved for the photographs of traffic accidents — and as they did so, media teams on both sides, that of the military and that of the democratic protestors, moved out into the countryside with their own versions of these traveling image fairs, narrating the images with competing explanations and repudiating each other's stories while insinuating that the photographs of their opponents had been retouched. Previously in Thailand the use of doctored images, especially those which showed the defacement of the prince's image, had been used to legitimate state repression. Yet, despite this history of manipulation, as I have argued elsewhere, a willingness to embrace photographic evidence remains powerfully active in Thailand.[19] As a result, photographic consumption remains a significant site for politicization.

In 1992 the crowds that initially gathered for the more carnal purposes of pleasurable viewing became available for such politicization, and it was partly the transformation of the more ephemeral and naïvely or sexually curious crowd into an agentive collective that gave to the democracy movement its particular potency.[20] It is my sense that the history of popular movements, in Southeast Asia and elsewhere, is to be understood not only through reference to economic factors and overt ideological conflict but through an analysis of precisely these kinds of inadvertent convergences: through a reading of the processes by which crowds become collectives and singular events are generalized in the narration of history.[21] Here, however, I want to pose the question of a possible relation between the imageries of the king and the pictures of the dead, between the portraiture of power and the depiction of force, which is to say power's failure. The question that frames this entire essay is, indeed, whether there is a logic and not merely a spatially and technologically overdetermined sequence that links these two moments in the histories of both photography and power.

When the conflict of 1992 was ultimately resolved through the national broadcast of photographs featuring General Khraprayoon and his populist opponent, Bangkok mayor Chamlong Srimuang, at the king's

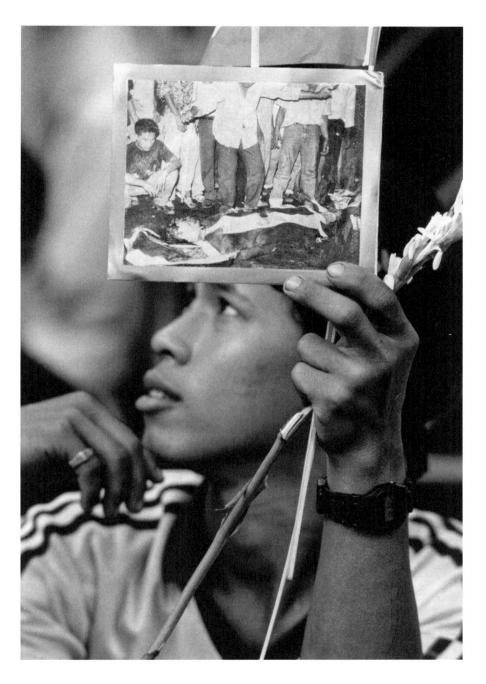

5. A protestor holds a photocopied photograph of a slain activist during street protests against the military junta, 1992. Reprinted by permission of OnAsia.com.

feet, nearly everyone remarked the picture for its domestic dramaturgy (fig. 7). It was as though two naughty boys had been summoned and repudiated for bad behavior. The image was also notable for the civilian modernity of the king's appearance. No ceremonial dress asserted his position. Only his physical situation above the kneeling men evidenced his title and his prerogative. By 1992 the king was a man whose face everyone knew. His ubiquitous appearance in the popular media and in the images mandated by laws governing commercial activity seem to have ensured that his status as king would need no further visual signs. Yet monarchy always needs signs, and the news media image of King Bhumipol above the chastised generals functioned as such. What it signified was a capacity for peace, or rather, for the suspension and deferral of violence. Two men, who only days before had led hundreds of thousands of people against each other, one group in uniform and bearing the force of arms, the other in street clothes and bearing the force of their own visibility in the transnational media, sat peaceably before the king. The king's unremarkable appearance, dressed as he was in a fine suit and tie, suggested that, if the monarchy still needs to be seen, it has at last been liberated from the need for purely ceremonial frames. What enframes it now is the fiction of an

6. A protestor bears a poster showing photojournalistic images of the wounded and the dead during the democracy protests of 1992. Photograph by Peter Charlesworth. Reprinted by permission of OnAsia.com.

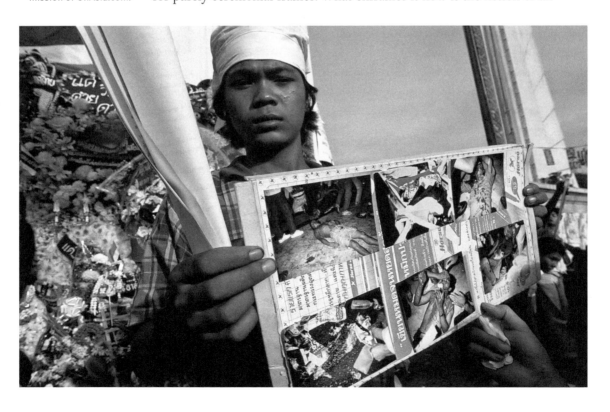

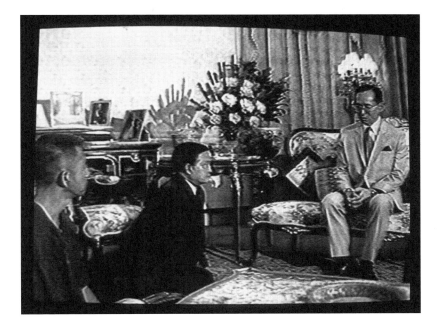

7. Gen. Suchinda Khra-
prayoon and Democracy
Movement leader Cham-
long Srimuang sit before
King Bhumipol Adulyadej
in a nationally broad-
cast, royally compelled
reconciliation, 1992.
Photograph by Peter
Charlesworth. Reprinted
by permission of
OnAsia.com.

identity between king and people. It is an immediacy made possible by
the fantasy of national being.

One is tempted to say that this possibility—of a monarch who no
longer needs to appear in regal forms to be recognized as king—is pho-
tography's achievement. But there is a limit. The king may appear in suit
and tie, the putatively unmarked attire of the man of the world, but we
can imagine that, today, he could appear only awkwardly in the uniforms
of French or Russian military men. If he were to do so, he could appear
to be a traitor to Thailand and, perhaps, an impertinent impersonator to
France or Russia. The limit is the nation, even if Thailand is no longer the
object of a king's command, but a nation represented by a king. Within
Thailand, most people interpreting the picture in response to the (real or
feigned) ignorance of the outsider referred to the photograph of recon-
ciliation as a picture of *the* king and Generals Khraprayoon and Cham-
long. Not *a* king. Not a particular person who might be substituted for
by another, but a person who is simultaneously unique and one of a type,
one who both incarnates and totalizes that type which is kingship. Be-
holding the picture that traversed the print and televisual media, they
pointed to a sovereign without comparison. And they did so because they
were at home, in Thailand, because the nation was not itself (not yet) in
question. One could hardly imagine asking "Which king?" in the face of
such certitude. Looked at in this manner, Bhumipol Adulyadej transcends

himself, just as sovereignty transcends subjectivity.[22] Such transcendence could occur because the photograph of a king functioned in this moment as an image of the king, and not merely as an index of a particular person who occupied the office in that moment. Indeed, the photograph staged and testified to that kind of person who can demand the recognition of subjects and the interruption of violence in order that his own power be conserved.

APERTURES

And yet the king's appearance above Generals Khraprayoon and Cham-long, and the photograph's arrival *after* the bloodshed, implies that his peacemaking power was absent during the unrest. The corpses and the blood that filled the streets of Bangkok, especially the regally titled Raja-damnern Street, suggest an incapacity of the king's power to sustain the peace and secure the law against a need for its enforcement. Perhaps this is because, during the protest, the king had been too generally invoked and therefore risked via his photograph. Protestors who carried the king's likeness on placards to legitimate their cause, as they commonly did, made of the image an accusation of defacement against the military (fig 8). In turn, they often actually defaced the images of the junta generals and circulated the feminized or otherwise caricatured pictures of the military men along with those of the bodies for which democracy activists held them responsible. The vulnerability of the king's image in the protest was perhaps the best evidence of its potential power, but it was both literally and figuratively contained in and by other pictures: of protestors carrying placards and of soldiers firing at them, of beatings and bodies, and of people in fear. As in the famous mirrors of eighteenth-century Dutch paintings, which duplicated the contents of the scene in a contracted form, the portraits of the king appear in these photographs as the distillation of a power in whose name the people act, but whose success and even survival depends on their own representation in images (which can then be circulated in the transnational media as the relatively abstract signs of "democracy *in potentia*") and thus as images. But the people themselves can cohere only if they identify with an image of themselves. That identification depended, in part, on the mobilization of the affective excitement that had been occasioned by the pictures of the dead and the transformation of that excitement into a consciousness of these pictures as images of power's failure. Partly, this meant that protestors and the

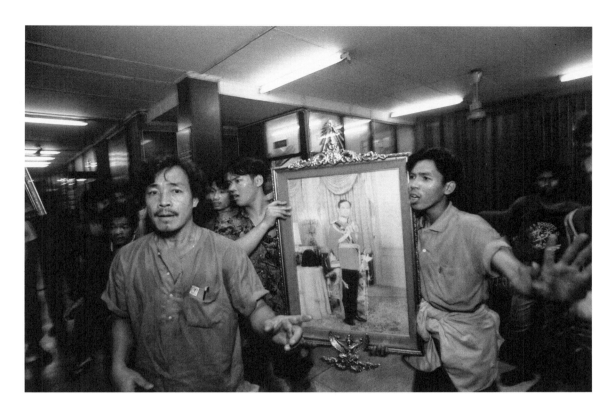

protest spectators who were not so much peripheral as a necessary exten-
sion and enframement of the movement (these spectators made up the
largest portion of the masses) were being seen from afar.

Let me explain. If global spectators, connected to this scene via CNN
and ITN, were enchanted by the spectacle of "people power," locally
many people who were not already politicized were initially as attracted
to the images of the dead as to those of the phenomenally large crowds,
and they were as little able to resist the images of the corpses as they were
able to turn away from those of the king. Perhaps less so. Many spectators
were, in fact, enthralled by these morbid pictures, which were reprinted
and photocopied, circulated by hand, put in albums, pasted on placards,
printed on T-shirts, and, of course, sold. It would, however, be wrong to
imagine that, though trafficked in ways that the king's images are also
trafficked, they possessed the same power. They were thought to have a
certain efficacy, to be sure, but this efficacy was immediate. The photo-
graphs incited rage, horror, nausea, and grief. But these are the affects
of immobility. To become something more, the pictures had to be ap-
prehended as signs of a fissure between the king and his representatives.
They did so in an odd moment of imagistic reflexivity or doubleness: by

8. Protestors bear an
image of King Bhumipol
during democracy pro-
tests, 1992. Photograph
by Peter Charlesworth.
Reprinted by permission
of OnAsia.com.

being read as both photographs, which is to say indexical traces of the event, and images, or the symbolically mediated representations of the structures within which these events could occur. Accordingly, they became the objects of both attraction and revulsion, silence and loquacity.

We often give the name of fetishism to such ambivalent relations toward images, and it is Freud or Lacan who stereotypically arrive by way of theoretical helpmeets. But it is perhaps useful to recall here that this same splitting is treated in Marx's analysis of a crisis in political representation and the farcical embrace of an antiquated imperial fantasy in bourgeois Europe. In Marx's language such crises can be understood only by recognizing the split between *vertreten* and *darstellen*, between the proxy and the portrait (or image, in the sense I elaborated earlier),[23] which afflicts not only the subject (of capital) but also class consciousness in general. That split is the corollary of a discontinuity between desire and interest, and it was the radical dislocation between desire and interest that Marx had to confront in order to grasp what baser economic determinism would find inconceivable, namely, the fact that classes often act against their own interests. In Thailand, a nation that, like so many others, lives in the shadow of revolution's abandonment, we would have to add that the perception of a split between the king and his military representatives is precisely what permits all classes to sublate their different interests in a shared desire for national unity. The king is the figure in whom and by virtue of whom this occurs—even when, as was recently the case, his function as the mediator of class difference could be mirrored and redoubled in the person of the media mogul turned representative politician, Prime Minister Thaksin Shinawatra.[24]

The democracy protests of 1992 culminated in a populist victory, and while the ignominious fall from grace that Suchinda Khraprayoon experienced was to be followed by Chamlong Srimuang's more ambiguous departure form the national political scene, the king's power was restored precisely to the extent that the people could fantasize him, once again, as their immediate and thus eminently photographable representative. The military, which had appropriated for itself a power that it was merely supposed to disseminate and guarantee, had, in effect, mobilized the substitutional dimension of representation at the expense of the signifying dimension. This act could be read by both the monarch and the common population as a usurpation, a coup not only against the elected body of representatives but, quite possibly, against the king as one who is one with his representation, his portrait. It is not incidental that the resolu-

tion of conflict should have been achieved in a photographic mode, but it is important to note that the photograph worked as an instrument of that resolution only to the extent that it surpassed itself and became an image of power, for which the king himself provided the mere form of immediacy.

AFTERIMAGES OF POWER

Not all such eruptions of violence in the space of the Thai nation have been resolved in this manner, however, with photographs providing the ground for a renewed and reconsolidated claim to power. In recent years, photographs have testified not only to a split between the monarch and his representatives, but in the idea of the Thai nation (*chat*) itself. The long history of a repression, namely, that of the difference occasioned by the presence of Muslim Thais in the southern, Malay-speaking provinces amid the dominant Theravada Buddhist, Tai-speaking population, has reached its limit.[25] Conjured by two other specters, those of Islamist internationalism and transnational narcotraffic, a politicized ethnic difference has returned to trouble the Thai monarchy's claim on representativeness and, equally important, the military's capacity to protect the king and what he is thought to represent. As in the past, the photographic record of this event has permitted a comparativist gesture to render the deaths legible in terms of other forces, and it is in the battle to negotiate which mode of foreignness will frame the photographs as images that the Thai state now finds itself so vulnerable to accusations of excessive and illegitimate force.

Let us then consider the last photographs in this selection from the visual archive of Siamese political history. They were taken in April 2004, when Thai police and drug enforcement and military agents undertook a raid in Pattani province, ostensibly to quell a narcoterrorist plot centered at the Krue Se mosque. That event led to the admitted deaths of 112 men and boys, none of whom was armed with anything more than a machete, most of whom were shot in the back while attempting to flee.[26] Pattani province, like much of southern Thailand, has been a scene of aspirations to autonomy for decades. Most of its largely Muslim population speaks a Malay dialect but is nonetheless obliged to receive education in Thai. For years residents have complained about the Thai bureaucracy's unwillingness or incapacity to recognize local needs and actualities (and, during midcentury, communists sympathized with the Muslim subjects of the

South in their efforts to evade the cultural mandates of the proto-fascist Phibul Songkram government). They have been especially opposed to the Thai government's confinement of Malay language use to religious institutions.[27]

In conservative Thai discourse the representation of local aspiration has been deeply fraught, though it has generally been written under the rubric of secessionism and in the shadow of a discourse that warns against national fragmentation and, increasingly, religious fundamentalism. Following the events of 28 April 2004 the government Public Relations Department released a report that described the militants as a "group who blindly uphold religious principles."[28] In attempting to repress insurgents in the South, the Thai state has often implied that its conflict with the Muslim states is symptomatic of a more general crisis, one with which other secular, neoliberal state powers, from the United States to Germany to Russia, might identify. When the state determined to quell what it believed was an activation and intensification of Muslim Malay political energies, it was conscious that the world, newly traversed by both American (Christian and neoliberal) and Islamist internationalisms, would be watching. Nor did its agents evade this look. And when, following the event, the Organization of Islamic Countries expressed concern about anti-Muslim sentiment and violence in Thailand, the prime minister's office dispatched representatives to Riyadh to advertise its own economic development programs in the South and to announce that it had already repaired Krue Se mosque, which the Office of the Prime Minister describes only as "an ancient religious structure and a place of interest in Pattani."[29]

Despite its generally conservative leanings and despite the fact that it is assiduously regulated by the state, the Thai media have been aggressively insistent on the necessity of revealing the campaigns against the South. Even during the assault on Krue Se mosque, photographers were taking pictures of soldiers and fleeing or machete-wielding "insurgents." Clearly, they were able to do so because they had been notified in advance of the impending confrontation. But photographic revelation is not yet explanation. In the aftermath of the hours-long assault, journalists photographed every corpse, and the photographs of these bodies appeared on the front pages of the major Thai-language newspapers along with both official explanations and justifications for the raids and editorial comments upon them. Official discourse, and much editorial opinion, maintained that the raids had been necessary to pacify a community poised

to not only wreak havoc through random violence, but to threaten national stability and the monarchy. Subsequently, this narrative was recast in the transnationally circulating idioms of global, drug-funded terrorism. Thus, the raids were said to have quashed a terrorist plot generated by heroin-addicted outlaws (the police claimed to have done chemical autopsies and found traces of heroin in the dead men's blood).

The rationale undergirding these representations is one that arises at the convergence of transnational geopolitical discourse and local political exigencies. Since 2001 the Thai government has been under pressure from the United States to keep the Muslim states under surveillance, and as early as October 2001 reports circulated among U.S. intelligence agencies suggesting that the area was a hotbed for Al Qaeda sympathy and possibly the location of one or more training camps for terrorists. The apparatus in place to effect U.S. foreign policy in Thailand is no longer the CIA, which was decisively involved in the establishment of the Border Patrol Police (and its anticommunist activities) during the U.S. wars in Southeast Asia, but the U.S. Drug Enforcement Agency. Narcopolitics has become a primary venue for ideological contest, and Thailand has been waging an intensive war against "suspected drug traffickers" since 2005, with an average of three thousand civilians killed annually by police under a procedure called extrajudicial killing (authorized by law in 1992).

Although the regimes of antiterrorist and antinarcotics policing reinforce each other, they also bespeak different interests within and different anxieties about state power. The southern provinces were placed under martial law in January 2004, following sporadic but repeated attacks on soldiers and military installations by members of a group called Gerakan Mujahideen Islam Pattani (affiliated with Islamic Jihad), even as Prime Minister Thaksin maintained the absence of any internationally affiliated terrorist groups in Thailand. For the nation-state, crime associated with narcotics constitutes a violation of the law of the state. But terrorism, it must be said, constitutes the law's repudiation. Hence, the admission of terrorism is the admission of that fissure in the nation which the king's presence is supposed to defer (and whose deferral he incarnates). One understands, then, that the construal of insurgency as a drug-related offense is an effort at containment, one that legitimates the state and the monarchy by authorizing the exceptional application of force *within* its own borders.[30]

The photographic record of the massacre in Pattani, like that of the

democracy protestors in 1992, led almost immediately to a competition between formal and informal media venues and quickly gave rise to a circuit of images. Though mediated by the market, this circuit also provided the apparatus for generalizing and transcendentalizing (if not sacralizing) the deaths of the so-called insurgents. As in 1992, the photographs implied a rupture in the rule of the land and revealed the failure of representation by documenting the literal application of force (which literalism renders everything a matter of visibility). But in Pattani the moment of resolution in and through the image of the king has not arrived. Instead, the insurgents and their supporters or sympathizers seek in the photographs of the dead the possibility of a different kind of representational afterlife. Ironically, this very possibility has a shared origin with the votive practices of viewing the king's portrait with which this essay began. Those practices became integral to the production of the king's status as one who lives even in dying. In Pattani, I want to suggest, we see the inverted legacy of a practice whose origins can be seen in the adornment of the monarch's portrait. There, photographs became integral to the production of a different kind of life in death. For some, this life in death takes the name of martyrdom. For others, it is an emblematic drive to self-representation in the form of political independence. For yet others, it is the specter of national catastrophe.

Let us turn at last to the pictures (figs. 9 and 10). These are but two images from an archive that is as dense with images as it is saturated with death. How shall we see them? At first glance, perhaps, they seem no different from those of the democracy protests of the previous decade. They are pictures, brutal pictures, of bodies in their mute bodiliness: bodies bloodied by bullets, lying in ignominious awkwardness, caught in flight and fallen as if torn between surrender and resistance. There are also photographs of walls splattered with blood, riddled by holes (archetype of indexicality), empty of even shadow. Some of the photographs depict the corpses after they have been numbered for police recording purposes; these appear to anticipate the impersonality of the morgue in which they will lie, tagged like the price-bearing commodities that they have come to resemble in a nationally capitalist regime that they now appear to threaten. The photographs themselves bear all the traces of journalistic haste. They frame their objects in a manner that resembles and repeats the framing that was undertaken in the moment of actual shooting. The angles seek the maximum exposure of the bodies, and the surfaces of the photographs are composed in a way that suggests an aspiration to

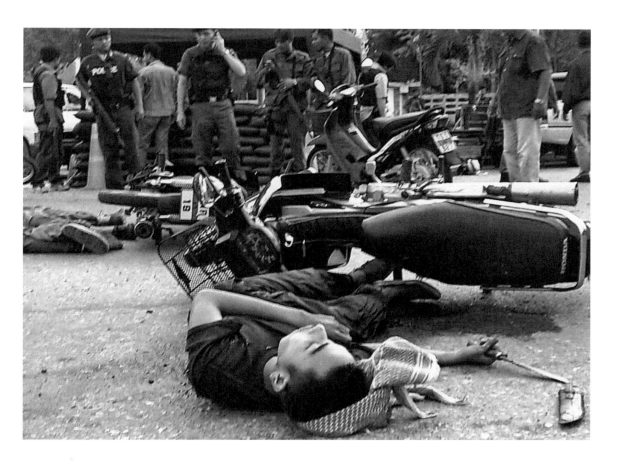

informational saturation. The police who appear in these pictures do so as much in the mode of the accountant or the surveyor as of enforcers of a failed law — as though the enactment of force was the mere distribution of law.

Moreover, in their sheer number and in the multiplicity and refinement of the angles from which they were taken, the enormous body of photographs produced by the media and the police in Pattani seems to suggest an aspiration to totality, that kind of photographic totality which Kracauer cautioned could become the ground and model of historicism without critique. Indeed, the ubiquity of these images quickly turned to near saturation of the public sphere. Unlike in 1992, when a ban on the display of photographs showing police beating protestors to death led to the clandestine circulation of photocopied pictures, April 2004 saw a promiscuous traffic in the photographs of corpses and competition among the dailies for the most gruesome pictures. Yet, despite this widespread circulation, the mosque inside of which thirty-two "militants" had sought

9. "Young militant, still holding a long knife in his hand, lies dead on a road," April 29, 2004. Reprinted by permission of *Bangkok Post*.

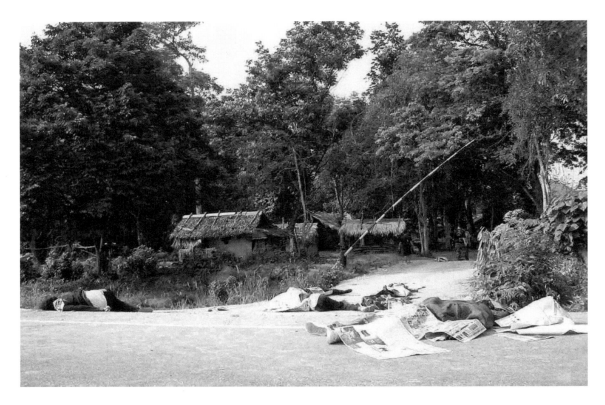

10. "Bodies of militants lie in front of a military outpost in Krong Pinong district." Reprinted by permission of *Bangkok Post*.

protection and where all had been killed also became a pilgrimage site at which photographers showed and sold images of corpses. Some of these were printed on plates and T-shirts.

The tourist rush on Krue Se mosque actually displaced the usual trajectory of pilgrims, who previously tended to visit a nearby shrine dedicated to the sister of the Chinese immigrant who built Krue Se mosque upon converting to Islam. Thus redirected by history, many of the tourists had their own photographs taken at the mosque and made a point of inspecting the bullet-pocked walls. However, when Prime Minister Thaksin Shinawatra (media mogul and figure of the mediatic era of politics in Thailand since deposed and exiled on the basis of corruption allegations) visited the mosque, police cleaned the place of photographs and attempted to shut down the quickly assembled stalls of the photograph vendors (who defended themselves by saying that they did not know they were not permitted to sell photographs of the massacre). This belated effort to quell what had become a vigorous trade in images of atrocious death was both impotent and irrelevant, given the alacrity and the enormity of the crowds descending upon the place.

The crowds, it must be said, were heterogeneous, spontaneously

gathering groups which both responded to and propelled the proliferation of pictures. They shared much with those visiting the media fairs following the democracy protests, in that they were not, at least not initially, primarily or exclusively political formations. Like all catastrophe tourists (by now a veritable genre of leisure travel),[31] they were making their bitter pilgrimages only partly in mourning. If some traveled to Pattani to experience or express their class, religious, regional, or ethnic interests, people from many different and indeed conflicting affiliations also visited the scenes of death. Their emergence as a group, whether of defenders of Pattani or opponents of the nation, of advocates for equal rights or for terrorists, will depend not only on their self-identification but on the circulation of images that can be identified with. And this circulation is eminently dependent upon the looks of those who remain distant from this place and its history. Those looks, from Bangkok and Washington, as from Riyadh and Kabul, enter the frame each time the photographs are apprehended and designated as images of something other than the now mute presence of the photographed dead.

PERSISTENCE OF VISION?

In the past, one can imagine, places like the Krue Se mosque would have been dangerous to visit. Bad deaths produce bad ghosts, hungry creatures whose rage and loneliness lead them to abduct the living in the pursuit of solace.[32] But the deaths of the militants (or perhaps simply Muslims),[33] like those of the democracy protestors, can produce specters only if conjured. The Thai state would undoubtedly like to see these pictures devolve into the mere emanations of events. As such, they would express force, but they would not represent it as the failure of power. But those who are bound to these events by nostalgia for an independent past or an aspiration to an autonomous future, and those who are bound by duty borne of solidarity with neighbors or coreligionists, want the deaths to be represented and, indeed, to become representative. It is they who conjure. But they do not conjure merely death (and they certainly do not conjure the dead). They also conjure the image of a collectivity which has not yet cohered. For only if they are actualized as an interest-bearing group can they make political claims on a regime that, despite its monarchical form, legitimates itself through electoral forms and processes. In this context, the eroticization of the dead via the photograph can serve many ends. So too the misrecognition of the crowd as a political collective can facilitate

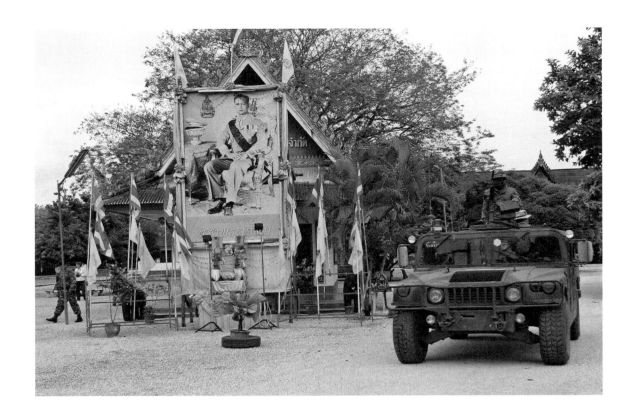

11. The entry to a temple converted into a military base is watched over by an enormous photograph of a younger King Bhumipol, 2007. Photograph by Patrick de Noirmont. Reprinted by permission of OnAsia.com.

an ironic but no less powerful representation. Just as the king exists in the perpetuity of kingship by virtue of his portrait, so the collective comes into being by virtue of its self-imag(in)ing.[34] In this sense, it matters not if the portrait is grasped with gold-dusted fingers and looked at with awe and submission or if it is purchased in a market and carried in a wallet. Or, as is increasingly the case, if this portrait stands guard above temples that double as military bases and increasingly seems to mark the boundary between territories still under royal oversight and those that exceed the monarch's capacity for encompassment (fig. 11). In each case of looking, the beholder sees the image of that which allows him or her the feeling of knowing who he or she is or is not. It may be that the failure (or at least the incomplete status) of the drive to self-representation in southern Thailand has something to do with the fact that, unlike monarchical nationalism or even the populist democracy uprisings of the early 1990s (which had Chamlong Srimuang as their personal and imaginal figurehead), the insurgency in the South has no face with which to present itself, no individual who can publicly claim to be a representative. If this is true, then

we can perhaps conclude that the persistent vision of power in Thailand depends on a kind of representative but still personal portraiture, a portraiture that became associated with the king in that country only with the arrival of photography. As King Rama IX, Bhumipol Adulyadej, ages, and as concerns about the future of the monarchy begin to reverberate beyond even the Islamic South, this long history will perhaps find a new form. Time will tell.

NOTES

1 As will become clear throughout the essay, I use the term *image* to refer to socially and historically mediated representational forms, whether photographic or linguistic. I use the word *photograph* to designate only those forms produced through the chemical and electronic processes associated with both photochemically generated negatives and digital positives. The photograph may be treated as an image, but it is often attributed an excess, or difference, which exceeds the question of representation or figuration. This excess and the force that emanates from it may also be socially determined, but it retains a fundamental ambiguity. This is because a photographic image is simultaneously indexical and spectralized in and through discourse. The term *picture* is used here rather more colloquially to designate photographs and other figures which are not yet analytically distinguished as images.

2 Barthes, *Camera Lucida*, 94.

3 Georges Coedès provides the classic account of the representational practices and histories by which sacral kingship emerged in Angkor and was then reimagined such that the king came to appear in the image of Buddha. See *Pour mieux comprendre Angkor*, especially 62. On the history of Buddhist kingship in Thailand, see Tambiah, *World Conqueror and World Renouncer*. Tambiah's analysis tends to reiterate the institutional self-representations of the clergy. A more critical history of the relationship between Buddhism and the state can be found in Ishii's, *Sangha, State, and Society*.

4 Kantorowicz, *The King's Two Bodies*.

5 For a history of the relationship between the Siamese monarchy and the religious institutions of Theravada Buddhism, see Christine Grey's magisterial dissertation, "The Soteriological State." Also see Ishii, *Sangha, State, and Society*.

6 Talbot, *Pencil of Nature*.

7 See Pinney, *Camera Indica*.

8 It is important to note that this distinction is not merely that between diegesis and exegesis, or, as Foucault would have it, between the fable and the fiction. It is, instead, a distinction that is proper to the medium as materiality rather than to the representational structures within which narrative voice operates. In *Discourse Networks 1800/1900* Friedrich Kittler makes this point with great lucidity in his

discussion of Goethe's *Faust*. Kittler is concerned with the moment in which writing becomes conscious of itself. He refers to the scene of ink spillage, when the pen produces a mark that cannot be read, and sees in it a parable of the emergence of authorship, of which development Goethe himself is an exemplary case. After this moment, the idea of writing as mere copying fails, and the fact of writing becomes an object whose elaboration and manipulation then becomes the ground of literary production, with writing lifting off from meaning and becoming its own referent.

9 There is some debate within Buddhological studies about the degree to which icons are venerated as traces or as actual presences. Bernard Faure argues that, despite orthodox philosophical statements to the contrary, "Buddhism, through its iconic and ritualistic tendency, remains an eminently concrete religion" and that "the cult of icons is characterized by strategies of presence." "The Buddhist Icon and the Modern Gaze," 768, 814. The best anthropological study of the treatment of icons within Thai Theravada Buddhism remains Stanley Tambiah's *The Buddhist Saints of the Forest and the Cult of Amulets*, which documents a practice that corroborates Faure's assertion. Nonetheless, theorists tend to take an antinomian view of the problem. Either the treatment of images is seen to be premised on a metaphysics of presence, and thus everyday practice is read as being in opposition to religious doctrine, or the tenets of religious doctrine are presumed to describe the actuality of image practice, and the investments and beliefs of those who adore the image as the re-presentation of divinity are treated as aberrations or failures. Faure himself attempts to elaborate a theory of the icon as operating a disjunction between presence and representation, iconicity and iconoclasm. In the end, he opts for a language of excess to evade the oppositional structure of the debate within Asian art history and turns to reader response theory for a less static concept of context to explain the instability of iconic effects. My position is that the opposition is a false one, and that the status of the image (as mere trace or as presence) is not a matter of context, which term implies a spatial and historical rather than performative dimension, so much as it is a function of the mediation of the image by foreignness. Foreignness is precisely what enters with the repetitious gesture of adoration.

10 An excellent account of this cult has been provided by Nitthi, "Lathipetthi Sadet Phor Rama."

11 Mauss, *General Theory of Magic*, 151.

12 In Siam, this representationalism was achieved in the form of a constitutional monarchy, installed in 1926 following a coup.

13 Marin, *Portrait of the King*. On the procession, see also Marin, "Establishing a Signification for Social Space."

14 Benedict Anderson has argued, indeed, that the history of modern Siam is one in which the constitutionalization of monarchy was followed by its resacralization. See "Studies of the Thai State."

15 Anderson, *The Spectre of Comparisons*.

16 As Marin writes in his commentary on Pascal, "Le portrait du roi, c'est le roi [The portrait of the king, it is the king]." *Le portrait-du-roi en naufragé*, 187.

17 I am conscious that this understanding of power as the mediation of force is somewhat at odds with the now popular analysis put forth by Walter Benjamin. Benjamin's analysis of lawmaking violence as "immediate" requires, as its ground and its ideal, a concept of divine violence — not only analytically but normatively. I am not prepared to endorse that particular model. It is, however, worth citing his description of lawmaking violence, both because it illuminates the principle of deferral that Marin attempts to elaborate in his account, and because it reveals the moment that such deferral is disavowed in the theorization of the political: "The function of violence in lawmaking is twofold, in the sense that lawmaking pursues as its end, with violence as the means, *what* is to be established by law, but at the moment of instatement, does not dismiss violence; rather at this very moment of lawmaking, it specifically establishes as law not an end unalloyed by violence, but one necessarily and intimately bound to it, under the title of power. Lawmaking is power making, and, to that extent, an immediate manifestation of violence." "Critique of Violence," 295.

18 Marin, *Portrait of the King*, 10.

19 Morris, "Surviving Pleasure at the Periphery."

20 My position here is clearly at odds with that enunciated by Antonio Negri and Michael Hardt in *Multitude*. I believe a historical anthropological reading of political uprisings reveals the need to distinguish precisely between the multitude (which always manifests as a crowd) and the collective. If the multitude obstructs capitalism's rationality by virtue of its very spontaneity and its amorphousness, it is nonetheless incapable of achieving any political goal. The multitude's incapacity to represent itself to itself into the future is the limit of its capacity to function in the service of the social.

21 Morris, "Giving up Ghosts."

22 It is often said, in the tradition of Carl Schmitt and Walter Benjamin, that the sovereign is the one who has the capacity to effect a state of exception, the one who can act without being restrained by law. This is sometimes construed as an absolute subjectivity or an absolute agency. The sovereign cannot, however, ever admit to subjectivity, for to do so is to admit to a location in both language and the world (and hence to a finitude that is inadequate to the force materialized in and through the state of exception). The sovereign can be referred to only in the singular but can speak of the sovereign self only in a pluralized form. In Thai, or in the regal language, Rajasap, the monarch speaks from the position of "rao," just as the English monarch speaks of the "royal we" in a gesture of impossible "self-reference," one that exceeds personal selfhood. Colloquially, we often speak of an individual aspiration to sovereignty. But this is an error, and we generally mean to imply by such formulations merely a robust and even lawless selfhood. This sovereign self, we might say, is always criminal. But the true sovereign is altogether beyond and before the law. The sovereign self is a radical subject; the sovereign is beyond subjectivity.

23 This distinction is specifically drawn out by Gayatri Chakravorty Spivak in her reading of Marx's *The Eighteenth Brumaire of Louis Bonaparte*. Spivak remarks the distinction in an effort to elucidate how Marx's theory of capital required him to

recognize a "dislocated and divided subject" and a class consciousness in which "desire and interest" remain noncontinuous. See "Can the Subaltern Speak?," 278. Here, of course, I am speaking not (only) of the subject of capitalism but of national capital and of a political system unlike that of France of 1848, save in its very ambivalence.

24 For an account of Thaksin's mediatic status and his role as the emblem of a misrecognized classlessness, see Morris, "Intimacy and Corruption in Thailand's Age of Transparency."

25 An excellent account of this relationship is provided by Thanet Aphornsuvan in "Origins of the Malay Muslim 'Separatism' in Southern Thailand." Thanet observes that the idea of separatism is underwritten by nationalist historiography's claim that the Malay provinces (he distinguishes Satul from Pattani, Yala, and Narathiwat as being relatively culturally integrated), which were annexed by Siam in 1906, were originally Thai and were only *reclaimed* by Siam, which had relinquished authority over them in an effort to stave off colonization by France and England. There is much compelling evidence not only that the Malay states were historically exterior to the various kingdoms located in Ayutthaya and Bangkok (residents are referred to in Tai, for example, as *khaek*, or guests), as Thanet rightly argues, but also that the questions which would later be rewritten under the rubric of secession or separatism were being articulated from the moment of annexation onward. In 1923, to take but one example, discontent in Pattani province became voluble enough to be a source of concern among the British administrators of the Federated Malay States, who were wary of any ethnonational sentiment that might affect people under their own jurisdiction. Correspondences from the British Foreign Office remark the Siamese monarch's efforts to placate the residents of Pattani with visits to the area but suggest skepticism about the efficacy of these perfunctory visits to achieve a sustainable peace. Records of the Colonial Office, CO 717/31 (3 May 1923); Foreign Office Letter Books 40/791 (4 April 1923).

26 There is some dispute regarding this number. As in all such conflicts, official estimates (of thirty-three militants and three police officers) are lower than those reported in the press.

27 This demand that Malay be spoken only in religious institutions (parochial schools and Mosque-based social organizations) betrays a conflation of ethnic and religious identity, for instruction in the Koran is undertaken in Arabic, and Malay is the language of everyday discourse for a population that shares its language with the other inhabitants of the Malay Peninsula and significant portions of the Malay Archipelago. In effect, Thai policy attempts to obstruct the possibility of Malay becoming the basis of a second public sphere, and hence of a split in the national body politic. Ironically, the Thai government now regrets the autonomization of religion.

28 Following the receipt of an investigative report into the incident, the Thai government released a statement that described the surviving insurgents, who are said to have surrendered, as fanatics: "The violent incident resulted in three police and

military officials killed and eight others wounded. As for the militants, 32 were killed and three gave themselves up to the authorities later. This group of people was found to blindly uphold religious principles." "Krue Se Investigation and a Census in Three Southern Border Provinces," Statement of the Public Relations Department, Office of the Prime Minister, Bangkok, 4 August 2004.

29 "Explanations of the Southern Situation to the Organization of the Islamic Conference," Statement of the Public Relations Department, Office of the Prime Minister, Bangkok, 4 March 2005.

30 The formal legitimation of extrajudicial killing and the police actions in Yala and elsewhere seem to suggest that Thailand is becoming, if it has not already become, a state of exception, in the sense developed by Benjamin, Schmitt, and, most recently, Agamben. However, this exceptionality is unevenly distributed, and there remain legal avenues for investigating and incriminating official abuses of power. Various countercorruption commissions, electoral surveillance bodies, and a still robust culture of investigative journalism sustain a critical opposition. Though extremely small and relatively tame compared to that which existed in Thailand in the 1960s and 1970s, there is reason to hesitate before invoking, as is so common today, the "state of exception."

31 I include in this category those who visit such sites as Ground Zero in New York and the battlefields of Gallipoli and Flanders and those who seek the thrill of proximity to violence in hotspots around the world. To be sure, some such visitors have direct or indirect experiences of loss associated with these places, and others make such visits the ground of a historical pedagogy. But however motivated by mourning or nostalgia, these journeys also express an affective investment that exceeds instrumentality.

32 This belief is widespread throughout Southeast Asia and continues to be held by many Thais, including those who profess and enact commitments to secular rationality. The belief in ghosts is not merely a vestige of a bygone era or an intransigent obstacle to scientific rationality. It is the expression of grief and the recognition of the aftereffects which memory of the dead exercises upon the living. To be sure, such ghosts imply a temporality that exceeds the time of rationalism, erupting as they do from the past into the present. But their arrival is generally seen as exceptional, and the melancholy they incarnate is invariably assuaged by ritual or psychologizing interventions.

33 It remains unclear whether all or any of the boys and elderly men killed in the confrontation were indeed militant aspirants to ethnoreligious autonomy. Machetes are carried by many rural men for farming purposes and are not, in themselves, indicative of militarism. Moreover, such arms are wholly inadequate to the task of political violence. Other scenes of separatist violence have been marked by the use of explosive devices. As for the possibility that the mosque was the scene of such organizing, the evidence that has been made public is extremely thin. In this context, to speak of the potential for politicization is not yet to assume that such politicization would occur, or that such politicization would necessarily tend toward autonomization.

34 To be sure, this process entails labor beyond that of mere wish fulfillment. It requires pedagogical investment, organizational labor, monetary resources, and institution building. I include this labor under the rubric of self-imaging, but here, in a consideration of photography, I focus more narrowly on the moment of self-representation that is most literally a matter of self-imaging.

PATRICIA SPYER

In and Out of the Picture

Photography, Ritual, and Modernity
in Aru, Indonesia

Several months before I first took part in the annual ritual of a pearl-diving community on Barakai Island in Aru, southeast Moluccas, "tradition" itself appeared to insist that I participate.[1] I had expressed this desire before, but had been met by wariness and repeatedly kept at a distance. On this occasion, the very tradition that my own presence threatened beckoned me to enter and bear witness to that which, in Aru, is continually under erasure. This, at any rate, was the interpretation that took hold after I was startled one night while returning from the outhouse by what I took to be a bare-chested man standing quietly near my home observing me. Not long after, I reassured myself that lack of sleep and lack of contact lenses had provoked the apparition and began dozing off again. When a gust of wind swung the shutter of my bedroom window open, causing it to clatter loudly against the side of the house, I awoke again. Startled, I screamed.

In the light of the following day and days thereafter, my muted, doubtful, and somewhat embarrassed description of what by then I insisted I might *not* have seen took on its own life. A divination arranged by my Bemunese family revealed that an ancestor had called on me. The diviner read my own tenuous sketch of a stocky, bare-chested man emerging from behind a bush in customary terms. The man was not merely bare-chested, but attired in customary garb, dressed from the waist down in an ancient "leaf loincloth." As the interpretation of the haunting went, this apparition from an Aru elsewhere had materialized to transform my frequently expressed wish to take part in the annual ritual into an obligation to participate, observe, describe, and record it. Nor, incidentally, was it all

that uncanny that dead custom had called. Bemun's ritual is, among many other things, a kind of mortuary ground from which all those who died during the preceding year are dispatched. Moreover, my own exhaustion and jittery nerves were themselves the result of having watched over, during successive nights, with other women and a handful of men, the last pains and fears of a dying woman.

How to account for the insistence with which tradition beckoned me to participate, when at every step such participation was itself hedged by doubts — doubts provoked by the pervasive sense that such participation itself represented a threat to tradition? Each step along the way demanded offerings and assurances to momentarily dispel the renewed misgivings. Of particular concern and a site of special restriction were the forms of mechanical reproduction — or what Samuel Weber in his reading of Benjamin more precisely translates as technological reproducibility[2] — that I wielded as an anthropologist: a camera and a tape recorder. In this essay I ask why the camera and, by extension, photography as an uncanny mode of representation, which inserts an elsewhere into the present and lingers as a relic or material trace, were seen as especially problematic. In so doing I look at the different framings which Bemun's performance and photography install and at the techniques of inscription, materialization, memorialization, and representation through which these are deployed, realized, and, relatedly, unhinged.[3]

I also trace the convergences and crossings between these disparate techniques — taking seriously, in other words, the desire of Aru tradition to be inscribed by and for an outsider and according to the terms dictated by mechanical reproduction. I aim to complicate the very notion of framing by taking the nervous, indecisive oscillation between participation and prohibition, absence and presence, and even tradition and mechanically reproduced modernity that informs the ritual's unfolding less as an index of a radically divergent and defensive performative logic than as something that issues from the political and historical specificity of Aru's ambiguous position in modernity.

ARU FRAMES

In the southeastern extreme of the Aru Islands, shading into the shallow seas rich with the trepang and pearl oysters for which this archipelago has long been known, Barakai Island is remarkable even in this setting for its centuries-long intensive involvement with trade, especially in luxury

products, for the entanglement of its inhabitants in long chains of commerce and communication, and for the related requirement placed upon them to engage and make the most of the shifting terms of global fashion and demand. Yet notwithstanding such dynamics, Aru is also peripheral with respect to the regional and national centers of power and knowledge, as suggested, for instance, by its official governmental definition in the mid-1990s in terms of a surplus of "communities left behind" (I. *desa tertinggal*).[4] It is also populated by people with a darker complexion and less education, generally perceived as "primitive" even in comparison with their Moluccan neighbors immediately to the south.

This is not the place to go into the structural conditions and complicated discursive histories that have made Aru what it is today.[5] Suffice it to note here that one privileged way that the men and women of Bemun, one of five villages on Barakai, have of situating themselves and negotiating the larger world around them is with respect to what I have described, drawing on their own pervasive terminology, as the two elsewheres of the Aru and the Malay or, in the indigenous Barakai language, *gwerka* and *malayu*. Rather than a foundation for the emergence of a sense of community or even multiple communities, the Malay and the Aru—respectively a gloss for the beyond of commerce, state, and church with respect to which Aruese do not feel entitled to full citizenship and a designation for custom's ever-receding space apart[6]—are figures of entanglement that are continually repositioned vis-à-vis each other and thus never achieve a singular, fixed, and stable form of imaginary identification. If more everyday circumstances offer Bemunese ample occasion to entertain and plot their fraught and fluid relations with these elsewheres, this highly fissured construction of their place and possibilities of communication within a larger world is staked out and radicalized once a year during the community's ritual.

Held at the transition from the east to the west monsoon to open the diving season and commercial trade in marine products at island stores, Bemun's "cassowary" performance turns upon the ritual work of extracting from the messy space of the everyday a "Malay" outside, with the aim of summoning forth an autochthonous and traditional residue that by contrast is designated the "Aru." It is through an elaborate and laborious process of framing set in motion during the very first of the three parts of the ritual that the cassowary—a furtive, ostrich-like bird native to New Guinea and the neighboring islands—is drawn to the community to reside briefly in its midst as the celebrated emblem of an ancestral Aru past.

The very possibility of this spirit's transient, elusive, and mobile presence at the center of the community hinges upon the objectification of an "external" Malay sharply set off against an Aru "interior," or the radical demarcation of a difference between malayu and gwerka.

As in Samuel Weber's illuminating reading of Derrida's essay on the *parergon*, the Malay frame serves in the ritual as the enabling limit and, by extension, the precondition for the emergence of the Aru.[7] Hence also, as we will see, the dynamics of Bemun's ritual in which all the initial effort is devoted to the production of a malayu frame or outside, which thereby gives Aru "custom" a recognizable contour, shores up the process of selection and criticism out of which the current cassowary ritual emerges and enables the annual rapprochement between Bemunese and their ancestral Aru past. As a parergon or hors d'oeuvre, the Malay, in contrast to the Aru, which has no existence apart from its annual contingent evocation, has a materiality of its own — a materiality, moreover, which allows the Aru to assume form and quite literally, in Weber's terms, to *take place*. To paraphrase Weber again, the Malay frame operates as that *other* which delineates precisely where the Aru *stops* and thus also where it *begins*.

Put simply, the annual ritual has three distinct parts which each have their own name. The first initiates and partially installs the separation of the Malay from the Aru in the context of, among other things, a fish poisoning held at an estuary. The second, core part of the performance lends the entire ritual cycle its name, "doing the cassowary" (B. *dai koder*), and revolves around the celebration of the autochthonous Aru in the form of the cassowary, with respect to which Bemunese assume the role of their ancestors. During this performative core the real cassowary native to the dense forests of Barakai's interior, together with other game animals, is the object of a communal male hunt that is carried out during each of the successive days (three to five days, depending on specific, ritually ordained circumstances) of this centerpiece of the ritual. At night all the members of the community engage in a danced version of this pursuit, when they track the Aru spirit's palm-frond effigy down the pathways of the village. Crucial to the radical separation of an Aru core from an externalized Malay is the participation of *all* Bemunese in their annual performance. Nonparticipation — for whatever reason — is consequently styled "gathering palm fronds," in this manner crediting nonparticipants with actively contributing to the production of the ritual's core emblem, the cassowary in its palm-frond effigy form. In so doing, even nonparticipation is circumscribed within the construction of a seamless Aru totality.

The nocturnal "hunt" of the cassowary effigy culminates in the Aru spirit's successive "killing" and, at dawn of the concluding night of the ritual, his banishment to the far uninhabited side of Barakai for the remainder of the year. In the third part of the ritual the Bemunese community reinstates its relations with the Malay through a large-scale communal distribution of white plates at named land and sea places that locally consolidate territorial claims and are of significance to pearl diving. Marking the location of important guardian spirits of the community, the white plates are also described as down payments for the pearl oysters that Bemunese men hope to gather during the trade season opened by their annual celebration.

At the core of the ritual, the Aru space-time with its cassowary emblem emerges through a double movement, characterized, on the one hand, by a general opening up of the community and the individual men and women who compose it to the dead, to memory, and to their imagined ancestral past and, on the other, by the objectification of the Malay under the rubric of the "prohibited" (B. *momosim*). Taken together, this double movement installs the experiential and performative parameters of the cassowary core to the annual ritual. Concretely, it is tracked in the progress of the cassowary spirit as he approaches the village, concealing himself in one marked place after another—at the head of the estuary where the fish poisoning is held, in an overgrown patch on the outskirts of the village, and so on—and in the alterations in appearance and disposition of Bemunese men and women as they approximate this spirit's space-time by adopting the guise of their ancestors.

The Aru surfaces out of, first, a displacement of the authority of the Malay language (B. *mala lir*) by Aru speech (B. *gwerka lir*) and by the breaking open of a space for the Aru to emerge. The entire ritual cycle is opened by the Prow, a "customary," or *adat*, official who initiates all the important action of the ritual and who operates in tandem with his counterpart, the Stern, who by contrast marks the endings of performative actions. It is through the concerted structuring of their actions, a repetitive tacking back and forth between beginnings and endings, that Bemun's coordinated communal endeavor is framed as a boat journey subject to particular hazards and risks, the subsequent arrival of the ancestors from an indeterminate "outside" Malay elsewhere to Barakai, and their killing of the first autochthone they see in Aru—being, of course, the cassowary. Note that the Prow and the Stern, whose houses at other times of the year mark the front and rear extremes of a symbolic boat anchored at the center of village space, become mobilized as beginning and

ending during the performance, demarcating thereby, to recall Weber's formulation, precisely where Aru custom *stops* and thus also where it *begins*.

When, as it is put, the Prow "walks" for the first time, dressed at this opening moment of the ritual alone and therefore anachronistically in the loincloth of an Aru past, he does so after having first "piled up the words of the sacred" and in order to call the men of Bemun together "to speak" on the first of three marked occasions. The content of this speech is less important here than its special marking as Aru and the fact that the men who gather at Bemun's center remove their shirts so that, I was told, the ancestors who also attend this meeting will not be startled and fail to recognize them. Rather than the dead, it is the living who at this moment should be startled, as, indeed, many claimed to be when, on one of several possible nights, the Prow hangs a lantern beside the door of his house to announce his "walk" or round of the village to summon the men to "speak." Since the Prow's walk should occur unseen and uninterrupted by encounters with his fellow villagers and since he is escorted by the ancestors, whose guise he assumes, the surprise of this opening is meant to elicit a response not all that different perhaps from my own startled encounter with tradition. Ideally, with the suddenness with which the night overcomes the day in the equatorial tropics, the Prow emerges in ancestral dress and makes his round. As I have argued elsewhere, his entry has the effect of staging a minor coup that transgresses and disrupts the space in which he moves, thus making way for something radically different.[8] In de Certeau's terms, this kind of artful ploy "*makes* a hit ('coup') far more than it simply describes one; its force lies in the effect it has of seeming to elude present circumstances through the creation of a fictional space — a space, as it were, of 'once upon a time there was. . . .'"[9] I have gone on at some length to foreground the shock and implicit violence with which tradition erupts upon the performative scene, the uncanniness of a lone — and, at this moment, anachronistic — apparition from the past, and the uneasy, charged, and somewhat abrasive conjuncture of tradition with otherwise everyday Barakai circumstances. I will return to these issues at the conclusion of the essay.

Besides the mild shock that most Bemunese say they experience when the Prow walks, the visits and offerings that families and individual men and women make to the graves of their dead in the late afternoon before the cassowary hunt begins are aimed at instilling an attitude corresponding to the space of "once upon a time." As the spirit's presence in the vil-

lage was felt to be imminent, many Bemunese became pensive, introspective, and sad. When this happened, they invariably claimed to be troubled by what conventionally at this time both men and women described in Indonesian as "long" or "far-reaching thoughts" (I. *pikiran panjang*) that concretized themselves as memories and longings for persons either dead or otherwise absent. If, taken together, the "coup" of tradition and the "long thoughts" of a nostalgic, memory-oriented pensiveness open a space for the play of once-upon-a-time and set the experiential parameters of the ritual, this Aru-marked space materializes against the thicket of bans and prohibitions that are erected against Malay contamination only on the morning that the cassowary hunt begins.

What is selected as worthy of representing the residual category of Aru custom that remains once the Malay is bracketed by prohibition is the result of the play in present-day circumstances between current foci of attention and the need to condemn to oblivion certain memories, experiences, desires, and forms of action, as well as the specific history of the celebration's past inclusions and exclusions. It follows that this Aru space comprises things that should be forgotten or, alternatively, that provide an inverse reflection of issues demanding attention on Barakai and causing concern in the context of the more everyday, more Malay lives of Bemunese—things such as language, trade, religion, and clothing. At least religion, to which Bemunese and other pagan Aruese were forcibly converted in the mid-1970s, is a relatively recent concern, while the others singled out in the performance have assumed varying contours under changing historical conditions. An inventory of the objects, artifacts, activities, and spatiotemporal arrangements of the ritual suggests that these are already preselected and configured according to the standards of perception, the politics of memory, and the prevailing concerns that inflect daily life on Barakai Island.

What does an inventory of the Malay as it is objectified under the rubric of the "prohibited" (B. *momosim*) in the ritual reveal? Given, as I sketched above, that the first onslaught of the Aru against the Malay is waged in the domain of language, it should not surprise that the Malay language is prohibited, or momosim, during the ritual and targeted for special attention. Besides the prohibition on speaking what linguists call Aru Malay, the written signs and vehicles of the national language, Bahasa Indonesia (with Aru Malay simply mala lir or "Malay language"), such as books, notebooks, paper, pencils, and pens, are all momosim. So too are the artifacts of print capitalism in the primarily popular form these take in Aru.[10]

In preparation for their celebration Bemunese clear their houses of all the wall hangings with which Moluccans across the province often decorate their homes: calendars of bikinied Asian beauties advertising stores in Dobo, Tual, Ambon, or Surabaya; posters of film and rock stars; calendars, crosses, and colored prints depicting religious scenes obtained by Catholic Bemunese from church representatives; and the odd photograph taken by a missionary, trader, or myself.

Not all these items fall exclusively under the prohibition against mala lir; the calendars advertising stores also overlap with the prohibition on any association with traders or commercial activity, while crosses and the like are also prohibited due to their link with custom's (I. *adat*) sometime rival, religion (I. *agama*). Along with the Malay language, trade stores and commercial transactions, religion, government or any reminder of regional, provincial, or national state presence, "Malay" clothing introduced to Aru by traders, Dutch colonizers, and missionaries is excluded from the space of the performance and stored out of sight with the other material artifacts mentioned above. From early in the morning that the hunt begins, Malay clothing, including any shoes, sandals, or thongs, as well as all curtains and cloth coverings that serve as doorways in homes, are taken down and put away for the duration of the ritual. At the request of Bemunese, the traders who live in the village also remove all curtains from their windows since these are visible from outside.

While each of these prohibitions comes with its own complexities, the one on Malay language bent on banishing all its sounds and signs is part of a more general refusal of inscription — in the narrow sense — that surrounds the figure of the cassowary and, by extension, the Aru. Beyond the circumscribed parameters of the Aru core to the annual ritual which culminates and concludes with the sending away of the autochthone's effigy, mentioning the cassowary or speaking of his celebration is actively discouraged, regarded by most Bemunese as risky, and rigorously observed. Singing or even humming the "Cassowary's Song," held to enumerate all the main attributes of his celebration, is strictly forbidden at other times of the year and is heard here and there in the village, whistled or hummed softly, only following the fish poisoning. All the objects with which the spirit is associated, such as loincloths, bells, and a special set of bow and arrows, are also hidden away. I was told that any questions I might have about the ritual should be asked while it was still in progress, specifically before the distribution of white plates that reopens Bemun to the world of trade and commodity circulation and preferably even before the

cassowary is sent away to his home deep in the Barakai forests. Nor was I allowed to carry around the pocket-size batik notebook and pen that accompanied all my activities in Aru; only after a substantial offering of plates and betel at the altars of the Prow and Stern was I permitted to take notes on the performance—but then only out of sight in my own room behind closed shutters and doors and only *in the Barakai language*.

Regarding the two forms of technological reproducibility that I wielded as an anthropologist, a camera and a tape recorder, I was permitted to photograph the cassowary and record his song, which animates the nightly dancing behind the effigy, only immediately before daybreak on the concluding night of the performance. This is the time when the final collective act of mourning for the villagers who have died since the previous year is accomplished with ablutions of palm oil poured out at the feet of the palm-frond effigy when he stops for the last time during his nightly round of the village at the house of the deceased. Equally important, this act of consubstantiation—through which the dead are materially subsumed in the effigy and thereby also within a soon-to-be-banished ancestral past—takes place immediately before the final "killing" of the cassowary and with it the erasure of the Aru spirit until the following year. What is more, the night of the concluding day of the ritual (during which the men have hunted the real animal for the last time) is already marked by a reorientation toward the Malay. Not only are spectators from the neighboring Barakai communities and, at least in theory, other outsiders allowed into the village for the first time since the hunt began to watch the singing and dancing of the ritual's concluding night, but other procedures have also relaxed some of the most stringent of the cassowary's prohibitions.

The timing of the narrow window of opportunity made available to me for taking photographs and recording the cassowary's song was crucial; it took place against the backdrop of the shrill wailing of the mourners, the cries announcing the spirit's imminent departure, and the tightening of a whirling circle around the effigy as Bemunese anticipated and prepared their ritual's culminating moment, in which they down the cassowary in a hail of palm-frond spears. This timing was of the essence for at least two reasons. First, as noted above, a reorientation toward the Malay had already been set in motion on this concluding day of the cassowary core of the ritual, allowing, among other things, some outside spectators into Bemun. Second, the violence which I believe many Bemunese identify in this context more than any other with the camera was brought in con-

juncture with their own intent to kill the cassowary.[11] Seen in this light, the violence of camera against cassowary prefigured the Aru spirit's own killing as itself the prerequisite for engaging in the Malay world of trade, religion, Indonesian citizenship, and technological reproducibility.

Put somewhat differently, it would seem as if the camera could be admitted into the space-time of the performance and the cassowary thus potentially made fleetingly present only at that precise moment when his absence and the silence surrounding this Aru emblem was about to be installed for the rest of the year. The moment when a snapshot could be taken coincided with the moment when the confrontation between the Aru and the Malay had been virtually decided in the latter's favor. Again, and importantly, it also took place within a more general setting of spectatorship. Recall that it is only on the concluding night of the ritual that spectators from neighboring villages and the odd government official who may happen to be around are admitted into Bemun as spectators of the "cassowary's play." Only on the concluding night as well does the cassowary procession stop in front of the houses of Bemun's Chinese Indonesian traders, who have been largely confined to their homes during the preceding days and emerge now with drinks and sweets for their fellow villagers and, importantly, trade store clients.

IN AND OUT OF THE PICTURE

Let me consider now more closely why the cassowary cannot be photographed — or, more precisely, why he could be photographed only when his exile was already impending. If, as Eduardo Cadava maintains, "citation" may be understood as "perhaps another word for photography," then given all I have said so far it would seem that the cassowary cannot be photographed because he is not made available for citation. Rather than being representable, reproducible, and serializable, such as is characteristic of the citational structure of photography,[12] everything in Bemun's ritual operates against this kind of inscription, attempting to ensure instead that the cassowary remains permanently out of the picture. Relatedly, I have intimated how the ritual, in instituting a reified Malay parergon offset against a starkly delineated Aru (although, in practice, all kinds of "seepages" occur between Aru and Malay which then require offerings to rectify them), ideally brings into being a kind of hypercontext, seamlessly folded upon itself and admitting no outside or remainder. Once the cassowary is sent away at dawn on the last night of the performance, the

silence that conventionally surrounds him is supposed to be in place until the following year. With his artifacts stored away and any reference to him, including mimicry of his dance or singing his song, prohibited, the Aru that in Bemun's performance annually is writ large is, for all practical purposes, under the sign of a stringent erasure.

Put otherwise, one possible take on Bemun's annual ritual is as a staging by Aruese themselves of the drama of their own historical erasure. It is worth recalling that, as with so many other peoples who inhabit the frontier spaces of modern nation-states, the price they often must pay for some kind of place therein is a forgetfulness of their own past and an exile into oblivion of specific condemned or suspect practices. Seen in this light, Bemun's annual ritual is one way of dramatically engaging this dilemma. Indeed, in Bemun as well as in the other four Barakai communities, the term "casting off" (B. *detebeen*) describes the process of giving up and distancing oneself from certain practices seen by the islanders and perhaps even more by others as "backward" or "primitive." Select aspects of the cassowary ritual have already been "discarded" in this fashion, yet when I participated in 1986 and 1987, it still included a number of potential candidates for such erasure. Notwithstanding the perception of such pressures from without, in annually conjuring up, summoning, celebrating, marginalizing, killing, and then exiling their imagined ancestral past, the community of Bemun claims for itself the power to remember and forget, to make certain things appear and disappear, as well as the prerogative of dispelling the Aru in order to engage in the Malay.

Beyond this politics of memory and representation and the related problem of circulation and "out of context" citation of the Aru, as well as the issue of who controls it, the violence of the photograph—in addition to that of the camera—deserves closer scrutiny. Recall that in the closing moments of the ritual, immediately prior to the killing of the palm-frond cassowary, the death-dealing characteristics of the camera were harnessed to the task at hand. Admitted only at the ritual's conclusion, the camera's flash immediately prefigured the cassowary's violent expulsion from the community and therewith the reinstatement of Malay hegemony. Regarding the photograph rather than the camera, as theorists of photography often note, the former signals an interruption, arrest, or fixation of historical movement, ritual process, or the thickness of experience in motion.[13] Along these lines, photographing the cassowary might be described, in a striking if unwitting correspondence to William Henry Fox Talbot's characterization of the technology, as "the art of fixing a

shadow," in the sense of arresting something that in essence is transitory and fleeting.[14] Beyond the autochthonous spirit, even the material effigy of the cassowary is assigned such qualities, as when Bemunese conventionally refer to it as "the cassowary's shadow."

At many different levels, too extensive and complex to go into here, Bemun's annual ritual sets up a carefully balanced tension between absence and presence, visibility and invisibility, distance and proximity vis-à-vis the cassowary. Yet if Bemunese banish the elusive cassowary rather than arrest him, as in a photograph, there is nevertheless a striking similarity, ontologically speaking, between this core emblem of the annual performance and photography itself, as I elaborate below. If the spirit's arrival in the community calls up all kinds of absences and memories that are normally kept at bay and that count among the most poignant for Bemunese, his own presence among them is always haunted by the fact that from the start he is doomed to again disappear. Thus, his nightly procession, an echo of the hunt that takes place during the day, quite literally begins as a game of hide-and-seek. Once the effigy of a given night has been completed and the man who first wears it puts it on, the cassowary runs to hide in an overgrown area on Bemun's outskirts, where he is tracked and routed by villagers who occasionally bark in imitation of hunting dogs. Even when the spirit materializes in the elusive "shadow" form that his effigy for Bemunese assumes, his presence is already haunted by absence: the cassowary's play enacts a drama of presence and absence as the effigy engages and eludes the villagers who, all the while dancing and singing his song, pursue, track, and taunt him with their palm-frond spears and, at the closing of each successive night, "kill" the effigy. In this way, the cassowary's furtive presence always conjures the futurity of his absence, thereby hinting also at the larger strategies and powers in Aru and beyond that will to erase, marginalize, and banish all that of which he is emblematic.

As opposed to this animated ambivalence of coming and going, arriving and fleeing as a movement which, among other things, enacts the Bemunese position with respect to the Malay — a subjectivity best instantiated by what I have elsewhere called runaway topographies[15] — a photograph of the cassowary signifies precisely this movement's interruption or arrest. In this respect, a photograph would short-circuit the ambivalent animatedness of the Aru emblem that is so central to the dynamics of the ritual and constitutive of the very way that the cassowary as simul-

taneously a spirit and a material artifact invests the performative scene. Lingering on as a relic beyond the Aru space-time of the ritual, the photograph and the technological reproducibility with which it is linked would in principle concretize as Malay a decision that Bemunese annually claim for themselves: that of summoning and embodying their Aru tradition and then banishing it, along with their recent dead, their ancestors, and the host of memories that cluster around the community's annual celebration.

Termed the "cassowary's shadow" or the "cassowary's skin," once the palm-frond effigy is animated by the adult men who don it by turn, the dancing shade fuses with the Aru spirit's heat, power, and energy. Importantly, this also means that the effigy is never entirely separate from the cassowary himself, just as, being a materially dense artifact, its effect is not distinct from the plastic form through which the spirit materializes nor from the procedures or the persons who produce and wear it. Describing a similar process for archaic Greek idols known as *xoanan*, Vernant argues that the power of these idols was inseparable from the processes through which they were made visible and present. Following this "presentification," the representation of the idol could never be wholly separated from the ritual actions directed at it: "Embedded within the ritual," Vernant writes, "the idol in its plastic form has not reached full autonomy."[16] On the one hand, the cassowary effigy is not entirely separate from the animal tracked in the forest; indeed, how could it be, given that the spirit returns with the hunters from the Barakai interior to animate the effigy they produce? On the other hand, he partly fuses with the men who take turns bringing the spirit to life when they dance and wear the effigy.

In ancient Greece, as Vernant describes it, a full-fledged auratic presence emergent out of a dense network of actions, persons, and materialities was at stake. By contrast, in Bemun, this process of auratic "presentification" is, as it were, hollowed out from the start. Among the many things which operate in productive tension with and undermine the cassowary's presentification are the repeated emphases in hunters' tales on the difficulties they experience in tracking the ever flighty cassowary and the repetition of this dilemma in the nightly drama of hide-and-seek which lends Bemun's ritual its characteristic form. As opposed to a full-fledged aura, the cassowary's evasive, mobile presence constantly recalls his own impending absence at the same time that it also conjures the most

intimate losses, memories, and loved ones of the past. It is, among other things, this play of animated materiality that a photograph of the cassowary would interrupt and short-circuit.

Along with the status of the cassowary performance as a hypercontext held to be sufficient to itself, as destined neither for representation, reproduction, nor serialization, the play of absence and presence on which it turns, and the animated materiality just described, we should not forget that the ritual is meant to receive, honor, and then, crucially, send away the dead. This in turn involves specific techniques of memorialization which, along with these other aspects, appear to make the celebration incompatible with or at least uncongenial to photography. As suggested earlier, Bemun's ritual installs an Aru memory space which is at one and the same time a mortuary ground. If you recall, it is exclusively at this time of year, following a visit to the graves of their dead relatives, which also extends an invitation to them to participate in the annual event, that many Bemunese are troubled — quite spontaneously, it seemed — by what they conventionally cast in this setting as "long thoughts" or pensiveness and nostalgia in the form of recollections of persons dead or simply far away. One noteworthy feature, incidentally, of such long thoughts is their promiscuity or tendency to stray far and wide, seizing on such non-Aru characters as ethnic Chinese, Butonese, and Buginese traders or bounty hunters, or others marked as decidedly Malay. This promiscuity of long thoughts only underscores how globalized, in many respects, Aru is, including Aru custom. It also suggests how difficult it is in the context of the ritual to bracket the Malay, how, again and again, the Malay erupts and spills over into the Aru, and how much of this, in turn, leads to a fortification of Aru custom which materializes as a surplus of offerings of white plates. Indeed, my friends in Bemun sometimes remarked that their annual ritual would be the time when my own absence would be felt most — yet another example of both the inherent porosity that inevitably and necessarily characterizes their annual rendition of the Aru and the memory work that animates the ritual. Yet notwithstanding such promiscuity of memory and imagination and though Bemunese men and women assume the guise and behavior of an imagined, ancestral Aru past, dance, eat, drink, and celebrate the cassowary alongside their ancestors, and are hemmed in by memories of the dead and absent, they also aim to banish all this at the end of their performance.

Siegel has remarked that what Freud called the work of mourning takes a long time in the West, whereas in Java such prolongation is avoided.

There funeral photography operates as an agent against memory, as a way of fixing the person in the image of a dead person, thus foreclosing the possibility of engaging with memories of him or her while alive.[17] While mourning in Aru is not avoided in this sense, it has its own specific time frame and should not be prolonged. The cassowary who subsumes the dead in the final collective rites of memorialization should also, in other words, carry them away. Although hauntings inevitably happen, his exile is intended to ensure that the dead will not return. When the dead *do* return, as in my own encounter with tradition, it is to trigger a memory. Relegated to the past, the dead arrive as a mnemonic to recall a voiced desire, to remind the living that offerings have been neglected, that a cement grave remains unfinished, and so on — in short, that obligations to them have been forgotten or remain unfulfilled. Yet just as the arrival of these dead is unexpected, so too are their desires often unclear.

Such visitations are disturbing and often violent; experientially these returns that erupt unanticipated into the present from a past elsewhere produce shock of various degrees and import. In everyday life on Barakai such hauntings of the living by the dead cause concern, anxiety, and, in the gravest cases, shock, which can trigger the (often temporary) flight of the soul from a person's body. My own mild shock at what Bemunese interpreted as a visitation by tradition is an example of such a disturbance, as is the more stylized anachronistic appearance of the Prow as he makes his lonely round of the village on the opening night of Bemun's performance. Indeed, at this time villagers should avoid encountering him outside their homes since, accompanied by the dead, a meeting could be dangerous. Instead, they await him in their houses on successive nights when the time for his walk is impending. Still, many Bemunese say they experience some surprise when the Prow suddenly appears out of the dark, clad in a loincloth and illuminated by his lantern, as a blast from a distant ancestral past to summon them. Sightings of the cassowary such as those which occasionally take place beyond the immediate parameters of his performance are similarly unsettling and signal his displeasure with some oversight or occurrence. Beyond such unanticipated hauntings, Bemun's entire annual performance, with its panoply of special effects deployed to instill the "once upon a time" of Aru tradition — from the "coup" that cleaves everyday Barakai life to make way for an elsewhere to, as we will see, the ritual's uncanny conclusion — can be glossed as one extended haunting. It is only, however, in those parts of the performance where the objectified Aru and Malay brush up against each other and

unavoidably inhabit the same space—especially, in other words, at the beginning and conclusion of the ritual or where the Aru begins and where it stops—that such haunting is registered in the form of shock, surprise, or even laughter.

At such moments what is fundamentally at issue is the "irreducible foreignness" of the Aru, a characterization that Rosalind Morris in this book's introduction uses to describe a prominent attribute of the photographic object. Arriving from an elsewhere much like a haunting or a coup that violently introduces something different, the photograph in all its irreducible foreignness is violent "insofar as *it fills the sight by force*, and because in it nothing can be refused or transformed."[18] Bent on figuring out the photograph's ontology and its affective impact on viewers, Barthes writes poignantly in the wake of his mother's death of "that terrible thing that there is in every photograph: the return of the dead." I have written elsewhere about the jolting "return of the dead" produced by an archival photograph that I brought to Aru of the leaders of a revolt against Dutch colonial oppression in the late nineteenth century,[19] an experience that in its recall of a dead ancestor exemplified "that terrible thing that there is in every photograph." To be sure, that experience suggested that Aruese are indeed sensitive to the return of the dead in photographic as much as other guises.

At the same time, if the photograph as an artifact is something simultaneously material and cultural and can be said ontologically to have certain attributes but also to be invariably yet every time differently contextualized,[20] then the question of semiological and ethnographic mediation and the tensions and operations that issue from it is an important one. While both the photographic object and that Aru object, the cassowary, are similarly marked by irreducible foreignness, defined by an inherent tension between absence and presence, visibility and invisibility, distance and proximity, past and present, and equally rupture the scenes upon which they intrude, a photograph of the cassowary would in another sense constitute the return of not simply the dead but a very specific mediation thereof. In this respect it would be somewhat different from the kind of mediation that the photograph of, say, a dead loved one makes possible. And it is here, perhaps, that the specificities of one form of material inscription versus another especially come to the fore. Unlike the Wintergarten photograph of Barthes's mother as a child, a photo of the cassowary would not, beyond that very general sense characteristic of all photographs, signal the return of the dead. Instead, it would represent a

return of a very specific mediation of the dead in the form of that figure that annually in Aru is meant to embody the dead as well as conclude public mourning for a given year. Yet beyond this public embodiment of all the dead, the cassowary, in condensing Bemun's ancestral past and objectifying the Aru as a whole, is also much more than that. It is a very specific and complex mediation of the dead, the past, and the distant Aru, and as such, in certain respects, not especially akin to the mediation entailed in the photo of a dead mother, sibling, or other intimate relation.

More important, in the late 1980s, when I participated in Bemun's ritual, there was no photograph at all, but only the future possibility of a photograph. This presence of a hypothetical rather than actual photograph seems crucial insofar as it suggests that what was at stake in the severe restrictions on photography had more to do with the operative rift between things Aru and things Malay in this context, the prohibition on citation of the Aru beyond it, and the vested interests of those persons with authority over the ritual than any attributes of the photograph as such, whether ontological or vernacular. Indeed, when I finally returned to Aru in August 2005 with my book *The Memory of Trade* containing a photograph of the cassowary spinning at the center of a tight circle of men only moments before his death, no one seemed in the least perturbed by it. Only one adolescent in the gathering around the book made any comment at all while observing it: "Kasihan," he said, "Beloved one," a remark that seemed to condense much of the affective power and beauty that their annual performance as a whole holds for many Bemunese.

The photographs that I was allowed to take during the culminating crescendo of Bemun's 1996 performance did not turn out, thereby confirming the prediction of many Bemunese. Two reasons were given at the time by different persons to explain not simply why the cassowary *should* not be photographed (although the restrictions were crucial, hence the emphasis on danger to myself and the need for offerings in my name at the altars of the Prow and the Stern) but, even more, why he *could* not be photographed. Some Bemunese maintained that the cassowary was just too refined and too ethereal (I. *halus*) to be caught on film; thus the spirit would leave behind no residue which could eventually yield a positive photographic image. Others argued that the cassowary and, by extension, his performance was itself too "hot" (B. *rara*) to enable photography; any attempt at making a photographic exposure of the effigy would be destroyed by its own exposure to the cassowary spirit in a powerful reversal of the violence identified by many in this setting, following my

argument, with the Malay camera. Most people who supported the latter view said that, upon confrontation with the spirit, the film would spontaneously combust right inside my camera. Both of these explanations reinforce the logic of the cassowary himself as not only dangerously hot but always already elusive and in excess of the many attempts to contain him — a trait, if you recall, which hunters also emphasized when they spoke of tracking the animal in the forest. Heat and *halus*ness — experiential rather than representable dimensions of the ritual — became in this discourse evasive, mobile, and destructive weapons against the camera's flash, against the very attempt to be captured. From the perspective of the physical inability to capture the cassowary on film as opposed simply to the restrictions against doing so, it would seem that the cassowary is not "in and out of the picture," but quite clearly beyond it.

THE AGE OF THE WORLD-PICTURE

Lest we take this insistent staging of a hypercontext or nonevent of the nonrepresentability of the Aru at face value, it is important to recall the contest waged at the heart of Bemun's ritual. This is a contest between the Malay occupants of an ancestral boat and the Aru autochthone first encountered upon their arrival at Barakai. If, as I have argued, Bemunese stage the drama of their own erasure, they also stage its excess. In framing the Aru they necessarily take on a Malay gaze, looking as spectators do, from the outside in. But at the same time they produce an excess of themselves as always already beyond the frame and beyond the attempts to contain them.

Seen in this light, Bemun's cassowary ritual should not be taken as an auratic regime reacting to a photographic outside but as a contest that unfolds within a place of peripheral modernity, one that is part of, on the edge of, and grappling with "the bringing-forth-and-setting-before (the subject) of all things" or the drive toward presentation demanded by what Heidegger called this "Age of the World-Picture" ("Die Zeit des Weltbildes"). The anticipation of being thus placed is understood by Heidegger as the essence of modern technology, as the total availability of being *placed* and *displaced* at will, or of being-placed-on-order.[21] If the core of Bemun's ritual is a dramatic reenactment of such displacement in the runaway topographies traced by the cassowary's furtive comings and goings, then its conclusion hints at what in Aru being-placed-on-order might look like. This anticipation of being what could be called camera-

ready and the contest on Barakai about who has the right to (re)present, what the terms and content of such (re)presentation might be, as well as who wields its techniques are all intimated in the striking denouement — a brief flash of only a few seconds — of Bemun's annual performance.

In the last of the three parts of the ritual, the men of Bemun set off in a sailboat, known at this time as "the Ship of Memory," dressed in the loincloths of an Aru past to distribute at named land and sea places the white plates collected the previous night by the community. In both 1986 and 1987, when they returned the men climbed the stone steps leading from Bemun's harbor into the village, which was silent and appeared deserted. The shutters and doors of all its fifty-odd houses were tightly closed and the women confined to their homes, with as many as possible crowded into that of the aforementioned adat official, the Stern. Lining up in boat formation between the two officials, the Prow and the Stern, for the last time during the ritual, the men carried the signs of the Memory Ship's mobility — its eight "Aru" oars and rudder — and jingled the sweet-sounding little bells that on Barakai summon and index the presence of the dead as they made their way slowly to the Stern's house. Leaning the rudder and oars against the side of the house, where they would remain for four days, and after only a few minutes to catch their breath, the men cried out exuberantly, "It's dawn!" (B. "Mairo!"). Awaiting this cue from inside the Stern's house, the women flung open the windows and doors and, facing the men, burst out laughing, thus greeting the laughs and smiles of the men making up the ancestral ship. The men then rapidly dispersed.

Heralding a new time, the men's cry of dawn announced the important opening of trade and collection of marine products, set to begin four days later, as well as the commencement of a brand-new Barakai year. Like other dawns and other transitions, this one brought to light a number of striking contrasts. Besides the marked gendering of difference that I have explored elsewhere, once the women faced the men — and then only for the brief moment registered in a laugh or camera flash — it was their distinctive style of dress that especially stood out. Emerging suddenly as the embodiment of the Malay in their everyday dresses, skirts, T-shirts, and occasional sarong before their men, clad scantily in loincloths, and conjuring perhaps therewith the modernizing forces of successive Protestant and Catholic missionaries, of Barakai's schoolteachers, of the Indonesian state, and of many of Aru's traders, the women's very presence exposed the vulnerability that for many Bemunese seems to be especially condensed in their Aru clothes.[22] When I commented on the abruptness

with which the ship broke up and the men scattered to their homes, several of the women replied that, embarrassed in their loincloths, they had run off to change their clothes.

Although I believe these women were probably right, the loincloths the men were wearing were the very same ones that they had hunted in, danced in, and hung around in during all the preceding days of the cassowary performance—and without, as far as I could tell or anyone else remarked, any signs of embarrassment. Yet the reaction of the women and the laughter on both sides which greeted the somewhat disconcerting, if also amusing, confrontation of an Aru past and a Malay present were not all that different from the curious, embarrassed giggles with which many Barakai Islanders poured over the photographs that I had found in Dutch colonial archives. Taken in the first three decades of the twentieth century, these showed men in loincloths and beads and bare-breasted women in short decorated skirts.

What distinguished the Aru core of the annual performance and its striking conclusion was that only the latter could be described as intimating the "being-placed-on-order" of the Aru past before a modern Malay world, of the potential revealed of the Aru being *placed* and also *displaced at will*—with the last triggered by the embarrassment of being suspended, however briefly, in an outsider's gaze.

Kracauer observes that in old photographs,

> it is the fashion details that hold the gaze tight. Photography is bound to time in precisely the same way as *fashion*. Since the latter has no significance other than as current human garb, it is translucent when modern and abandoned when old. The tightly corseted dress in the photograph protrudes into our time like a mansion from earlier days that is destined for destruction because the city center has been moved to another part of town. Usually members of the lower class settle in such buildings. It is only the very old traditional dress, a dress which has lost all contact with the present that can attain the beauty of a ruin. The effect of an outfit which was still worn only recently is *comical*.[23]

The Aru past is not fully imbued with the beauty of a ruin or "the beauty of the dead," de Certeau's phrase for the nostalgic recovery of the "popular" or, by extension, the "ethnographic" as discrete aestheticized objects rising out of a violent extinction.[24] Thus, the exposure of the men in their loincloths is both comical and somewhat uncomfortably off. Not having relinquished "all contact with the present" and no matter how relegated

to the margins and circumscribed, the Aru has no clear status. No aestheticized dead object, the Aru is more a haunting that erupts from time to time or protrudes into the present uncomfortably, like that mansion from earlier days that is destined for demolition or assigned to the limits of the town. When the Aru does brush up against the Malay or stand off against it, as in the conclusion to Bemun's ritual in the embodied materialization of Malay clothing worn today and tomorrow and Aru loincloths worn as recently as a few days before, then the effect of such juxtaposition can only be uncanny. Because the Aru still has "contact with the present" it is both in and out of the picture. The desire to be represented and framed, and its opposite, the need to conjure an excess beyond the frame, operate in tandem on Barakai. My own haunting by an Aru past demanding representation, recording, and *placement*, and the hurried dispersal of men in loincloths eluding the predicaments of being *placed-on-order*, are no contradiction here but an intimation of the complicated colonial and postcolonial histories, memory politics, and techniques of inscription, representation, and memorialization that go into the making of one peripheral place in the modern age of the world-picture.

NOTES

1 Fieldwork in Aru, southeast Moluccas (1984, 1986–88, 1994), was funded by a U.S. Department of Education Fulbright-Hays Dissertation Fellowship, the Wenner-Gren Foundation for Anthropological Research, the Institute for Intercultural Studies, the Southeast Asian Council for the Association for Asian Studies with funds from the Luce Foundation, and the Netherlands Foundation for the Advancement of Tropical Research and was conducted under the sponsorship of the Lembaga Ilmu Pengetahuan Indonesia and the Universitas Pattimura in Ambon. I would like to express my gratitude to these institutions for their generous support of my work. Thanks are also due to Rafael Sánchez for his helpful suggestions on several versions of this essay, to Rosalind Morris for her excellent editorial interventions, and to the anonymous readers for their incisive comments. I am especially indebted to the many people in Aru who helped me with my work and to the Bemunese men and women who, notwithstanding their initial misgivings, led me through and taught me about their cassowary ritual.

2 Weber, *Mass Mediauras*, 83.

3 For a more general assessment of issues of framing and unframing in current discussions of photography, see my essay "Photography's Framings and Unframings."

4 In this essay, the abbreviation "I." stands for Bahasa Indonesia, the national language of the Republic of Indonesia, as well as its relevant Moluccan variants, such

as the regional Ambonese Malay and the local Aru Malay. "B." refers to Bara-kai, the language spoken by the approximately three thousand inhabitants of the island of the same name.

5 See Spyer, *The Memory of Trade*, especially chapters 1 and 2.

6 In this connection, see Marilyn Ivy's inspiring study, *Discourse of the Vanishing*.

7 Weber, *Mediauras*, 22–23.

8 De Certeau, *The Practice of Everyday Life*, 79.

9 Ibid.

10 On print capitalism, see Anderson, *Imagined Communities*.

11 Aruese have had ample occasion to experience the violence of the camera: photos taken in the context of a wave of rebellions against Dutch colonialism in the late nineteenth century and early twentieth, photographs documenting the coerced conversion of pagan Aruese to state-recognized religions in the mid-1970s, and the requisite snapshots on Indonesian citizens' identity cards more recently. Yet if they have come to recognize the death-dealing powers of the camera, they also, as do many people elsewhere, enjoy having their pictures taken and covet those they possess of themselves, their loved ones, and their dead family members. See Spyer, "The Cassowary Will (Not) be Photographed."

12 Cadava, *Words of Light*, xvii.

13 Barthes, *Camera Lucida*, 91; Cadava, *Words of Light*; Siegel, *Solo in the New Order*, 257–76.

14 Talbot, quoted in Batchen, *Each Wild Idea*, 11.

15 Spyer, *The Memory of Trade*.

16 Vernant, *Mortals and Immortals*, 155.

17 Siegel, *Solo in the New Order*, 260.

18 Barthes, *Camera Lucida*.

19 Spyer, "ZAMAN BELANDA."

20 Batchen, *Each Wild Idea*, ix.

21 Heidegger, quoted in Weber, *Mass Mediauras*, 77, 79.

22 For a fascinating analysis of the mutual entailment of tradition, fashion, and photography, or what Rosalind C. Morris calls "the historical emergence of the *performativity* of surfaces" beginning in nineteenth-century Thailand, see her *In the Place of Origins*, 199.

23 Kracauer, "Photography," 55.

24 De Certeau, *Heterologies*. See also Ivy, *Discourse of the Vanishing*.

NICKOLA PAZDERIC

Mysterious Photographs

Illusion is not the opposite of reality, but another more subtle reality
which enwraps the former kind in the sign of its disappearance.
—JEAN BAUDRILLARD

Photographs fix light impressions to produce the appearance of permanence for that which they also reveal to be fleeting. What happens, however, when they make literal both appearance and disappearance by exposing not only what has vanished but also points of loss, fractures of enframement, and failures of cameras? During the 1990s in Taiwan, certain photographs, called *lingyi zhaopian* (mysterious photographs), became widely popular.[1] They materialized these gaps, cracks, and breaks and made them a matter of public discourse. The images possessed qualities that many viewers acknowledged to be uncanny, and they may be likened to what English speakers in the nineteenth century referred to as "spirit photographs" or "ghost photos."[2] It is my contention that these images materialized the internal faultiness of photographic technology and that the discourse about them exposed and expressed contradictions at the heart of Taiwan's supposedly miraculous modernity. This modernity has combined economic growth with economic disparity, progress with nostalgia, military autocracy with neoliberal antistatism. Such forces and the values they counterpose intrude upon even the most intimate relationships. Hence, it is often in the photographic portraiture of personal relations that one sees the traces of macroscopic historical processes. This essay is an exploration of the doubled process by which the simultaneous appearance and disappearance of times and values came to be visible in the realm of Taiwanese photography.

Mysterious photographs emerged from private circulation into popular media at the close of the martial law era in Taiwan. Martial law began in 1949 with the arrival of the Nationalist Party (KMT) government and army after its defeat in the Chinese Civil War. As the president of the Republic of China and chairman of the KMT, Chiang Ching-kuo receives credit to this day for bringing martial law to an end on 17 June 1987. However, Chiang's history on Taiwan was not simply one of economic and political triumph. During the 1950s, he served as head of the secret police while his father, Chiang Kai-shek, ruled as president. During this period, Chiang Ching-kuo was at the top of the command chain, and he is known to be directly responsible for the *baise kongbu* (white terror) that followed the occupation. Approximately four thousand people were summarily executed, eight thousand imprisoned, and twenty thousand prosecuted on sedition charges.[3] The terror secured acquiescence to the takeover of the former Japanese colony of roughly four million people. Sufficient was the fear and pervasive enough was the threat of reprisal that ordinary Taiwanese dared not speak, until well into the 1980s, the phrase "baise kongbu" for fear of attracting KMT spies and disappearing at night in the trucks of the secret police.

The Chiang regime maintained its policy of terror in the name of Chinese national unity, claiming authority over the island as well as the mainland. Yet following expulsion from the United Nations in 1971, the death of Chiang Kai-shek in 1975, and the transfer of U.S. diplomatic recognition to the Beijing government of the People's Republic of China in 1979, Chiang Ching-kuo and other party leaders could no longer credibly deny that the party's claim, maintained through the 1950s, 1960s, and 1970s, to remain the legitimate government of the mainland was absurd. In this context, Chiang began to groom a populist image and to refer to himself as Taiwanese. In 1986 repressed groups coalesced to form the Democratic Progressive Party (DPP), promising to establish a national-cultural identity and to lead the island's return to the United Nations under the name Taiwan.

Without a plausible national-cultural project, under pressure to develop according to a liberal democratic model that served the ideological and economic ends of the United States, and with the hope of drawing continued local support to the party, the president and the party did not

prosecute the leaders of the DPP for their seditious platform. Chiang died the next year, and the reform-minded, Taiwan-born agricultural economist Lee Teng-hui became the president and acting chair of the KMT.

These political developments allowed for the expansion of democratic institutions that eventually ended the KMT's totalitarian hegemony. Nevertheless, all political parties in Taiwan remain fundamentally concerned with ensuring Taiwan's economic prosperity. Thus, although the DPP became the ruling party in 2000 via presidential elections it helped secure and Lee Teng-hui left the KMT to organize another pro-independence party thereafter, the right-of-center economic regime built under KMT rule remains largely unchallenged.

Prior to democratization, Taiwan had become the thirteenth most powerful trading economy in the world. People born during the 1960s and 1970s had little direct knowledge of the white terror because of compulsory nationalistic education in first through ninth grade, a culture of public secrecy surrounding the KMT occupation, and a rapidly changing material and social environment brought about by Taiwan's prosperity. The physical and psychological structures of authoritarianism did not, however, pass away entirely with martial law. In fact, the forms and effects of this era, including many of the silences, sadly and scandalously persist to this day. But by the late 1980s and Taiwan's emergence as a miraculous sign of capitalism's powers of transformation, a new directive began to rule society: Get rich and appear glamorously successful through the display and consumption of consumer goods. That such appearances were and are maintained through the consumption of formerly restricted import commodities served well the interests of Washington for a more favorable balance of trade.[4] Taiwan was no longer, as its old-fashioned masters said, "marching to modernity"; it had arrived, and it now had to prove it through consuming its share.

As in so many locations of the globalizing world order, the entrenchment of commodity logics is accompanied by disparate investments in the occult, signaling the mysterious underside of capitalism's own powers of transformation. In an atmosphere of shifting dominions, in which appearances generally came to assume more and more value, uncanny photographs also began to get public exposure on illegal cable television shows that featured call-in discussions of geomancy, astrology, and other aspects of Taiwanese folk life. Prior to this emergence, they shadowed the development of ordinary photographs under various names, such as

kongbu zhaopian (terrifying photographs) and *guiguai zhaopian* (ghost photographs). By the 1990s, however, these images had come to constitute a genre of imagery and an object of intense public scrutiny.

Cable television, which flourished with the relaxation of political control over the media despite being illegal, was made legal on 11 August 1993. Competition for advertising dollars compelled a KMT-controlled network to follow the trend, and, on 15 January 1994, Taiwan Television put these circulating supernatural photographs on a popular program, *The Rose Night* (Meigui zhi ye). This show mimicked the variety show formats of illegal broadcasts after its inception in October 1991. On this Saturday night program, mysterious photographs were shown under the classical-sounding and thus properly (and ghostly) national name, lingyi zhaopian, a name which echoes the title of a classic collection of horror stories from the early Qing Dynasty, *Liaozhai zhiyi* (The Strange Tales of Liaozhai). This name quickly became the commonly accepted designation for uncanny images and images of the uncanny.

For several reasons, by the turn of the millennium mysterious photographs became something of a joke, as the hosts and comedians who once cowered at their sight began to parody the photographs and their previous relation to them. The demise was as rapid as was their ascent to popularity in the early 1990s. I want to suggest that, for a brief moment, the ghost photographs expressed an ambivalent horror of Taiwan's new material and social life, a life of concrete buildings, nuclear families, speed, and luxury. These images constitute a valuable document of the transformations affecting Taiwanese society. Viewed in their collective totality, they depict loss, excess, and, in a world of advertising-driven fantasies, something of the real experience of people.

This essay is not only about ghost photographs but also about "the strangely occult capacity of photographs," which Rosalind C. Morris contends "underscores the power of photography" in general.[5] From fragmentary entries in a widely used Chinese–English dictionary I choose the phrase *mysterious photographs* to both translate the term *lingyi zhaopian* and to name this essay.[6] I do so with the following well-known (translated) sentence of Karl Marx in mind: "A commodity . . . is a mysterious thing, simply because in it the social character of men's labor appears to them as an objective character stamped on the product of that labor."[7]

Photographs share with commodities a structural logic. They present worlds objectively produced by labor but render invisible all people devoted to their material production. Marx's theory of the commodity

emerged roughly simultaneously with the dissemination of photography across Europe's middle classes. By "a logic of historical convergence that some might call coincidence," according to John Pemberton,[8] we can conceive of photographs as vivid incarnations of the emerging reign of commodities. But what commodities conceal, photographs make available once again, in a new and magical form. In keeping with their common structure and social cathexis, appearances are celebrated. In photographs, however, losses of labor, love, and life are not so much hidden as made instantly available to their possessors for recollection. Although mysterious photographs make losses of development and all phenomena literal, all photographs as commodities partake of this structure and process. Thus, in this essay I reflect upon how photographs enwrap those pictured in the sign of their disappearance.

To make lucid this structure and process, I juxtapose photographic genres that are usually separated by unwritten rules of decorum, namely, wedding photographs and mysterious photographs. That this juxtaposition does not generally occur in conversations in contemporary Taiwan does not imply that these two forms do not appear collated in telling ways. Certain wedding photographs with uncanny patterns resembling spirits in the background have been known as mysterious photographs. Likewise, television segments that feature mysterious photographs have been linked via commercial advertisements for wedding cakes that utilize the wedding photograph form. Moreover, mysterious photographs emerged in public media space simultaneously with the transformation of Taiwan into a society of glamorous consumption that finds no clearer depiction than in wedding photography, a genre that took its contemporary vogue form during the mid- to late 1980s.

This ethnographic essay retraces a path first charted by Freud in his essay on the uncanny and makes evident once again that the opposition between the uncanny and the normal (the *Unheimlich* and the *Heimlich*) in photography is practically, historically, and theoretically unwarranted. Taken as a whole, the photographic practices of Taiwanese generally make this clear. In the case of wedding photographs, poignant avowals of the occult often correspond to the socially mandated condition depicted in them. Locked technologically in timeless poses, couples become enframed signifiers of glamour, purity, and perfection that, according to local logics, can only be anticipated as recalled in times yet to come. The technical and social production of wedding photographs fabricates this experience of loss of couples to themselves as they appear in marvelous

and perfect form. Under the conditions of neoliberalism's social and economic minimalism, such instant and haunting nostalgia, typical of the fetish of the photo,[9] serves an economy that demands both a stabilizing family imaginary centered on lost romance and internalized senses of privation for purposes of technological and social transmutation in the service of glamorous success.

While the necessity of transmutation finds expression in official proclamations and everyday sentiment in Taiwan in countless ways, the techno-functionality of the always mysterious photo goes strangely misrecognized by locals and theoretical anthropologists alike. This misrecognition finds its conceptual cover in part through the notion that wedding photography provides a stabilizing, even ritual service for ordinary people, who wish only to keep their feelings of love and lives of meaning alive in fast-changing times.

Consider, for example, the writings of a Taiwanese ethnographer, Professor Lee Yu Ying, who argues for the shared "spiritual meaning" and "ritual significance" of the "practice" of wedding photography.[10]

The title of Professor Lee's article, "Shixian ni de mingxing meng—Taiwan hunsha de xiaofei wenhua fenxi," was translated for purposes of social science indexing thus: "'Dreams Come True'—Wedding Photography in Contemporary Taiwan." Analysis of this rendering affords simple access to the ideological value accorded these social facts. Another possible, literal, and telling translation of the title, "Realize Your Glamorous Dreams—An Analysis of the Consumer Culture of Wedding Photography in Taiwan," bespeaks a demand that affects Taiwanese but may appear concealed to those who wish to believe that dreams have simply and miraculously come true. For the verb *shixian* (realize), which may also be translated as "make real," denotes a subjectively experienced injunction that accords with the global political necessity that Taiwan maintain its status as a sign of capitalism's power of glamorous transformation. In what follows, I try to disclose the power of photography in making real these compulsory dreams and the haunting losses that ensure them and ensue from them.

ON HOW ALL PHOTOGRAPHS APPEAR MYSTERIOUS

To approach the mysterious in the ordinary production of dreams, memories, and miracles, I ought to begin with an ethnographic exposition of

a simple fact: Taiwanese acknowledge, though usually indirectly, that photographs and photographic equipment possess powers in excess of those ordinarily attributed to them.

The manner in which Taiwanese typically refer to photographs provides the first instance in this exposition. Vicente Rafael writes that late nineteenth-century middle-class Filipinos would "speak of photographs as proof (*prueba*) and memory (*tanda*) of one's love, even and especially in one's absence."[11] Similarly, Taiwanese aver that photographs are but simple objects that preserve a souvenir (*liunian*) or memory (*huiyi*) that visually proves or bears witness to (*jianzheng*) the lasting significance of a relationship, whether of family, friends, acquaintances, or even a spouse. In common social photography, the memory is manufactured in the experience of photography insofar as all parties to a photographic act assume that the souvenir will be for memory. The proof comes later, in the form of a finished photograph that visually establishes an object that will externalize and, eventually, substitute for subjective memory in material perpetuity. The very fact that such relationships, which exist most potently in the act of imagining a shared position from which to view the past, must be visibly proven indicates that the relationship displayed on or in the photograph may be less than self-evident or enduring (as is the case with many hastily arranged group photographs). Such proofs also imply that much of contemporary experience appears on the verge of fading away to personal and collective memory. Photographs sustain through visual proof that which is not self-evident or enduring without them.

In this way photographic proofs participate in the pervasive social assumption that the material fact of a photograph, while perhaps not sufficient, remains necessary to the indefinite perpetuation of the memory of the appearance of social relations. Integral to this assumption is the notion that photographs mark what must be in social relations by the very act of taking a picture. For this reason, to consent to a picture is to consent to the appearance of a relationship that will presumably endure in the form of a proof of the relationship but which will actually constitute the supplementary gesture of sealing the relationship. Conversely, to refuse to have photographs taken with others is cause for significant social tension, just as exclusion from group photographs is often cause for personal alarm. Yet, despite the importance given the appearance of familiarity to the relations themselves, once a photograph is taken, printed, and dis-

tributed, jealousies, mysteries, sexual tensions, and other aspects of social intercourse become concealed by the very objects that supposedly give vivid material form to the memory of the relationship.

In conversations about photography with nonspecialists, it is rare to hear this process spoken of directly, if at all. Since both the social cost of not appearing in pictures and the benefits that supplemented memories bring are recognized, it seems reasonable to conclude that most deny in a way that announces, nonetheless, the power of photography. Investigating this misrecognition, I have more than once sought to bring these implicit capacities and conceptions of the photograph to the surface of conversation through questions such as "Do people believe that photographs are more than mere objects that sustain memories and prove relationships?" At other times I have asked, "Do photographs have mysterious powers over the lives of people?" On several occasions the reply has gone something like this: "We Taiwanese do not believe photographs have such powers, but some tribes in Africa, they believe photographs steal people's souls."

The racial and historical divide evoked in this reply is spoken as part of a direct address to me, the foreign anthropologist, who is presumed to be aware of these supposed African superstitions. Just as such pseudo-enlightenment operates in the United States to stymie critical thought about the occult at the heart of the modern, it also prohibits conscious acknowledgment by Taiwanese of the sentiment that elsewhere gets expressed as a belief in the mysterious powers in photographs. I have heard it said, for example, that photographic equipment captures "low-frequency energy fields" (similar to radio waves) produced by both ghosts and individuals. Some mysterious photos are said to result from this capacity. Moreover, although most do not make a conscious link between mysterious photographs and ordinary social photography, employers, teachers, suitors, and others with a personal stake in the character of others will study photographs intensely for clues to the spirit of the person in question. In this way, ID photographs actually become central to one's identity, and not mere tokens of bureaucratic status. If a smile is too broad or a hair out of place, the photographs must be taken again, lest the identified subject appear strange and even sick. As a sign of the spirit of the person in question, the ID photo also serves to mark gravesites and ancestor shrines with a lingering image (*yizhao*) of the deceased. If these examples are insufficient, there is also an abiding belief in Taiwanese so-

ciety that photographs are so powerful that three people should not pose together in any single photograph. Should this occur, an imbalance of yin and yang can shorten the life of the person squeezed in the center. I have on more than one occasion rehearsed these points. While some may downplay the importance of one or another of the examples, depending on whether I am talking with my friends, colleagues, family members, or students, most ultimately acknowledge their discounted occult-like conceptions, hearing in my descriptions an accurate account of that which they would often prefer not to disclose.

My own sense of the powers attributed by Taiwanese to photographs and their technologies stems as well from my tenure as a doctoral candidate ethnographer (1996–98), during which time I generally carried a camera wherever I went in Taichung, Taiwan's central and third largest city. During that time, I often sensed that the device altered fields of social relations. (For this reason, I would sling it over my shoulder to point the lens away from people with whom I spoke.) This feeling found concrete social expression during research into a quasi-religious practice in Taichung, known as Hochi.[12] By decree of the Hochi master, cameras are excluded from the moments of intense and abject encounters with the Hochi forces of the universe that lead to the spiritual rebirth and subjective reconstitution of practitioners in the electrospiritual field of "universal love" (da ai). Cameras amplify "negative messages" (fumian xunxi). These messages issue from ordinary humans in the form of electromagnetic waves and can be registered on the bodies of practitioners at their most vulnerable moments during the purgative practice. Moreover, cameras can record unusual energy patterns that occur; thus, the simple presence of the device can obstruct practitioners from revealing and discovering their "true selves" (zhenwo), which is to say that the device would capture their true natures all too clearly, for perpetuity, and prior to their reconstitution in the social order. This last instance demonstrates that in a religious pursuit of the traumatic truth of the self, photographic proofs are neither necessary nor helpful. In fact, they are dangerous. However, when Hochi practitioners come together for conferences and other social events, they pose in pursuit of a memory of their social relationships, just the same.

The device is considered powerful throughout the society in other ways. For example, Taiwanese speak with dismay of unsanctioned photographs. To take pictures of young women who shop, walk, or talk un-

aware of the photographer is "to steal shots" (*toupai*). It may seem that people simply object to having images seized for the use or pleasure of others. Yet people find themselves videotaped during the normal course of the day, and most do not seem to mind this surveillance so long as it is done for security purposes.[13]

Why is this so? Christian Metz distinguishes the technologies and products of cinema and photography to conclude, "The snapshot, like death, is an instantaneous abduction of the object out of the world into another world, into another kind of time — unlike cinema, which replaces the object, after the act of appropriation, in an unfolding of time similar to that of life."[14] Recognition of the suddenness, permanence, and violence of photography is regularly conveyed, even when taking photographs of those prepared for the occasion. People frequently and, many would say, customarily hold the fingers of their outstretched arms in the form of a "v" for victory when photographed, as if vanquishing the gaze of the camera. Many also huddle close when photographed, for fear someone will be left out, even though most know from personal experience that the photographer ultimately controls the frame. Equally important, people press close because this togetherness allows everyone to feel lively and fun (*hao wan*) in the face of the snatching camera. Both instances demonstrate that the experience of having a photograph taken is not humdrum. An aggression appears to excite resistance.

Nor is this the mark solely of an African superstition. On 18 May 2001 an elderly man spoke very clearly to me about the potential of the camera to wrest reality suddenly of its life force. As a young man, he was compelled at gunpoint into the Nationalist Army at his ancestral home in Shandong province during the Chinese Civil War. Until his death in 2007, he met with a group of friends in the afternoon at the park in central Taichung, adjacent to Taichung's famous San Min Road wedding photography district. Under banyan trees planted early during the Japanese occupation, I asked him about photographs:

NP: Did your family have photographs when you were young?
Mr. Wei: Yes.
NP: I mean when you were a kid, did you have photographs around your house?
Mr. Wei: Only after I was ten years old or so.
NP: Do you remember when you first saw a camera?
Mr. Wei: Back then it was a box, with a lens, and a black hood. The

photographer held this thing in his hand and squeezed it when every-
one was ready. It went puff!

NP: Did he come out to the countryside or did you go . . . ?

Mr. Wei: There were no photographers in the countryside back then.
The country bumpkins [*tubaozi*] all said, "You can't take any photo-
graphs because the camera will suck out your essence [*xixue*]."

He pointed to his body as he said this. I asked him to clarify.

Mr. Wei: Well, the bumpkins all thought that the film in the back of
the camera that the photographer pulled out contained [their] essence.
And they would say that the camera came from the West and that it
was dangerous for this reason. But Shanghai, Beijing, Qingdao — these
places all had photographers everywhere.

Those bumpkins!

I was eighteen or nineteen. I tried to take my wife to get some
photographs taken, but she wouldn't. She believed they'd suck out her
essence. She said, "When the light flashes, that's when they get it!"

Perhaps his wife, who demonstrated her living memory by waiting
forty years (1946–86) for his return home from forced exile in Taiwan,
understood the power of the camera in ways now lost to Taiwanese.[15] Her
literalism conceals a more abstract truth. For while contemporary Tai-
wanese like Mr. Wei prefer to attribute naïveté and the fear of photo-
graphic violence to local bumpkins and Africans, the camera reduces
the essence of reality in the name of the memory of reality. Ironically, it
is this lost vivacity that professional photographers promise to restore.
Store employees and photographers would often tell me that wedding
photographs should convey a "lifelike feeling" (*shenghuo hau* or *shenghuo
de ganjue*). To transmit these feelings, couples are made to smile, lean
forward, and strike dramatic poses that suggest supercharged sexuality
or eternal adoration, poses unimaginable in the Shandong or Taiwanese
countryside of the 1930s. Apparently, without dramatically staged poses
something less than alive would be all that remained in the photographic
record.

To come alive in the wedding photograph is to transmogrify from the
ordinary to the glamorous. The responsibility falls most heavily on women
who garner the acclaim of starlets, if only for a spell. A frequently heard
expression of sanction and yearning puts it like this: "Every girl wants to
be a Cinderella [*hui guniang*]." In modern Mandarin, *hui guniang* literally

means "gray lady" or "ashen miss," with an implied sense of encounter with a passing night of glamour. People tell me that without the full-color regalia of wedding photography, women remain undistinguished, gray, and not lifelike. But as young women pursue something distinguished, colorful, and alive in photographs, their friends and associates, as if aware that the dead is alive and the alive is dead, find pleasure in analyzing the construction of wedding photographs. They do so to the degree that through speech they debase the star to the sum of makeup, clothing, and props. A young woman told me, "I always say something nice about them, but I'm really looking at the makeup and dress and thinking about their flaws." She added in a gesture of balance, "We like those things and poses that make them lively and fun." In support of her findings regarding the pleasure of critiquing photographs of women by women, a process she calls "deconstruction," Professor Lee quotes a *Cosmopolitan* magazine motto: "There are no ugly women, just lazy ones."[16] To be lazy is to not come alive in the image. Yet once women come alive as prescribed, deconstructive techniques dismantle their appearance. No matter how pleasurably women deconstruct their images, they have themselves photographed just the same. In this sense, the continual deconstruction of the subject seemingly generates more need for the subject to materialize once again as a princess (or friend or simply identified citizen) in but another round of photography.

WEDDING PHOTOGRAPHY

On Taichung's San Min Road there were over forty wedding photography shops in 1997, according to one business owner I interviewed. While studios change names and get new façades, it seems to me that this count remains fairly indicative of the stability, if not the exact number, of shops. Professor Lee cites a *New Bride Magazine* report that the wedding industry generated approximately NT$700 million in income per year during the mid-1990s.[17] Because Taiwanese businesses frequently conceal earnings and because of the persuasive social injunction to be glamorously photographed, I think it is much higher.

As is the case with all big businesses, elements of the social logic that support the enterprise can be detected in presumptions of conduct and expectations of results. A formidable presumption dictates that couples must spend about the monthly salary of a beginning elementary school

teacher (NT$30,000–35,000) to have photographs professionally produced before their wedding. If not, they will look "strange" (*yilei*) before their peers, families, and institutions.[18] People prefer, however, not to think of the negative injunction but of the positive expectation that having wedding photographs professionally done is fun.

The fun consists of a day or a half-day of hair and makeup styling, costume changes, travel, and modeling. Photographs are taken with various props, such as wineglasses and falling balloons, against backgrounds that connote class, such as hotel stairways, and in natural scenes that enfold couples within the appearance of an affirming nature. While subjects of wedding photography may have some say in the pose, lighting, props, and place, photographers as expert artists make most choices. Giving the power of decision to experts, handling themselves according to the dictates of taste, and acting certain of the exact length and purpose of sessions, couples undergo an experience that deviates from the routines of work only inasmuch as they become the self-conscious focus of production.

Men are supposed to be nonchalant about the experience, as if they merely support dutifully the transformation of their fiancées. Meanwhile, women typically assert most insistently the fun of the affair, even though they experience the strain of being stars most keenly. In either case, spontaneous expressions of joy or rapturous pleasure, should any unexpectedly occur, detract from the aims and professionalism of sessions. The fun remains, however, linked to the masquerade via a supposed reversal of power relations. Women evidently become powerful, if only for a day. But like the claim to fun that disguises the ordinary, the assertion of power reversals conceals the facts that (1) within middle-class nuclear families many women yield formidable power and (2) no matter who is the star, the media and their agents prevail in the name of visible proof of love and memory.

Negative injunctions and positive expectations that in turn structure the enactment of fantasies are sustained by a fear of the loss of the couple's memory outside of its own memorial. Businesses capitalize on this principle in ingenious ways. For example, knowing that in recent recessionary times couples do not want to spend NT$30,000 to 50,000 for wedding photographs, businesses advertise a much lower price. But when it comes time to select proofs for inclusion in gilded wedding albums, customers are asked to discard the images they do not want rather than select the

images they do. At this point, photographers become salespeople and literally x out unchosen but rarely unwanted photos. The gesture pains couples, and many decide to keep, and pay for, the previously discarded photos.

Ironically, however, it is precisely the pain of seeing memories disappear that compels many photographers to take, as it is said in English, pictures. Perhaps this contradiction explains why photographers I have interviewed invariably tell me that while their job is pleasurable, it strains their *jingshen*, a term that can be translated as "psyche" or "spirit." Thus, it should come as no surprise that since the establishment of wedding photography in central Taiwan by an adopted son, Lin Tsao, of the aristocratic Lin family of Wufeng in 1901, photography has always served the double purpose of salvaging that which it simultaneously enwraps in the sign of loss.

While at work, Lin Tsao took wedding photographs of the rich in Western styles adopted from Japan; at leisure he photographed the comings and goings of ordinary people, including wedding customs. This prototype came to fruition in his favored fourth son, Lin Chuan-chu. Abiding by the family mantra, "If you don't take the photograph today, you can't do it tomorrow," young Lin experimented in color wedding photography during the 1940s, built a beauty school above his photography studio, and spent his sparse free time photographing nearly every common scene in Taichung. He did so with a passion born of the certainty that *all* would soon be gone.[19]

Held in conjunction with a celebration of San Min Road wedding photography, a December 2000 exhibition of Lin's photography revealed that nearly every person, object, activity, and custom in Taichung seemed to him about to disappear and, therefore, in dire need of photography. Many of the scenes were shot in the vicinity of Lin's San Min Road studio. In interviews with me, one of his sons spoke often of the "warm-hearted" (*rexin*) eagerness and devotion to photography that his father possessed. Having photographed the former city center (now in the throes of urban decay) intensely myself, I could understand the stories well, imagining Lin stumbling from his studio after a day or week of shooting marriage portraits to catch an afternoon light—a light, like that in the pictured scenes, that passes quickly into the night. For, as I believe most photographers know and as Lin expressed through the family mantra, the world demands to be photographed everywhere. As one object or scene is

seized for perpetuity, another emerges that must be had. Thus, in relation to the camera, the world's demands to be pictured can easily overwhelm the photographer who is bent on saving it all from disappearance.

In the materials about Lin's life that I have examined, his death from a heart attack while photographing in a Taichung riverbed is given extended attention. To die of a heart attack is recognized by Taiwanese as indicative of collapse under the agitation and strain of overwhelming transformation, whereas to die by cancer is to succumb to impurity and incorrect living. Of a piece with the violence of his death, Lin passed away in a place famous for overpowering seasonal flash floods. The reports further note that as he died, he called for his wife and clung to his camera as though convinced of the salvational power of the device, as only the possessed can be. Precisely then the heavens reportedly opened up in a "great storm" (da yu), a symbol understood by Taiwanese as not unlike that which followed the death of Chiang Kai-shek in 1975.[20] It indicates that the heavens share in the tears of loss and that heaven and earth have transformed and a new mandate from heaven has arrived. Following this confluence of allusions, it is not a stretch to construe that, like many emergent Chinese dynastic rules chronicled by nationalist textbooks, the age of the camera comes with the force of floods, just as it promises the power to tame them.

The transforming and saving structure of photography surfaces unselfconsciously in wedding photographs called *fugu* (return to the antiquated or nostalgic). This genre uses dream scenes to stage couples against and within the frames of times apparently but not entirely gone by. Wedding photographs of couples posed as Qing Dynasty aristocrats have been common since the 1980s. Late in the 1980s and into the 1990s, men appeared dressed in KMT officer uniforms with modern but modest wives in black and white. At the turn of the millennium, San Min Road fugu sample portraits featured scenes of trains, broken fences, dirty pedestrian underpass tunnels, and other signs and debris of Taiwan's contemporary production. The pattern of nostalgia is easy to discern: a China-centered imaginary of the KMT period, a yearning for a return to authoritarian order under the democratic Lee Teng-hui, and a longing for the material reality, if only the glamorously photographed ruins, of Taiwan's miracle in an era of Toyotas, computers, and high-rises.[21] The phrase *fugu zhuyi* refers to the conservative "doctrine of return to the ancients," as opposed to the corrupting influences of modernity. In this sense fugu presents the

opposite of *lishi* (history), which denotes a conscious attempt to examine historical causality rather than to hasten to the supposedly pure Chinese classics for purposes of moral education in the face of any and every transformation.

Implied purity is important for wedding photography insofar as the wedding and especially the bride are supposed to be pure (*chunjie*). But to pose in page after wedding album page of only fugu photographs, especially those with Taichung's wreckage as a background, would not be pure. Such photographs would either overwhelm viewers with images of loss or frighten them, perhaps in the same way that lingyi zhaopian once horrified people. In fact, one uncanny wedding photograph I have seen was a fugu portrait shot against an abandoned building in which the outline of a ghost could be seen in the dirt and paint of the wall. Instead of such signs of loss, however, strategically selected static memories of lost worlds generate additional significance to the pages that follow: scenes of luxury and romance — scenes that, moreover, appear to play to that truly big Other, America. Like the dyed hair that has been popular in Taiwan since the mid-1990s or like kindergarten children who learn English with the primary aim of performing at Christmas and other seasonal functions, much that appears both trendy and substantial is meant to copy and pose for America.

Nowhere is this clearer than in the use of English-language writing over images. Though studio workers could not cite percentages of prevalence, many couples have English words inscribed over their Taiwanese photographs. Phrases such as "I love how you love me," "We've only just begun," and "Culture Romance Photography Story" appear widespread. When I ask why people do this, I am invariably told, "We Taiwanese lack self-confidence. We think English is higher class." An assertion of envious desire that finds expression in mimesis: what we lack, you have; therefore, we copy you. In fact, we write your words over our images that already imitate you (such as white wedding dresses).

Marketing themselves to the world in the international language of English, couples write their eternal beauty on photographic paper and produce bio-techno-reproduction that cannot be admitted as such. As Taiwanese well know, they must not copy in the process of technological transmutation, lest the United States slap what it calls Super 301 trade and copyright sanctions against the island and ruin the economy.[22] Yet as Taiwanese also know, people must copy just to remain in the picture, a world

picture that Heidegger solemnly said renders all of us subject.[23] And here the reality of the illusion and the sign of loss come full circle. The backdrop proper is no longer the grand stairway, an affirming nature, or even railroad tracks but the couple themselves, overwritten by pronounced, glamorous, and enviable English.

As a sign and supplement of memory for that which supposedly was, these images require regular, storied returns. When I ask people whether they really believe wedding photographs are sexy, meaningful, or even interesting, I regularly hear in response, "You may feel skeptical now, but you won't when you're sixty." I often wonder if people understand the cruelty of this retort. For not only must those photographed in wedding parlors face the loss of youth in old age, but they are enjoined to return to images that signify, above all, that beauty, perfection, glamour, and even love are already lost and unrecoverable.

Because wedding photographs have the ability to project a haunting loss across the life of the couple in the name of future memory, they evidently have the power to secure marriages. In this way, as "once in a lifetime" icons linger they serve as a final barrier to divorce. Hence, to smash a wedding photograph displays a dangerous contempt for the dream that seems to demand that the dream be recovered. A military officer (*jiaoguan*) who taught required military training courses at a school where I worked once candidly told me that she became so angry at her husband for not treating her as he did in the photograph hanging in their bedroom that she tore it in half. But in order to save the marriage, that is, to save the picture, she returned to San Min Road to have them both restored.

Professor Lee provides evidence of how couples return to these instantly nostalgic images to recover an otherwise failed memory of socially prescribed desire, one that must be in the picture by definition but appears somehow lost in the gigantic images on display. A woman reported to her:

Actually, the biggest [wedding photograph] that we have hangs on the wall facing our bed. . . . It lets us see it in a special way. When we want to go to bed or when we wake up, there it is. So, I don't have to go anywhere to remember the affairs of the day we had our photographs taken. When I see the photograph, I get a warm feeling or a feeling of being loved. When I see that photograph, it is not that the photograph has some special . . . some special something, it is just like that kind of feeling or when I look at this beautiful picture, I have this kind of feel-

ing. I feel it is a good feeling right now. When I look at the photograph it will make me believe things aren't so bad. That's right! Sometimes when I see my old man still sleeping, I will wake him by saying: look at that! (ha ha).[24]

This translation comes as close as I can to the "feeling" conveyed in Chinese. There is a simultaneous search for and incantation of a feeling, a feeling that must be there and is there only because everyone intuits and perhaps fears, though cannot say, that it is not. Perhaps because of this absence, this woman's husband can be made to awaken from his dream.[25]

MYSTERIOUS PHOTOGRAPHS

Is not the experience of the uncanny also a kind of awakening? Does not the body register truth through tingling, which Taiwanese call chicken skin (*jipi*), prior to cognition? Likewise, for a brief time that coincided with the end of the old repressive regime and the emergence of one less easily identifiable but certainly as pervasive and demanding, mysterious photographs provoked uncanny awareness of that which official or academic discourse could not so easily say: people were now caught in time tunnels, energy fields, and photographic dreams that enwrapped them in the sign of loss.

On *The Rose Night*, a "professional student of spirits" (*lingxue zhuanjia*), Qiu Fengsen, gave voice to a synthetic discourse of science and mystery in a discussion of mysterious photographs.[26] His synthetic discourse matched his appearance and title. He joined the hosts and guests wearing the costume of a Taoist master but taking the title of a schooled professional. He was clearly deferred to, and his commentary invariably brought the photographs into a local, interpretative discourse that blended scientific-sounding accounts with folk cosmological idioms that sound mysterious to people removed from the life-worlds in which cosmologies explain things.[27]

Qiu Fengsen spoke, thus, in two registers, drawing viewers into an uncanny relationship to the dream world that contemporary Taiwan has become. For instance, in Taiwan the train has turned into an established sign of nostalgia. Coffee-table photography books picture old trains in black and white. They signal times gone by, when love was demonstrated not via e-mail messages but by quiet, uncertain trips to visit loved ones slowly (by today's standards) across time and space. In at least one photo-

graph discussed on the show, a reflection appeared to some as a lingering face on an otherwise simply nostalgic train. Qiu noted:

> The spirits of people who died without natural causes often cling to any objects or space to find a chance to cast their sufferings. The Qing dynasty shadow in the train is like that. The spirit appears in a time tunnel [*shikong suidao*], and it happens to remain in contact with the train; it results in the picture. It is basically not a bad thing.[28]

A nostalgic train escapes its sign to appear in its historical effulgence, and people, including the young man posed before it, get scared. But such appearances beyond the pale of nostalgia are not so bad, according to Qiu, just uncanny. For after all, like the spirit that remains in contact with the train, we all live in a world of time tunnels, where the past and future can be accessed via the click of a mouse, the change of a cable television station, or the turn of a wedding album page.

However, not all photographs are so innocent. Qiu also analyzed images in which macabre forms are seen as haunting presences, intruding upon the space of the living with malevolent force. When a photo of a group of smiling, college-age women displayed a dark abnormality in the frame, Qiu cautioned:

> This is a ghost who died without a good cause. The dead person at the moment was very ugly so the real face doesn't appear; instead a black veil covers the ghost face. Reasonably speaking, if a group of people had a lot of *yangqi* [constructive energy], the abnormal spirit should not have appeared. You can see the dead must have died very badly with very deep suffering. The group of people in the picture can also have chronic diseases. They should pave spiritual ways to peace as soon as possible.[29]

The appearance of the sign of loss made too literal, a ghost, appears. But where is peace to be found? No one expects it to be found in everyday Taiwanese life, which is full of machinations and violence, both symbolic and real. The ghostly figure is tormented not only by a bad death, but by the impossibility of a peaceful afterlife. The image foreshadows a sentiment and a predicament: a dream of escape pervades the dreamland of Taiwan.

A photograph of beach footprints that appear not as depressions in the sand but as swellings from the sand led Qiu to comment:

This is a mysterious photograph. When I look at it, I get goose bumps all over me from my feet up, and the back of my brain feels like needles are poking it. In the universe, the first space black hole world [*kongjian heidong*] is called the *Axiuluo* spirit field. These feet are attempting to escape the arrest of spirits. Because these spirits have exactly the opposite footprint as humans, their footprints come from under the earth's spirit field. This is just an appearance, not connoting bad luck or connection. Whoever took this picture was just having strange relations at the time. There is nothing wrong.[30]

One can expect strange relations with those who search for and not merely long for a way out, but a photograph of a small group of people with what appears to be a covering of smoke led to a warning much stronger than caution:

White Tiger spirit [*baihu qi*] belongs to the White Tiger star. Sometimes it connects with the family death star — indicating the worst luck. Not only will accidents happen, they will occur constantly. When one runs into White Tiger spirit, one should go to the *Chenghuang* temple to dissolve the bad luck. The White Tiger spirit covered the whole person in this picture, and this indicates frequent and consistent sickness or death.[31]

A surplus of constructive energy or spirit can keep repressed the emergence of disruptive energy or spirit. Nonetheless, contemporary times are experienced by Taiwanese in terms of threatening chaos, not to mention vapor from internal combustion engines. No doubt, for this reason, to be swept away by smoke-like White Tiger spirit is far more dangerous than the occasional appearance of nostalgic stands-around-the-trains or escaping spirits.

It should be noted that spirits of disorder and loss would remain invisible to most eyes were it not for the camera. The device, however, is also marked by science and mystery because it captures energy patterns and because its lens is conceived as yang (intrusive, ordering, and male) while its negatives (*fumian*) are deemed yin (receptive, disordering, and female). What is more, the phenomenological referents of black holes, time tunnels, and spirit fields also share much in common with the ambivalent ontology of the camera insofar as these signifieds theoretically hold the universe together while threatening to suck the life out of it. In this way, the synthetic discourse of the professional student of spirits

expresses more precisely what people really do see than does most talk about love and memories.

That which is seen but left out of the picture of normality appears similar to the sensational subject of news photographs or attempts by the Taiwanese avant-garde to shake the middle class free of its preoccupations long enough to embrace new forms of living—but only to a point. In the case of news photographs, what is portrayed remains a disaster someplace else, a someplace else produced in part by the capacity of the camera to reduce the world to its prosthetic and substitutional memory. The disaster is someplace else and, equally important, the photograph is proof of its pastness. In the case of avant-garde art, practitioners and their products can be ignored or dismissed as psychologically disturbed (*shenjingbing*) or, as one young woman explained to me in reference to her cropped-hair female coworker, "They are those who are not like themselves." On the other hand, mysterious photographs place the failure, the disaster, the breakup, the loss, the excess, and the extraordinary at the heart of normality and its memory. They are photographs of people very much like themselves.

At the height of their popularity, mysterious photographs were not always considered genuine. In obviously enjoyable discussions people discovered the hidden hands of pranksters or the marks of technological failure. In the former case, the possibility of fakery would compel people to question whether a person or a ghost placed the abnormality in the frame. The very uncertainty spurred intense discussion, leading to conclusions similar to those championed by conspiracy buffs or economic theorists, who appeal to the invisible hand to explain the coincidences of the world. In the case of many mysterious photographs, in which the sign of a ghost was precisely a missing appendage, the hidden hand was clearly a literal phenomenon.

But in the case of technological failure, what remains are usually the traces of faulty shutters, scratched negatives, inadvertent double exposures, and other common photographic glitches. Acting the role of an analyst in the interpretative tradition, the professional student of spirits worked, as Lacan emphasized was at the heart of Freud's method, from the parallaxes, stutters, and slips (that is, from the failures or losses) that mark the psychopathology of everyday (photographic) life.[32] Doing so, he drew the fractured experience of the subject into a synthetic discourse in which the difference between humanity and technology dissolves. The cure came via objectification of these phenomena in terms of the yin

world of ghosts. In this way, viewers could enjoy the horrors of their lives from the imagined security of a yang or ordered humanity, all the while knowing, nonetheless, that the gates of hell have opened (*guimen kai*) and ghosts lurk among those who look like themselves but are nonetheless lost to the memories of their images — a group known as the living.

By the turn of the millennium, the literal truth of mysterious photographs had been rooted out, in part through a government education campaign against a religious charlatan named Song Qili, who used double exposures and other photographic tricks to, for example, picture him in two places at once. The state maintains an interest in protecting its official miracles from lesser ones. Mysterious photographs also died from overexposure and new photographic techniques. The glare of weekly television can turn any ghost into a joke (and, no doubt, vice versa), and, nowadays, people can use software to make ghosts in a stroke. Moreover, unlike their parents of a generation ago, everyone can and must, according to the new rules of consumerism, spot a fake, whether in a photograph or a designer handbag. Insofar as the photograph represents the world picture of the reign of the commodity, to shop, to pose, and to see (ourselves) in the picture is to serve the master, the global economy. It is also, as Taiwanese in so many ways acknowledge, to suffer reduction to the ghosts of ourselves in everyday photographic life. Without seeking liberation from the strictures of this reign, photographs will continue to remind us of the reality of our own disappearance.

NOTES

1 A note on transliteration: for the most part I utilize pinyin in the text. However, when a name, such as Chiang Kai-shek or Taichung, may be known outside of Taiwan in a form other than pinyin, I follow the more widely recognized form.

2 Gunning, "Phantom Images and Modern Manifestations."

3 Mei-chun Lin, "Ceremony Recalls White-Terror," *Taipei Times* 13 March 2001, 2.

4 Chu, *Taiwan at the End of the 20th Century*, 88.

5 Morris, "Surviving Pleasure at the Periphery," 344.

6 Liang, *A New Practical Chinese–English Dictionary*, 1204, 657. The phrase *lingyi zhaopian* may be peculiar to Taiwan. It receives not a single entry in a sample of Chinese–English dictionaries produced in Beijing, Hong Kong, or Singapore. For example, *The Warmth Modern Chinese–English Dictionary* includes compounds common to Taiwan that begin with the phoneme "ling," such as *linghun* (soul, spirit) and *lingche* (hearse [566]), but *lingyi zhaopian* and *lingyi* do not appear. Similarly, the Singapore-published *Learner's Chinese–English Dictionary* and Lin,

Chinese–English Dictionary of Modern Usage, make reference to, for example, *lingche* but do not have entries for either *lingyi* or *lingyi zhaopian*.

7 Marx, *Capital*, 83.

8 Pemberton, "Disorienting Culturalist Assumptions," 119.

9 Metz, "Photography and Fetish."

10 Lee, "'Dreams Come True,'" 158.

11 Rafael, *White Love and Other Events in Filipino History*, 93.

12 Hochi practice is dedicated to helping individuals find health, beauty, compassion, and love in a disorderly social and material universe that continuously bombards people with destructive negative energy. It developed in Taiwan during the 1990s, and today there are over ten thousand practitioners, centered mostly in central and northern Taiwan. See Pazderic, "Recovering True Selves in the Electro-Spiritual Field of Universal Love."

13 Miniature surveillance devices became a serious nuisance in Taiwanese society in the late 1990s. Hidden video cameras have recorded women, in particular, in toilets, and they have been used to document celebrity affairs. Many young women, in particular, fear that their private activities can be recorded by voyeurs. However, there remains a difference between the violence of the snapshot and the lurid pleasure provided those who sneak miniature cameras into restrooms. The snapshot always comes with violence. For example, it is nearly impossible for people to imagine a security guard photographing library patrons, whereas it is entirely normal that people are videotaped inside libraries. Likewise, film crews come and go, but the solitary photographer draws the attention given an imagined hunter.

14 Metz, "Photography and Fetish," 158.

15 It was only in the late 1980s that servicemen from China could legally return to visit their families left behind after the retreat of 1949.

16 Lee, "'Dreams Come True,'" 177.

17 Ibid., 159.

18 For much of the 1990s, NT$30,000 could purchase at least US$1,000. However, the NT dollar began to slide against the greenback, from highs of 25 to 1 in the early 1990s to approach lows by 2001 not known since 1973, when the government controlled the currency and valued it at 38 to 1 U.S. dollar. In June 2001 the value had slid to 34.5 to 1, indicating that miracle-era economic expectations have passed.

19 The information on Lin Chuan-chu was provided to me at an exhibition of his photography, held 15–24 December 2000 at the Taichung Wenying Guan, and by Lin's descendents.

20 For an account of Chiang's farewell, see Wakeman, "Mao's Remains."

21 Middle-aged people who lived and often labored through the years of the so-called miracle's production are often at a loss to explain these kinds of fugu portraits, just as they are at a loss to explain why their sons and daughters prefer to dress in "broken and old clothes" (*popo jiujiu de yifu*) when socializing with their friends.

22 Super 301 sanctions are a device by which the United States can enforce copyright and trade agreements.

23 Heidegger, "The Age of the World Picture."

24 Lee, "'Dreams Come True,'" 178.

25 "In the religious register, the phrase is often used — *You would not seek me if you had not already found me*. The *already found* is already behind, but stricken by something like oblivion. Is it not, then, a complaisant, endless search that is then opened up?" Lacan, *The Four Fundamental Concepts of Psycho-Analysis*, 7.

26 Examples are taken from the following collections of *Meigui Zhi Ye* stories and photos: Cai, *Guihua lianpian 2*, and Cai, *Guihua lianpian 3*; Xie and He, *Yue ye yue kongbu*. Note that the photos in each volume appear on unnumbered pages.

27 This kind of synthesis is very similar to that of Art Bell, the host of *Coast to Coast with Art Bell* and *Dreamland*, American AM radio programs that claimed nightly audiences of nearly twenty million listeners during the 1990s. A great part of Bell's allure was his simultaneous evocation of mystery, found, for example, in discussions of Sphinx-like monuments hidden deep in the Rocky Mountains of Montana, and an air of scientific realism, expressed, for example, in his commercials for clocks that automatically synchronize with the official time of the U.S. government via reception of regular satellite transmissions. Osborn, *The Art of Talk*, 219, 220, displays a color photograph of a ghost photographed by a stonemason. Bell has this to say about it:

> In looking at the photo, you'll discern what appears to be the white, cloudy outline of some being hovering in the room where this stonemason had done his work. I believe this being was a ghost. I happen to believe ghosts are spirit beings (probably spirits of the dead) which are trapped here for some reason on earth.
>
> Apparently, there were at least two crews on the house who just walked off the job. Eventually, this particular stone mason did the work. Yet, during the course of the work, the workers did have some unusual experiences. On one occasion, a couple of workers were going up a stairway, when all of a sudden a strong invisible force pushed them back. They toppled backward down the stairs as a result.

28 Fengyi, *Guihau lianpian 2*, n.p.

29 Ibid., n.p.

30 Ibid., n.p.

31 Ibid., n.p.

32 Lacan, *The Four Fundamental Concepts of Psycho-Analysis*, 25.

CARLOS ROJAS

Abandoned Cities Seen Anew

Reflections on Spatial Specificity
and Temporal Transience

At this historical junction, permeated by the dust of the years, the present century is about to draw to a close and the next century is about to arrive. As these old cities are gradually fading from our humanity's collective sight, could it be possible, through the publication of this series, to erect them again on our bookshelves? We certainly hope so.
—AFTERWORD TO THE *OLD CITIES* SERIES

The specter of death has long haunted photography. One of the Chinese words for taking a photograph, *zhaoxiang*, for instance, is a nearly exact homophone of an earlier term for portraiture, which was itself a synthesis of two more specific terms that have largely fallen out of use: *xiaozhao*, or portraits of living subjects, and *yingxiang*, or portraits of the deceased.[1] This lexical association is not coincidental, insofar as photographic portraiture is frequently imagined as giving posthumous life to the deceased while at the same time uncannily anticipating the future deaths of the living. In his mortuary discussion of photography in *Camera Lucida*, Roland Barthes famously remarks, "Each photograph always contains this imperious sign of my future death," and Derrida similarly notes, "The spectral is the essence of photography."[2]

Anchored by a long-standing tradition of funeral portraits in many cultures, the association between photography and death is further reinforced by the fact that photographs, more than many other kinds of visual representation, are imagined as enjoying a peculiarly direct relationship with the object or scene being represented. To borrow a distinction proposed by the early twentieth-century semiotician Charles Sand-

ers Peirce, photography stands not merely in an *iconic* relationship with its referent (meaning that the signifier bears a visual resemblance to its referent), but also in an *indexical* relationship (meaning that there is a direct contiguous and causal link between signifier and referent).[3] During the early years of photography, this indexical immediacy contributed to the perception that photographs constituted not merely photosensitive traces of a visual image, but furthermore were capable of capturing layers of the subject's very soul. For instance, in a discussion with one of the early masters of photography, Nadar (Gaspard-Felix Tournachon), Balzac expressed his concern that in the process of sitting for a portrait, successive layers of the subject's spectral skin might be peeled off and deposited on the daguerreotype's light-sensitive surface.[4] Similarly, in a well-known essay on early attitudes toward photography in China, published in 1925, Lu Xun criticized the once popular belief that photography had the potential to capture one's soul, and specifically the peculiar fantasy that photographs were derived from the act of peeling vestigial images off the retinas of human corpses.[5] In both Balzac's and Lu Xun's discussions, therefore, photography's indexical immediacy evokes an anxiety that the photograph might consist not merely of an image of the subject, but has a more palpable physical bond with that subject.

As photography's subsequent ubiquity helped to naturalize it in the eyes of many viewers, the belief that it has the potential to literally capture a subject's soul or "spectral skin" has in turn become comparatively rare. Nevertheless, the underlying assumption that the photograph necessarily stands in a direct causal and mimetic relationship with its referent has continued to condition the ways photographs are viewed and understood.[6] At a practical level, however, the mortuary connotations of photography's iconic and indexical status help to explain the contemporary Chinese nostalgia for old photographs. On the cusp of the new millennium, as the visual appearances of many Chinese metropolises were being transfigured through unprecedented construction and expansion, there emerged a widespread interest in old photos from the late nineteenth century and early twentieth.[7] One particularly interesting intersection of these themes of urban nostalgia and photographic fetishism can be found in a series published by Jiangsu Art Publishing House. Beginning in 1998 with volumes on Beijing, Nanjing, Shanghai, and Tianjin, the series added volumes on Xi'an, Guangzhou, Wuhan, Kunming, Chongqing, Hong Kong, and even two more volumes on Beijing.[8] One of the things which makes this Jiangsu series unusual is that, unlike many other Chi-

nese fin-de-siècle photography volumes, which typically include little or no textual commentary, each of the *Old Cities* volumes contains a lengthy and thoughtful narrative by an author associated with that particular city. These narratives sometimes comment directly on the photographs with which they are juxtaposed, but just as often text and images simply run parallel to one another.

The cover of each volume beckons the reader with an ornate red frame, within which is reproduced one of the images from that particular volume and behind which there appears *another* photograph, literally framing the frame itself (fig. 1). Upon opening the volume (the paperback edition), the reader finds a smaller, black-and-white version of the cover frame standing alone on a blank page (in the hardback editions, the corresponding frame contains an actual hole, through which a portion of the photograph on the following page is visible). This theme of framing articulates rather elegantly the editorial approach to the layout of each volume, as well as the attitudes toward photography that underlie the series as a whole. Each volume literally cuts old photographs out of their original contexts and reframes them within an artfully arranged collection of other photographs, explanatory captions, and running narrative. In this way, the editors note, they are able to grant the *Old Cities* series "its own new personality, which could be summed up most succinctly with the phrase 'image and text flourishing together.'"[9] More abstractly, the recursive series of frames and metaframes in the cover art capture the way contemporary China is currently caught in a recursive spiral wherein an obsession with progress and modernization has contributed to a generally myopic culture of amnesia, which in turn has helped give rise to a widespread sense of cultural nostalgia. As Andreas Huyssen argues in a similar context, these cultures of nostalgia and amnesia are not directly opposed to each other; rather, the contemporary culture of nostalgia constitutes a sort of "mnemonic fever that is caused by the virus of amnesia that at times threatens to consume memory itself."[10]

In the following discussion, I examine this paradoxical intersection of memory and amnesia as it is played out in the *Old Cities* series, and specifically how the photographs in these volumes function to "re/cover" the past, "re/cover" being used here in the double sense of both "to recover or retrieve" and "to re-cover or re-bury."[11] At issue is the manner in which photographs mediate between past and present while at the same time foregrounding the fundamental contingency upon which that relationship is grounded.

老上海

已逝的时光

吴亮 著文

江苏美术出版社出版

中国第二历史档案馆
上海图书馆供稿

老城市

OLD CITY

Formerly known as Chang'an, the city of Xi'an in northern China's Shaanxi province has been the capital of thirteen Chinese dynasties, including the Zhou (eleventh century BCE–256 BCE), Qin (221 BCE–206 BCE), Han (206 BCE–220 CE), and Tang (618–907). The city is particularly rich in historical significance, one of its most famous attractions being the mausoleum of Emperor Qin Shihuang and his famous army of terra-cotta warriors (not rediscovered until 1974). Against this backdrop of epic history, one of the initial *Old Cities* volumes, *Old Xi'an*, develops a more localized and immediate nostalgia for city life during the late nineteenth century and early twentieth.

The author of *Old Xi'an* is one of Shaanxi's native sons, Jia Pingwa, an acclaimed author whose reputation became inextricably linked with contemporary Xi'an following the controversy surrounding the 1993 publication of his erotic novel, *Feidu* (Abandoned Capital).[12] Denounced for dramatizing modern Xi'an's and China's cultural decadence and sexual perversity, the novel nevertheless insistently refers to the city using its historical name, Xijing (Western Capital), and explicitly reflects on the pervasive nostalgia that characterizes contemporary China. The nostalgia of this earlier novel in turn becomes an object of nostalgia in its own right in the *Old Xi'an* volume.

For instance, at one point in *Old Xi'an*, Jia alludes not only to *Abandoned Capital*, but also to the process of urban reconstruction that serves as the backdrop for the *Old Cities* series as a whole:

> What I included in my novel *Abandoned Capital* were basically Xi'an's actual roads and alleys. After the book's publication, many people went to those same roads and alleys to conduct textual research. There were even some people from Beijing who did folk photography, who went to those roads and alleys to take some pictures. Unfortunately, when they left, they took all of their material with them. Immediately afterwards, Xi'an underwent a large-scale urban transformation, with the result being that now most of the old roads and alleys no longer exist. All that has been left behind is their names and their distant, and not-so-distant, memories. (69)

It is this specter of imminent destruction, or what Akbar Abbas describes as a prescient sense of "déjà-disparu," which underlies the desire to preserve traces of an urban landscape which is already on the verge of dis-

(opposite)
1. Cover of *Old Shanghai* volume. Courtesy of Jiangsu Art Publishing House.

appearance.[13] In Jia's anecdote, the nostalgic gesture upon which the *Old Cities* series as a whole is premised is, however, collapsed from a temporal span of a century or more to one of just a few years following the 1993 publication of *Abandoned Capital*. As a result, the process of urban transformation essentially turns in upon itself, becoming so fleeting that one feels that perhaps it is precisely the process of disappearance itself which the *Abandoned Capital* fans are nostalgically trying to capture and preserve. What is produced, therefore, is essentially what Fredric Jameson describes as a "nostalgia for the present": an anticipatory nostalgia that basically anticipates the future loss of the present moment.[14]

Jia's description of *Abandoned Capital* fans coming to Xi'an in the hope of collecting souvenirs echoes one of the more memorable idiosyncrasies described in *Abandoned Capital* itself. In the novel, one of the oddest predilections of the protagonist, Zhuang Zhidie, is his habit of collecting stones from Xi'an's famous city wall. At one point, for instance, he hauls home a massive stone balanced precariously over the back wheel of his bicycle, only to be mocked by his wife for his insistence that the stone dates back to the Han Dynasty. In *Old Xi'an*, meanwhile, Jia revisits this theme of wall-stone collection, though this time claiming the practice as his own: "[Xi'an] built/repaired [*xiu*] a city wall from the Han dynasty to the Tang, from the Tang to the Ming, and from the Ming to the present. In the 1980s, when the city wall was rebuilt once again, I took several old bricks from the construction grounds. I fashioned one into an ink stone, on another I carved a relief sculpture, and yet another I didn't do anything with at all, except to admire its simple and unadorned [beauty]" (69). City walls not only serve the obvious purpose of circumscribing a city's geographical territory, but, on account of their very permanence, provide an Ariadne's thread linking the city's present to its distant past. Jia accordingly begins this passage by emphasizing the wall's role in linking past and present, but then proceeds to stress how this appearance of continuity is necessarily grounded on an incessant process of dissolution and dissemination.[15] Indeed, his own account of collecting several old bricks and taking them home underscores the degree to which the wall, like a living body, exists only in a holistic sense, even as its constituent elements may be constantly in flux.

Like city walls, languages and regional dialects also spatially circumscribe a region or community, while at the same time reinforcing the region's links to its own past. It is therefore appropriate that it is precisely

in the context of a discussion of historical maps of the city that Jia reflects upon this question of the role of language in linking past and present:

> [Upon receiving] a late Qing or early Republican period map of the Xi'an region, and [finding] that all of the names of those streets and allies were identical to today . . . we can speculate that these names originated from the Han and Tang dynasties, or at the very latest, from the Ming (1368–1644). Xi'an is a city which specializes in preservation, and does its best to preserve archaic vocabulary within its own contemporary language. When many local dialects are written down, they turn out to be refined classical Chinese. (67)

Even as the old Xi'an map visually demarcates the geographic limits of the city, the map itself, particularly the place names its contains, points to the historical continuity linking the city back to its earlier incarnations. This discussion of the continuity of names in turn speaks to a long-standing debate within philosophy of language over the nature of naming. Descriptivism, often associated with Frege, contends that the semantic value of proper names lies in their descriptive content, while an influential critique of descriptivism by Saul Kripke and others in the early 1970s contends that proper names instead function as rigid designators, whereby their meaning resides in their direct tie to a concrete referent.[16] This contrast between descriptive and antidescriptive approaches, furthermore, overlaps with Peirce's distinction between iconic and indexical signifiers, wherein the referential content of an icon lies primarily in its descriptive or mimetic power, while that of an index is essentially antidescriptive in that it lies in the icon's being positioned in a direct causal chain leading back to a specific referent.

With these overlapping theories of semiotics and reference, it becomes possible to restate the implicit contrast in this passage between Jia's "old map" and the old photographs that are the focus of the volume as a whole. Whereas photographs are typically perceived as mimetic icons, visually resembling their referents, maps are better understood as antidescriptive indexes, in which the linkage to the referent is grounded, not on direct resemblance, but on the existence of a direct causal chain linking it to that referent (together with the contextualizing information, such as captions, legends, and keys, which make the chain meaningful). In the case of the historical photographs that are collected and reproduced in the *Old Cities* series, however, their mimetic status is paralleled, and at times

overshadowed, by the knowledge (underscored by the captions and running narrative) of their direct causal link with the historical period from which they originate.

FESTIVALS

While Xi'an is best known as China's historical capital, Beijing is, of course, its current one. A peculiarly hybridized space, contemporary Beijing is one of the most modernized and sanitized of China's cities, while at the same time making considerable efforts to preserve the distinctive and insular feel of "Old Beijing." The author of *Old Beijing*, Xu Beicheng, points to the role of festivals, and specifically New Year's festivals, in negotiating this process of historical transition from the past to the present: "Beijing's transition from the late Qing to the Republican period certainly constitutes a great step forward in terms of historical stages. However, there is one thing which has not changed, and that is the importance placed on the lunar calendar's New Year's festival" (221). Annual holidays such as the New Year's festivals are characterized by a sort of paradoxical temporality. On the one hand, they are explicit markers of a forward movement from one season to the next, while, on the other hand, the inherent repetitiveness and ritualistic nature of the festivals combine to underscore their links to the festivals of the past.

The New Year's festival was a period of considerable jubilation, of freedom from ordinary routines, but at the same time it was associated with rituals of its own, specifically ones concerned with establishing the ligature between past and present: "Ever since the old days, the three major [lunar] holidays have had one thing in common — namely, that they allow people to free themselves from their normal social personas and immerse themselves into established historical tradition and sedimentation. It is the women and children who do this first, and they, in turn, influence the men in the household, after which the head of the household is affected as well" (229). Xu explains that household heads take longest to be infected by the carnivalesque fever of the New Year's festival because it is they who must balance the household account books at year's end. Like photographs, household account books provide a tangible connection to the past, while at the same time marking the boundary between past and present (i.e., the year-end closing of the books).

The Chinese New Year's festival is traditionally a monthlong celebration beginning in the middle of the final lunar month and concluding

with the Yuanxiao jie, or "Lantern Festival," on the fifteenth day of the new year, when people hang lanterns outside their houses or parade them through the street. *Old Beijing*, for instance, includes one photograph of a cluster of irregularly shaped lanterns on sticks and another of polyhedral lanterns decorated with translucent illustrations of female figures (228, 230). With their internal illumination, these lanterns resemble a kind of inverse cinematography in which the image, rather than being projected onto a screen, emanates out of the decorated fabric enveloping the dragon lanterns: "In this lantern fair, all kinds [of lanterns] are represented. Not only are there carp jumping over a dragon gate, and eight immortals crossing the ocean, there are also rabbit lanterns and running horse lanterns — leaving observers completely dazzled to the point that they can't bear to tear themselves away" (228).[17] This quality of reverse illumination is figuratively reinforced by the carnivalesque reversals of social and cultural hierarchies which characterize these festivals, as evocatively captured in Ye Shengtao's autobiographical novel, *Ni Huan-zhi*, published in 1929. The work describes a festival in which young boys dress up in feminine drag in order to attract the scopophilic gaze of the other villagers, particularly the women, who scrutinize the transvestite boys with the same penetrating eye with which they would other women: "All a man is interested in is looking at a pretty face, whereas the first thing a woman wants to ascertain is whether the other woman is superior to her in any way, *and so her eye strips the cosmetics off the other woman and sees her as she really is.*"[18]

Just as the illustrated lanterns are grounded on a fundamental disassociation of form and content, the female spectators in Ye's text are similarly seduced by a performative image of femininity that has been explicitly disassociated from any female referent. The cross-dressed boys, who "looked not so much like tea-picking girls as *mannequins modeling clothes for fashionable women*,"[19] are imitating not women but the disembodied *images* of women. Therefore, the moment the women's penetrating gazes actually succeed in *seeing through* the artifice of the boys' transvestite costumes, the result is not a truer perception but the dissolution of the entire perceptual edifice.

FASHION

Located just 135 kilometers south of Beijing, Tianjin is China's third largest city (after Beijing and Shanghai), though it arguably lacks the cul-

tural and historical cachet associated with cities that are otherwise considered its peers. This general sense of cultural inferiority can be seen, for instance, in Lin Xi's discussion in *Old Tianjin* of a 1930s brand of Shanghai cigarettes, called Meili pai (literally, "Beautiful" brand, but translated quasi-phonetically as "My Dear" cigarettes), which were marketed with a picture of a fashionable young Shanghai woman on the box. The *Old Tianjin* volume includes reproductions of two such advertisements, with one caption explaining, "The attire of the modern [*modeng*] women in the [Shanghai] cigarette advertisements was what the Tianjin girls and women modeled themselves on" (183). The caption for the second advertisement addresses the issue of why this brand of cigarettes was more popular in Tianjin than one of Tianjin's own brands: "In old Tianjin, the native Tianjin 'Front Gate' [*qianmen*] brand of cigarettes can't outsell the Shanghai My Dear cigarettes. The reason for this is that on the My Dear cigarette packs there is [an image of] the sort of beautiful woman *whom everyone likes*" (187, emphasis added). While Lin may very well have been correct in stating that "everyone like[d]" the My Dear beauties, it is nevertheless quite likely that men and women expressed that liking in different ways. For men, the female images encouraged a desire which could then be displaced from female image to commodity, while the women themselves were more likely to attempt to emulate the models' sartorial fashion.[20]

The efficacy of the My Dear marketing was bifurcated not only along gender lines, but, equally important, along temporal and regional lines. Lin addresses the temporal disjunction inherent in the nature of fashion when he observes, "In any age, and in any nation, both the state of being in fashion [*xing shimao*], as well as that of being in the pursuit of fashion [*gan shimao*] always begin with the young women of that period. These young women will always be fashion's standard" (187). Lin establishes a distinction here between the state of "being in fashion" (xing shimao) and the more aspirational "pursuit of fashion" (gan shimao), with the former being clearly valued over the latter. The difference between these two attitudes toward fashion is particularly stark when one compares Shanghai and Tianjin:

> Tianjin people's fashionableness [*shimao*] is actually just a pursuit [*gan*] of Shanghai. With respect to eating, drinking, dress and adornment, not to mention receiving people and exchanging gifts, everyone who is anyone will take the evaluation of being "the same as Shanghai

people" as being a high honor. Anyone who is unable to keep up with Shanghai [*ganbushang Shanghai*] is merely an old bumpkin who has not had a chance to see the world.

It is indeed somewhat tragic for the people of a certain region to be unable to create their own aesthetic temperament, to be unable to create in their daily lives their own unique mode of self-presentation. But Tianjin people live precisely this kind of life: after having pursued fashion [*gan shimao*] for so many years, in the end it is finally precisely *in the pursuit of fashion* that they are able to constitute their own aesthetic consciousness and their own unique form of existence (188–90; emphasis added).

Lin goes on to observe that people from other regions frequently take Tianjin as their own fashion model; as a result, what, for Tianjin, was originally merely a sort of derivative fashion has itself been transmuted into a fashion standard in its own right. Lin concludes by asking rhetorically, "Actually, could we not see the pursuit of fashion [*gan shimao*] as itself a kind of fashion?" (190).

While Lin Xi in *Old Tianjin* is concerned with the impossibility of keeping up with the moving target that is Shanghai fashion, Wu Liang in the *Old Shanghai* volume focuses instead on how even a sense of untimeliness can become a kind of fashion. In a section entitled "Behind the Times" ("Beishi"; literally, "Backed against Time"), for instance, he observes, "To be behind the times has always been the enemy of fashion, but that only applies to being 'slightly behind the times.' If you uncover old objects from decades or even a century ago, it may be so far behind the times that it has already entered into a new fashion cycle. If a watch is a minute slow, that indicates that the watch is defective. However, if a clock on a wall is twelve hours slow, then the watch hand will still be pointing to the right time" (25). Both the Tianjin and the Shanghai discussions, therefore, underscore the degree to which fashion is paradoxically both a standard which others seek to emulate and at the same time itself constantly shifting.

Women are typically linked to the fashion of a period. Like fashion itself, women's images may become emblematic of a certain historical moment, while simultaneously underscoring the unreliability of the images themselves. As Wu observes:

When the image of the women of a specific age coalesces like this, if we close our eyes, these "full and plump" smiling faces and "sweet and

mellow" dulcet voices will suddenly appear before us—this is a sort of "collective hallucination" inspired by images [*tuxiang*], causing us to reminisce for a kind of reality (beauty? womanly virtue? docility? health?) which might have existed in the past. Perhaps this leads us to a contrary kind of "truth" [*zhenxiang*]: namely, that the posture and expression of some women, when they appear before a camera lens, are completely unreliable. (103; items in quotation marks similarly flagged in original)

Here, Wu echoes Lin's reflections on how Tianjin's "fashion" lies precisely in its symbolic appropriation of the temporal gap resulting from always being a step or two behind Shanghai's "normative" fashion. Just as Lin argues that Tianjin converts the *failure* of mimicry into a normative model in its own right, Wu identifies the "truth" of female beauty as lying in its own significatory failure.

The term for "fashion" in the preceding discussions is the binome *shimao*, consisting of the characters *shi*, or "time," and *mao*, which is an archaic term for a young girl's bangs. The presence of this allusion to girls' hair or hairstyle embedded within the term for fashion is particularly apropos because it is often precisely in young women's hairstyles that modern fashion is made most immediately visible. More generally, this etymological linkage of fashion and women's hair serves as a reminder that fashion, like hair, is always potentially detachable from the referent (i.e., a specific historical moment) to which it is linked.

HAIR AND SHOES

Despite being one of China's largest and wealthiest cities, Guangzhou (Canton) is nevertheless firmly located on the nation's geographic and cultural periphery. At China's southern tip, abutting the former British colony (and current Chinese special administrative region) of Hong Kong, Guangdong is itself like a detachable appendage. It is therefore appropriate that peripheral appendages such as women's hair and shoes are an explicit concern in the *Old Guangzhou* volume.

Old Guangzhou's author, Huang'ai Dongxi, describes in some detail, for instance, the early twentieth-century phenomenon of "self-combing women" (*zishu nü*). As he explains, at the time it was traditional for unmarried women to wear their hair in a braid, bringing it up into a bun only after marriage. Therefore, the act of prematurely combing one's own hair

into a bun constituted a symbolic rejection of the institution of marriage. This practice was nevertheless frequently complicated by issues of mortality and commemoration, in the sense that "Cantonese people believed that unmarried women have no status or place, they are consequently not entered into the family genealogies, nor are they entitled to be buried in the ancestral tombs," leading some self-combing women to enter into a marriage "in name only" (187). Left unstated in the text, however, are the specific material conditions that made this social practice possible in the first place. That is, it was the highly developed silk industry in the region which allowed single women to comfortably support themselves through sericulture.[21] Not only does the *Old Guangzhou* text *not* mention this particular economic dimension of the phenomenon, but it underscores the exemplarily loyal service of these self-combing women as household maids: "The reason why we mention the 'self-combing women' while writing about Guangzhou is because the personal maids employed in many of the big households in old Guangzhou were in fact 'self-combing women.' For instance, the 'virtuous sisters' of Xiguang were very famous; and their loyalty and attentiveness is something about which elderly Cantonese still reminisce to this day" (191). This nostalgic reminiscence about the singular "virtue" and self-effacing "loyalty" of self-combing women reappropriates the potential challenge to the patriarchal hegemonic order embodied by these women, who, through deliberate manipulation of their own visual appearance, openly proclaimed their refusal to be interpolated into that same order.

Like women's hair, shoes are a detachable appendage. During the historical period represented in the *Old Cities* volumes, these shoes could represent the height of modernity or the hold of tradition, as with the three-inch lotuses (*Old Shanghai*, 33) and prostitutes' slippers (*Old Guangzhou*, 74). A particularly interesting example of this latter phenomenon can be found in Huang'ai's contrast, in *Old Guangzhou*, between Shanghai's glitz and glamour and Guangzhou's "sunken-eyed" and "thick-lipped" women in their wooden clogs: "Just as Shanghai residents are fond of jazz and cafés, similarly the personality of Guangzhou residents has its own characteristic accessories. . . . If someone wanted to find a simple means of recreating, in the pages of a periodical, the characteristic spirit of old Guangzhou, they could simply go look for a pair of wooden clogs and let a sunken-eyed, thick-lipped, honey-skinned woman wear it with her bare feet, having her either walk or stand in the cobble-stone streets of Xiguan" (19). Noting that clothing stands in a parergonal relationship to

the human body, Derrida asks whether shoes (and here he is specifically discussing a famous van Gogh painting of a pair of old peasant shoes) could perhaps be seen as a "*parergon* without *ergon*? A 'pure' supplement? An article of clothing as a 'naked' supplement to the 'naked'?"[22] It is precisely this status of being a second-order supplement, a "pure" supplement, which allows women's shoes to become unique repositories of symbolic significance. More specifically, the arch-parergonal status of women's shoes comes to assume a particular significance in late imperial China due to the force of the metonymic association of women's shoes and bound feet. Bound feet not only effectively bound women's physical mobility, but they also stood at the symbolic boundaries of the naturalized body. An object of fetishistic attraction, bound feet were nevertheless quintessentially invisible, never to be viewed in their nakedness. The gradual disavowal of foot binding during the early twentieth century coincided with the unprecedented entry of Chinese women into the workforce and the public sphere.

Women's position within this chiasmus of private invisibility and public visibility is most evocatively illustrated in a dark and grainy reproduction of a black-and-white photograph in *Old Guangzhou*. Virtually the only details that can be discerned in the reproduction are the Chinese characters *nü ce* (women's lavatory), appearing twice on the righthand side of the photograph. To the left of the two latrine-door signs there is a sharply foreshortened near-blur of textual markings. Approaching the limits of intelligibility, the blur proves to be another sign, consisting of three Chinese characters, *nü gong ce* (women's public lavatory), written on a wall positioned at a right angle to the picture plane. The overall effect of the image is reminiscent of Hans Holbein's painting *The Ambassadors*, completed in 1533, which depicts two lavishly dressed men surrounded by the accoutrements of the sciences and the arts but shadowed by what Lacan describes as a "strange, suspended, oblique object in the foreground." It is only upon viewing the painting from a sharply oblique angle that the mysterious object comes into focus as a human skull. In his discussion of this work, Lacan notes that the viewer must first disidentify with the primary plane of representation in order to glimpse this "anamorphic ghost"—this figure of the subject as annihilated—which haunts this work produced precisely during the period that geometric optics and the very notion of the subject were being developed.[23]

Just as Lacan dates Holbein's painting to the period during which the invention of receding perspective coincided with the development of

Enlightenment notions of the subject, the *Old Guangzhou* caption to the lavatory photograph similarly positions the image at a crucial historical juncture: "Guangzhou's unique geographical position has located it in the middle of the tide of Easterly-flowing Western influence, frequently placing it at the forefront of the civilizing progress. This [image depicts] a unique phenomenon in China at that time: a women's public lavatory [*nü gong ce*]" (104). The equivalent of the skull in Holbein's painting is the "*nü gong ce*" sign, specifically the character *gong* (since the other two characters also appear elsewhere in the image). Literally meaning "public," this *gong* ideograph suggests the subsumption of the individual within the collective, while at the same time pointing to a crucial epistemological precondition for the emergence of the individual subject in the first place. In abstract terms, *gong* represents the social collective that is an enabling precondition of (individual) subjectivity, but is also a reminder of its ultimate impossibility (in the sense that the assumption of a "collective" identity is, at some level, antithetical to the articulation of a purely "individual" one).[24] More concretely, it was precisely during the Republican period that Chinese women began to enter the public sphere in large numbers for the first time, but it was also at this time that (mostly male) reformers began to exploit the themes of "woman" and "women's liberation" for their own nationalistic purposes. The "public" which enabled the emergence of a female subject during this period, therefore, represents, to paraphrase Lacan's discussion of Holbein's skull, "the subject as annihilated," located "at the very heart of the period in which the [female] subject emerged."[25]

PORTRAITURE

Just as the social mobility of Chinese women (particularly upper-class women) was tightly constrained during the late Imperial period, women's portraiture was generally restricted to fairly specific contexts (chief among which were mortuary purposes). In fact, so unusual were portraits of living women that it became conventional in Chinese literature and drama to regard them as, in effect, "auto-effigies," unwitting anticipations of the subject's own demise.[26] During the early twentieth century, however, a number of new genres of portraiture, including women's portraiture, began to emerge.

One such genre was that of the "calendar poster illustration" (*yuefen pai hua*), which typically consisted of a realistic image of a woman or a

historical scene, framed by a calendar and commodity advertisements. In his discussion of this genre in *Shanghai Modern*, Leo Lee describes the typical poster as consisting of "an oblong square frame, as in a traditional Chinese painting, with the portrait of a woman occupying about two-thirds of the frame, and at the bottom a calendar; above either the large frame or the calendar is printed the name of the company which is advertising its commodity, mostly cigarettes and medicine."[27] Influenced by the transnational spread of Western capitalism and the late nineteenth-century introduction of lithographic printing techniques, the calendar posters first appeared at the very end of the nineteenth century and were subsequently popularized during the first decades of the twentieth by the American Tobacco Company, among others.[28] Although it eventually became common to print the posters without the calendars, the posters nevertheless continued to go by the name "calendar posters."

These calendar posters (featured most prominently in the *Old Guangzhou* volume, which has no fewer than thirteen such illustrations in the section euphemistically entitled "By-gone Buddhist Nunneries" ["Cong-qian ni'an"]) bring together the theme of inscribing temporal change onto women's bodies, discussed in the preceding section, with the earlier theme of the sublation of historical change within the visual spectacle of traditional lunar festivals. To begin with, the images contained in the calendar posters represent a combination of modern and traditional fashions and settings. That is, the calendar depicts many of the women dressed in the height of contemporary fashion, but images of women in more traditional settings are also included. Furthermore, this intersection of "modernity" and "tradition" at the level of the *images* themselves is mirrored by a parallel intersection at the level of the representational *form* of those images. On the one hand, the calendar poster format is noteworthy because, aside from photography, it represented one of the most explicitly mimetic representational genres in Republican-period China, featuring subtleties of color shading and lighting contrasts explicitly indebted to European representational practices and largely unknown in traditional Chinese painting. On the other hand, the posters' very appearance drew on two separate older representational traditions of "New Year's pictures" (*nianhua*) and "beautiful woman" portraits (*meiren tu*), both of which were markers of contemporaneity and historical change (e.g., the new year, and the latest women's fashions), while at the same time connoting a sort of timelessness and ahistoricism (e.g., the way both genres explicitly model themselves on a long tradition of similar images).[29]

Like women's portraits, Chinese imperial portraits during the premodern era were also generally sequestered from the wider public, while the visibility and circulation of political portraits increased dramatically during the Republican period. This contrast between imperial and modern practice is underscored, for instance, in the *Old Nanjing* photograph of Sun Yatsen, the first president of the Republic of China, giving a speech while standing beneath a portrait of Zhu Yuangzhang, founder of the Ming dynasty (67). While the *Old Nanjing* author, Ye Zhaoyan, suggests that the photograph indicates "the veneration that Sun Yatsen had for the first emperor of the Ming dynasty, Zhu Yuanzhang," it is ironic that this particular mausoleum portrait actually presents a negative caricature of the notoriously tyrannical Ming ruler, depicting him with an oversized chin and a deeply pockmarked face.

Sun's juxtaposition with this Ming dynasty imperial portrait is also significant insofar as Sun's presidency marked a crucial moment for the status of Chinese political portraiture. To be more precise, it was during the four years between Sun's death in 1925 and his eventual burial in Nanjing in 1929 that the public dissemination of his portraits reached its peak. As the historian John Fitzgerald recounts, "Over these four years Sun's portrait came to be imprinted on every dollar bill in circulation around the country, on packets of cigarettes, and on the backs of watch cases. His picture was framed in the halls and classrooms where students and government employees met and paid their respects each Monday morning. It hung in shop windows where picture-framers mounted his portrait in the finest frames on display."[30] The significance of this circulation of Sun's portraits was also explicitly remarked upon by contemporary observers, as in the following piece from the *Peking Leader* (written in 1929, shortly after Sun's interment):

> It is no small gain to China that it should have acquired such a symbol *to which all eyes can turn*, as the *transformed* [emphasis in the original] Sun Yat-sen has become. Through the centuries *the visible symbol of the throne* served as *the focal point* for governmental activities and for such sense of national unity as existed. With the establishment of a Republic this symbol disappeared and there was nothing to take its place. . . . In these four years since he died, Dr. Sun has come in no small measure to supply that lack.[31]

The visual tropes in this passage (italicized here for emphasis) underscore the significance of Sun's postmortem existence as a specifically visual sig-

nifier, suggesting the degree to which the unprecedented diffusion of the leader's image marked a crucial turning point in the way political authority itself was viewed (setting the stage for, among other things, Mao Zedong's subsequent careful cultivation of his public image).[32]

Photography's status as both memorial and anticipatory effigy comes together particularly nicely in Wu Liang's discussion of a 1914 photograph of an anonymous Shanghai woman boarding a tram, which he begins with an apparent non sequitur by observing matter-of-factly, "At the time of this photograph, Zhang Ailing did not yet exist" (71). After a three-page discussion of the photograph itself, Wu returns to the comparison with Zhang Ailing: "The woman boarding the tram could not have imagined that, thirty years later, another woman by the name of Zhang Ailing would also frequently board similar trams, and would furthermore include trams in her fiction" (75). These allusions to the celebrated author Zhang Ailing (also known by her anglicized name, Eileen Chang) are particularly apropos because, just as the *Old Cities* series as a whole seeks to preserve a historical urban vision in the penumbra of its demise, Zhang Ailing's last published work, *A Record in Contrasts*, brings together photographs of herself and her family on the very eve of her own death.[33] In this way, Chang's *A Record in Contrasts* functions quite literally as an auto-effigy, using an assortment of always already alienated photographic images as a prism through which to *look back* on her own life, while at the same time implicitly looking forward to how Chang would be remembered after her death.

REPETITION AND DIFFERENCE

Both the calendar posters and the postmortem circulation of Sun Yatsen portraits derive their power and fascination precisely from their status as spectral vestiges of absent presence. Wu Liang captures this spectral quality well near the beginning of *Old Shanghai* when he observes, "A photograph's ability to strike me lies in its ability to remind me that there are some things which do not exist anymore, but which may have left behind 'signs,' the traces of which can still be discovered. The photograph also tells me that the spatial location has not moved, but the temporal dimension has forever passed away from it. All of this is enough to leave you stupefied" (44). As Wu notes later in the same volume, however, the ability of photographs to evoke "things that do not exist anymore" is predicated on the photographs' own inherent reproducibility:

The repetitive citation of photographs does not necessarily imply that they are canonical, but rather it may simply be a question of convenience: there is no need to overturn the box and dump them onto the counter, add captions, or specify their original source. Just like the portraits of movie stars, which are posted everywhere on roads and alleys, shop-windows, bill-boards, and magazine covers, photographs similarly may, at any time, appear before your eyes. Therefore, who would [want to] go seek out the "original creation"? These simulacra already constitute a "real object" in reality [*xianshi li de "shiwu"*] that anyone can appropriate at will. (233)

Wu's description of piecing together photographic traces of the past aptly describes not just the *Old Shanghai* volume itself, but more generally the way each volume in the series seeks to preserve a sense of urban identity, even as the actual cities in question are in the process of being continually demolished and rebuilt.

Building on his earlier discussion of how the "truth" of women's photographic images resides precisely in their inherent and necessary "unreliability" (103), Wu here suggests that the "truth" or "reality" of the photograph resides not in the authority of some "original creation," but in the inherent reproducibility of the photograph itself. In fact, the images used to illustrate this contention that "simulacra already constitute a 'real object' in reality" are, in fact, images of women. Specifically, Wu's preceding discussion of movie star portraits is juxtaposed with a series of photographs of the early twentieth-century movie star Hu Die, appearing in a still from one of her films, in flyers for other films, and even in an advertisement for hand soap. The resulting sense of a web of endlessly reproduced simulacra without origins is aptly conveyed by the actress's stage name, which is a homophone for "butterfly" and consequently evokes Zhuangzi's famous epistemological dilemma: he was not sure whether he was Zhuangzi dreaming that he was a butterfly or was a butterfly dreaming that it was the philosopher Zhuangzi.

Wu Liang concludes the preceding discussion of photography by returning to this theme of the inherent reproducibility (and consequent unreliability) of the photographic image, this time using as his backdrop, not the figure of "woman," but the modern cityscape itself:

Repeatedly cited photographs are important protagonists in our visual life. Together with other relics, they collectively constitute a montage element seeking to close the temporal gap [between that age and our

own]; bringing us into contact with a daily life which is not entirely believable, but at the same time is completely real. It seems as if we still inhabit the city depicted in those photographs, enjoying together with that past era the same sun and neon lights. *Optical illusions are necessary, and can inspire in people a sense of immortality*. (235; emphasis added)

This passage is juxtaposed with a striking photographic montage of a 1917 image of the Shanghai Parliament building, in which the original photograph has been cut into about half a dozen mutually overlapping fragments, which are then arranged on the page as though glimpsed through a miniature kaleidoscope. The resulting image suggests a process of disarticulation and imperfect suture, whereby the fault lines from the original separation remain clearly visible within the finished product.

This gesture of simultaneously looking backward and forward effectively frames the unstable temporal bounds of the present. The *Old Cities* volumes reinscribe old photographs within the new frame of the albums. This figurative frame, in turn, functions as a sort of prophylactic railing, circumscribing our mortal existence while at the same time shielding us from that which lies beyond. Photographs symbolically mark the encroachment of death into the realm of the living, at the same time compartmentalizing that threat and holding it at arm's length. As Wu observes at the end of *Old Shanghai*, "Old photographs seduce viewers into reminiscing about bygone people in the prime of their life, enabling the viewer to avoid the terrors of mortality. Therefore, reiteratively citing a few old photographs can function as a figurative railing which surrounds and protects us" (235).

NOTES

1 Qian et al., *Zhongguo sheying shi*, 18.

2 Barthes, *Camera Lucida*; Derrida, *Right of Inspection*, p. iv of the French text (the English translation is not paginated); see also Derrida, "The Deaths of Roland Barthes."

3 Peirce, "Logic as Semiotic"; Krauss, *The Originality of the Avant-Garde and Other Modernist Myths*.

4 Morris, *In the Place of Origins*, 189; Krauss, "Tracing Nadar."

5 Lu Xun, "Lun zhaoxiang zhi lei," (On photography and related matters), in *Lu Xun Quanji* (complete works of Lu Xun), (Beijing), 185, translation taken from Kirk Denton, ed., *Modern Chinese Literary Thought: Writings on Literature, 1893–1945* (Stanford: Stanford University Press, 1996).

6 These assumptions about photography's fundamental mimeticism persist, despite a recognition among theorists that, as John Tagg argues, "*every* photograph is the result of specific and, in every sense, significant distortions which render its relation to any prior reality deeply problematic." *The Burden of Representation*, 2. See Goodman, *Languages of Art*, for a detailed discussion of this issue. Even a poststructuralist theorist such as Barthes, however, may fall back on a perception of photography as representing a uniquely direct instantiation of meaning, a "message without a code." Barthes, *Camera Lucida*, 19.

7 This trend includes publications such as Hu Zhichuan and Chen Shen's *A Record of Old Chinese Photos: A Collection of Early Chinese Photographic Works: 1840–1919* (1999); Qiu Shiwen et al., *Old Hong Kong Photographs* (1999); Roberta Wue et al., *Picturing Hong Kong: Photography 1855–1910* (1997); Hu Piyun, ed., *Historical Photos of Old Beijing* (1996); as well as the 1997 Shandong Huabao Publishing House *Old Photographs* series and the 1998 Jiangsu Art Publishing Company series by the same name.

8 Of these, the following are discussed in this essay: Ye Zhaoyan, *Lao Nanjing*; Wu Liang, *Lao Shanghai*; Lin Xi, *Lao Tianjin*; Huang'ai Dongxi, *Lao Guangzhou*; Jia Pingwa, *Lao Xi'an*; Xu Chengbei, *Lao Beijing*. Page numbers are cited parenthetically in the text. The translations are mine.

9 From the unpaginated afterword to each volume in the series.

10 Huyssen, *Twilight Memories*, 7.

11 Derrida captures a similar conjunction of meanings in his term *mise en crypte*, which he uses in the dual sense of "entombment" and "encrypting," with the additional twist that, for Derrida, the "crypt" is itself located at the intersection of the "hermetic" and the "transparent": "Everything is visible in it, shop-windowed under the plate of altuglass (what a word), accessible through all its surfaces, and yet closed, crypted, nailed, screwed down: impenetrable." "The Parergon," 46, and "Cartouches," 185, both in *The Truth in Painting*.

12 For a detailed discussion of this aspect of Jia's novel, see Rojas, "Flies' Eyes, Mural Remnants, and Jia Pingwa's Perverse Nostalgia."

13 Abbas, *Hong Kong*.

14 Jameson, *Postmodernism*, 279.

15 For a discussion of these issues as they relate to China's Great Wall, see Rojas, "The Great Wall of China and the Bounds of Signification."

16 Frege, "On Sense and Reference"; Kripke, *Naming and Necessity*. For a more recent perspective, see Soames, *Beyond Rigidity*.

17 A "running horse" lantern is one with decorative figures along the top band, which revolve as the hot air inside the lantern rises. The technology and name of this sort of lantern coincidentally evoke the groundbreaking work of Eadweard Muybridge, who, in the late 1870s, succeeded in producing a series of sequential photographs of running horses—this sort of systematic sequencing of the visual experience being one of the necessary preconditions for the cinematic technology which was developed soon after (and of which the "running horse" lanterns can also be seen as a rudimentary precursor).

18 Ye Shengtao, *Ni Huanzhi*, translated by A. C. Barnes as *Schoolmaster Ni Huan-chih* (Beijing: Foreign Language Press, 1958), 124, emphasis added.

19 Ye Shengtao, *Schoolmaster Ni Huan-chih*, 125, emphasis added.

20 This asymmetry of desire and identification probably contributed to the fact that cigarette marketers in China historically have been generally unsuccessful in making their products fashionable among women.

21 Topley, "Marriage Resistance in Rural Kwangtung."

22 Derrida, "Restitutions," in *The Truth in Painting*, 302.

23 Lacan, *The Four Fundamental Concepts of Psycho-Analysis*, 88, 89.

24 See Liu, *Translingual Practice*, chapter 2, "The Discourse of Individualism."

25 Lacan, *The Four Fundamental Concepts of Psycho-Analysis*, 88.

26 See Zeitlin, "Making the Invisible Visible."

27 Lee, *The Shanghai Modern*, 77.

28 Chen, "Wo kan lao yuefen pai"; Lee, *The Shanghai Modern*, 76.

29 Lee, *The Shanghai Modern*, 77.

30 Fitzgerald, *Awakening China*, 27.

31 Quoted in Bland, *China*, 57, emphases added.

32 See, for example, Kantorowicz, *The King's Two Bodies*; Takashi *Splendid Monarchy*.

33 Chang, *Duizhao ji*. Selected excepts of this work can be found in English translation in Chang, "Reflections."

MARILYN IVY

Dark Enlightenment

Naitō Masatoshi's Flash

(For Ben Anderson)

Bleached to the whiteness of bones, the man's face forms a featureless silhouette in the dark surrounding him, a veritable cut-out in a field of black. We make out his suit coat well enough, and we see the sharp branches of the trees behind him. The trees would look dead if it weren't for the improbable flowers blooming on a branch floating in the middle distance. But the man's head exists only to outline the negative place of what should have been there in the photographic revelation, as the image pushes illumination past the point of no return until light becomes its obverse, a blinding nullity with the indeterminacy of darkness (fig. 1).

Such a photograph immediately, imperatively announces its production through artificial light. We know we are seeing the blanched after-effects of flash, a flash that has been trained to efface what it would normally seek to illuminate. It is a photograph of the densely overgrown trees of a shrine on Mt. Hayachine in far northeastern Japan; the man with no face is the descendant, it is said, of one Fujikura, a hunter from the nearby region of Tōno. As legend has it, Fujikura was hunting near the summit of Mt. Hayachine long ago, when he heard the barking of a dog; at that same moment he became aware of the divine spirit of the mountain glittering with a golden light. He proceeded to build a new shrine to the deity. The sparkling golden light of the deity is here transformed into the silvery blast of the photoflash, which not only suffuses Fujikura's descendant but erases him, as it turns the luxuriance of the mountain's trees into jagged sticks.[1]

Through this image and others produced by the photographer Naitō Masatoshi from 1970 to 1985, I want to think about how the substantial

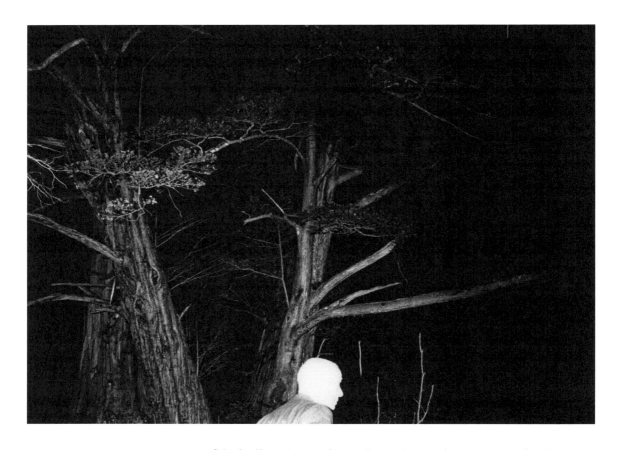

1. Sacred trees
at Mt. Hayachine
shrine, 1971. From
Naitō Masatoshi,
*Tōno monogatari:
Naitō Masatoshi
shashinshū* (Tokyo:
Shunseisha, 1983).

powers of flash allegorize modernity's aporia, nowhere more so than in
Japan of the postwar period.[2] Taken in Tōno, the flashed photograph of
Fujikura's descendant marks a moment in the ongoing efforts in Japan
to account for modernity and its remainders. To recognize the name of
Tōno is to know that it has been the most famous site of the folkloric
in Japan, a site repeatedly remarked as the countermodern homeland of
Japan, a site of resistance, imagined and otherwise, to state-sponsored
demands for "civilization and enlightenment" (*bunmei kaika*) from the
Meiji period (1868–1912) onward. Far rural Tōno represented to mod-
ernizing Japanese that which was not illuminated, that which was dark
with superstition, poverty, and death. At the same time, through its very
positing as the representative site of Japanese modernity's before, Tōno
emerged as a place open to a nostalgic afterlife, even if it meant an im-
possible return to a world of darkness and death (or a framing of this
deathliness in the guise of the recognizably folkloric).[3] And if Tōno came
to represent the shadowy pre-enlightened world of the Japanese folk,
Tokyo stood in for another, perhaps even darker world at the far edge of

enlightenment. Naitō's photographs of Tokyo, many shot concurrently with his Tōno series, form an extension of his belief that photography, particularly flash photography, can make visible worlds of darkness.

Naitō Masatoshi (b. 1938) is a significant postwar Japanese photographer, most noted for his photoflashed images of sites and occasions of the Japanese archaic.[4] Early collections of his photographs focused, for example, on sacred mountains, highly charged topoi of magico-religious sentiment in Japan. Tōno, the object of an entire volume of his photographs, first attained notoriety for an incipient nativist ethnology (*minzokugaku*) through a collection of tales, stories, legends, hearsay, and local history poetically unified and published by Yanagita Kunio (1875–1962), who was to become the undisputed father of Japanese folklore studies.[5] This text, *Tōno monogatari* (The Tales of Tōno), received little attention on its publication in 1911 but was discovered some years later by Japanese seeking to encounter an older, magical Japan after decades of unremitting industrialization. *The Tales of Tōno* riveted citified Japanese with its macabre content, an effect heightened by its prose style, which presented an explicitly literary rendition of the oral tales that went against the grain of the so-called *genbunit'chi* movement of the time and its calls for the standardization of written and spoken Japanese, so distinct from each other in pre-Meiji Japan.[6]

Yanagita Kunio's *The Tales of Tōno* (for which he claimed authorship, although he concurrently claimed that he did nothing but write down oral tales as he heard them from the Tōno storyteller Sasaki Kizen) were filled with haunted goings-on, gruesome murders, mysterious disappearances, and the chilling pranks of mountain deities.[7] A history of violence, even trauma, thus marks the origin of Japanese folklore studies itself, as *The Tales* became the obsessively canonical founding text of the discipline. The novelist Mishima Yukio, in an appreciation of *The Tales* for newspaper readers, thus spoke of Japanese folklore studies as filled "with the smell of corpses," a gruesome description indeed of an academic discipline (and Mishima's description is not unambiguously negative).[8] The repeated attempts to come to terms with the seductive terrors evoked in *The Tales* — attempts to rewrite *The Tales*, to reinterpret *The Tales*, to photograph Tōno as evoked in *The Tales* — suggest that native ethnology is a species of hysterical symptom formation surrounding the traumas which punctuate Yanagita's text and the abject history of rural poverty it references. These traumas stemmed both from the external intrusions of the modernizing nation-state into the local agrarian communities

(Yanagita had much to say about this rupturing in his copious writings on agriculture) and from the legacies of local, internal violence: traumas of modernization and traumas of *non*-modernization. Psychic trauma, in the psychoanalytic sense, always subsists in zones of dislocation between the interior and the exterior, between past and future; trauma comes to be recognized only after the fact, through the operations of repression and deferred memory.[9] The traumas that *The Tales* signified pointed to the gap between the uneven temporalities of modernity in early twentieth-century Japan, between the nonsynchronous experiences spatially distributed between the country and the city.[10] Minzokugaku and its allied endeavors sought to theorize this gap and, in some of its political uses, to ameliorate or even close the chasm by advocating a return to a time before industrialization. To get back to an origin before modernization and its inevitable association with the colonizing West, minzokugaku sought to revalue the singularity of a primordially Japanese experience of trauma. Other singularities were invoked as well, ranging from ritual practices to pottery forms to architecture: the entire panoply of folk life as similarly excavated by folklorists in Europe. But the specificity that *The Tales of Tōno* repeatedly inscribes are the profoundly local forms of shock and their ghostly aftereffects found in the remote mountains of northeastern Japan. The efforts by *The Tales* to reclaim the singularity of origins was fated to be repetitively reenacted through the years in a relay of haunted reinscriptions that recalls traumatic repetition.

In photographing these sites in Tōno Naitō has placed himself within the domains of what might be thought of as folkloric photography, as he perpetually labors to evoke a dark landscape on the margins of the enlightened discourses and scenes of Japanese modernity triumphant.[11] He also takes his place in a lineage of aesthetic practitioners who have conjoined darkness with the place of nativist homecoming, with an essential Japan. Darkness and its meanings within a specifically Japanese cultural milieu have never been more delicately and daringly approached than by Tanizaki Jun'ichirō's *In Praise of Shadows* (In'ei raisan). Written in 1933, at a time when the depravations and wonders of modern technologies were fully installed in urban Japan (yet when memories of an older, pre-electrified and preindustrial Tokyo remained), *In Praise of Shadows* evoked a countermodern netherworld, an ambiguous but irrevocably beautiful realm of darkness (even with, or even because of its grime, dimness, and densities) that Western-style modernity could never appreciate nor overturn. The darkness Tanizaki evoked was best produced by candlelight;

indeed, the electric light was his nemesis, as his ecstatic meditations on archaic Japanese darkness reveal:

> The color of "darkness seen by candlelight" . . . was different in quality from darkness on the road at night. It was a repletion, a pregnancy of tiny particles like fine ashes, each particle luminous as a rainbow. . . . The elegant aristocrat of old was immersed in this suspension of ashen particles, soaked in it, but the man of today, long used to the electric light, has forgotten that such a darkness existed. It must have been simple for specters to appear in a "visible darkness," where always something seemed to be flickering and shimmering. . . . This was the darkness in which ghosts and monsters were active.[12]

This was a darkness before electric light, certainly before flash. Tanizaki's meditations formed themselves around places and objects of refined elegance (if, indeed, in an inverted sense: one of his famous passages concerns the beauty of the Japanese-style toilet). Naitō's photography intensifies the capacities of electric illumination to bring back darkness by its very negation, by a negative illumination and an illumination of the negative, as his photographs of abjection and decay testify. To photograph Tōno as an exemplary site of abjection and magic has been virtually compulsory for all Japanese photographers (for example, the photographs of Tōno taken by Moriyama Daidō, one of the most famous Japanese photographers in the United States today, after full-blown solo retrospectives in American museums in 2000).[13] Moriyama, like Naitō, placed himself in the genealogy of those who are compelled to represent Tōno, photographically or otherwise. Yet Naitō has returned more faithfully than most of his modernist colleagues to the occulted scenes of the folkic, not only through his photographs, but also through his copious writings: He is a well-regarded folklorist who has written a wide number of books and essays on such topics as archaic metallurgy, mountain worship and asceticism, the structure of ritual, and the temples and shrines of Tokyo.[14]

The irreducible feature of Naitō's photographs is their black-and-white darkness. A relentless, fathomlessly dense blackness pervades his photographs, a blackness which is not thereby relieved by the astounding contrasts picked out by his camera's strobe. On the contrary, the blackness becomes the product of the light itself, as his strobe, pointed into the blackness, allows the dark to manifest. His photographs produce a flashed darkness, a darkness made visible. The contrast between the lights and

the darks of a Naitō Masatoshi photograph is almost unbridgeable. Daytime photographs are hardly less suffused with darkness than his nighttime shots explosively illuminated by flash. It is often impossible for the untutored viewer to tell whether a photograph was taken in the daytime or the nighttime, as day for night becomes the dictum of this world.

Naitō shot most of his photographs of Tōno from 1971 to 1975; they were first serialized, as is often the case in Japan, in photography magazines. The photographs were later assembled and published in 1983 as *Tōno monogatari: Naitō Masatoshi shashinshū* (The Tales of Tōno: The Collected Photographs of Naitō Masatoshi). The photograph of Fujikura's descendant is part of the collection, and each photograph is evocatively referenced to the locales—the hamlets, mountains, rocks, shrines—of the Tōno region, with names that have become resonant from generations of literary and visual critics repetitively performing the same textually referenced pilgrimages. It is in the afterword to this collection that Naitō wrote of the flash:

> At that time [the early 1970s], I used strobe [*suturobo*] in a very focused manner. Nowadays, such a technique has become quite typical, but at that time, it hadn't gone beyond being one specialized technique for newspaper photographers. I was the first person in the world to use strobe in a conscious, focused way as photographic expression. With this series [on Tōno] that I started in 1971, I expanded the range of use of the strobe from focusing on people and things to landscape—I didn't know if the light from the strobe would reach the surrounding landscape or not. In my first attempt, the landscape floated up from the center of the darkness in the instant of the flash, and in truth it was a thrilling experience.[15]

This is a grand claim that Naitō makes, that he was the "first person in the world" to use strobe "as photographic expression." From the hyperbole of that claim, we grasp the fetishized place of flash in Naitō's photography, and it is to flash that I want to turn, for relatively little has been written about the theoretical (as opposed to the technical) force of the flash in photography. This scarcity of reflection is allied with the uncomfortable place that flash occupies within the photographic imagination. "Of all the technical aids, it is certainly the use of flash that has caused the most controversy among photographers, to the extent that some of them dislike admitting its use and avoid it in all their personal work"; so writes Sue Davies in her foreword to the exhibition catalogue *Floods of Light:*

Flash Photography, 1851–1981.[16] That exhibition was dedicated to showing the varieties of flash and to rehabilitating flash from its derivative status — a substantial labor. For as Cartier-Bresson advised readers of *Photography* magazine in December 1955, "And no photographs taken with the aid of flashlight either, if only out of respect for the actual light — even where there's not any of it."[17] Even more starkly put is André Kertesz's formulation in a 1982 interview: "Flash killed the original ethic."[18]

Flash operates as a supplementary source of light, a source that fills in or adds to natural light, the "available light," in those dire instances when there is not enough light available (although Cartier-Bresson advised that no light at all was preferable to flash light). "Respect for the actual light," even when there is no light, was an initial imperative for the photographer as artist. The use of flash as addition and replacement is the classic technique of the lowly press photographer, with Weegee (Arthur Fellig, 1899–1968) the exaggerated exemplar. Many news photographers use a flash without thinking about film speed (thus Naitō's reference to news photographers as somehow outside the artful realm of "photographic expression"). That, indeed, is what a flash is fundamentally for: it illuminates the whole scene. But in the photographic formulations of art photographers invested in distinguishing themselves from press photographers (and thus invested in the distinction between aesthetics and documentation), flash operates not as a helpful prosthesis, extending the light, but as a dangerous supplement.[19] That which is supposed to add to and fill in instead replaces and renders obsolete the naturally existing domain it was intended merely to assist. The manifestation of such artificial light and its powers calls into question the very clarity, sufficiency, and completeness of actual light; if actual light were all it should be, then artificial light would not be necessary. Flash light thus instates a condition of loss in its very employment, at least in the photographic imagination as revealed by Cartier-Bresson and Kertesz. It exposes the insufficiency of light-as-it-is, and its ability to augment this insufficiency artificially is no consolation for those dedicated to real light, available light. In a technological relationship not unlike that between speech and writing, the domain of the natural is exposed as opened to prosthetic supplementation, and thus to a profound undoing (and thus to profound nostalgia).

Flash indeed "kills," as Kertesz would have it. It is no accident that flash has at its origins the suggestion of violence. If photography in and of itself registers loss by its imaging of the once-there, flash light intensifies that loss by its supplemental punctuation of the moment when the

image falls away from the referent. That intensification is a recent one, but thoroughgoing in its implications. Only around 1930 did flashbulbs come into wide use, and five years later synchronized flash emerged. As David Mellor states in his indispensable essay, "The Regime of Flash," "This technological change did far more than license pressmen to photograph in poor light, in dark streets or interiors, and still be confident of obtaining a serviceable negative. By changing the codes of lighting it also displaced virtually all the other prevailing photographic codes of time and space."[20] The flash-lit landscape—the emergence of night— went together with new technologies of surveillance and the rise of the totalitarian state.[21] The abrupt illumination of the strobe was always accompanied by the explosive pop of the flashbulb, inevitably referencing a violence linked to bombs and warfare (press photographers were called "flashgunmen"). With electronic flash the unnerving sound of the flashbulb was silenced, but not the explosions of light that still intensified the photographic moment—and not the residual click or hum that still accompanies any photographic event, even a digital one.

The career of Harold R. Edgerton illuminates the articulation of flash with violence in a startling way. An engineer and inventor of a distinctly American cast, Edgerton is famous for his work at MIT in developing high-speed strobe flash technology. He used this technology for photographically freezing "dynamic events" in action: the coronet a drop of milk makes when it hits a liquid surface, a speeding bullet, a hummingbird in flight (a hummingbird's wings beat fifty-five times per second). To stop motion, to stop time, a series of stroboscopic flashes is needed (thus the enigmatic relationship of time and motion to light). Edgerton worked on providing flash units for surveillance aircraft during the Second World War, but it was in the postwar period that some of his most important work occurred. Having formed a corporation with two other engineers, Edgerton was hired by the Atomic Energy Commission to carry out the "design and construction of timing and triggering systems for atomic bomb tests." He and his firm were thus responsible, through their refinements of flash technology, not only for developing the triggering systems, but also for almost all the photographic images in the early nuclear era of harrowingly spectacular mushroom clouds rising above the island test sites of the Pacific.[22] The ultimate in Edgerton strobe technology— the so-called RAPATRONIC camera, which could makes exposures as short as 1/1,000,000 of a second—was used to photograph the ultimate flash itself: an atomic explosion. The brilliance of the *pika*, the flash, accom-

panied by the *don*, the explosive boom, of the bomb over Hiroshima has been repeatedly described by survivors of that August day in 1945. The apogee of flash technology, in more ways than one, the atomic bombs used on Japan situate postwar Japanese photography in an overdetermined relationship to the supplemental aesthetics of flash.[23]

I bring up the degree zero of flash — nuclear brilliance — to return to Naitō and his place as a Japanese photographer of postwar Japan and his obsession with using flash to reenchant the rationalized landscapes of late modernity. Moving the supplement into the place of primacy, Naitō doubles this technique by thematically focusing on what we might imagine as supplements to the Japanese modern, the residual places that nevertheless come to occupy crucial positions in the formation of national culturalism in modern Japan. Tōno is one such critical place, maybe none more critical. And Tokyo, by its very centrality, also becomes open to Naitō's supplemental aesthetics of enchantment.

Although strobe is the dominant technique in Naitō's photographs (and in his exegesis of his photographs), he uses flash in conjunction with other techniques to create an ambiguity.[24] There is a movement to achieve a balance between flash and ambient light; one means to attain this balance is to underexpose and overdevelop the film. In other words, the photographer "pushes" the film; by using 400-speed black-and-white film, for example, and a shutter speed that is too fast for it, the film is treated as though it were 1600- or 1800-speed. The film is then overdeveloped, and the grain of the photo is thus exaggerated: the silver clumps together because the photos stay in the developing solution longer than they normatively should and more grain develops. Another effect of such pushing of the film is that it amplifies the contrast that is there: blacks are blacker, whites whiter. With the use of high-contrast developing paper, more contrast develops at the outer ends of the spectrum of tones, with distinctions between shades of gray dropping out. In short, what emerges are starker contrasts. Thus, the darkness seems to crowd in as a feeling of massive density is created. The photographs seem unframed, as some commentators have noted, with blackness seeping in from the edges. In viewing a Naitō photograph compared to one by Weegee (the American photographer who emblematically represented the "flashgunman" with his shocking New York City street photographs), one observer stated, "When I look at a Weegee photograph, I feel that what I see in the photograph extends beyond the frame; I imagine that I'll just see more along the lines of what's there. When I see a Naitō photograph, I can't imagine

that; I can't extend the photographed image. I only envision blackness around it."[25] This observer echoes exactly what others have felt when they remark on the abyssal darkness of these photographs.

The use of artificial light in photography has a long history, from Nadar's chilling photographs of the Paris catacombs in 1865 with magnesium light, to Jacob Riis's illuminated shots of the destitute of New York, to Bill Brandt's dark images of postwar English life (it is perhaps Brandt's photographs that come the closest to Naitō's). So is there more to Naitō's insistence on his originality than simple hyperbole, compounded by a feeling of occupying a peripheral position in the history of global photography (peripheral, that is, as a Japanese person)? Perhaps when Naitō marks his originality, he might be pointing to the fact that he uses flash in conjunction with pushing the film, as he plays the ambiguity between just using a flash and not pushing the film to get dark effects, and using a flash and pushing the film. It is this combination, this play on ambiguity, that might indeed have been unusual, or unusual to thematize, circa 1970. His photography thus serves as a metacommentary on flash.

What more of flash? The flash itself becomes an event that punctuates the before and after of the photograph, the historicity it references and the future viewings it anticipates. And this punctuation always has about it the suggestion of trauma. If the photograph, with its "dynamite of the split second," violently discloses the "optical unconscious," the photoflash doubly intensifies that moment of disclosure as blinding event (the flash is always an explicit event for the human subject, revealed by the role of the blink, if nothing else).[26] I can always remember the tensing for the photograph at family gatherings, the fearful anticipation of the burst of light (for the interior shots were always flashed), the effort not to blink, and the additional anticipation of the developed photograph itself, wondering if it would show my eyes open, perhaps this time. The blink itself (and the record left of the closed eyes, or the half-opened ones) marks the delicate calibration of past and future, the attempt to be awake for the moment and the difficulty of doing so. The fate of the blink indicates the historical vicissitudes of synchronized flash, now refined by the digital pulsations of red light that precede the actual flash in the hopes of reducing blink (or "red eye").

In Jean-Martin Charcot's photographs (or, rather, the photographs that Charcot commissioned) of hysterics at the Saltpêtrière Hospital in late nineteenth-century Paris, the improbable poses of the patients were frozen by mortifying bursts of flashlight. In the attempt to catch unsus-

pecting hysterical patients "in the act," and thus expose their incorrigible theatricality, the photographer's flash did nothing more than reveal bodies made rigid by a blinding light suddenly released in a darkened chamber. As Ulrich Baer has clarified, the flash opens up a gap between the present and past of the event; making the event visible, it allegorizes that gap. It also allegorizes the gap between perception and cognition, in Baer's terms: the gap between the moment of the flash and cognition, which can only be retrospective. The surprise of the flash can disaggregate the two, in a kind of traumatic intervention that doubles the hysteria it was employed to record, in the case of Charcot's experiments.[27] The flash marks a rupture in temporality that exceeds the break that photography with available light institutes, and the *ambiguity* or difference between available light and flashed light recapitulates the temporal divide between past and present, as light, motion, and time convene in the moment of the flashed image.

These ambiguities, which Naitō exploits, are deeply allegorized by the thematic topoi of his gaze: conventionalized, but not stabilized, Japanese sites of darkened premodernity (and, in the case of his photographs of Tokyo, of putatively enlightened high modernity, now rendered explicitly darkened). The ambiguity is doubly allegorized by Tōno as the name for a site that marks a temporal split in the conception of Japanese modernity. It marks other substantial divides: Tōno is also the referent for a text that located an undecidable difference between literature and ethnographic science (*The Tales of Tōno* is claimed as canonical by literary scholars and ethnographers alike) and a text that powerfully delineated significant differences between speech and writing in early twentieth-century Japan.[28] The symptom formation of native ethnology itself attempts to illuminate, in the mode of textual and visual documentation, obscurities that preceded modernity's flash.

When Naitō presents his flashed images of Tōno (and always we think of Yanagita's text), there is a redoubling of technique and object, of technology and aesthetics that lends considerable force to his photographs. How is technique related to the aesthetic object? When asked why he uses flash so exclusively, Naitō has replied pragmatically: because all those old temples and shrines in northeastern Japan are so dark. Yet we know that a photographer who has made so much of the notion of phantasm (*gensō*), of the magic of photography, would not be ultimately limited by the pragmatics of darkness.

The flash illuminates, massively; it is the hypersign of enlightened dis-

enchantment. Yet Naitō's flash (and his fantasies about his flash) works to reenchant by that very excess of light. We find in Tōno, not unlike Charcot's hysterics, the perfect subject for the temporal division that flash opens up. That is because Tōno names a kind of impossible site in Japanese modernity: a site which had to be overcome in order to be modern, and a site which could never be fully relinquished for that very reason. It named that which was saturated with a darkness before the rupture of modern Western enlightenment (and the enlightenment of the modernizing Japanese state), but it was a darkness known only retrospectively. It is the technical and thematic recursiveness in Naitō's photographs of Tōno that compels — perhaps too much so. One colleague, on viewing these photographs, called them "crude"; later, elaborating on his initial impressions, he stated that the photographs bear this message: "So you want the aura — here it is." The aura would be that which inhered in the cultic object before mass technological reproducibility, such reproducibility being the very hallmark of photography. It is as if the excessiveness of flash catches modernity "in the act," in the moment of its theatrical attempt to cover up its impossible origins. As Baer states, "Photography did not only make certain 'hysterical' symptoms suddenly readable; it also supplemented hysteria's already extensive symptomatology by creating entirely new symptoms brought to light by the flash."[29] In the gap between those origins and the time of their manifestation, between perception and cognition, auratic remainders shine through. But here, not as a nimbus around the image or as the wrenching realization of the effect of a distance. Rather, the auratic remainder appears vivid, sinister, stark, crude: the produced effects of *camera noir* and its flash light.[30]

The metaphor of enlightenment is surely one based on the notion of available light, not the denigrated blast of artificial light the photoflash represents. With photoflash, we get the revelation of moments and objects unseen, yes. But there is also the emergence of blackness not visible before and foreground objects blanched by too much light: an intensification of darkness as the surround of hypervisibility.

In the photographs of Tōno we see the appearance of flashed darkness as it emerges as the counterpart to the darkness of the enlightenment that Tōno has negatively evoked. The photographs from Tōno are divided into three sections in Naitō's volume: the living, the dead, the gods. It is in the photos of the living, many of which were taken outdoors, that one can see most clearly the effects of Naitō's strobe and the way the distant landscape becomes the blackened focus of his camera. The bursts of light

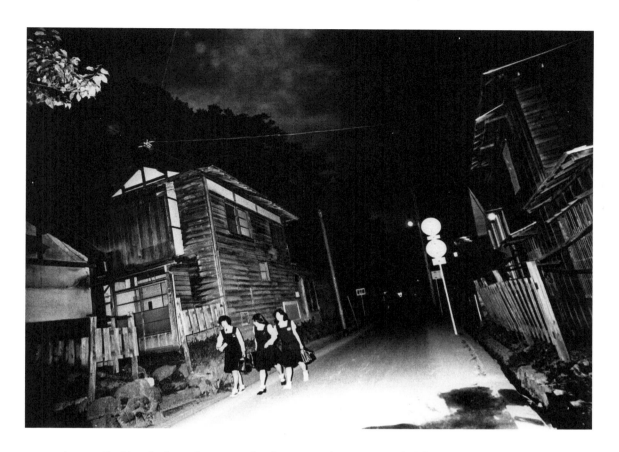

2. A Tōno neighborhood, 1975. From Naitō Masatoshi, *Tōno monogatari: Naitō Masatoshi shashinshū* (Tokyo: Shunseisha, 1983).

that eerily bleach the subjects in the foreground seem intended less to illuminate them than actually to produce the blackness of the surround, and the whites that are set off in contrast are almost radioactive in their intensity. The faces and forms of the living, those inhabiting this world, emerge out of the blackness as if they could be drawn back without resistance. Schoolgirls walk home in ominous darkness (fig. 2); a farm woman seems to be sitting on a sofa in the middle of the road at night (closer viewing reveals a horse-drawn cart; a pickup truck lies on its side by the road; fig. 3); the left hands of farmers at an awards ceremony glow white while their right hands remain shadowed (fig. 4); teeth gleam in a preternatural twilight (fig. 5). When landscape becomes Naitō's aim, he allows the rapidly attenuating burst of light to cover faraway hills or trees with a wash of grays and charcoals (it was the turning of the flash onto the landscape to see what would "float up" that constituted the initial thrill of originality for Naitō; fig. 6).

Naitō composed an entire series of photographs of prewar portraits of the dead, paintings that hang in the temples and homes of Tōno to

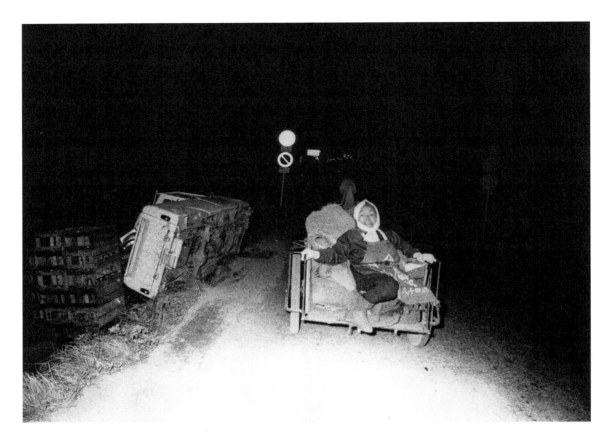

3. In the vicinity of
Kamigumi, 1971. From
Naitō Masatoshi, *Tōno
monogatari: Naitō Masa-
toshi shashinshū* (Tokyo:
Shunseisha, 1983).

commemorate the departed. Not until after the Second World War were photos the norm for these memorial portraits; oil, pencil, and charcoal paintings predominated before then. With these images we have photographs of portraits, portraits that insist that they are analogons of others who were present too, but who are now dead. Even more, the portraits are expressly memorial portraits, portraits that are displayed to memorialize the dead. Their presences, and thus their absences, are doubly recalled by the photograph: phantasms through the medium of phantasm.

And how to evoke the gods? How to represent them? Here, the gods (*kami*) appear as things: masks, plaques, carved statues, scrolls, strange phallic rocks, a woman's long black hair hung from a temple rafter. The objects are often decaying, in the last throes of dissolution, virtually embodying that decay of the aura that Walter Benjamin identified. They emerge as veritable fetish objects, reinvested as such by Naitō's camera as itself fetishized (fig. 7).

Ending with the evocation of gods in his photographic itinerary through Tōno, Naitō returns to the imagined territory of the premod-

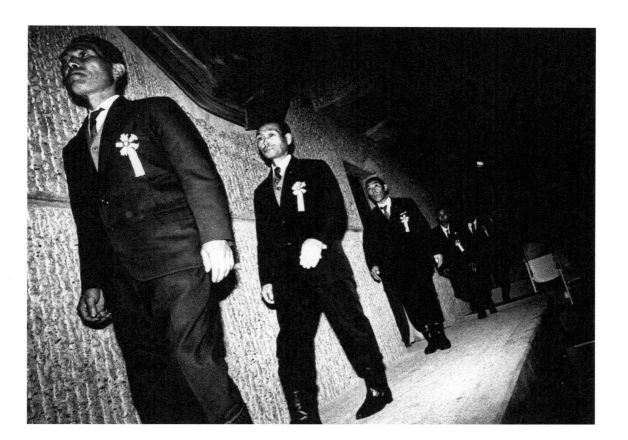

vern countryside. Yet the difference between available light and artificial light, between natural light and its supplement, reproduces in yet another way the gap between the country and the city, a foundational dualism in modernity in Japan and elsewhere. In his photographs of Tokyo, Naitō compounds that gap in ways that recapitulate the split that flash photography embodies. He writes of his photographs of Tokyo as attempts to draw forth the magical traces of Edo in the late modern megalopolis. Whether the object is Tōno, a site which has performed as a counter-modern exemplar, or Tokyo, the modern exemplar, both are reimagined as phantasmatic landscapes in which photographic darkness reminds us of the role of light — and enlightenment — in the habitations of modernity.

Anthropologists such as Kurimoto Shin'ichirō have spoken of Tokyo itself in terms of light and dark — a city of light, a city of darkness — in their structuralist excavations of the power-differentiated domains of Edo. In the Tokugawa period (1603–1868), the city was differentiated according to a calculus of purity and pollution, in which burial sites, exe-

4. Awards ceremony, 1971. From Naitō Masatoshi, *Tōno monogatari: Naitō Masatoshi shashinshū* (Tokyo: Shunseisha, 1983).

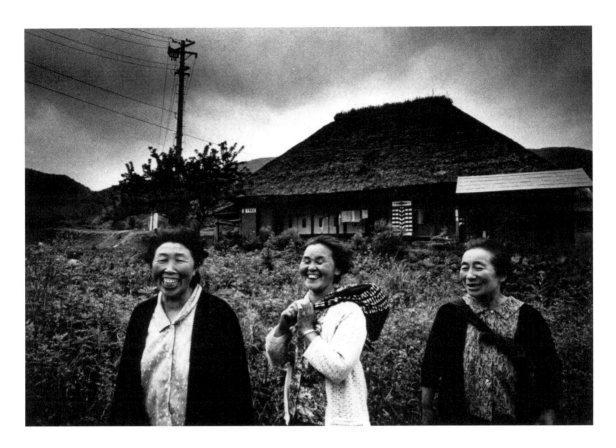

5. Going out to a funeral, 1975. From Naitō Masatoshi, *Tōno monogatari: Naitō Masatoshi shashinshū* (Tokyo: Shunseisha, 1983).

cution grounds, theater districts, and prostitution areas were demarcated and segregated from the domains of light, in Kurimoto's terms: domains of administration, commerce, and samurai neighborhoods. Temples and shrines formed a nexus of magical "power points," according to Naitō and other folklorists, and Chinese-derived directional and geographical magic laid out the location of these sites.

It is this sort of ordering that is overturned with the formation of the modern city, in which capitalist social relations and bureaucratic rationalities work to neutralize earlier differentiations with the impersonalized logics of the market. Although the history of Edo still structures residential patterns in Tokyo today (an uptown/downtown distinction still obtains, with the uptown area considered higher class), the particular semiotic richness of Edo no longer structures the grids of Tokyo. Or so it might seem, but not to Naitō, who wants to secure the magical traces of Edo in the cityscape of late modern Tokyo, discovering the city of darkness as he manifests it in his tenebrous photographs (fig. 8).

Thus his collection of photographs of Tokyo, shot from 1970 to 1985,

is titled *Tokyo: Hallucinating the Darkness of the City* (Tōkyō: Toshi no yami o genshi suru). Darkness becomes the literal trope of modernity's other, the underside of civic enlightenment and progressive history. If Tōno epitomized that other in the rural, primitivist mode, while thus becoming the strange exemplification of Japanese tradition at its most essential, Tokyo (or at least a certain Tokyo) becomes the margin at the center, a veritable heart of darkness within the late modern megalopolis.

To quote from Naitō's commentary on the photographs:

> In this megalopolis we call "Tokyo" I sometimes find here and there dark crater-like spots. Right below some neon sign there may be a certain darkness that makes me think of the mysteries of the black hole. Perhaps it is there, in that obscurity and mystery, that the real psyche of Tokyo is hidden, and can be discerned.
>
> In the past, the Japanese believed that there existed another place (another scene), a marvellous dark site, somewhere outside: in the mountains, far from where the people dwelt. . . . These "dark," "hid-

6. From Sasaki Kizen's grave, 1972. From Naitō Masatoshi, *Tōno monogatari: Naitō Masatoshi shashinshū* (Tokyo: Shunseisha, 1983).

7. Portraits of the dead, 1972. From Naitō Masatoshi, *Tōno monogatari: Naitō Masatoshi shashinshū* (Tokyo: Shunseisha, 1983).

den" refuges fed the Japanese with a tremendous spiritual vitality. . . . In the many pictures I have taken in these past sixteen years, I have often found remnants of Edo that still lie imprinted beneath the surface of Tokyo. Edo, a darkness that yet shines, continues to reveal the depths of the mind. . . . Here, I have striven to depict, to reveal these deep, dark, and complex elements of Edo . . . an ever-lasting Edo we now call "Tokyo."[31]

It is important to emphasize how standardized and orderly city life is in Japan, in which the great majority of the population claim middle-class status (however misleading that claim might be) and virtually full literacy obtains. Japan also has had one of the lowest crime rates of the advanced industrial nations, and the safety of the streets and the subways has been legendary (notwithstanding the poison gas subway incidents of 1995 and more recent instances of random violence). With that kind of security and safety, of course, comes the diminution of danger, of difference, and of certain erotic possibilities of the city. To find those "spots of darkness" in

Tokyo today is to find those instances of poverty, deprivation, and crime that are less visible, less common than in American cities, say.

Thus, Naitō's photographs of Tokyo come close thematically and visually to what we might imagine as press photographs in their attempts to capture city life in its eventfulness, where such eventfulness usually means crime, accidents, or the untoward. Indeed, many of his photographs of Tokyo center on precisely those subjects. Naitō, in contemporary Tokyo, works to create an image of lost aura (what aura would look like if there were still aura) with his themes of disaster, homelessness, indifference and pleasure, working-class eroticism, and the grotesque as the everyday transformed.

It is revealing that Naitō states that, except for his own work, use of the flash was generally restricted to press photographers in the 1960s, and that he asserts that he was the first photographer in the world to use this technique artistically. Revealing because Naitō's photographs of Tokyo remind one, in all their referencing of urban press photo sensationalism and their reliance on flash light, of the photographs of Weegee,

8. Skyscraper, Shinjuku, 1983. From Naitō Masatoshi, *Tōkyō— Toshi no yami o genshi suru: Naitō Masatoshi shashinshū* (Tokyo: Meicho Shuppan, 1985).

the "greatest crime photographer of all time," a reputation secured in his years of capturing eventfulness in New York. Weegee epitomized the flash photographer, with his quasi-magical power to be at the scene before events unfolded, in anticipation of the unearthly speed of the strobe itself (thus his name, "Weegee," from the Ouija board). In later years, his fame led him to tour the United States; on one tour, people called in to the radio station and begged him not to come to their neighborhood. It was imagined that if he showed up with his camera, an awful crime would occur — one which he would, in effect, cause. These apocryphal stories and many others point to Weegee's relationship to his camera as fetish.

Naitō speaks of his camera as an implement of enchantment, a sorcerer's tool, and in this he comes close to revealing his own notion of the camera as fetish. (The Japanese terms reinforce this analysis: Naitō uses the term *jugu* to refer to his camera in this way; the closely related *jubutsu* is a term used to translate "fetish.") He theorizes his own photographic practice, revealing a mystified relationship to it, in his desires to imagine a continuity with premodern, magical forms of representation, as he moves back and forth across the epistemological break that the technology of the photograph institutes.

Weegee's photographs were the epitome of press photographs, mass images taken only to sell, pure commodities (he would make the rounds and sell them to different newspapers). His photographs were the antithesis of art, and as mass images they took part in that vast "democratization of the image" that the photography critic John Tagg documents.[32] What this democratization entails is an instrumentalization of everyday life. In a mass-produced milieu, and to the extent that democratization is actually effective, the everyday loses its value: it is no longer erotic, if by erotic one means the power of difference to attract.

Weegee attempted to reeroticize the American city and its everydayness, and the only way this could occur was by recording what irrupted into everyday life. To represent those irruptions, to photograph shock, is what the spectacular press photograph is all about: an attempt to capture singularity at the core of mechanical reproduction. For this, Roland Barthes's meditations on the press photograph — on the press photograph's hyperrealism, its brute facticity — are reliably provocative: the press photograph is fully invested in denotation, in the sense that the photograph seems just to denote what is there. The black-and-white press photograph represents pure denotation, without style. (There is a need to rethink the press photograph, particularly since that staunch upholder of

front-page black-and-white photographs, the *New York Times*, gave in to the imperatives of color years ago.) As such, the photo serves as the alibi, as the anchor in reality, for the text of the associated newspaper story, where connotation—secondary interpretative procedures—then embellish the photo. The photo is crucial—the black-and-white photograph, rather, which announces itself as a press photo—because it makes the story seem as if it must be true by its linked presence on the same page.[33]

Weegee's photographic practice relied on the discovery of trauma, on events which ruptured the fabric of instrumentalized urban life and which could momentarily stop the process of connotation (thus Barthes's definition of a traumatic photograph as pure denotation).[34] His explosive flashes of light could come under the domain of trauma, producing as much a sense of shock in the objects of his voyeurism as the crime or accident itself.

Naitō's photographs of Tokyo also seek to recover a poetics of contingent shock, of the city's found subjects: homeless person, police raid, beggar. With the preceding remarks on Weegee in mind, we can see Naitō's photos as simulacra of press photographs, as attempts to use the style of press photos (those photos which allegedly are without style) to push the limits of denotation. His use of wide-angle lenses brings a surreal expansion to the scenes of the city (again, the grotesque), and his overdeveloping of his film to get a grainy texture simulates the graininess of the printed press photo (figs. 9 and 10). The contrasts and textures remain startling, spectral and spectacular, particularly in the night shots with massive flashes of light.

Perhaps Japanese photographers, at least until recently, have had a closer affinity to press photographers because of their relationship to the printed page. Japanese photographers usually exhibit their work serially in photography magazines and journals (of which there are many in Japan). Their relationship to the printed page is strikingly different from that of American photographers, who fetishize the print for exhibition. When one thinks of the flash in conjunction with the printed page, the vocation of artificial light becomes clearer. At New York's International Center for Photography show of Weegee's photographs in 1997–98, I saw only one framed newspaper clipping of a Weegee photograph, a famous one of a couple holding an armful of clothes after escaping a fire.[35]

In the printed or exhibited form, the photo is massively black and white, deeply saturated. In print, and on the yellowed paper that reveals the erasure of such contrast, the tones are gray and more gray, ever more

9. Crouching vagrant, Tsukiji, 1971. From Naitō Masatoshi, *Tōkyō— Toshi no yami o genshi suru: Naitō Masatoshi shashinshū* (Tokyo: Meicho Shuppan, 1985).

ephemeral and indistinct as time goes on. At the Weegee exhibition I was reminded of the massive contrasts necessary for print journalism, for printed impact. The aggressive violence of the flash has been deemed necessary to produce the contrastive shock — thematically, technically, and temporally — that compels the mass commodity to circulate. The materialities of newsprint, techniques of printing, ink, and paper systematized through technologies of mass reproduction, have been intimately enmeshed with the photographic apparatus of flash.

But Naitō's photographs are inserted into a regime of representation different from the regime that Weegee's photos inhabited. They do not bear the burden of verifying the truth of captions in newspapers as mass purveyors of truth. Naitō's photographs, like most photography in Japan, were originally published in photography magazines, then reprinted with all their glossy possibilities as photography books. Urban trauma was common, but still not everyday, in 1930s New York; such eventfulness is less accessible today in Japan, and the search for traumas to

represent more difficult. Weegee's photographs are filled with corpses; Naitō's aren't (as disturbing as these photographs are). Instead, we find only quasi-corpses: drunks, homeless people sleeping. Naitō's photos are restylings of press photographs, those photographs that he claims specifically fail to incorporate the expressive powers of flash. In his stylization, we can see the connotation procedures right in the textures of denotation, that connotation that Barthes said was typically felt to be missing from the press photograph, with its dependence on the photograph as an analogon of reality.[36] Indeed, through Naitō's writings, we are not at a loss to understand what those connotations might signify. To recover the city of darkness, he has formed a photographic practice itself based on darkness; he works to materialize darkness through the photographic flash. As such, photography as the mechanical yet inevitably haunted reproduction of irreducible moments doubles the themes of Naitō's photographs, obsessed as they are with the spectral residuum of a haunted modernity. Both Weegee and Naitō have labored, in their urban

10. A vagabond at flower-viewing time, Ueno, 1983. From Naitō Masatoshi, *Tōkyō — Toshi no yami o genshi suru: Naitō Masatoshi shashinshū* (Tokyo: Meicho Shuppan, 1985).

11. Adult toy store, Shinjuku, 1970. From Naitō Masatoshi, *Tōkyō—Toshi no yami o genshi suru: Naitō Masatoshi shashinshū* (Tokyo: Meicho Shuppan, 1985).

photographs, to find what is repressed in industrial capitalism, and they see the city as the ground for the production and circulation of the mass image. But for Naitō, the name "Edo," Tokyo before it became Tokyo, emerges to anchor this circulation through the magical traces of archaic singularities (one wonders what the analogue for New York City would be). And the poetics of pika, the atomic flash, can never be fully evaded in a photography that identifies itself with the place of Japan as fully as Naitō's does. Naitō has invested in dualities of dark and light, of black and white, that nevertheless fail to keep the shadows away. In the most improbable photograph of the Tokyo series, we see through a lit window a woman's outstretched legs, suspended as if in a pirouette in midflight or in an unearthly leap toward the ceiling. We don't see the upper half of her body (fig. 11). In the photographs of Tōno's gods (kami), one shot lights up what appears to be the ripped wallpaper of a room, disclosing layers of newsprint underneath (fig. 12). The supplement of the flash exposes auratic decay; deities find themselves in traumatic suspension. In his attempts to capture this decay and its stasis, Naitō reveals how inescapably

modern he is. For the recovery of the auratic is imaginable only from the perspective of its loss, and the countries and cities of darkness emerge only in the afterimages of their enlightenment.

12. Deserted house, 1971. From Naitō Masatoshi, *Tōkyō — Toshi no yami o genshi suru: Naitō Masatoshi shashinshū* (Tokyo: Meicho Shuppan, 1985).

NOTES

My gratitude to Professor Naitō Masatoshi for his kind generosity in giving me the permissions and prints necessary to reproduce his photographs; my gratitude also to Yukiko Koga for her assistance with Japanese-language correspondence with Professor Naitō. I would like to thank the audiences and interlocutors at Amherst College; Cornell University; University of California, Berkeley; Harvard University; New York University; McGill University; and the Art Gallery of Ontario who engaged with my work on Japanese photography over the past several years. I would particularly like to thank Andrew Gordon, Harry Harootunian, Thomas LaMarre, Samuel Morse, and Alan Tansman for their invitations to present this work.

1 All photographs of Tōno used in this essay were previously published by the photographer Naitō Masatoshi in his volume *Tōno monogatari*. The photographs

reimagine many of the sites made famous through their depictions in the foundational 1911 literary compilation of folktales and legends, *Tōno monogatari* (The Tales of Tōno), written by the so-called father of Japanese folklore, Yanagita Kunio. The legend of the founding of Hayachine Shrine by Fujikura is relayed next to its photographic instancing on page 28 of Naitō's book. All translations are mine unless otherwise noted.

2 Japanese names are given in Japanese fashion, with surname first, unless quoting from a text or giving a citation where a name is used in English-language fashion, with surname last. Thus, when I discuss the photographer Moriyama Daidō, I do so with his surname first; when I give the title of an English-language catalogue devoted to his photographs, however, his name appears as Daidō Moriyama.

3 See my book *Discourses of the Vanishing* for extended engagements with the haunted dynamics of Japanese modernity and its dialectic of revulsion toward and nostalgic desire for a precapitalist past.

4 Naitō was included, for example, in the exhibition and catalogue *New Japanese Photography* by John Szarkowski and Shoji Yamagishi, which was the first extensive attempt to present a survey of contemporary Japanese photography to a non-Japanese audience. There were fifteen photographers selected, and Naitō was one of them. He has also won major photography prizes in Japan. Naitō does not enjoy quite the international reputation of such photographers as Fukase Masahisa and Moriyama Daidō, however, two of his contemporaries.

5 Historians of Japanese folklore studies, such as Gerald Figal and Alan Christy, have expanded the range of our knowledge about minzokugaku, placing the discipline within a larger field and moving the focus away from Yanagita (and Tōno, for that matter). They argue that there has been too much focus on Yanagita and his *Tales*. While it may be true that Tōno has been misrepresented as the canonical departure point for folklore studies, what is critical is not whether Yanagita really was the sole founding figure of minzokugaku (or whether *Tōno monogatari* was really the founding text). What is crucial is that Yanagita and his *Tales* have been discursively situated as singularly foundational, in both the popular and the academic imagination. Certainly the visual power of Tōno, its seductions for several generations of postwar photographers, has resided precisely in this canonical insistence that the site is *the* homeland of Japanese folklore studies, with Yanagita the undisputed founder. See Ivy, "Ghostlier Demarcations."

6 There are many works on *genbunit'chi*, the "unification of the spoken and written languages," and its implications not only for literature (and folklore studies), but also for politics and policy. I have written on this relationship of writing and speech in *The Tales of Tōno* and their parallels in distributing the differences between literature and ethnography in "Ghostlier Demarcations."

7 See the published English translation by Ronald Morse of Yanagita Kunio, *The Legends of Tōno*.

8 Mishima Yukio, "Tōno monogatari" (Tales of Tōno), *Yomiuri shimbun*, 12 June 1970.

9 Freud theorized trauma (classically as childhood sexual trauma) as coming into conscious awareness only after a temporal deferral, such that the time of its re-

membering really constituted the *first* time; traumas are not really experienced, in this model, at the time of the occurrence but only afterward (thus Freud's notion of *Nachträglichkeit*, or "deferred interpretation"). Taken from the surgical notion of an external wounding of the body, psychic trauma, in Freudian terms, spoke of external sources of injury, but coupled this understanding of externality with considerations of "predisposition" to trauma. Trauma thus emerges from the Freudian corpus as always doubled, split in both its temporal and spatial possibilities. Freud's *Studies in Hysteria* (1895) marked one of the earliest usages of that term in his writing. It also plays an important part in his *Introductory Lectures on Psycho-Analysis* (1916–17); his crucial rethinking of trauma defines *Beyond the Pleasure Principle* (1920). My understanding of trauma relies on Laplanche and Pontalis's *The Language of Psychoanalysis* as well as their equally valuable *Life and Death in Psychoanalysis*.

10 Harry Harootunian's works are groundbreaking for their theorization of modernity and different forms of contemporaneity. See particularly *Overcome by Modernity* and *History's Disquiet*.

11 Following Max Horkheimer and Theodor Adorno in their *Dialectic of Enlightenment*, I keep in mind how enlightenment produces its own darkness through a dialectical movement in which rationality, when most fully realized, proves to be irrationality unbound. Enlightenment is never free from its constitutive darkness, but only imagined to be, and only desired to be. Those attempts to purify enlightenment, to accomplish fully the project of modernity, produce the opposite: "The wholly enlightened earth is radiant with triumphant calamity" (1).

12 Tanizaki, *In Praise of Shadows*, 34.

13 Moriyama Daidō's exhibition "Daido Moriyama: Stray Dog" was staged initially at the San Francisco Museum of Modern Art in the summer of 1999; after that, it traveled to the Japan Society Gallery in New York (with photographs also exhibited at the Metropolitan Museum of Art), to Switzerland, Germany, and back to Harvard University Art Museum and the Museum of Photographic Arts, San Diego, in late 2000 and early 2001. See the catalogue with the same title, *Daido Moriyama: Stray Dog*, by Sandra S. Phillips, Alexandra Munroe, and Daidō Moriyama. Moriyama's book of photographs of Tōno was published as *Tōno monogatari*.

14 Naitō's most recent books, for example, continue this obsession with indigenous magicality. One is entitled *Nihon "ikai" hakken*; another is *Nihon no miira shinkō*, the latest expansion of his long-standing obsession with so-called *sokushinbutsu*, ascetic practitioners who were able to starve themselves and preserve their corpses from corruption (thus their designation as "mummies").

15 Naitō Masatoshi, "Atogaki" (Afterword) to *Tōno monogatari: Naitō Masatoshi shashinshū*, 150. All translations are mine unless otherwise noted.

16 Sue Davies, foreword to Martin, *Floods of Light*, 7.

17 Henri Cartier-Bresson, *Photography*, December 1955, 33, quoted in Martin, "Introduction: Angels of Darkness," in *Floods of Light*, 8.

18 André Kertesz, conversation with Rupert Martin, 28 October 1982, quoted ibid., 8.

19 Reflections on supplementation and its dangers for any regime of knowledge that would assert a presupplementary (or, rather, a nonsupplementary) realm of actuality, reality, or nature (to use three terms that might designate this realm) were most famously presented by Jacques Derrida in *Of Grammatology*.

20 Mellor, "The Regime of the Flash," 28.

21 Wolfgang Schivelbusch's *Disenchanted Night: The Industrialization of Light in the Nineteenth Century* recounts how the powers of darkness receded as cities, drawing rooms, and public spaces came to be electrically illuminated.

22 Bruce, *Seeing the Unseen*, 49.

23 Benedict Anderson first drew my attention to the necessary affinity between flash photography and the atomic bomb in Japan. Akira Mizuta Lippit has written, beautifully, about the intricate weave of technology, writing, and forms of envisioning (including the flash of the atomic bomb) in Europe and Japan. See his *Atomic Light* (*Shadow Optics*).

24 I am indebted to Christopher Brown for his invaluable help in explaining the intricacies of flash photography and the subtleties of developing.

25 Burlin Barr, comment after my presentation on Naitō's photographs at Amherst College, May 2001.

26 The notion of the optical unconscious is Walter Benjamin's. See "A Small History of Photography," 243. On the "dynamite of the tenth of a second" (referring in this instance to film but fundamentally resting on the opening first provided by photography), see Benjamin's "The Work of Art in the Age of Mechanical Reproduction," 236.

27 Baer, "Photography and Hysteria."

28 See Ivy, "Ghostlier Demarcations."

29 Baer, "Photography and Hysteria," 55.

30 *Camera noir* is a repetition of film noir, as it points to the relationship of black-and-white press photographs to the black-and-white films imagined as film noir. Alain Bergala has described how Weegee's photographs partake of the vision of film noir, insisting that "he was the only photographer of his age to cover the *other side of the path*, where his photography approached cinema, the cinema that was strictly his contemporary: film noir. . . . His way of photographing is singularly cinematic, generating fictional effects, *on the borderline* between the two territories." "Weegee and Film Noir," 72.

31 Naitō, "Tokyo: A Vision of Its Other Side," 22.

32 See Tagg, *The Burden of Representation*.

33 Barthes, "The Photographic Message."

34 Barthes's thoughts on trauma and the traumatic photograph retain their interpretative force after many years. Consider these reflections:

> Is this to say that a pure denotation, a *this-side of language*, is impossible? If such a denotation exists, it is perhaps not at the level of what ordinary language calls the insignificant, the neutral, the objective, but, on the contrary, at the level of absolutely traumatic images. The trauma is a suspension of language, a blocking of meaning. . . . Truly traumatic photographs are rare, for in photography the trauma is wholly dependent on the certainty that the scene

"really" happened. . . . Assuming this . . . the traumatic photograph . . . is the photograph about which there is nothing to say. . . . One could imagine a kind of law: the more direct the trauma, the more difficult is connotation; or again, the "mythological" effect of a photograph is inversely proportional to its traumatic effect. ("The Photographic Message," 30–31)

One could extend these thoughts, however, by wondering if the blocking of meaning itself becomes an incitement to unblock meaning and reinstate connotation in the face of its suspension. In this understanding, trauma is ever only momentary, and the movement to interpretation succeeds the moment of traumatic blockage (at least for the critic of photography).

35 The exhibition was titled "Weegee's World: Life, Death, and the Human Drama" and was organized by the International Center of Photography; it was on view at ICP from 21 November 1997 through 22 February 1998.

36 See Barthes, "The Photographic Message."

THOMAS LAMARRE

Cine-Photography
as Racial Technology

Tanizaki Jun'ichirō's Close-up
on the New/Oriental
Woman's Face

Like many European commentators in the interwar period, Tanizaki Jun'ichirō became fascinated with moving pictures and their impact on everyday life. Yet, while he shared with such contemporaries as Béla Balázs, Jean Epstein, Walter Benjamin, and Siegfried Kracauer an interest in how cinematic experience collapsed perceptual distance and brought images unbearably close to viewers, Tanizaki saw this cinematic "shock to the body" in terms of the ugliness of the Japanese face and a gap between Japan and the West. In 1934, for instance, when he recalled his past enthusiasm for moving pictures, some fifteen to twenty years previously, he remarked, "As I looked at [Onoe] Matsunosuke's pictures,[1] Japanese drama and faces seemed thoroughly hideous to me. . . . At that time, nothing delighted me more than going to see Western films at the Imperial theater or Odeon theater, and I felt that the discrepancy between Matsunosuke's films and Western ones was precisely the discrepancy between Japan and the West."[2]

In other words, for personal as well as historical reasons, Tanizaki found it impossible to think of the experience of moving pictures in isolation from geopolitical concerns that were less obvious to European commentators. Of particular importance was the sense of a quasi-colonial discrepancy between the West and Japan.[3] He expressed these concerns in terms of an experience of the ugliness of the Japanese face in close-up, or "large shot" (*oo-utsushi*), as he also styled it, which, as I discuss below, is more a problem of photography than of cinematography. In fact, in 1933 Tanizaki would also comment, "One need only compare American,

French and German films to see how greatly nuances of shading and coloration can vary in motion pictures. In the photographic image itself, there somehow emerge differences in national character. If this is true even when identical equipment, chemicals, and film are used, how much better our own photographic technology might have suited our complexion, our facial features, our climate, our land."[4] As this passage indicates, Tanizaki continued to see motion pictures in terms of the problems posed by the photographic image.

The problem of photographing the Japanese face looms so large in Tanizaki's film work that his enthusiasm for moving pictures between 1915 and 1925 can be read almost entirely in terms of an attempt to produce photographically a sublime experience of the Japanese face. He became so entranced with film that, after writing a series of film stories and essays prior to 1920, he left his career as a novelist to devote his energies fully to cinema. In two years he made four films with Kurihara Thomas (Kisaburō): *Amateur Club* (*Amachua Kurabu*, 1920), *The Sands of Katsushika* (*Katsushika sunago* 1920), *The Night of the Doll Festival* (*Hinamatsuri no yoru*, 1921), and *The Lust of the White Serpent* (*Jasei no in*, 1921). None of these films survives today. There remain only Tanizaki's screenplays and promotional stills.[5] Tanizaki ended his career in film in 1921 and returned to writing novels and plays. Yet two of his major novels center on moving pictures, one of which (*Nikukai*, 1923) tells a story about two filmmakers in Yokohama in the early 1920s, drawing directly on his experiences in film production with Kurihara; subsequent to his work in film production, cinematic experience and the photographic image remained central to his fiction. Yet after 1922, Tanizaki did not return to filmmaking. In a brief essay from that year, he remarks, "When one sees the face of a young, beautiful Western woman in a moving picture in close-up, one often gets a sublime feeling. For some reason or another this does not work with Japanese actresses."[6] In sum, if one takes his word for it, the history of Tanizaki's film work can be read as a failed attempt to redeem the Japanese face cine-photographically.

What is striking is how the discrepancy between Japan and the West is reinscribed in an experience of the Japanese face. Tanizaki's obsession points to a racial experience at the heart of the cinematic experience, and thus calls attention to a set of geopolitical concerns, specifically imperial and colonial relations. Of course, Tanizaki's fuss over rectifying the ugliness of the Japanese man can be read into a general history of Japanese consciousness of racial inferiority, which is often said to begin in earn-

est, or at least to gain greater visibility, with Natsume Sōseki's comments in "Letters from London" (and elsewhere), where he spies his reflection in a shop window and describes himself and the Japanese abjectly: "We are country-bred hicks, wild nincompoop monkeys, dwarf, earth-colored bizarre people."[7] Still, it is crucial to note how cinematic production displaces and transforms this racial consciousness in Tanizaki, quite literally magnifying it.

I here use the terms *magnification*, *enlargement*, *large shot*, and *close-up* as synonymous because Tanizaki himself, like many other commentators, uses them synonymously. Bringing the camera closer to a face (or the face closer to a camera) differs technically from changing the focal length of the lens, but for Tanizaki, as for Benjamin and Balázs, it was the general experience of a loss of perceptual distance between the viewer and the magnified face that counted.

In any event, lest one leap to the conclusion that Tanizaki's problem with the Japanese face in close-up is exclusively a matter of the disempowering ascendancy of the West over the non-West made manifest in a sense of racial inferiority, I would add that this photographic magnification marks a moment and site of power. While the photographic image appears as a site of Japanese subjection to the West in the form of racial experience, suffice it to say that Tanizaki also sees in moving pictures a way to seize their technical force, thus to redeem the Japanese face and, by extension, to rival the Western nations photographically and cinematically. This is a moment of techno-aesthetic rivalry.[8] In this respect, the photographic image, in the form of the cinematic close-up, implies a site of national and imperial rivalry in which Japan's national empire is not merely a (failed) imitation of Western national empires, but a rival formation. It is telling in this respect that Tanizaki frequently conflates the Japanese face and the "Oriental" face, and his film work often evokes Japan's colonies.

Tanizaki's film work implies a moment that is doubly colonial, concerned both with sustaining the nation's own colonies and warding off colonization by Western (increasingly American) markets, much as Kristin Ross suggests in the context of 1950s France.[9] The difference is that Japan, unlike 1950s France, was not so much concerned with retaining as expanding colonies and transforming relations to colonies in cultural and economic terms.[10] The photographic image was ultimately for Tanizaki an expression of this doubly colonial situation because it at once marked Japaneseness (as inferior) and promised to elevate and redeem it

(as rival). It is a subjective technology in the sense of a subjection that serves simultaneously to subject and to "subjectify," that is, to confer a kind of subject status.

What is more, that Tanizaki's doubly colonial "race trouble" translated into a technical fuss over close-ups of Japanese actresses recalls Paul Gilroy's comment that "gender is the modality in which race is lived."[11] Yet here too I would like to add that, while this translation between gender trouble and race trouble can be read in terms of the power of men over women (patriarchy) and the use of native women to secure and patrol national boundaries, Tanizaki's film work points to a more complex (because doubly colonial) situation. Particularly important is his use of the close-up to juxtapose the New Woman and the Oriental Woman, to produce a hybrid figure in which modernity and tradition, the foreign and the native, appear to coincide and coexist. This is surely because the figure of the New Woman, especially as mediated in photographic images in the early decades of the twentieth century, also entailed a kind of subjective technology that promised to "subjectify" women, to transform the subjected (women) into a subject position (the so-called self-aware woman).

In sum, the cine-photographic image entailed translation between race trouble and gender trouble, pointing to a subjective technology related to a doubly colonial situation. Understanding this power of the photographic image, which is predicated on its radical and practically irreducible foreignness, demands a closer look at (1) transformations in moving pictures from 1915 to 1925, (2) transformations of the New Woman in relation to the emerging film journals that circulated photos of starlets, and (3) the subjective technology implicit in the cine-photographic image, especially in the close-up, double exposure, and overlap dissolve. If Tanizaki's personal obsessions appear as much symptomatic of Japan's doubly colonial situation, as a critical response to it, it is because the structures of fantasy operative in his film work constitute a formation of desire in which the personal and the political are inseparable.

CINE-PHOTOGRAPHY

When film historians delineate the periods or stages of Japanese cinema, the Pure Film Movement (*jun'eigageki undō*) that gathered momentum from about 1915 typically signals the beginning of film as art in its own right. The pivotal year is 1917 or 1918. Iijima Tadashi, for instance, titles

the first section of his history "From the Initial Importation to 1918: Before Film Art."[12] In his history, Tanaka Jun'ichirō chooses the year 1917 as the moment of an "awakening to film art" from a "period of extravagance."[13] At this time there is also a major shift in terminology, from "moving pictures" (*katsudō shashin*) to "cinema" (*eiga*), which provides one way to get a handle on the complex transformations in film production, reception, and expression. While moving pictures is a reasonable translation for *katsudō shashin*, because *shashin* refers to photography rather than drawing or painting, *katsudō shashin* might as well be rendered "moving photographs," "motion photography," or even "action photography." In this context, because Tanizaki's interest lay primarily in the photographic, I will use yet another term, "cine-photography," which nicely captures the photographic emphasis in Tanizaki's imagination of moving pictures.

Tanaka writes that, from the Meiji period into the early Taishō period, there was no social consensus to see moving pictures as art or culture; they were seen as *misemono*, sideshow attractions or spectacle.[14] It was a time when foreign imports were rare, and newspapers and journals rarely addressed moving pictures as an independent issue.[15] Only in the second decade of the twentieth century does one see the gradual emergence of a sense of film as a distinctive form of entertainment, largely through the debates generated around the Pure Film Movement.

Most histories of cinema discuss this shift in terms of a transformation in film form or style, stressing how pure film reformers, deeply influenced by changes in European and American cinema, strove to eliminate or alter certain practices then standard in the Japanese film industry.[16] The reformers criticized Japanese films as overly static and theatrical and sought to redefine cinematic style by introducing long, medium, and close shots, in conjunction with more analytic styles of editing. They also favored new styles of acting, characterized as less theatrical and more realistic. They thus favored actresses in women's roles rather than *oyama*, or female impersonators, which was a convention of Japanese theater that had been extended to film. Reformers argued for the elimination of *benshi* or *katsuben*, live commentators who supplied dialogue, narrative explanations, and comic banter at screenings, in favor of intertitles.[17] Finally, they insisted on a detailed screenplay.

As the pure film reformers' attack on theatricality indicates, they saw katsudō shashin more as photographed action than as movies. They especially wanted to get away from using the movie camera merely to photograph staged actions, as was common practice at the time; many moving

pictures, or "moving photographs," consisted of a play performed before a stationary camera. Unfortunately, since few films remain from this era, it is difficult to assess their evaluation of film form, but clearly, the pure film reformers' rejection of theater-based films and their emphasis on moving the camera, editing, and naturalistic styles of action were calculated as a break with the "photographed action" implicit in katsudō shashin. In this respect, the promotion of *junsui eiga*, or "pure cinema," constituted a shift from a sort of action photography to cinematography.

In addition, if this shift can also be said to mark the emergence of cinema as a form of entertainment distinctive from others, it is because the elimination of benshi and the insistence on a screenplay (to be written prior to filming) also afforded an exclusive focus on the diegetical space of the screen. Simply put, everything that was needed to understand and consume the film drama occurred within the film and on the screen. Not only did film drama thus become an autonomous form of expression, but viewers at different locations were now, in theory, seeing the same production. Consequently, even as pure film reformers placed the emphasis on the autonomy of film as art, such transformations also made their "pure film drama" (*junsui eigageki*) subject to greater standardization and regulation, industrially and socially.

At this transitional moment in the history of cinema, Tanizaki threw himself into the Pure Film Movement at a fairly early stage, writing an essay for the reform of moving pictures in Japan for the literary journal *Shinshōsetsu* (New Novel) entitled "The Present and Future of Moving Pictures" ("Katsudō shashin no genzai to shōrai," 1917). Therein he argues against current moving picture practices, especially the use of theater conventions: "Of the actors, stage directors, and managers who film the movies characteristic of Japan today, I would first request one thing: not to copy theater for no good reason." This is because of the tendency to "use a long, shallow, two-tiered stage, and convey the story at length in a single location."[18] In effect, Tanizaki is arguing against the stasis characteristic of photographed action, in which a stationary camera records staged actions.

Significantly, however, while he recommends movement of the camera, techniques of editing, and the use of long, medium, and close shots, he has precious little to say concretely about how to use them. In his account of cinematic techniques that should break with the static camera, what comes to the fore is a fascination with the enlargement or close-up. "When one isolates a portion of a certain scene and enlarges the

image, that is, when one is able to present details, how incredibly much this heightens the effect of the performance and aids with transitions," he writes. "In this sense, film is far closer to painting than is theatrical performance."[19] For him it is above all the close-up that manifests the power of moving pictures.

Two aspects of Tanizaki's imagination of moving pictures are important here. First, for all his dislike of the stasis and staginess of moving photographs, he doesn't resolutely break with photography in favor of cinematography. This is echoed in his use of the term *katsudō shashin* rather than *eiga*, or "cinema," a term then emerging but not yet widespread. Tanizaki is still in the space of moving photographs, or more precisely, in between the old moving pictures and the new cinema, in the realm of cine-photography, where new cinematic techniques allow more for heightened photographic effects than for cinematography. When he introduces movement, it is largely in the guise of closing in on things, making them appear larger than life on the screen, especially the human face and body. It is not surprising that he likens moving pictures to the plastic arts. Here the analogy is to painting, but more often he sees cinema as akin to sculpture, seal carving, and doll making.[20] In other words, it is as if the motion inherent in moving pictures allowed for a dimensional, almost 3-D, larger-than-life production of human figures.

Second, while Tanizaki champions the reality effects afforded by moving photographs, this is not an indexical reality. Moving pictures for him do not afford a relation to the real that somehow captures a moment in time that would thus allow for a historical relation, or a cinematic realism in the manner of, say, Bazin.[21] Rather than generating a record of something out there, moving pictures bring something to life; they produce something larger and livelier than life. In brief, for Tanizaki, the introduction of greater motion into moving photographs enables the production of realer-than-real figures, a kind of simulation that promises to surpass indexical or referential relations to reality. Walter Benjamin also lingered on the photographic effects of cinema to highlight how it brought things closer to viewers, stressing the almost surgical quality of cine-photographic perception (which ultimately tended to destroy perceptual distance altogether, resulting in an image that struck viewers). In contrast, although Tanizaki too sees a destruction of perceptual distance in cine-photography, he delights in its capacity for detailed exploration of surfaces, which enables the production of simulacra. Yet, as is so often the case, the production of simulacra remains nevertheless compro-

mised by some reality, constrained by some materiality. For Tanizaki, that reality arrives in the form of an experience of the ugliness of the Japanese face. In response to this harsh reality (a perceived reality, an experience of racialization), his fascination with cine-photographic simulation entails a bid to elevate and redeem the Japanese face. In the same essay, for instance, he writes:

> The human face, no matter how unsightly the face may be, is such that, when one stares intently at it, one feels that somehow, somewhere, it conceals a kind of sacred, exalted, eternal beauty. When I gaze on faces in "enlargement" within moving pictures, I feel this quite profoundly.[22] Every aspect of the person's face and body, aspects that would ordinarily be overlooked, is perceived so keenly and urgently that it exerts a fascination difficult to put into words. This is not simply because film images are made larger than actual objects but probably also because they lack the sound and color of actual objects.[23]

While he writes here of the human face in general, the key to his fascination with the close-up lies in his interest in imparting a sacred and eternal beauty to any face, however unsightly. As his remarks about how hideous he found the face of Onoe Matsunosuke attest, Tanizaki turned to Western films and then to the Pure Film Movement in an attempt to move beyond that Japanese ugliness. A film story published the following year, "The Tumor with a Human Face" ("Jinmenso," 1918), makes clearer what is at stake for Tanizaki in the cinematic techniques associated with pure film.

"The Tumor with a Human Face" tells the story of a moving picture starring a famous Japanese actress recently returned from Hollywood to Tokyo. The actress hears a rumor of this movie showing in rather odd theaters in and around Tokyo, yet, when her friends explain the story to her, she has absolutely no recollection of having made such a film. Tanizaki takes this opportunity to describe the film (titled in English *The Tumor with a Human Face*), drawing on his favorite films, such crime and adventure serials as *Zigomar*, *The Broken Coin*, and *The Exploits of Elaine* (all cited in his essay "The Present and Future of Moving Pictures"), as well as such proto-horror, proto-expressionist films as *The Golem* and *The Student of Prague* (both cited in the story). The film in his story entails a vengeful destruction of Western romances of the Orient, typified by *Madame Butterfly*. In an evocation of *Madame Butterfly*, the story opens with a Japanese courtesan in Nagasaki pining for the return of her

beloved American sailor (usually referred to simply as "the white man"). Tanizaki's courtesan, however, journeys to America, where she eventually kills her lover and enslaves any number of white men. If one of the aims of the Pure Film Movement was to correct or counter the Western images of the Orient that culminated in such films as Griffith's *Broken Blossoms* (1919), Tanizaki does so with a vengeance, creating a ruthless and vengeful Japanese woman, a poison lady, who seems bent on the total destruction of the "beautiful" relation between Western men and Japanese women. Appropriately, the Japanese title of the film is said to be *Vengeance*.

What is disturbing, however, is that this vengeance is exacted on the Japanese woman as well. To flee Japan together, the white man and the courtesan used the services of a hideous flute-playing beggar, who, in exchange for his aid, asked to spend a night with the courtesan, with whom he had fallen in love. The white man agrees, but the courtesan, repulsed by the ugliness of the beggar, tricks him out of the promised night. In response, the beggar puts a curse on her: he returns in the form of a tumor that sprouts from her knee, and it is the tumor, bearing his hideous face, that spurs the woman to violence. Although the courtesan takes pains to hide the tumor and succeeds in marrying a rich marquis, in the end, incessantly tortured by the tumor with a human face, she plunges a dagger in her chest. In sum, it is the Japanese man who exacts vengeance, cursing the body of the Japanese woman in order to destroy the romance of the white man and Japanese woman. Significantly, his monstrous power derives from his ugliness, and it is the close-up that enacts his power.

The mystery surrounding the origins and effects of *The Tumor with a Human Face* makes clear that the ugliness of the Japanese man is a racial ugliness. As it turns out, the film has terrible effects on viewers: when men screen it alone in the dark, they lose their senses, fall ill, and sometimes die. The deadly effects derive from the terror experienced when the film shows the face of the ugly beggar in close-up. Oddly, however, despite the amazing performance of the actor playing the beggar, no one knows who he is or where he comes from (and likewise with the film), even though all the other players are identifiable. One character speculates, "The man's appearance is downright tumorous, with a round corpulent face and glaring eyes, so dark that you can't say whether he's Japanese or a native of the South Seas."[24] In brief, it is racialization that haunts this tale of cine-photographic effects, the possibility that the Japanese man might appear indistinguishable from other men of color.

Oddly, however, in view of Tanizaki's comments that he fled from Japanese films to Western films because he found the face of Onoe Matsunosuke so hideous, "The Tumor with a Human Face" imparts great power to the allegedly ugly face of the Japanese man. It gives his ugly face the power to destroy Western romances of the Orient. In particular, it is the new cine-photographic techniques that Tanizaki associates with pure film—the close-up and double exposure—which enable the racialized man to exact his vengeance. It is the close-up that transforms the ugliness of the Japanese man's face into a supernatural force, as if there were racial power inherent in the experience of racial trauma (seeing oneself as the despised racial other). In this respect, racialization is at once evoked and disavowed: the Japanese woman can almost succeed in passing into the white American world (but for the ugly tumor face on her knee), while the Japanese man remains decidedly dark, unable to travel so easily; his racial appearance prevents his passage into whiteness, and he in turn prevents her passage. The tumor that undermines her beauty is like a racial taint. Still, this racialization is not disempowerment. On the contrary, not only is the film incredibly, supernaturally powerful in its effects, but the story lingers on the transnational movement of the film. In fact, the story ends with the promise of a global expansion of the film's monstrous power. The actress's friend remarks that the film has become the property of Globe Studios, and "because they're in it for themselves, they'll surely make many copies and distribute it widely this time. That's exactly what they'll do."[25]

In sum, while Tanizaki leapt into the Pure Film Movement to transform katsudō shashin into eiga, his thinking about cinema remained focused on cine-photographic techniques, and he tended to place the motion of motion pictures in the service of a heightened photographic effect, as manifested particularly in the close-up of the human face. What interested him in the close-up was its potential to impart seemingly supernatural power even to an unsightly (that is, racialized) face. As "The Tumor with a Human Face" attests, the idea was not only to erase and disavow racialization but also to empower it. There is profound ambivalence in his take on the close-up, one that speaks to Japan's doubly colonial situation. For Tanizaki sought to produce with cine-photographic techniques an experience of the Japanese face in which its racialization would appear at once marked and unmarked, under erasure, as it were. This is most evident once he entered into film production and labored to produce a racially and temporally hybrid New/Oriental Woman on the screen.

In 1916 a journal appeared called *Katsudō no sekai*, *Active World* or *The World of Motion*. Although the title suggests an affinity with moving pictures (katsudō shashin), the journal did not initially present itself as a film journal. Rather, it aimed to present a world of healthy, vigorous, and active lifestyles for men and women. Although articles related to film did appear, moving pictures were but a part of the broader world of activity and vitality. In other words, the "motion" or "action" associated with motion pictures coincided with other general social activities that had begun to transform gender roles and relations. For a variety of reasons, however, despite its initial mission, *Katsudō no sekai* rapidly transformed into a film journal. By the third issue all of its articles addressed moving pictures. This serves as a reminder of how integral cinema was to the imagination of a new world, a world of action and motion in which new women and men of action were to live.[26]

Crucial to this new active world was the promotion of new roles for and images of women. The inaugural issue of *Katsudō no sekai* included an essay on "Japanese women's lack of vitality," in which the author, Yamawaki Fusako, begins with an account of how women in Europe during the recent tragic war took on the activities of men in their absence; thus, she advances the cause of the "New Woman."[27] The figure of the New Woman had emerged years earlier, first through the mediation of women's social movements that stressed the "the universalization of modern human values such as 'equality,' 'human rights,' and the 'individual.'"[28] Subsequently, particularly around the Bluestocking Society that began publishing the journal *Seitō* (Bluestocking) in 1911, there emerged a new stance that might be thought of as cultural politics, with an emphasis on creative freedom and unfettered activity for women, which coalesced around the New Woman as a "self-aware woman" (*jikaku no onna*).[29] By the 1920s, with the debates surrounding the emergence of yet another variation on the New Woman, the *moga*, or "modern woman," it was clear that a new middle-class women's culture had emerged, in the form of a mass consumer culture offering a dramatic redefinition of women, with a range of new identities presented in women's journals with wide circulation.[30] In the 1920s, Barbara Sato remarks, the "media projected hope for urban middle-class women to participate actively in the creation of this burgeoning culture, without an intermediary. By going to the movies, for

example, women could visually absorb, firsthand, everyday practices different from their own."[31]

A journal such as *Katsudō no sekai* appears at a point of transition, a transition from the self-aware woman to the modern woman, at which cine-photographic images of women proved central to redefining women's roles. This variation on the New Woman might be thought of as the "woman of motion (pictures)" or the "woman of action" (*katsudō no onna*), whose representation was closely tied to the emergence of a new culture of moving photographs promoted in film journals. The rapid transformation of *Katsudō no sekai* into a film journal speaks to the connection between moving pictures and the attempt to imagine the active woman.

The tension underlying the journal's endorsement of active roles for women is most evident in the juxtaposition of photographs of starlets with statements like those of Yamawaki promoting the New Woman. In fact, the visual impact of the journal lies in the wealth of photographs of actresses (and some actors), mostly in the form of studio portraits, usually of head and bust but sometimes of lounging or reclining figures and occasionally of women playing sports. Such photos constituted a new way of looking at women, but it is less obvious how such images relate to the call for women who can replace their male counterparts in the workplace, as Yamawaki suggested. While the photos surely appealed to male consumers who wished to ogle sexy young women, the problem of these photographs is not simply one of objectification, of making women into inert and passive objects for the male gaze. There is also the power of the image, and the cine-photographs present women who appear somehow full of power or potential, but powerful in the way that a fetish is powerful, as a restless and dynamic figure that demands constant attention. As fetishes, such images ask to be taken out of general circulation and cultivated within a personal space of fantasy, while at the same they derive power from expanded circulation. This is the paradox of the imaging of the new "woman of motion": the image elicits an affective response that would remove it from circulation even as it necessitates circulation. In the circulation of such photographs of starlets, one can see the emergence of a subjective technology for the production of "women of motion," which increases their range of action and circulation (imparting a sense of agency) while subjecting them to social (masculine) affection that circumscribes their movements.

This subjective technology implicit in the "woman of/in motion" echoes that subjective technology that Tanizaki detected in the cine-photographic close-up, which at once marked and promised to redeem racialized subjects. Likewise, photos of starlets at once liberated and circumscribed female subjects. Naturally, this happened in images of both women and men, but cine-photographs tended to refine their mixture of activation and mobilization in relation to women in particular. It is not surprising, then, that Tanizaki gravitated toward the world of starlets and screen sirens and in his film work channeled his energies into producing images of the new Japanese woman of action in action. While this interest in screen sirens was a personal obsession and fantasy for Tanizaki, it is important to recall again, via Gilroy, that gender is the modality in which race is lived. In other words, Tanizaki's libidinal investment in the cinematic woman of motion (especially the bathing beauty or screen siren) cannot be separated from race trouble. What is interesting in this context is how race is lived *cine-photographically* in gender.

Usually, readers and commentators construe Tanizaki's obsession with the New Woman as part of his obsession with the West and Western things. The novel *Naomi* (*Chijin no ai*, 1924–25), in which the Japanese heroine's resemblance to a Western screen actress (Mary Pickford) spurs the protagonist's obsessive devotion to her, is commonly called upon to reinforce this interpretation. Some commentators even portray Tanizaki's imagination of the New Woman in terms of "Occidentalism," a compulsive idealization of the West.[32] It is true, of course, that images of Western actresses inspired his imagination of the New Woman, much as European women inspired Yamawaki's call for the New Woman in *Katsudō no sekai*. Yet dwelling exclusively on the relation between Japan and the West suppresses the problem of Japan's Orient, which is equally prevalent in Tanizaki's film work, not to mention in the history of Japanese cinema more generally. In fact, scholars in Japan and the West have tended to mobilize Tanizaki as an exemplary figure for working through their fantasies about Japan's love of the (Anglophone) West, overlooking questions about Japan's Orientalism and Japanese empire that also crop up in his film work. Historically, the emphasis on the novel *Naomi* to represent Tanizaki's relation to cinema has worked to direct critical attention exclusively on Japan-West relations, while *Nikukai* (A Lump of Flesh, 1923), his novel of film production written one year prior, has received little attention, surely because it explicitly evokes relations between Japan

and China, drawing analogies between Yokohama and Shanghai, dwelling on the production of Orientalist films, and generally calling attention to Japan's colonies.

The question is not simply one of whether the Japanese "woman of motion (pictures)" was fashioned on the model of European and American actresses (she was). Rather, the question is whether this fashioning ever entailed a *simple* imitation or emulation of the West. Clearly it was not simple, but how does one get at the complexity? Postcolonial theory suggests that, even as the non-West strove to copy the West, imitation failed for historical, material reasons, resulting in a copy whose differences from the original show the fault lines of the original (Western) modernity. Such "failures" can subsequently be recuperated as successes, as signs of authentic difference. The result is a second moment of displacement or disavowal, in which national difference is mistaken for an alternative to Western modernity, even as it subjects local differences ever more ruthlessly to the dictates of (national) modernity.

While in some ways this is a serviceable point of departure, it continues to focus attention somewhat exclusively on Japan-West relations, making Japan appear primarily as a (post)colonial nation and only secondarily (if at all) as a national empire, as if Japan's empire itself could be construed only as a failed and somehow inauthentic imitation of Western empire. Consequently, as critics as different as Shu-mei Shih and Rey Chow have remarked, there is a tendency in such theory to evoke the non-West only to shore up and accrue power to the West, demanding ever more sophisticated analyses of Western power.[33] For such reasons, it is crucial to understand the hybridity that arises in the context of the Japanese New Woman not simply as a failure to replicate Western models due to material constraints, which then stands for the persistence of native authenticity. The example of Tanizaki's imperious screen beauties suggests that hybridity is the sign not merely of the failure of Japanese modernity but also of its success. While we may still insist that Japanese modernity is (in)operative, this is not simply in relation to an omni-operative West.

Even in "The Tumor with a Human Face," for instance, Tanizaki explicitly depicts the cinematic woman of action as a hybrid figure: "Her smooth, ample figure ranked her favorably with American and European actresses, and her lovely face tempered Occidental coquetry with Oriental modesty. In her appearances on the silver screen, she showed a degree of vigor rare in Eastern women, and because she was possessed of pluck and liveliness that enabled her to laugh her way through adventurous

scenes, she seemed to excel at roles that required both charm and agility, such as women bandits, dragon ladies, or female detectives."[34]

While, on the whole, Tanizaki's Japanese woman of action is noteworthy for her Occidental physique and physical vigor, it is important that "her lovely face tempered Occidental coquetry with Oriental modesty." In other words, at the level of the face at least, with a slapdash use of stereotypes Tanizaki strives to imagine a hybrid figure rather than a look-alike. It is significant that the face is the site of hybridization, for Tanizaki consistently evoked the face of Japanese women in his imagining of skin, skin texture, and skin color, and his imaging of race frequently settled on the face in close-up. As his description of the actress in "The Tumor with a Human Face" suggests, at this juncture in the history of his obsession with constructing his fantasy woman, Tanizaki imagined a sort of racialized act-alike, a slightly Orientalized woman who acted like Western adventure serial actresses. Ironically, perhaps, in this respect, he was not entirely at odds with the Hollywood film industry's interest in exotic beauties.

In general, in his imagination of the New Woman of motion pictures, Tanizaki resorted to hybrid figures, usually ones that evoke a mixture of East and West, rather than straightforward replications of the Western model. The hybridity implicit in Tanizaki's imaging of the New Woman becomes most explicit in *Nikukai*, his novel centered on film production in Yokohama, which, as I mentioned above, tends to be overlooked in favor of the novel *Naomi* because *Naomi* does not trouble analyses based exclusively on Japan-West relations that apparently remain appealing to Japanology.

In *Nikukai* the ideal actress is of mixed race, or "between races" (*ai no ko*). In one scene, at a ball, the protagonist stares at her, marveling over how her appearance hovers between the traditional and the modern.[35] He notes her resemblance to an exotic film beauty, Viola Dana, and continues to stare, fascinated by her eyes. What is more, the films concocted by the ambitious screenwriter in *Nikukai* tend to revolve around China. His first collaboration tells the story of a Chinese prince who encounters a Western mermaid (which recalls another of Tanizaki's film stories, "The Mermaid's Lament"), and his second film concerns a Japanese girl who favors Chinese styles of dress, who turns out to be a Chinese princess. Moreover, the novel itself abounds in scenes of Japanese men and women in Chinese dress in Yokohama, a town famous for its Chinatown and Western settlement, which is thus said in the novel to resemble Shanghai.

Such is the type (or rather archetype, given her almost primordial power) of New/Oriental Woman that Tanizaki strove to bring to the screen in the early 1920s. In his first collaboration with Kurihara, *Amateur Club* (1920), he cast his wife's younger sister, Hayama Michiko (Ishikawa Seiko),[36] to play the tomboyish heroine, apparently on the basis of her resemblance to Western actresses. Much like the character Naomi in the novel *Naomi*, the character played by Hayama Michiko is usually construed as Tanizaki's effort to replicate his favorite Western starlets, and in many of the publicity stills, Hayama adopts poses made famous by Western actresses (figs. 1 and 2). What is more, the film *Amateur Club* is often deemed one of the most Western of Japanese comedies of the era, and certainly the most Western of Tanizaki's collaborations.

Nonetheless, even if the film apparently bypasses an overt reckoning with the problem of racialization that otherwise haunts Tanizaki's imagination of the New Woman, hybridity arises in another register, that of tradition versus modernity, which reprises the relation between Japan and the West in a temporal register, only to produce an imperiously hybrid figure.

Amateur Club plays with the relation between the traditional and the modern. The relation is, above all, playful, as one would expect of a madcap comedy. The screenplay begins at the beach, introducing the hero and heroine, Muraoka Shigeru and Miura Chizuko (Hayama Michiko), both of whom are young, high-spirited, and attractive. The opening sequence includes a number of scenes that linger on Chizuko in her bathing costume, in her "repetition" of Western bathing beauties (figs. 3 and 4). Significantly, the screenplay includes directions to shoot her with the men visible behind her, in effect assuring that she becomes the object of the male gaze (scene 38).[37] While the first sequence establishes Shigeru's romantic interest in Chizuko on the beach, it also cuts to scenes of two thieves pilfering valuables, among them Chizuko's clothing, from the beach house. Scandalously, she decides to return home wearing only her swimsuit.

The screenplay then cuts back and forth between Chizuko's home and Shigeru's home. At Chizuko's home, the family is airing out and cleaning the family heirlooms. Rather obviously, Chizuko is equated with the family heirlooms, the newest in a long line of treasures. As her father dotingly explains the heirlooms to her, the willful Chizuko tries on various costumes. In one sequence, in which she plays with an ancient halberd, the screenplay calls for an overlap dissolve from the contemporary Chi-

zuko to Chizuko dressed as in ancient times, and back again (scene 108). Indeed, overlap dissolve becomes the key to imagining and depicting the relation between past and present. One of the subsequent scenes (111) calls again for overlap dissolve from present to past, and back to the present. In effect, the logic of overlap dissolve structures the entire screenplay, for the screenplay involves a continual overlapping and dissolving of boundaries between the traditional (figured primarily as the Tokugawa-derived past) and the new or modern (contemporary youth).

In *Amateur Club*, the antinomies of male and female as well as tradition and modernity become condensed in the overlap dissolve of Chizuko that presents her simultaneously as modern girl and ancient warrior. In keeping with the devices of romantic comedy, such antinomies are ultimately resolved. In the final scenes the two families meet, and as the two fathers chat and laugh, Chizuko and Shigeru show signs of becoming friendly, even intimate. Ultimately, then, even though Chizuko is a woman of action (exotically tomboyish and even warlike), she can also be a girlfriend. Nonetheless, as elsewhere in Tanizaki, the moment of gen-

1. An image of Annette Kellerman in the October 1920 film journal *Katsudō kurabu*. From Makino Mamoru, ed., *Katsudō kurabu fukkokuban*, of *Nihon eiga shoki shiryō shūsei* (Tokyo: Sanichi shobō, 1990–92).

2. Hayama Michiko, in the publicity stills from Tanizaki and Kurihara's first film, *Amateur Club* (1920), adopts Kellerman's famous "bathing beauty" or "mermaid" pose. Courtesy of Kawakita Memorial.

3. A still of Hayama Michiko
on the beach at Yuigahama
in *Amateur Club*. Courtesy
of Kawakita Memorial.

der trouble that the cine-photographic techniques serve to condense (in overlap dissolve) implies race trouble. The image of the modern woman in traditional male dress not only troubles gender but also evokes tradition to generate a sense of racial hybridization: that this girl is, after all, a Japanese girl despite her modern frolics.

Interestingly, *Amateur Club* also includes a moment of the modern boy in traditional female attire (fig. 5): much of the action of the film revolves around the amateur production of a kabuki play that demands an oyama, a man playing the woman's role—precisely what the pure film movement, and Tanizaki himself, presented as anathema to the true nature of moving pictures. How does the oyama nonetheless make an appearance in this effort at pure film? Evidently, in this attempt to produce pure film at least, the power of pure film lay not in purification in the sense of a complete elimination of what was allegedly theatrical, unnatural, and therefore uncinematic. Rather, pure film could reprise these elements as hybridized forms: it is the modern boy (not a traditional actor) who plays the oyama. And, in effect, it is the appearance of a tomboy in the principal female role that also safeguards the appearance of this uncinematic and unmodern mode. Simply put, despite the appellation, this so-called pure film is all about hybridity.

In his last collaboration with Kurihara, *The Lust of the White Serpent*

4. In the opening sequences of *Amateur Club*, Muraoka Shigeru (played by Ueno Hisao) and his friends watch Miura Chizuko (Hayama Michiko) swimming and then stretching on the beach. Later, the four boys tease Chizuko. Courtesy of Kawakita Memorial.

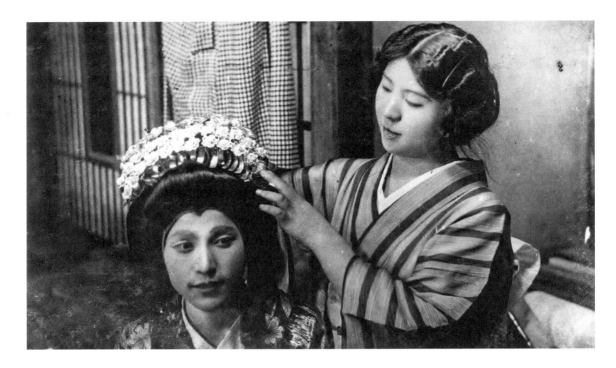

5. In *Amateur Club*, the members of the Amateur Club stage a performance of the classic play *Taikōki*. In scene 147, the maid helps Ono Kamekichi into the costume of Mitsuhide's mother, Satsuki. Courtesy of Kawakita Memorial.

(*Jasei no in*, 1921), Tanizaki makes clearer his push toward racial hybridization in the Japanese actress. *The Lust of the White Serpent* is a traditional ghost story set in "classical" times (the late Heian period) about a young man who is seduced by a snake woman (fig. 6). Even after he breaks off his marriage with her, the snake woman continues to pursue him, taking control of his second wife's body. A moment of terrifying revelation occurs when the face of the snake woman reappears on the face of his sweet new wife, in double exposure and in close-up (scenes 189 and 191).[38] The double exposure is calculated to present, in the same image, types that are apparently incommensurable: the dark seductive beauty from the ancient past and the bright modest beauty of the present.

As these examples indicate, in terms of cine-photographic techniques, Tanizaki in his film work showed as much fondness for double exposure (or superimposition) and overlap dissolve as for the close-up. In fact, he often combined them, as in the close-up of the tumor face superimposed on the beautiful skin of the courtesan in "The Tumor with a Human Face." Again it is clear that he imagines the power of cinema largely in terms of cine-photographic techniques. Moreover, it makes sense that he would gravitate from the close-up to such devices as the overlap dissolve and double exposure. Both are techniques of combining opposites or contraries in a single image; just as the close-up promised to make the un-

sightly face exalted, so overlap dissolve and double exposure allowed the viewer to see two apparently contradictory states at once: past and present, tradition and modernity, Oriental and Occidental, modesty and sexual appeal. Where the close-up affords a technical transformation of a racialized face into an exalted face, the overlap dissolve or double exposure serves as a reminder that the idea for Tanizaki is not truly to erase the racialized (or the traditionalized) altogether but to elevate it, to sublimate and even to sublate it, raise it to a different power. It is not surprising that he not only favors both close-up and overlap dissolve but also sees them as analogous, compatible techniques. Both offer a way to see two states at once, thus combining opposites in order to raise the lesser one to a new power. This may recall a dialectical synthesis, but it is more like Benjamin's dialectical image in that the idea is to see the two contradictory states at once. But then, for Tanizaki, in this cine-photographically doubled vision lies potential redemption of the "antithesis" as the de-

6. Scene 51 of *Lust of the White Serpent*, which Tanizaki directs thus: "Put carbon in the lamp's shadows, or illuminate only the area around the two with a spotlight. The entire interior should not be illuminated. On the sliding door behind them, the two figures should cast huge and terrible shadows." Courtesy of Kawakita Memorial.

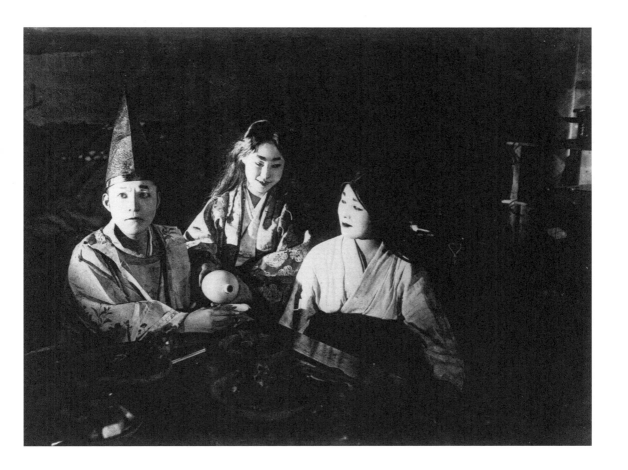

valued term, that is, redemption of the Oriental, the racialized, and the traditional as the devalued antithesis to the West. Rather than a synthesis of opposites, he favors dialectical rivalry.

The result was a cine-photographic image in which the New Woman and the Oriental Woman appeared simultaneously, in double exposure, as a hybridized New/Oriental Woman. In conjunction with double exposure, the close-up promised not so much to redeem the Oriental Woman as to exalt hybridity by marking and elevating what was perceived as racially Oriental via its double exposure with the New.

WHITER THAN WHITE

After he left the world of film production and returned to literature, Tanizaki construed these attempts as a failure, for a variety of reasons. While the film and screenplay are lost and only publicity stills remain from his third collaboration with Kurihara, *The Sands of Katsushika* (*Katsushika sunago*, 1921), these stills, in conjunction with passing remarks by Tanizaki about his goals, suggest that he strove to present a film that was "purely Japanese in style." Even here there is some evidence of efforts at hybridization, insofar as the film oscillates between images of the young woman dressed as a courtesan by night and images of her in everyday attire (figs. 7 and 8). Yet, in an essay that appears to have been written between the release of *The Sands of Katsushika* and *The Lust of the White Serpent*, in which Tanizaki continues the discussion begun in "The Present and Future of Moving Pictures," he complains of his efforts with *The Sands of Katsushika*, "Whenever one strives to make a film purely Japanese in style, the greatest obstacle is the lack of actresses with faces like those in ukiyoe prints. If I may say so, most young women these days, especially those who wish to become actresses, without exception, reek of Westernness." In his words, "It is the women above all who present an obstacle."[39]

Elsewhere he blames his failure to produce the New Woman on the "materiality" of Japanese women, that is, their face and physique, as here in "Love and Sexual Desire" ("Ren'ai oyobi shikijō," 1931):

We aspired to raise the Japanese woman, long burdened with ancient traditions, to the status of Western women, but because spiritually and physically this would take countless generations of discipline, we could not be expected to accomplish this in a single generation. To

be brief, the Western style of beauty relates first of all to a woman's figure, her facial expressions, and her walk. To make a girl spiritually superior, one must first make use of her flesh of course. . . . For our women to possess a beauty truly equal to theirs, we would have to live their myths, worship their goddesses as our own, and transplant to our land an aesthetics that for them goes back some thousands of years. At present I may at last confess that I myself entertained such a preposterous dream and also experienced the incomparable sadness of a dream that could never be realized.[40]

With such remarks, Tanizaki himself returns us to a postcolonial framework that emphasizes the failure of the non-West to replicate the Western model and to the instrumental use of women by men to establish and secure the boundaries of the nation: Japanese women embody the material constraints that consign to failure the efforts of Japanese men to achieve Western modernity, even as they mark the boundaries of Japaneseness. Oddly, however, where Japanese women in 1921 all "reek[ed] of Westernness," in 1931 they all fail to achieve Westernness, apparently condemned to Japaneseness.

I previously contested a simple postcolonial explanation of Tanizaki's obsession with cine-photographic images of Japanese women, and would also complicate it here, precisely because his distress about the failure of Japan's women in relation to Western modernity is articulated alongside a comparison of Japan to other locations in the "Orient," especially to China. In "Love and Sexual Desire," he concludes, "While Oriental women are inferior to Occidental women in beauty of face and figure, they surpass them in beauty of skin and in delicacy of complexion. . . . As far as I know, Chinese women rank first in delicacy of complexion and softness of skin, but in comparison with that of Westerners, the skin of Japanese women is also far more delicate, and while it is not as white, in certain instances a tinge of pale yellow lends it greater depth and adds to its suggestiveness."[41]

As such comments suggest, Tanizaki's connoisseurship of Occidental and Oriental women allows him ultimately to situate Japanese women favorably in relation to Western women, but only by referring them to Chinese women. Throughout his essay, which reads as a parody of Watsuji Tetsurō's *Culture and Climate* (*Fūdo*, 1935) but replaces climatology with sexology, Tanizaki situates Japan between the Occident and the Orient, in a hybrid position that ultimately empowers Japaneseness.[42]

In other words, he seems to resolve the doubly colonial situation of Japan by condensing it into the figure of the Japanese woman, finding in her skin the "tinge of pale yellow" that "lends it greater depth" than purely Occidental or Oriental complexions. This fragile moment of hybridity is where subjection (to the West) confers subject status on Japan over its Orient. It is an imperial moment predicated not on Japanese purity but on its racial hybridity, resulting in a subjective technology of hybridity that bears consideration in relation to Japan's multiethnic empire and ideologies of pan-Asianism.

Crucial here is the status of cine-photography. Until about 1921 Tanizaki showed great enthusiasm for and confidence in the capacity of cine-photographic techniques to "resolve" the racial ugliness of the Japanese face. The close-up, overlap dissolve, and double exposure were to make for an experience, however fleeting or fragile, of the coexistence of otherwise incompatible and even incommensurable modes: past and present, tradition and modernity, East and West, and, of course, something like "color" (racialization) and "whiteness" (deracialization).

In the early 1930s, however, Tanizaki denounced the cine-photographic image as unsuited to Japanese facial features: "In the photographic image itself, there somehow emerge differences in national character. If this is true even when identical equipment, chemicals, and film are used, how much better our own photographic technology might have suited our complexion, our facial features, our climate, our land."[43] Even as early as 1921 he complained that it was impossible to produce an experience of the sublime with the faces of Japanese actresses in close-up. But what is at fault, the face of the Japanese woman or the cine-photographic techniques used to render it? Where does racialization happen?

If Tanizaki oscillates, sometimes placing the blame on the face and figure of the Japanese woman, sometimes indicting cine-photography, it is because he implicitly understands cine-photography as a subjective technology. Race does not truly exist in faces, and yet it isn't simply an effect of photography either, and so he oscillates in how he situates it, aware at once of its constructedness and the very real impact of that construction. Earlier, Tanizaki became aware of how cine-photography racialized Japanese faces, and yet he knew that such constructs are not simple effects or merely subjective stances that can be easily swept away or remedied. But it is clear that transformation has to take place in the realm of subjective technologies, in the realm of the cine-photographic image. And so, in the 1930s, even as he denounced Western photography as unsuited to Japanese faces, he strove to produce an analogue, something like an indigenous Japanese cine-photography. He was still thinking cine-photographically. What is more, although in the early 1930s he overtly denounced cinema, it is important to recall that cinema of the 1930s differed profoundly from earlier moving pictures. In effect, Tanizaki's disenchantment with the cinema of the late 1920s and early 1930s allows him to remain faithful to the cine-photography of an earlier era when it still seemed to him that he could use the cine-photographic image to produce a redemptive hybrid. In fact, if we return to one of his earliest film stories, "The Mermaid's Lament" ("Ningyo no nageki," 1917), we find that cine-photography produces precisely those effects that Tanizaki attributes to traditional Japanese art in the early 1930s.

In "The Mermaid's Lament," Tanizaki imagines the city of Nanjing during the Qing Dynasty through the lens of Italian historical epic films and spins a tale of a Chinese prince who falls in love with a mermaid or siren (*ningyo*) from the West. Here the term *siren* refers not only to a

fish-woman or mermaid but also to the bathing beauty of the film world, the siren of the silver screen. In fact, the poses of Hayama Michiko in her bathing suit in the manner of Annette Kellerman are ningyo or siren poses (figs. 1 and 2, above). Indeed, the Kellerman photo bears the caption "Human or siren?" ("Hito ka ningyo ka?"). In any event, in a crucial scene in the story the Chinese prince gazes on the siren in her glass jar that replicates the effects of close-up on the silver screen:

> Above all, what caught his eye and enchanted his heart was the color of her skin, pure white, spotless, unblemished, without a hint of darkness. The luster of her skin was so white that the adjective "white" could not possibly describe it. It went so far beyond "white" that it would have been better to speak of a "radiant sparkle" that emanated from the entire surface of her skin like the light in her eyes. It was of such whiteness that it recalled the glow of moonlight, which made him wonder if there was not a source of light concealed in her bones, which shone through her flesh.[44]

What is more, the prince's experience of his racial ugliness in "The Mermaid's Lament" reprises, almost word for word, the experience of a film spectator named Tanizaki in the story "The German Spy" ("Dokutan," 1915) who imagines his Japanese ugliness as he watches European films: "Why had I, who received life on the surface of the same globe, been born as a man ugly and stunted in stature, in a backward place so far removed from them? It would have been more fortunate to be raised as a slave in their land than to live as a prince in this one."[45]

As Tanizaki displaces the problem of racial ugliness onto the Japanese woman of motion pictures, it is the power of men over women that comes into play. Note that, in this story, the man frees the mermaid from captivity, allowing her to become a woman of action, but only in the oceans; yet freeing her results in a vast increase in the man's mobility across land and sea. This serves as a reminder that male affection for the New Woman often served to "free" her into circumscribed domains, while the new man enjoyed access to less fettered circulation. It echoes Tanizaki's recommendation for geisha to become movie actresses, for in films they can enjoy global attention.[46]

At the same time, it is the power of the cine-photographic image that promises to produce an experience of the Japanese woman's face that is "beyond white." The direct descendent of the screen siren in "The Mer-

maid's Lament" is the Kyoto geisha that Tanizaki champions in the 1930s, who paradoxically becomes, in the wavering shadow of a lantern, "whiter than the whitest white woman I know."[47] Needless to say, just as the siren is a hybrid figure (though she comes from the West and has the allure of a Western screen siren, she is a hybrid of human and animal, a supernatural mixture that elevates bestial traits into radiant splendor), so the Kyoto geisha is a hybrid figure. Simply put, it is hybridity that allows for a realization of the "whiter than white," and such hybridity is produced cine-photographically, assuring that a tinge of pale yellow indeed imparts greater depth. Cine-photography is a subjective technology of racialization as hybridization, and it is a subjective technology well suited to a doubly colonial situation.

In sum, even as he denounced cinema and photography as Western technologies in the 1930s, Tanizaki continued to cling to this cine-photographic subjective technology (and it clung to him). If many of his comments about race and women appear today rather silly and downright offensive, it is because he vacillated in how he located race and gender: sometimes these appear as natural physical properties of bodies, sometimes they appear as effects of cine-photographic technologies of imaging. If I have emphasized the latter tendencies in Tanizaki's take on the cine-photographic image, stressing racialization over race, it is not simply because these tendencies today afford a better critical understanding of the doubly colonial situation of Japan in the 1920s and 1930s. It is also because the radical instability inherent in cine-photographic images frequently pushed Tanizaki's film work beyond a symptomatic expression of Japan's doubly colonial situation toward a critical understanding of hybridization as a subjective technology anchored in cine-photographic technologies. There is indeed in the close-up of the human face a "fascination difficult to put into words" that troubles simple attributions of race and gender and forces us to think how imaging technologies work to racialize and gender bodies.[48] While the doubly (or multiply) colonial situation of today's empire of globalization surely differs in its biopolitics, looking at the hybridizing effects of the cine-photographic image may allow us to think more critically about the digital image, whose modulating multimedia effects are often alleged to bring the play of difference to the fore. In the digital age, Tanizaki's close-up and double exposure are not mere precursors but mark the genealogical fault lines of cine-photography at its inception.

1 Onoe Matsunosuke (1875–1926), an actor who became extremely popular in the early days of Japanese cinema, worked closely with the director Makino Shōzō, making a number of pictures (168 between 1909 and 1911) in which Onoe played a wizard or sword hero who always triumphed with courage and trickery. He starred in the famous *Chūshingura* that Makino filmed and released in segments between 1910 and 1913.

2 Tanizaki, Jun'ichirō "Tōkyō o omou" (*Tanizaki Jun'ichirō zenshu*, hereafter abbreviated *TJZ*) 21: 9. All translations are mine unless otherwise indicated.

3 Jon Kraniauskas alludes to this problem of the colonial unconscious in his article on Walter Benjamin, "Beware Mexican Ruins!" There has been a great deal of scholarly work in recent years related to early film and silent film that looks at the "cinematization of the world" in relation to the sensory environment of urban modernity, technologies of space and time, and the emergence of mass culture. Recent studies by David Bordwell and Ben Singer propose grouping these efforts under the rubric of a "modernity thesis." See Bordwell, *On the History of Film Style*; Singer, *Melodrama and Modernity*. While the so-called modernity thesis does not necessarily preclude an analysis of race or class or gender (in fact, I see in it the possibility of shifting an analysis of power formations away from representational politics toward the operations of media), these problems are not crucial in the theorists (Benjamin, Kracauer, Simmel, and others) who have been central in shaping discussions of cinema and modernity.

4 Tanizaki, *In Praise of Shadows*, 9.

5 None of these films is extant, but three screenplays survive as published in journals, as well as a "film play" entitled *Murmur of the Moon* (*Tsuki no sasayaki*, 1920). Significant portions of an early film by Kurihara Thomas, *Sanji Goto*, are extant (with the title *Narikin* in Japanese). The details of the film's production are unclear, but the predominant explanation is that Kurihara made the film in 1918, but under the name of his famous mentor, Thomas Ince. A recent exhibition entitled The Japanese Film Heritage: From the Non-Film Collection of the National Film Center, which opened in the fall of 2002, presented *Narikin* as part of Japan's film history.

6 Tanizaki, "Onna no kao," *TJZ* 22: 124–25. See also "A Woman's Face," 264.

7 Natsume, "Letter," 13: 86. See also Masao Miyoshi's discussion of Sōseki's sense of racial inferiority in *Accomplices of Silence*.

8 I would argue in this respect that Sōseki does something analogous in the space of the novel, transforming the racialized position into a subjective technology of narration analogous to Gustave Flaubert's *bêtise*, a force of stupidity in narrative that comes to rival and even surpass Western narrative technologies.

9 Ross, *Fast Cars, Clean Bodies*.

10 See, for instance, Akira Iriye's discussion of the transformation into a cultural policy of Japanese colonial policy toward Korea in *China and Japan in the Global Setting*.

11 Gilroy, *Black Atlantic*, 85.

12 Iijima Tadashi, a former pure film reformer, provides this outline in *Nihon eiga shi*.

13 Tanaka, *Nihon eiga hattatsu shi*. Tanaka subsequently continued from this first volume in 1957 to an expanded and revised five-volume history. The periodization for the early period remains consistent. For a discussion of Tanaka's film history, see Cazdyn, *The Flash of Capital*, 67–75.

14 The early association of moving pictures with sideshow spectacle, or *misemono*, is a common theme in Makino, Ogasawara, Gerow, and others. Iwamoto Kenji recently published an important prehistory of cinema centered on *gentō*, or "magic lantern," which was considered almost synonymous with cinema for many years: *Gentō no seiki*.

15 Given that very few of the films are extant today, much of the study of the pure film movement tends to be archival by default, with particular attention to the film journals that emerged after 1910, such as *Katsudō gahō*, *Katsudō hyōron*, *Katsudō kurabu*, *Katsudō no sekai*, *Katsudō shashinkai*, *Kinema junpō*, and *Kinema record*, which magazines provided a forum for Pure Film reformers. I draw here on Ogasawara Takeo's discussion in "*Katsudō no sekai* sōkan no toshi ni tsuite," as well as Gerow, *Visions of Japanese Modernity*.

16 Makino Mamoru has edited facsimile reproductions of extended portions of many of these journals in a series entitled *Nihon eiga shoki shiryō shūsei*, as well as *Kinema Junpō* with Iwamoto Kenji.

17 *Benshi* or *katsuben* were performers who provided live dialogue, narration, and commentary when silent films were shown in Japan. (Although Tanizaki uses the terms interchangeably, *benshi* denotes a speaker or performer, while *katsuben* specifically refers to the benshi who performed with moving pictures.) Katsuben were so important to movie audiences that they often got higher billing than the stars. They began to decline in importance in the early 1920s as new filmmakers moved away from theater-derived cinema to make films with more elaborate mise-en-scène, editing, and intertitles. Nonetheless, katsuben remained popular in certain venues well past the rise of talkies.

18 Tanizaki, "The Present and Future of Moving Pictures," 68, 69.

19 Ibid., 67.

20 Especially telling is the story "Mr. Aozuka's Story" ("Aozuka-shi no hanashi," 1926), in which a crazed film fan collects stills of his favorite actress in order to construct life-size doll replicas of her.

21 See Philip Rosen's discussion of Bazin, indexicality, and history in *Change Mummified*.

22 Tanizaki uses the term *oo-utsushi*, or "large shot," to refer to what in English became the close-up. In other film essays, he translates *oo-utsushi* as "close-up" (using the English term), but like other commentators, such as Jean Epstein, he tended to think of the close-up as an effect of magnification. For an excellent point of comparison with Tanizaki, see Epstein, "Magnification and Other Writings."

23 Tanizaki, "The Present and Future of Moving Pictures," 68.

24 Tanizaki, "The Tumor with a Human Face," 99.

25 Ibid., 101.

26 Ogasawara, "*Katsudō no sekai* sōkan no toshi ni tsuite." In this article he discusses this transformation; he also suggests the translation "active world" for *katsudō no sekai*. Cinema was generally part of the new active world associated with Asakusa Park in the Taishō era. A special issue of *Chūō kōron* solicited impressions of the "three ĸs"—car, cinema, and café (*kuruma, kinema, kafee*)—in 1918, to which Tanizaki contributed an occasional essay called "Asakusa Park" ("Asakusa kōen").

27 Yamawaki, "Katsudōryoku naki nihon no fujin."

28 Kano, *Jiga no kanata e*, 7, cited in Sato, *The New Japanese Woman*, 42.

29 See, for instance, Sharon Sievers's account of the Bluestocking Society in *Flowers in Salt*.

30 Naturally, there were also bids for a "new man"; an insert accompanying Yamawaki's article elects Shibuzawa Danshaku as the exemplar of the new man in Japan. See Donald Roden's essay on the new woman and the new man in the general context of gender ambivalence and androgyny: "Taishō Culture and Gender Ambivalence." More recently, Miriam Silverberg has written on the café waitress as a sort of new agency in Taishō Japan, in "The Café Waitress Serving Modern Japan."

31 Sato, *The New Japanese Woman*, 76.

32 Ken Ito, in *Visions of Desire*, writes at length of Tanizaki's "Occidentalism." Emphasizing Japan's Occidentalism runs the risk of establishing parity between Japan's Occidentalism and the West's Orientalism, thus stripping the problem of Orientalism of the power dynamics that made an important site of analysis. Aptly, however, as Ito's discussion turns to Tanizaki's years in Kansai, he emphasizes the hybrid nature of Tanizaki's Oriental traditions.

33 See Shih, "Towards an Ethics of Transnational Encounters"; Chow, *The Age of the World Target*.

34 Tanizaki, "The Tumor with a Human Face," 86.

35 Tanizaki, *Nikukai*, TJZ 9: 66–67.

36 Ishikawa Seiko adopted the screen name Hayama Michiko. Later she used her married name, Wajima Sei.

37 I am indebted here to Bernardi's translation of *Amateur Club*, in *Writing in Light*, 269–99.

38 Tanizaki, *The Lust of the White Serpent*, 216.

39 Tanizaki, "Miscellaneous Observations on Cinema," 120.

40 Tanizaki, "Love and Sexual Desire," 330.

41 Ibid., 345.

42 The philosopher Watsuji Tetsurō's (1889–1960) *Fūdo* (*Culture and Climate*, 1935) was first drafted as a series of lectures in 1928–29 based on his travels abroad in 1927–28. Tanizaki and Watsuji had been friends since their schooldays. Indeed, Katsube Mitake's biography of young Watsuji, *Seishun no Watsuji Tetsurō*, is really a book about Tanizaki as well, detailing their friendship as students, their collaboration on the journal *Shinshichō*, and their careers and ideas till 1918. See also Tanizaki's "Wakaki hi no Watsuji Tetsurō." After his move to Kansai, Tanizaki and

his wife often socialized with the Watsujis, and Tanizaki's essays and stories show his familiarity with Watsuji's philosophy. Nevertheless, Tanizaki's essay is not a repetition of Watsuji's ideas. On the contrary, it shifts the logic of *Climate and Culture* into a pornographic register, where Watsuji's more Platonic and Kantian framework is undermined, much as in "Mr. Aozuka's Story." See chapter 21 in La-Marre, *Shadows on the Screen.*

43 Tanizaki, *In Praise of Shadows*, 9.
44 Tanizaki, "The Mermaid's Lament," 45–46.
45 Tanizaki, "Dokutan," *TJZ* 3: 243–44.
46 Tanizaki, "Miscellaneous Observations on Cinema," 120–21.
47 Tanizaki, *In Praise of Shadows*, 43.
48 Tanizaki, "The Present and Future of Moving Pictures," 68.

Abbas, Akbar. *Hong Kong: Culture and the Politics of Disappearance*. Minneapolis: University of Minnesota Press, 1997.

Alloula, Malek. *The Colonial Harem*. Minneapolis: University of Minnesota Press, 1986.

Anderson, Benedict. *Imagined Communities: Reflections on the Origin and Spread of Nationalism*. London: Verso, 1991.

———. *The Spectre of Comparisons: Nationalism, Southeast Asia, and the World*. New York: Verso, 1998.

———. "Studies of the Thai State: The State of Thai Studies." In *The Study of Thailand: Analyses of Knowledge, Approaches and Prospects in Anthropology, Art, Economics, History and Political Science*, ed. Eliezer Ayal Papers in International Studies, Southeast Asia Series, 54. Athens: Ohio University Center for International Studies, 1978, 193–247.

Baer, Ulrich. "Photography and Hysteria: Toward a Poetics of the Flash." *Yale Journal of Criticism* 7, no. 1 (1994): 41–77.

Barnes, A. C. *Schoolmaster Ni Huan-chih*. Beijing: Foreign Language Press, 1958.

Barthes, Roland. *Camera Lucida*. Trans. Richard Howard. New York: Noonday Press, 1981.

———. "The Photographic Message." In *Image Music Text*. Trans. Stephen Heath. New York: Noonday Press, 1977, 15–31.

Batchen, Geoffrey. *Each Wild Idea: Writing, Photography, History*. Cambridge, Mass.: MIT Press, 2001.

Baudrillard, Jean. *Photographies 1985–1998*. New York: Distributed Art Publishers, 1999.

Bell, Art. *The Art of Talk*, ed. Jennifer Osborn. New Orleans: Paper Chase Press, 1998.

Benjamin, Walter. "Critique of Violence." 1955. In *Reflections: Essays, Aphorisms, Autobiographical Writings*. Trans. Edmund Jephcott. New York: Schocken, 1978, 277–300.

———. "A Short History of Photography." 1931. In *One Way Street*. Trans. Edmund Jephcott and Kingsley Shorter. London: Verso, 1979, 230–57.

———. "The Work of Art in the Age of Mechanical Reproduction." In *Illumina-*

tions. Ed. Hannah Arendt. Trans. Edmund Jephcott. New York: Schocken, 1969, 217–51.

Bennett, Tony. *The Birth of the Museum.* New York: Routledge, 1995.

Bergala, Alain. "Weegee and Film Noir." In *Weegee's World*, ed. Miles Barth. New York: International Center of Photography, 1997, 69–77.

Bland, J. O. P. *China: The Pity of It.* London: William Heinemann, 1932.

Bordwell, David. *On the History of Film Style.* Cambridge, Mass.: Harvard University Press, 1997.

Boulger, D. C. "The Scramble for China." *Contemporary Review* 78 (1900): 1–10.

Bruce, Roger R. *Seeing the Unseen: Dr. Harold E. Edgerton and the Wonders of Strobe Alley.* Rochester, N.Y.: George Eastman House, 1994.

Cadava, Eduardo. *Words of Light: Theses on the Photography of History.* Princeton: Princeton University Press, 1997.

Cai, Fengyi, ed. *Guihua Lianpian 2* [A Series of Ghost Stories 2]. Taipei: Pingshi Publishing, 1996.

———. *Guihua Lianpian 3* [A Series of Ghost Stories 3]. Taipei: Pingshi Publishing, 1996.

Cazdyn, Eric. *The Flash of Capital: Film and Geopolitics in Japan.* Durham, N.C.: Duke University Press, 2002.

Céphas, Kassian. *Yogyakarta: Photography in the Service of the Sultan.* Leiden, Netherlands: KITLV Press, 1999.

Chang, Eileen [Zhang Ailing]. *Duizhao ji: Kan lao zhaoxiang bu* [Mutual Reflections: Reading Old Photographs]. In *Zhang Ailing quanji* [Complete Works of Zhang Ailing], vol. 15. Taipei: Huangguan, 1994.

———. "Reflections: Words and Pictures (Excerpts)." Trans. Janice Wickeri. *Renditions* 45 (1996): 13–24.

Chen Shi. *Wo kan lao yuefen pai* [My Reflections on Old Calendar Pictures]. Introduction to Song Jialin, *Lao yuefen pai* [Old Calendar Pictures]. Shanghai: Shanghai hauban chubanshe, 1997.

Chow, Rey. *The Age of the World Target: Self-Referentiality in War, Theory, and Comparative Work.* Durham, N.C.: Duke University Press, 2006.

Chu, Jou-juo. *Taiwan at the End of the 20th Century: The Gains and Losses.* Taipei: Tonsan, 2001.

Coedès, Georges. *Pour mieux comprendre Angkor: Cultes personnels et culte royal, monuments funéraires, symbolisme architectural, les grands souverains d'Angkor* [To Better Understand Angkor: Personal Cults and the Royal Cult, Funerary Monuments, Architectural Symbolism, the Great Rulers of Angkor]. Paris: Maisonneuve, 1947.

Darrah, William. *The World of Stereographs.* Gettysburg, Pa.: W. C. Darrah, 1977.

Davis, Sue. "Foreword." In *Floods of Light: Flash Photography 1851–1981*, ed. Rupert Martin. London: The Photographers' Gallery, 1982.

de Certeau, Michel. *Heterologies: Discourse of the Other.* Trans. Brian Massumi. Minneapolis: University of Minnesota Press, 1986.

————. *The Practice of Everyday Life*. Berkeley: University of California Press, 1984.

Denton, Kirk, ed. *Modern Chinese Literary Thought: Writings on Literature, 1893–1945*. Stanford: Stanford University Press, 1996.

Derrida, Jacques. "The Deaths of Roland Barthes." In *Philosophy and Non-Philosophy Since Merleau-Ponty*, ed. Hugh Silverman. New York: Routledge, 1988, 259–95.

————. *Of Grammatology*. Trans. Gayatri Chakravorty Spivak. Baltimore: Johns Hopkins University Press, 1997.

————. *Right of Inspection*, photographs by Marie-Françoise Plissart. New York: Monacelli Press, 1998.

————. *The Truth in Painting*. Trans. Geoffrey Bennington and Ian McLeod. Chicago: University of Chicago Press, 1987.

Edwards, Elizabeth ed. *Anthropology and Photography, 1850–1920*. New Haven: Yale University Press, Royal Anthropological Institute, 1992.

Epstein, Jean. "Magnification and Other Writings." Trans. Stuart Liebman. *October* 3 (1977): 9–31.

Farwell, Bryon. *Queen Victoria's Little Wars*. New York: Norton, 1972.

Faure, Bernard. "The Buddhist Icon and the Modern Gaze." *Critical Inquiry* 24, no. 2 (1998): 768–814.

Fitzgerald, John. *Awakening China: Politics, Culture, and Class in the Nationalist Revolution*. Stanford: Stanford University Press, 1996.

Fontein, Jan. "Kassian Céphas: A Pioneer of Indonesian Photography." In *Towards Independence: A Century of Indonesia Photographed*, ed. Jane Levy Reed. San Francisco: Friends of Photography, 1991, 44–52.

Frege, Gottlob. "On Sense and Reference." In *Translations of the Philosophical Writings of Gottlob Frege*, ed. Peter Geach and Max Black. Oxford: Blackwell, 1952, 56–78.

Freud, Sigmund. *Beyond the Pleasure Principle*. 1920–22. In *The Standard Edition of the Complete Works of Sigmund Freud*, vol. 18. Ed. and trans. James Strachey. London: Hogarth Press, 1955.

————. *Introductory Lectures on Psycho-Analysis*. 1916–17. In *The Standard Edition of the Complete Works of Sigmund Freud*, vols. 15 and 16. Ed. and trans. James Strachey. London: Hogarth Press, 1963.

————. "Jokes and their Relation to the Unconscious." 1905. In *The Standard Edition of the Complete Works of Sigmund Freud*, vol. 8. Ed. and Trans. James Strachey. London: Hogarth Press, 1958, 1–247.

————. "The 'Uncanny.'" 1919. In *The Standard Edition of the Complete Works of Sigmund Freud*, vol. 17. Ed. and trans. James Strachey. London: Hogarth Press, 1955, 217–56.

Freud, Sigmund, with J. Breuer. *Studies on Hysteria*. 1895. In *The Standard Edition of the Complete Works of Sigmund Freud*, vol. 2. Ed. and trans. James Strachey. London: Hogarth Press, 1953.

Fujitani, Takashi. *Splendid Monarchy: Power and Pageantry in Modern Japan*. Berkeley: University of California Press, 1996.

Geertz, Clifford. *The Religion of Java*. Chicago: University of Chicago Press, 1960.

Gerow, Aaron. *Visions of Japanese Modernity: Articulations of Cinema, Nation and Spectatorship 1895–1925*. Berkeley: University of California Press, forthcoming.

Gilroy, Paul. *Black Atlantic: Modernity and Double Consciousness*. Cambridge, Mass.: Harvard University Press, 1993.

Goodman, Nelson. *Languages of Art*. New York: Hackett, 1976.

Grey, Christine. "Thailand: The Soteriological State." Ph.D. diss., University of Chicago, 1986.

Groeneveld, Anneke. *Toekang Portret: 100 Jaar Fotografie in Nederlands Indie 1839–1939* [Photographer: 100 Years of Photography in the Netherlands Indies, 1839–1939]. Amsterdam: Fragment Uitgeverij, n.d.

Groneman, J. *De Garebeg's te Ngajogyakarta met photogrammen van Céphas* [The Garabeg Ritual in Jogjakarta with Photographs by Céphas]. The Hague: Martinus Nijhoff, 1895.

Guillot, Claude. "Un example d'assimilation à Java: Le photographe Kassian Céphas (1844–1912)" [An Example of Assimilation in Java: The Photographer Kassian Céphas (1844–1912)]. *Archipel* 22 (1982): 55–73.

Gunning, Tom. "Phantom Images and Modern Manifestations: Spirit Photography, Magic Theater, Trick Films, and Photography's Uncanny." In *Fugitive Images*, ed. Patrice Petro. Bloomington: Indiana University Press, 1995, 42–71.

Haraway, Donna. *Simians, Cyborgs and Women*. New York: Routledge, 1991.

Harootunian, Harry. *History's Disquiet: Modernity, Cultural Practice, and the Question of Everyday Life*. New York: Columbia University Press, 2000.

———. *Overcome by Modernity: History, Culture, and Community in Interwar Japan*. Princeton: Princeton University Press, 2000.

Headrick, Daniel. *The Tools of Empire*. New York: Oxford University Press, 1981.

Heesen, Anke te. *The World in a Box: The Story of an Eighteenth-Century Picture Encyclopedia*. Chicago: University of Chicago Press, 2002.

Heidegger, Martin. "The Age of the World Picture." In *The Question Concerning Technology and Other Essays*. Trans. William Lovitt. New York: Harper and Row, 1977, 115–54.

Hertz, Neil. *The End of the Line*. New York: Columbia University Press, 1985.

Hevia, James. *English Lessons: The Pedagogy of Imperialism in Nineteenth Century China*. Durham, N.C.: Duke University Press, 2003.

———. "Remembering the Century of Humiliation: The Yuanmingyuan and Dagu Museums." In *Ruptured Histories: War, Memory, and Post-Cold War Asia*, ed. Sheila Miyoshi Jager and Rana Mitter. Cambridge, Mass.: Harvard University Press, 2007, 192–208.

———. "Secret Archive: The India Army Intelligence Branch and 'Reconnaissance' in China, Central Asia, and Southeast Asia." Unpublished paper presented at the Barney Cohn Memorial Conference, University of Chicago, 13–14 May 2005.

Holmes, Oliver Wendell. "Doings of the Sunbeam." *Atlantic Monthly*, July 1863, 1–15; reprinted In *Soundings from the Atlantic*. Boston: Ticknor and Fields, 1864, 228–81.

———. "The Stereoscope and the Stereograph." *Atlantic Monthly*, June 1859; reprinted in *Soundings from the Atlantic*. Boston: Ticknor and Fields, 1864, 122–65.

———. "Sun Painting and Sun Sculpture." In *Soundings from the Atlantic*. Boston: Ticknor and Fields, 1864, 166–227.

Horkheimer, Max, and Theodor W. Adorno. *Dialectic of Enlightenment: Philosophical Fragments*. Trans. Edmund Jephcott. Stanford: Stanford University Press, 2002.

Huang'ai Dongxi. *Lao Guangzhou: Jisheng fanying* [Old Guangzhou: Clattering of Clogs, and the Shadows of Sails]. Nanjing: Jiangsu meishu chubanshe, 1999.

Huyssen, Andreas. *Twilight Memories: Marking Time in a Culture of Amnesia*. New York: Routledge, 1995.

Iijima, Tadashi. *Nihon eiga shi* [A History of Japanese Cinema]. 2 vols. Tokyo: Hakusuisha, 1955.

Iriye, Akira. *China and Japan in the Global Setting*. Cambridge, Mass.: Harvard University Press, 1992.

Ishii, Yoneo. *Sangha, State, and Society: Thai Buddhism in History*. Trans. Peter Hawkes. Honolulu: University of Hawaii Press, 1986.

Ito, Ken. *Visions of Desire: Tanizaki's Fictional Worlds*. Stanford: Stanford University Press, 1991.

Ivy, Marilyn. *Discourses of the Vanishing: Modernity, Phantasm, Japan*. Chicago: University of Chicago Press, 1995.

———. "Ghostlier Demarcations: Textual Fantasy and the Origins of Japanese Nativist Ethnology." In *Culture/Contexture: Readings in Anthropology and Literary Study*, ed. E. Valentine Daniel and Jeffrey M. Peck. Berkeley: University of California Press, 1996, 296–322.

Iwamoto, Kenji. *Gentō no seiki: eiga zenya no shikaku bunkashi* [Magic Lantern Century: A Cultural History of Pre-Cinematic Perception]. Tokyo: Shinwasha, 2002.

Jameson, Fredric. *Postmodernism, or, The Cultural Logic of Late Capitalism*. Durham, N.C.: Duke University Press, 1991.

Jia Pingwa. *Lao Xi'an: Fedu xieyang* [Old Xi'an: Evening Glow of an Imperial City]. Nanjing: Jiangsu meishu chuganshe, 1999.

Jussim, Estelle. *Visual Communication and the Graphic Arts: Photographic Technologies in the Nineteeth Century*. New York: R. R. Bowker, 1974.

Kanō, Mikiyo. *Jiga no kanata e—kindai o koeru feminizumu* [Going beyond the Self: Feminism beyond Modernity]. Tokyo: Shakai hyōronsha, 1990.

Kant, Immanuel. *Critique of Judgment*. Trans. Werner S. Pluhar. Indianapolis: Hackett, 1987.

Kantorowicz, Ernst. *The King's Two Bodies: A Study in Medieval Political Theology*. Princeton: Princeton University Press, 1957.

Kielstra, E. B. *Beschrijving van den Atjeh-Oorlog met gebruikmaking der officieele Bronnern, door het Departement van Koloniën daartoe afgestaan* [Description of the Atjeh War with Use of the Official Sources Given by the Colonial Department for That Purpose]. The Hague: De Gebroeders van Cleef, 1883.

Kipling, Rudyard. *Barrack-Room Ballads*. New York: Signet Classics, 2003.

Kirby, Lynne. *Parallel Tracks: The Railroad and Silent Cinema*. Durham, N.C.: Duke University Press, 1997.

Kittler, Friedrich. *Discourse Networks 1800/1900*. Trans. Michael Metteer with Chris Cullens. Foreword by David E. Wellbery. Stanford: Stanford University Press, 1990.

Kracauer, Siegfried. "Photography." 1927. In *The Mass Ornament: Weimar Essays*. Trans. Thomas Y. Levin. Cambridge, Mass.: Harvard University Press, 1995, 46–63.

Kraniauskas, Jon. "Beware Mexican Ruins! 'One-Way Street' and the Colonial Unconscious." In *Walter Benjamin's Philosophy: Destruction and Experience*, ed. Andrew Benjamin and Peter Osborne. London: Routledge, 1994, 139–54.

Krauss, Rosalind. *The Originality of the Avant-Garde and Other Modernist Myths*. Cambridge, Mass.: MIT Press, 1986.

———. "Photography's Discursive Spaces: Landscape/View." *Art Journal* 42, no. 4 (winter 1982): 319–31.

———. "Tracing Nadar." In *Illuminations: Women Writing on Photography from 1850 to the Present*, ed. Liz Heron and Val Williams. Durham, N.C.: Duke University Press, 1996, 39–40.

Krausse, Alexis. *Russia in Asia: A Record and a Study*. 1899. New York: Barnes and Noble Books, 1973.

———. *The Story of the China Crisis*. New York: Cassell, 1900.

Kripke, Saul. *Naming and Necessity*. Cambridge, Mass.: Harvard University Press, 1980.

Lacan, Jacques. *The Four Fundamental Concepts of Psycho-Analysis*. Trans. Alan Sheridan. Ed. Jacques-Alain Miller. New York: Norton, 1981.

LaMarre, Thomas. *Shadows on the Screen: Tanizaki Jun'ichirō on Cinema and "Oriental" Aesthetics*. Ann Arbor: University of Michigan Center for Japanese Studies, 2005.

Landor, Henry Savage. *China and the Allies*. 2 vols. New York: Scribner's, 1901.

Laplanche, J., and J.-B. Pontalis. *The Language of Psychoanalysis*. Trans. Donald Nicholson-Smith. New York: Norton, 1973.

———. *Life and Death in Psychoanalysis*. Trans. Jeffrey Mehlman. Baltimore: Johns Hopkins University Press, 1976.

Latour, Bruno. "Drawing Things Together." In *Representations in Scientific Practice*, ed. Michael Lynch and Steve Woolgar. Cambridge, Mass.: MIT Press, 1990, 16–68.

————. *The Pasteurization of France*. Cambridge, Mass.: Harvard University Press, 1988.

Learner's Chinese–English Dictionary. Revised ed. Singapore: Nayang Siang Pau and Umum, 1990.

Lee, Leo Ou-fan. *The Shanghai Modern*. Cambridge, Mass.: Harvard University Press, 1999.

Lee, Yu Ying. "'Dreams Come True'—Wedding Photography in Contemporary Taiwan." *Taiwan: A Radical Quarterly in Social Studies*, no. 36 (December 1999).

Liang Shih-chiu, ed. *A New Practical Chinese–English Dictionary*. Taipei: Far East Book Co., 1991.

Lin Xi. *Lao Tianjin: Jinmen jiushi* [Old Tianjin: Jin Gate and Old Events]. Nanjing: Jiangsu meishu chubanshe, 1998.

Lin, Yutang. *Chinese–English Dictionary of Modern Usage*. Available at http://human um.arts.cuhk.edu.hk, November 2001.

Lippit, Akira Mizuta. *Atomic Light (Shadow Optics)*. Minneapolis: University of Minnesota Press, 2005.

Liu, Lydia. *Translingual Practice: Literature, National Culture, and Translated Modernity—China, 1900–1937*. Stanford: Stanford University Press, 1995.

Lu Xun. "Lun zhaoxiang zhi lei" [On Photography and Related Matters]. In *Lu Xun Quanji* [Complete Works of Lu Xun]. Beijing: Renmin Chubanshe, 1981, 181–90.

Lucas, Christopher. *James Ricalton's Photographs of China during the Boxer Rebellion*. Lewiston, Maine: Edwin Mellen Press, 1990.

MacKenzie, John. *Propaganda and Empire*. Manchester: Manchester University Press, 1986.

Makino, Mamoru, ed. *Nihon eiga shoki shiryō shūsei* [A Compendium of Early Japanese Cinema Documents]. 14 vols. Tokyo: Sanichi shobō, 1992.

Marin, Louis. "Establishing a Signification for Social Space: Demonstration, Cortege, Parade, Procession." 1994. In *On Representation*. Trans. Catherine Porter. Stanford: Stanford University Press, 2001, 14–37.

————. *Le portrait-du-roi en naufragé: Pascale, Premier Discourse sur la condition des Grands, parabole* [The Portrait-of-the-King in Ruins: Pascale, the First Discourse on the Condition of Great Men, Parable]. In *Des Pouvoirs de l'image: Glosses* [Powers of the Image: Glosses]. Paris: Editions du Seuil, 1993, 186–95.

————. *Portrait of the King*. Trans. Martha Houle. Introduction by Tom Conley. 1981. Minneapolis: University of Minnesota Press, 1988.

Martin, Rupert. "Introduction: Angels of Darkness." In *Floods of Light: Flash Photography, 1851–1981*, ed. Rupert Martin. London: Photographers' Gallery, 1982.

Martin, Rupert, ed. *Floods of Light: Flash Photography, 1851–1981*. London: Photographers' Gallery, 1982.

Marx, Karl. *Capital: A Critique of Political Economy*. Trans. Samuel Moore and Adword Aveling. Ed. Frederick Engels. New York: Modern Library, 1906.

————. *Grundrisse*. Trans. David McLellan. New York: Harper and Row, 1972.

Mauss, Marcel. *General Theory of Magic*. 1950. Trans. Robert Brian. New York: Routledge, 1972.

Mellor, David. "The Regime of Flash." in *Floods of Light: Flash Photography, 1851–1981*, ed. R. Martin. London: Photographers' Gallery, 1982, 28–32.

Metz, Christian. "Photography and Fetish." In *The Critical Image: Essays on Contemporary Photography*, ed. Carol Squiers. Seattle: Bay Press, 1990, 155–64.

Military Order of the Dragon, 1901–1911. Washington, D.C.: Press of B. S. Adams, ca. 1912.

Mitake, Katsube. *Seishun no Watsuji Tetsurō* [The Young Watsuji Tetsurō]. Tokyo: Chûōkōron, 1987.

Mitchell, Timothy. *Colonizing Egypt*. Berkeley: University of California Press, 1988.

Miyoshi, Masao. *Accomplices of Silence: The Modern Japanese Novel*. Berkeley: University of California Press, 1974.

Moore, Rachel. "Marketing Alterity." *Visual Anthropology Review* 8, no. 2 (fall 1992): 16–26.

Moriyama, Daidō. *Tōno monogatari* [Tales of Tōno]. Tokyo: Asahi Sonorama, 1976.

Morris, Rosalind C. "Giving up Ghosts: Notes on Trauma and the Possibility of the Political in Southeast Asia." *positions* 16, no. 1, Special issue on "War Capital Trauma," ed. Tani Barlow and Brian Hammer, spring 2008, 209–37.

————. *In the Place of Origins: Modernity and Its Mediums in Northern Thailand*. Durham, N.C.: Duke University Press, 2000.

————. "Intimacy and Corruption in Thailand's Age of Transparency." In *Off Stage, On Display: Intimacy and Ethnography in the Age of Public Culture*, ed. Andrew Shryock. Stanford: Stanford University Press, 2004, 225–43.

————. "Surviving Pleasure at the Periphery: Chiang Mai and the Photographies of Political Trauma in Thailand, 1976–1992." *Public Culture* 10, no. 2 (1995): 341–70.

Mrázek, Rudolf. "From Darkness to Light: Optics of Policing in Late-Colonial Netherlands East Indies." In *Figures of Criminality in Indonesia, the Philippines, and Colonial Vietnam*, ed. Vicente Rafael. Ithaca, N.Y.: Cornell University Southeast Asia Program, 1999, 23–46.

Naitō, Masatoshi. *Nihon "ikai" hakken* [The Discovery of Japan's "Other World"]. Tokyo: JTB Shuppan, 1998.

————. *Nihon no miira shinkō* [Mummy Beliefs in Japan]. Tokyo: Hōzōkan, 1999.

————. *Tōkyō — Toshi no yami o genshi suru: Naitō Masatoshi shashinshū* [Tokyo — Hallucinating the Darkness of the City: The Collected Works of Naitō Masatoshi]. Tokyo: Meicho Shuppan, 1985.

————. "Tokyo: A Vision of Its Other Side." Trans. Kazue Kobata and Arturo Silva in Naitō, *Tōkyō — Toshi no yami o genshi suru: Naitō Masatoshi shashinshū* [Tokyo — Hallucinating the Darkness of the City: The Collected Works of Naitō Masatoshi]. Tokyo: Meicho Shuppan, 1985.

————. *Tōno monogatari: Naitō Masatoshi shashinshū* [The Tales of Tōno: The Collected Photographs of Naitō Masatoshi]. Tokyo: Shunseisha, 1983.

Natsume, Soseki. "Letter: April 10, 1901." In *Sōseki ʒenshū*. 18 vols. Tokyo: Iwanami shoten 1966–87, 13: 86.

Negri, Antonio, and Michael Hardt. *Multitude: War and Democracy in the Age of Empire*. New York: Penguin, 2004.

Nieuwenhuis, C. *Expeditie naar Samalanga: Dagverhaal van een Fotograaf te velde* [Expedition to Samalanga: Diary of a Photographer in the Field]. Amsterdam: Van Holkema and Warendorf, n.d.

Nieuwenhuys, R. *Met vreemde ogen: Tempo doeloe — een verʒonken wereld: fotografische documenten uit het oude Indië 1870–1920* [With Foreign Eyes: *Tempo Doeloe* — a Submerged World: Photographic Documents from the Old Indies]. Amsterdam: Querido, 1988.

Nitthi Aersiwongse. "Lathipetthi Sadet Phor Rama" [Beliefs and Rituals Regarding the Royal Father Rama V]. *Silapa Watthanatham* [Arts and Culture] 14, no.10 (1993): 78–102.

Ogasawara, Takeo. "*Katsudō no sekai* sōkan no toshi ni tsuite." In *Nihon eiga shoki shiryō shūsei* [Collected Materials on Early Japanese Film], ed. Makino Mamoru. Tokyo: Sanichi shobō, 1992, 3: 1–17.

Parker, Elliott S. "John Thomson, 1837–1921: RGS Instructor in Photography." *Geographical Journal* 144, no. 3 (November 1978): 463–71.

Pazderic, Nickola. "Recovering True Selves in the Electro-Spiritual Field of Universal Love." *Cultural Anthropology* 19, no. 2 (2004): 196–225.

Peirce, Charles Sanders. "Logic as Semiotic: The Theory of Signs." In *Philosophical Writings of Peirce: Selected Writings*, ed. Justus Buchler. New York: Harcourt, Brace, 1986, 78–104.

Pemberton, John. "Disorienting Culturalist Assumptions: A View from 'Java.'" In *In Near Ruins: Cultural Theory at the End of the Century*, ed. Nicholas Dirks. Minneapolis: University of Minnesota Press, 1998, 119–46.

———. *On the Subject of "Java."* Ithaca, N.Y.: Cornell University Press, 1994.

Phillips, Sandra S., Alexandra Munroe, and Daidō Moriyama. *Daido Moriyama: Stray Dog*. San Francisco: San Francisco Museum of Modern Art, 1999.

Pinney, Christopher. *Camera Indica: The Social Life of Indian Photographs*. Chicago: University of Chicago Press, 1997.

Poll, Jan. "Op een Suikerfabriek" [At a Sugar Factory]. In *Zóó Leven Wij in Indië* [How We Live in the Indies]. Amsterdam: W. van Hoeve, 1945, 148–71.

Qian Zhangbio et al., eds. *Zhongguo sheying shi: 1840–1937* [A History of Chinese Photography: 1840–1937]. Beijing: Zhongguo sheying chubanshe, 1987.

Rafael, Vicente L. *White Love and Other Events in Filipino History*. Durham, N.C.: Duke University Press, 2000.

Ricalton, James. *Pekin*. New York: Underwood and Underwood, 1902.

Richards, Thomas. *The Imperial Archive: Knowledge and the Fantasy of Empire*. London: Verso, 1993.

Roden, Donald. "Taishō Culture and Gender Ambivalence." In *Culture and Iden-*

tity: Japanese Intellectuals in the Interwar Years, ed. J. Thomas Rimer. Princeton: Princeton University Press, 1990, 36–55.

Rojas, Carlos. "Flies' Eyes, Mural Remnants, and Jia Pingwa's Perverse Nostalgia." *positions: East Asian Critique* 14, no. 3 (2006): 749–73.

————. "The Great Wall of China and the Bounds of Signification." *Connect: Art, Politics, Theory, Practice* 2, no. 2 (spring 2002): 49–58.

Rony, Fatimah Tobing. *The Third Eye: Race, Cinema, and Ethnographic Spectacle*. Durham, N.C.: Duke University Press, 1996.

Rosen, Philip. *Change Mummified: Cinema, Historicity, Theory*. Minneapolis: University of Minnesota Press, 2001.

Ross, Kristin. *Fast Cars, Clean Bodies: Decolonialization and the Reordering of French Culture*. Cambridge, Mass.: MIT Press, 1995.

Ryan, James R. *Picturing Empire: Photography and the Visualization of the British Empire*. Chicago: University of Chicago Press, 1997.

Ryle, Gilbert. *The Concept of Mind*. New York: Barnes and Noble, 1949.

Said, Edward. *Orientalism*. New York: Pantheon, 1978.

Sand, Jordan. "Was Meiji Taste in Interiors 'Orientalist'?" *positions* 8, no. 3 (2000): 637–74.

Sato, Barbara. *The New Japanese Woman: Modernity, Media, and Women in Interwar Japan*. Durham, N.C.: Duke University Press, 2003.

Schivelbusch, Wolfgang. *Disenchanted Night: The Industrialization of Light in the Nineteenth Century*. Berkeley: University of California Press, 1995.

————. *The Railway Journey: The Industrialization of Time and Space in the 19th Century*. Berkeley: University of California Press, 1986.

Sekula, Allan. "The Traffic in Photographs." *Art Journal* 41, no. 1 (spring 1981): 15–25.

Sharf, Frederic, and Peter Harrington. *China, 1900: The Eyewitnesses Speak*. London: Greenhill Books, 2000.

Shih Shu-mei. "Towards an Ethics of Transnational Encounters, or, 'When' Does a 'Chinese' Woman Become a 'Feminist'?" In *Minor Transnationalism*, ed. Françoise Lionnet and Shu-mei Shih. Durham, N.C.: Duke University Press, 2005, 73–108.

Shinoku Pekin kojo shashincho [Photographs of Palace Buildings of Peking]. Tokyo: Ogawa Kazume Shuppanhu, 1906.

Siegel, James T. *Fetish, Recognition, Revolution*. Princeton: Princeton University Press, 1997.

————. *The Rope of God*. 1969. Revised ed. Ann Arbor: University of Michigan Press, 2000.

————. *Shadow and Sound: The Historical Thought of a Sumatran People*. Chicago: University of Chicago Press, 1979.

————. *Solo in the New Order: Language and Hierarchy*. Princeton: Princeton University Press, 1986.

Sievers, Sharon. *Flowers in Salt: The Beginnings of Feminist Consciousness in Modern Japan*. Stanford: Stanford University Press, 1983.

Silverberg, Miriam. "The Café Waitress Serving Modern Japan." In *Mirror of Modernity: Invented Traditions of Modern Japan*, ed. Stephen Vlastos. Berkeley: University of California Press, 1998, 208–25.

Simmel, Georg. "The Metropolis and Mental Life." In *The Sociology of Georg Simmel*. Trans. Kurt H. Wolff. New York: Free Press, 1950, 409–24.

Singer, Ben. *Melodrama and Modernity: Early Sensational Cinema and Its Contexts*. New York: Columbia University Press, 2001.

Sirén, Osvald. *The Imperial Palaces of Peking*. 1926. New York: AMS Press, 1976.

Smith, Arthur. H. *China in Convulsion*. 2 vols. New York: Fleming H. Revell, 1901.

———. *Chinese Characteristics*. 1894. Port Washington, N.Y.: Kennikat Press, 1970.

Soames, Scott. *Beyond Rigidity: The Unfinished Semantic Agenda of Naming and Necessity*. Oxford: Oxford University Press, 2002.

Sontag, Susan. *On Photography*. New York: Farrar, Straus and Giroux, 1977.

Spivak, Gayatri Chakravorty. "Can the Subaltern Speak?" In *Marxism and the Interpretation of Cultures*, ed. Cary Nelson and Lawrence Grossberg. Urbana: University of Illinois Press, 1988, 271–313.

Springhall, John. "'Up Guards and at Them!' British Imperialism and Popular Art, 1880–1914." In *Imperialism and Popular Culture*, ed. John MacKenzie. Manchester: Manchester University Press, 1989, 49–72.

Spyer, Patricia. "The Cassowary Will (Not) be Photographed: The 'Primitive,' the 'Japanese,' and the Elusive 'Sacred' (Aru, Southeast Moluccas)." In *Religion and Media*, ed. Hent de Vries and Samuel Weber. Stanford: Stanford University Press, 2001, 304–19.

———. *The Memory of Trade: Modernity's Entanglements on an Eastern Indonesian Island*. Durham, N.C.: Duke University Press, 2000.

———. "Photography's Framings and Unframings: A Review Essay." *Comparative Studies in Society and History* 43, no. 1 (2000): 181–92.

———. "ZAMAN BELANDA: Song and the Shattering of Speech in Aru, Eastern Indonesia." *Indonesia* 70 (2000): 52–70.

Szarkowski, John, and Shoji Yamagishi. *New Japanese Photography*. New York: Museum of Modern Art, 1974.

Tagg, John. *The Burden of Representation*. Minneapolis: University of Minnesota Press, 1988.

Talbot, William Henry Fox. *Pencil of Nature*. New York: Da Capo, 1969.

Tambiah, Stanley J. *The Buddhist Saints of the Forest and the Cult of Amulets: A Study in Charisma, Hagiography, Sectarianism, and Millennial Buddhism*. Cambridge: Cambridge University Press, 1984.

———. *World Conqueror and World Renouncer: A Study of Buddhism and Polity in Thailand against a Historical Background*. Cambridge: Cambridge University Press, 1976.

Tanaka, Jun'ichirō. *Nihon eiga hattatsu shi* [The History of the Development of Japanese Film]. Tokyo: Chūō kōronsha, 1957.

Tanizaki, Jun'ichirō. *Amachua Kurabu* [The Amateur Club]. *Katsudō ʒasshi* [Motion Picture Journal] 7, no. 6 (June 1921): 150–55; no. 7 (July 1921): 140–47; no. 8 (August 1921): 134–38; no. 9 (September 1921): 136–40; no. 10 (October 1921): 108–9.

———. *Amateur Club*. Trans. Joanne R. Bernardi. In *Writing in Light: The Silent Scenario and the Japanese Pure Film Movement*. Detroit: Wayne State University Press, 2001, 269–99.

———. *Dokutan* [The German Spy]. In *Taniʒaki Jun'ichirō ʒenshū* [Collected Works of Tanizaki Jun'ichirō]. 30 vols. Tokyo: Chūō kōronsha, 1981–83, 3: 243–44.

———. *Hina matsuri no yoru* [The Night of the Doll Festival]. In *Taniʒaki Jun'ichirō ʒenshū* [Collected Works of Tanizaki Jun'ichirō]. 30 vols. Tokyo: Chūō kōronsha, 1981–83, 9: 409–26.

———. *In Praise of Shadows*. Trans. Thomas J. Harper and Edward G. Seidensticker. Stony Creek, Conn.: Leete's Island Books, 1977.

———. *Jasei no in* [The Lust of the White Serpent]. In *Taniʒaki Jun'ichirō ʒenshū* [Collected Works of Tanizaki Jun'ichirō]. 30 vols. Tokyo: Chūō kōronsha, 1981–83, 8: 149–222.

———. "Love and Sexual Desire." In *Shadows on the Screen: Taniʒaki Jun'ichirō on Cinema and "Oriental" Aesthetics*, ed. and trans. Thomas LaMarre. Ann Arbor: University of Michigan Center for Japanese Studies, 2005, 319–55.

———. *The Lust of the White Serpent*. In *Shadows on the Screen: Taniʒaki Jun'ichirō on Cinema and "Oriental" Aesthetics*, ed. and trans. Thomas LaMarre. Ann Arbor: University of Michigan Center for Japanese Studies, 2005, 179–236.

———. "The Mermaid's Lament." In *Shadows on the Screen: Taniʒaki Jun'ichirō on Cinema and "Oriental" Aesthetics*, ed. and trans. Thomas LaMarre. Ann Arbor: University of Michigan Center for Japanese Studies, 2005, 45–46.

———. "Miscellaneous Observations on Cinema." In *Shadows on the Screen: Taniʒaki Jun'ichirō on Cinema and "Oriental" Aesthetics*, ed. and trans. Thomas LaMarre. Ann Arbor: University of Michigan Center for Japanese Studies, 2005, 120–30.

———. "Mr. Aozuka's Story." In *Shadows on the Screen: Taniʒaki Jun'ichirō on Cinema and "Oriental" Aesthetics*, ed. and trans. Thomas LaMarre. Ann Arbor: University of Michigan Center for Japanese Studies, 2005, 276–305.

———. *Night of the Doll Festival*. Trans. Thomas LaMarre. In *Shadows on the Screen: Taniʒaki Jun'ichirō on Cinema and "Oriental" Aesthetics*, ed. Thomas LaMarre. Ann Arbor: University of Michigan Center for Japanese Studies, 2005,

———. *Nikukai* [A Lump of Flesh]. In *Taniʒaki Jun'ichirō ʒenshū* [Collected Works of Tanizaki Jun'ichirō]. 30 vols. Tokyo: Chūō kōronsha, 1981–83, 9: 66–67.

———. *Onna no kao* [A Woman's Face]. In *Taniʒaki Jun'ichirō ʒenshū* [Collected Works of Tanizaki Jun'ichirō]. 30 vols. Tokyo: Chūō kōronsha, 1981–83, 22: 124–25.

————. "The Present and Future of Moving Pictures." In *Shadows on the Screen: Taniȥaki Jun'ichirō on Cinema and "Oriental" Aesthetics*, ed. and trans. Thomas LaMarre. Ann Arbor: University of Michigan Center for Japanese Studies, 2005, 65–74.

————. "Tōkyō o omou" [Thinking of Tokyo]. In *Taniȥaki Jun'ichirō ȥenshū* [Collected Works of Tanizaki Jun'ichirō]. 30 vols. Tokyo: Chūō kōronsha, 1981–83.

————. "The Tumor with a Human Face." In *Shadows on the Screen: Taniȥaki Jun'ichirō on Cinema and "Oriental" Aesthetics*, ed. and trans. Thomas LaMarre. Ann Arbor: University of Michigan Center for Japanese Studies, 2005, 86–102.

————. "Wakaki hi no Watsuji Tetsurō" [Early Days with Watsuji Tetsurō]. *Kokoro* (March 1961): 82–86.

————. "A Woman's Face." In *Shadows on the Screen: Taniȥaki Jun'ichirō on Cinema and "Oriental" Aesthetics*, ed. and trans. Thomas LaMarre. Ann Arbor: University of Michigan Center for Japanese Studies, 2005, 264–65.

Taussig, Michael. *Defacement: Public Secrecy and the Labor of the Negative*. Stanford: Stanford University Press, 1999.

Thanet Aphornsuvan. "Origins of the Malay Muslim 'Separatism' in Southern Thailand." Asia Research Institute, Working Paper Series No. 32. Singapore: National University of Singapore, 2004.

Thomson, John. *Illustrations of China and Its People, a series of two hundred photographs with letterpress description of the places and people represented*. 4 vols. London: Sampson Low, Marston, Low, and Searle, 1873–74.

————. "Photographic Chemicals and Apparatus." In *Vocabulary and Handbook of the Chinese Language*, Section 27, 1870(?).

————. "Three Pictures of Wong-nei-chung." *China Magaȥine*, August 1868, 52–56.

Topley, Marjorie. "Marriage Resistance in Rural Kwangtung." In *Women in Chinese Society*, ed. Margery Wolf and Roxane Witke. Stanford: Stanford University Press, 1975, 67–88.

Trachtenberg, Alan. *The Incorporation of America*. New York: Hill and Wang, 1982.

Tsuchiya, Kenji. "Javanology and the Age of Ronggowarsita: An Introduction to Nineteenth-Century Javanese Culture." In *Reading Southeast Asia*, ed. Takashi Shiraishi. Ithaca, N.Y.: Cornell University Southeast Asia Program, 1990.

Unique Photographs of the Execution of Boxers in China. Brighton: Visitors' Inquiry Association, n.d.

U.S. War Department. *Reports on Military Operations in South Africa and China*. Washington: U.S. Government Printing Office, 1901.

van der Linden, Liane. "Inleiding" [Introduction] to Anneke Groeneveld, *Toekang Portret: 100 Jaar Fotografie in Nederlands Indie 1839–1939* [Photographer: 100 Years of Photography in the Netherlands Indies, 1839–1939]. Amsterdam: Fragment Uitgeverij, n.d.

Vernant, Jean-Pierre. *Mortals and Immortals: Collected Essays*. Ed. Froma I. Zeitlin. Princeton: Princeton University Press, 1991.

Wakeman, Fredrick, Jr. "Mao's Remains." In *Death Ritual in the Late Imperial and Modern China*, ed. James L. Watson and Evelyn S. Rawnski. Berkeley: University of California Press, 1988, 254–86.

The Warmth Modern Chinese–English Dictionary. Beijing: Beijing waiyu jiaoxue yu yanjiu chuban shebian, 1997.

Watsuji, Tetsurō. *Fūdō* [Culture and Climate]. 1935. Translated by Geoffery Bown as *Climate and Culture: A Philosophical Study*. Tokyo: Hokuseido Press, 1961.

Weber, Samuel. *Mass Mediauras: Form, Technics, Media*. Stanford: Stanford University Press, 1996.

White, Stephen. *John Thomson: A Window on the Orient*. Preface by Robert A. Sobiezsk. London: Thames and Hudson, 1895.

Wu Liang. *Lao Shanghai: Yishi de Shiguang* [Old Shanghai: Light That Has Already Faded]. Nanjing: Jiangsu meishu chubanshe, 1998.

Xie, Huizhen, and He Jinyun. *Yue ye yue kongbu* [The More Night, the More Frightening]. Taipei: Pingan Wenhua, 1997.

Xu Chengbei. *Lao Beijing: Didu yiyun* [Old Beijing: In the Shadow of the Imperial Throne]. Nanjing: Jiangsu chubanshe, 1998.

Yamawaki, Fusako. "Katsudōryoku naki nihon no fujin" [The Lack of Dynamism among Japanese Women]. *Katsudō no sekai* [Motion World] 1 (January 1916): 102–5 (facsimile page numbers).

Yanagita, Kunio. *The Legends of Tōno*. Trans. Ronald Morse. Tokyo: Japan Foundation, 1975.

Ye Shengtao. *Ni Huanzhi* [Schoolmaster Ni Huanzhi]. Beijing: Renmin wenxue chubanshe, 1953.

Ye Zhaoyan. *Lao Nanjing: Jiuying qinhuai* [Old Nanjing: Reflections of Scenes on the Qinhuai River]. Nanjing: Jiangsu meishu chubanshe, 1998.

Zeitlin, Judith, "Making the Invisible Visible: Portraits of Desire and Constructions of Death in Sixteenth and Seventeenth-Century China." In *Crossing Boundaries, Attending to Early Modern Women*, ed. Jane Donawerth and Adele Seeff. Newark: University of Delaware Press, 2000, 48–79.

Zentgraaff, H. C. *Atjeh*. Batavia, Indonesia: Koninklijke Drukkerij de Unie, n.d.

Zweers, Louis. *Sumatra: Kolonialen, Koelies, en Krijgers: Met vele unieke foto's* [Colonials, Coolies, Soldiers: With Many Unique Photos]. Houten, Netherlands: Fibula, 1988.

JAMES L. HEVIA is director of the International Studies Program at the University of Chicago. He has written several articles on aspects of European imperialism in East Asia and is the author of *English Lessons: The Pedagogy of Imperialism in Nineteenth Century China* (2003). His current research is on British India Army intelligence in Central and East Asia.

MARILYN IVY teaches anthropology at Columbia University. She is the author of *Discourses of the Vanishing: Modernity, Phantasm, Japan* (1995). Her recent writings focus on media, art, youth, and neonationalism in contemporary Japan.

THOMAS LAMARRE teaches in East Asian Studies and Art History and Communications Studies at McGill University. His books include *Shadows on the Screen: Tani ̣aki Jun'ichirō on Cinema and Oriental Aesthetics* (2005), *Uncovering Heian Japan: An Archaeology of Sensation and Inscription* (2000), and *Difference in Motion: How Anime Thinks Technology* (forthcoming).

ROSALIND C. MORRIS is a professor of anthropology and associate director of the Institute for Comparative Literature and Society at Columbia University. She is the author of *In the Place of Origins: Modernity and Its Mediums in Northern Thailand* (2000) and *New Worlds from Fragments: Film, Ethnography, and the Representation of Northwest Coast Cultures* (1994) as well as essays on the media, the politics of representation, gender, and sexuality. She is a member of the editorial board of *positions* and a former editor (with Radhika Subramaniam) of *connect: art, culture, theory, politics*.

NICKOLA PAZDERIC is a cultural anthropologist. He has taught at the University of Washington, Yale University, and several universities in Taiwan. He has written on contemporary religion, media transformation, photography, and neoliberal economics and tertiary education in Taiwan. He resides with his family in Seattle.

JOHN PEMBERTON teaches anthropology at Columbia University and is author of *On the Subject of "Java"* (1994). He is currently writing on Javanese

shadow-theater, possession, and the twin specters of time and coincidence. His current research also includes work on music, performance, and the craft of transmission.

CARLOS ROJAS is an assistant professor of modern Chinese cultural studies at Duke University. He is author of *The Naked Gaze: Reflections on Chinese Modernity* (2008); editor (with David Der-wei Wang) of *Writing Taiwan: A New Literary History* (Duke, 2006); and editor (with Eileen Cheng-yin Chow) of *Rethinking Chinese Popular Culture: Cannibalizations of the Canon* (forthcoming).

JAMES T. SIEGEL is a professor of anthropology and Asian studies at Cornell University. He has published several books, mainly on various topics concerning Indonesia. Until recently he was the associate editor of the journal *Indonesia*. He should not be confused with the person of the same name who is an advertising agency executive and the author of thrillers.

PATRICIA SPYER holds the chair of Cultural Anthropology of Contemporary Indonesia at Leiden University and is Global Distinguished Professor at New York University's Center for Religion and Media and Department of Anthropology. She is the author of *The Memory of Trade: Modernity's Entanglements on an Eastern Indonesian Island* (Duke, 2000), editor of *Border Fetishisms: Material Objects in Unstable Spaces* (1998), and co-editor of the *Handbook of Material Culture* (2006). She has published, among other topics, on violence, media and photography, historical consciousness, materiality, and religion. Her current project, *Orphaned Landscapes*, focuses on the mediations of violence and postviolence in the aftermath of the recent religiously inflected conflict in the Moluccas, Indonesia. An edited volume, *Images that Move*, with Mary Steedly of Harvard University is forthcoming with the School of Advanced Research Press.

Rosalind C. Morris is a professor of anthropology and associate director of the Institute for Comparative Literature and Society at Columbia University. She is the author of *In the Place of Origins: Modernity and Its Mediums in Northern Thailand* (2000) and *New Worlds from Fragments: Film, Ethnography, and the Representation of Northwest Coast Cultures* (1994) as well as essays on the media, the politics of representation, gender, and sexuality. She is a member of the editorial board of *positions* and a former editor (with Radhika Subramaniam) of *connect: art, culture, theory, politics.*

Library of Congress Cataloging-in-Publication Data
Photographies East : the camera and its histories in East and Southeast Asia / edited by Rosalind C. Morris.
p. cm. — (Objects/histories : critical perspectives on art, material culture, and representation)
Includes bibliographical references and index.
ISBN 978-0-8223-4188-8 (cloth : alk. paper) — ISBN 978-0-8223-4205-2 (pbk. : alk. paper)
1. Photography — Social aspects — East Asia. 2. Photography — Social aspects — Southeast Asia. 3. Photography — East Asia — History. 4. Photography — Southeast Asia — History.
5. East and West. I. Morris, Rosalind C. II. Series: Objects/histories.
TR183.P4825 2009
770.95 — dc22 2008048055